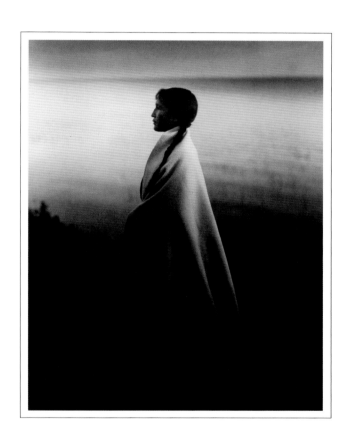

WOMEN

THE **NATIONAL GEOGRAPHIC**
IMAGE COLLECTION

INTRODUCTION BY SUSAN GOLDBERG
EDITOR IN CHIEF OF *NATIONAL GEOGRAPHIC* MAGAZINE

NATIONAL GEOGRAPHIC
WASHINGTON, D.C.

A woman walks across a sidewalk in Toronto, Canada. *Sam Abell, 1978*

Page 1: A portrait of an Ojibway, or Chippewa, woman in Minnesota *Roland W. Reed, 1907*

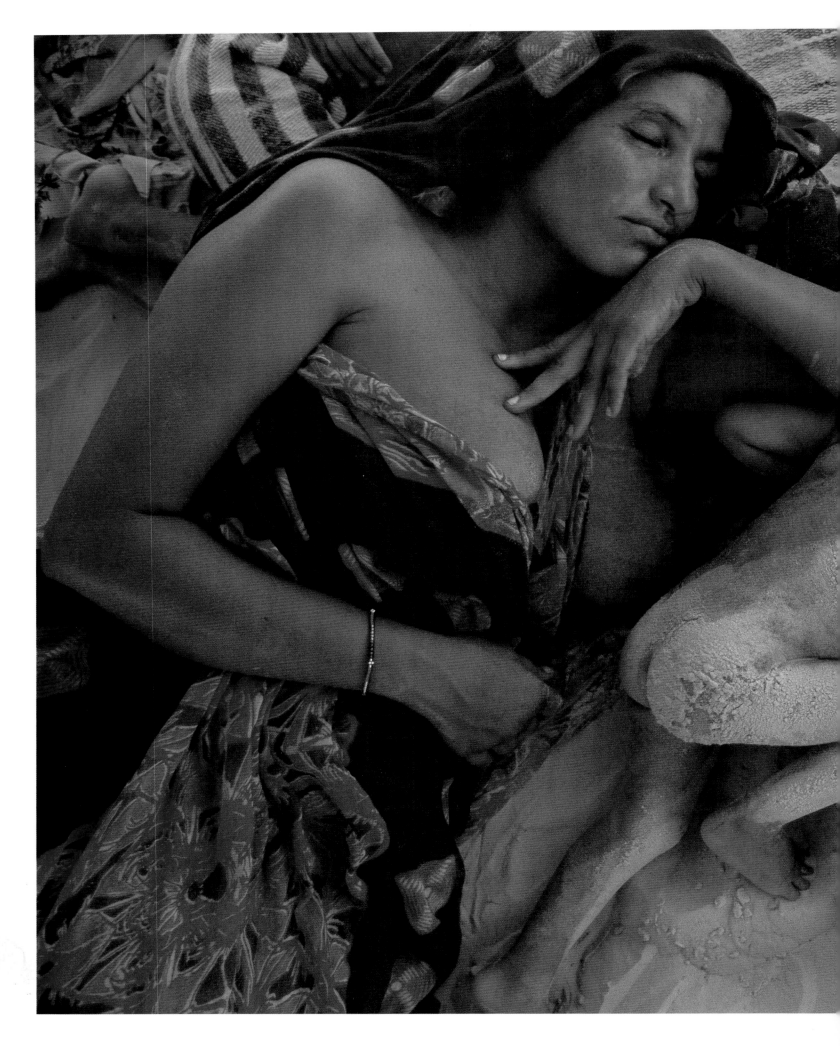

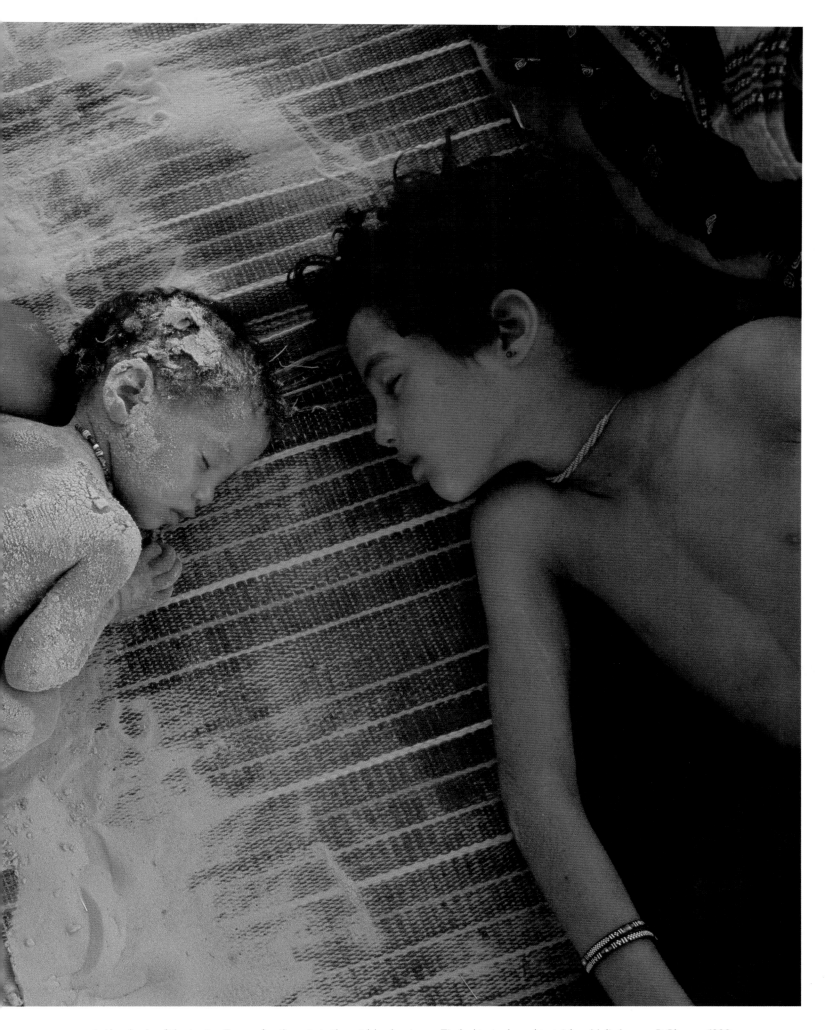

In the shade of the tent, a Tuareg family rests in the midday heat near Timbuktu in drought-stricken Mali. *Joanna B. Pinneo, 1998*

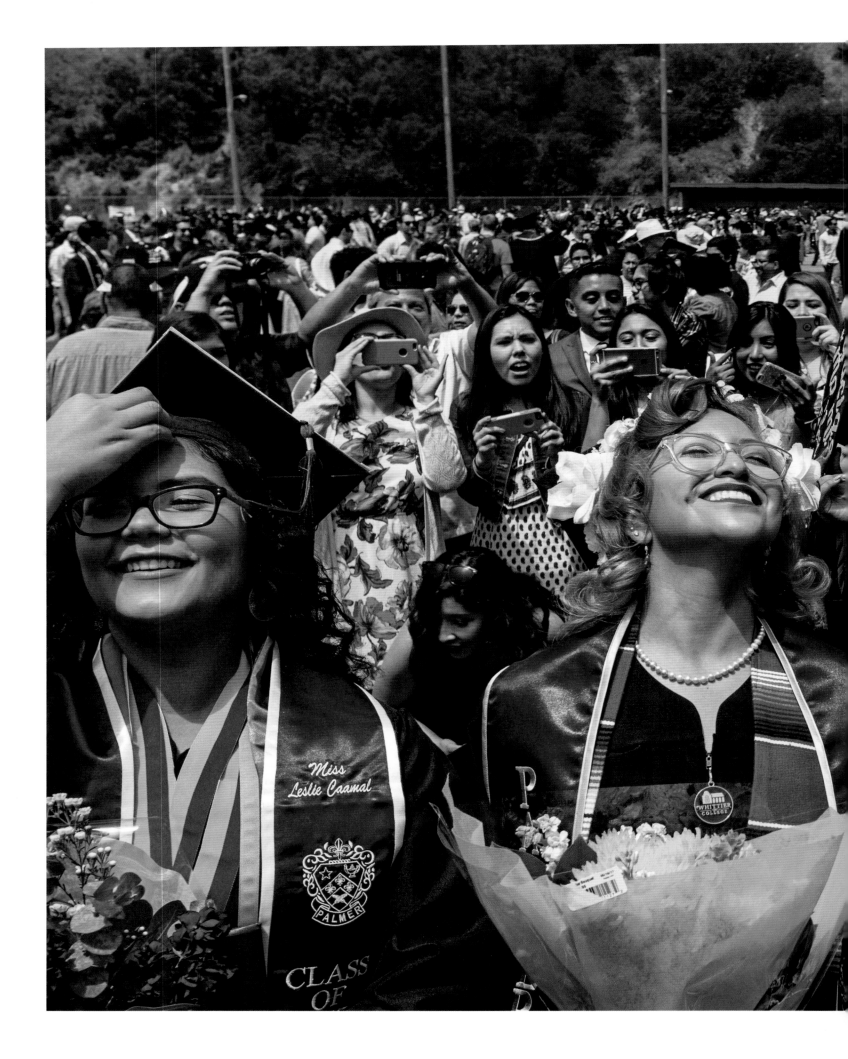

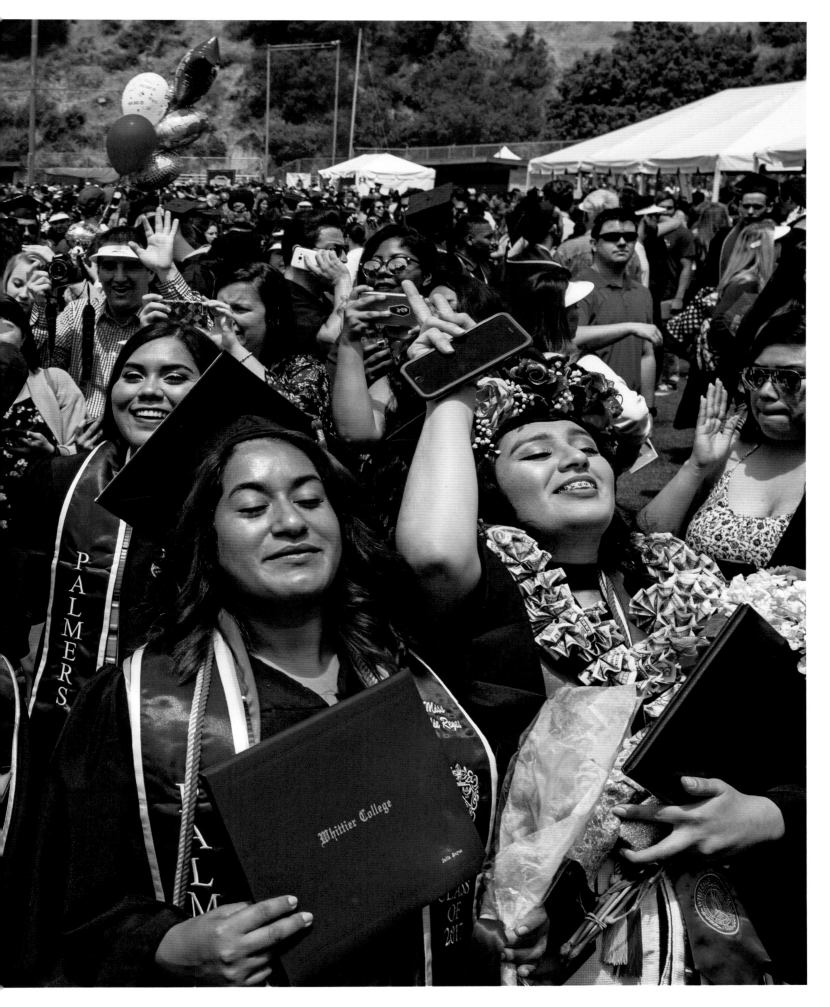

Members of the Palmer Society, a campus women's organization, enjoy graduation day at Whittier College, one of the most diverse universities in the United States. *Karla Gachet and Ivan Kashinsky, 2017*

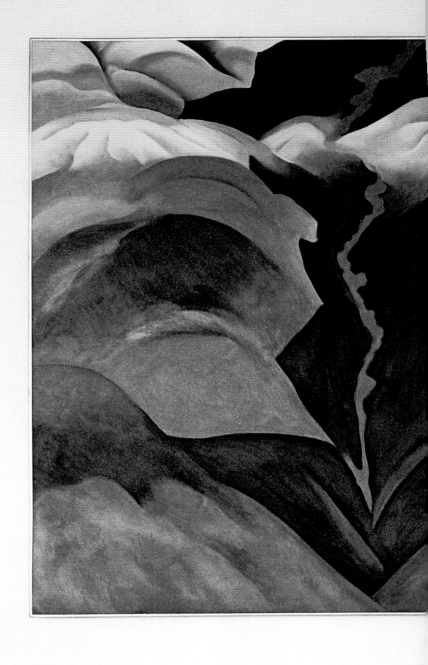

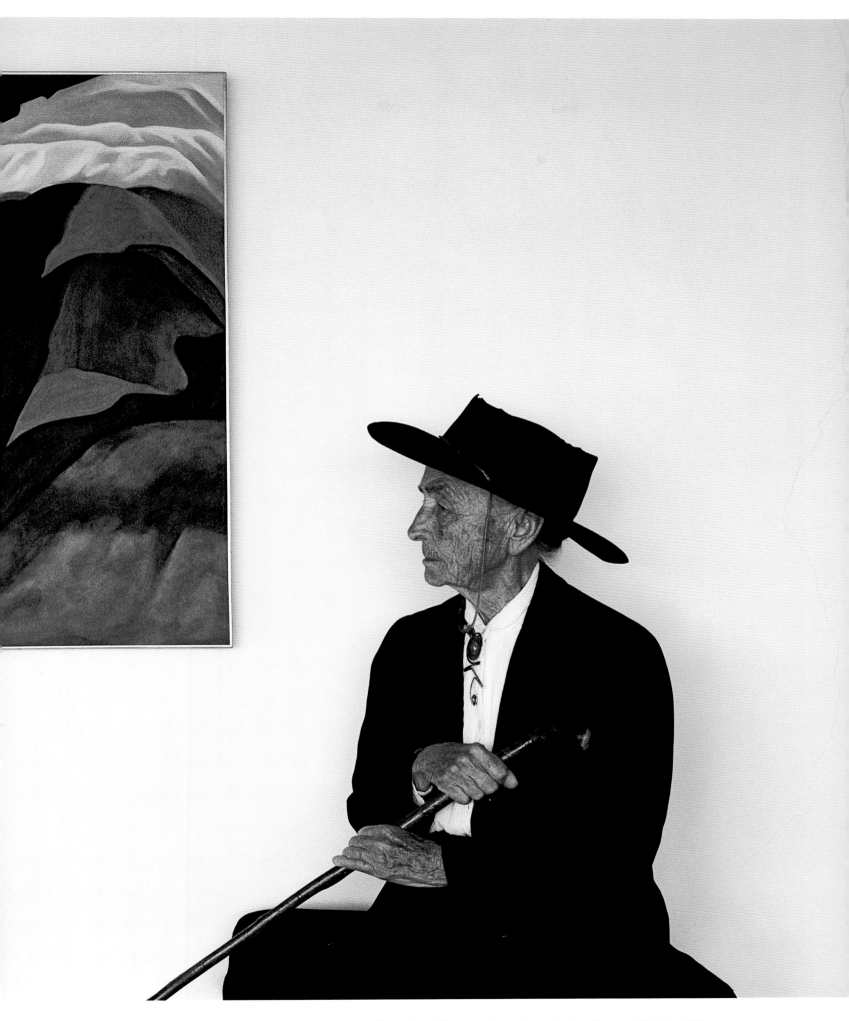

Painter Georgia O'Keeffe sits before her painting, "Black Place III," at a gallery in New Mexico. **George F. Mobley, 1980**

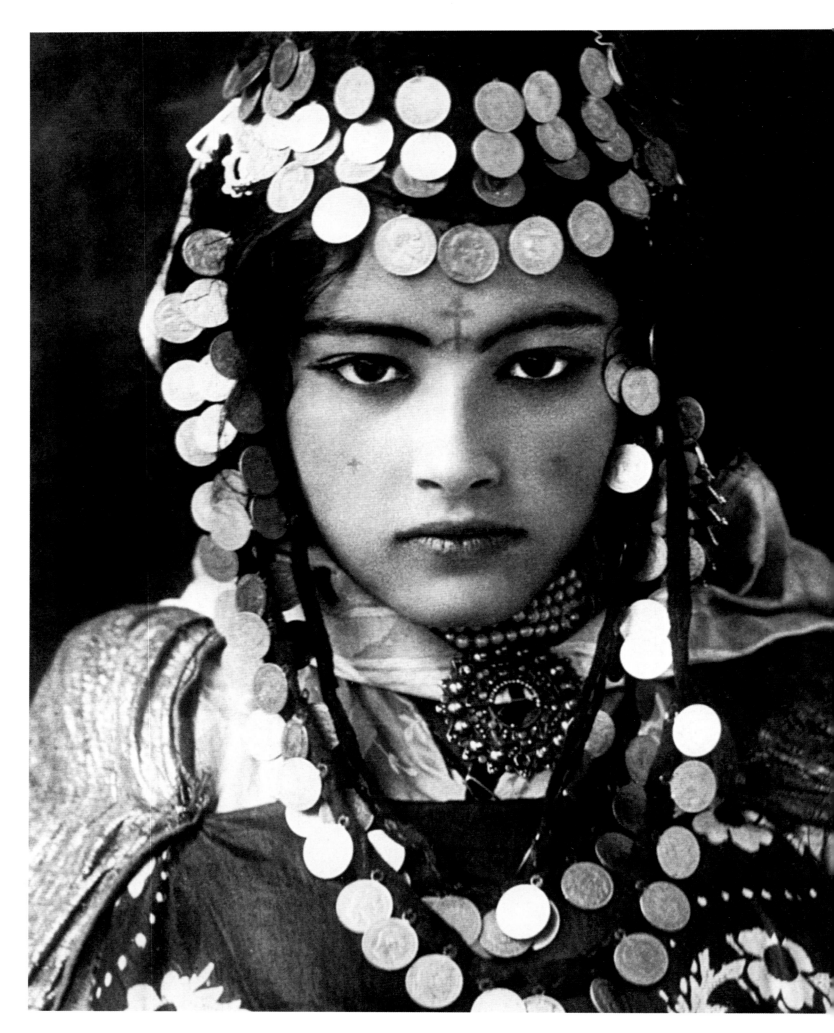

An Ouled Nail woman in Algeria displays her dowry of gold coins. *Lehnert & Landrock, 1905*

CONTENTS

FOREWORD

I MAY HAVE BEEN the first woman elected Chairman of the Board in the National Geographic Society's 131 years, but—as this book so clearly shows—women have been central to the organization's storytelling throughout our history.

This book delves deep into National Geographic's extensive photo archives to bring to light the wide range of women across the world who have graced the pages of the magazine and caught the eye of National Geographic's world-renowned photographers as they cover the globe.

The chapter titles of this book appropriately embody the qualities of the images throughout: Joy, Beauty, Love, Wisdom, Strength, and Hope. I hope you are as inspired as I am by these stories and all the women who are pushing boundaries and carving new pathways in our world today. I can only imagine the transformative effect of the many contributions of women everywhere in the days ahead. ■

JEAN CASE
Chairman of the Board
National Geographic Society

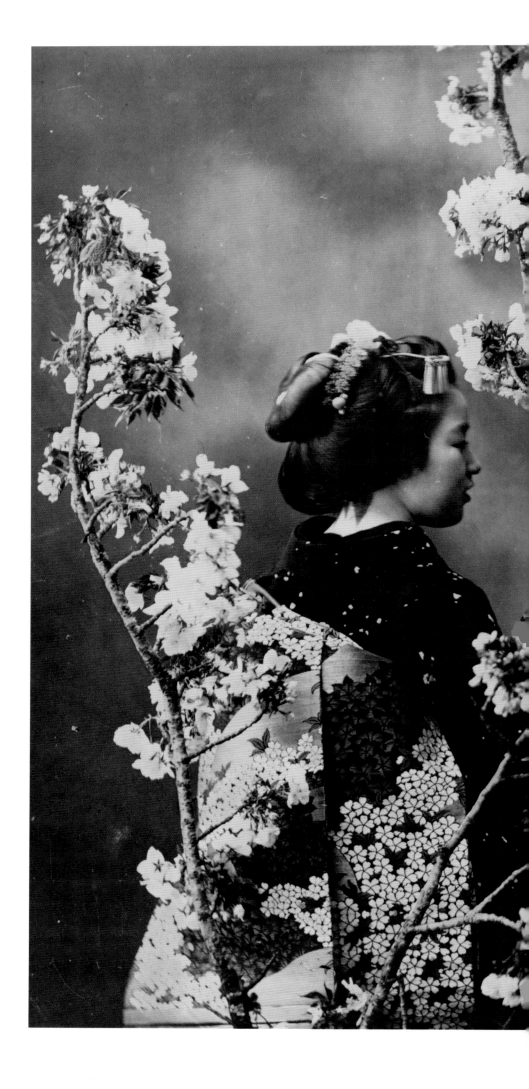

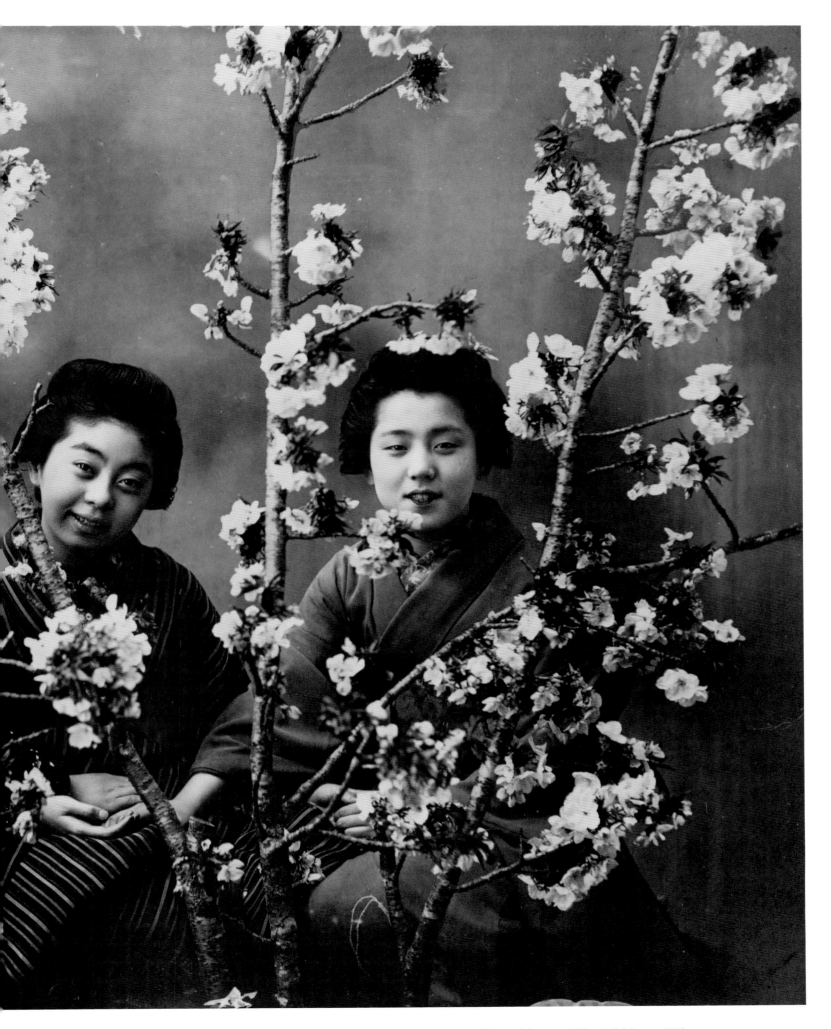

Three Japanese women dressed in traditional kimonos pose behind cherry blossoms. *Eliza R. Scidmore, 1918*

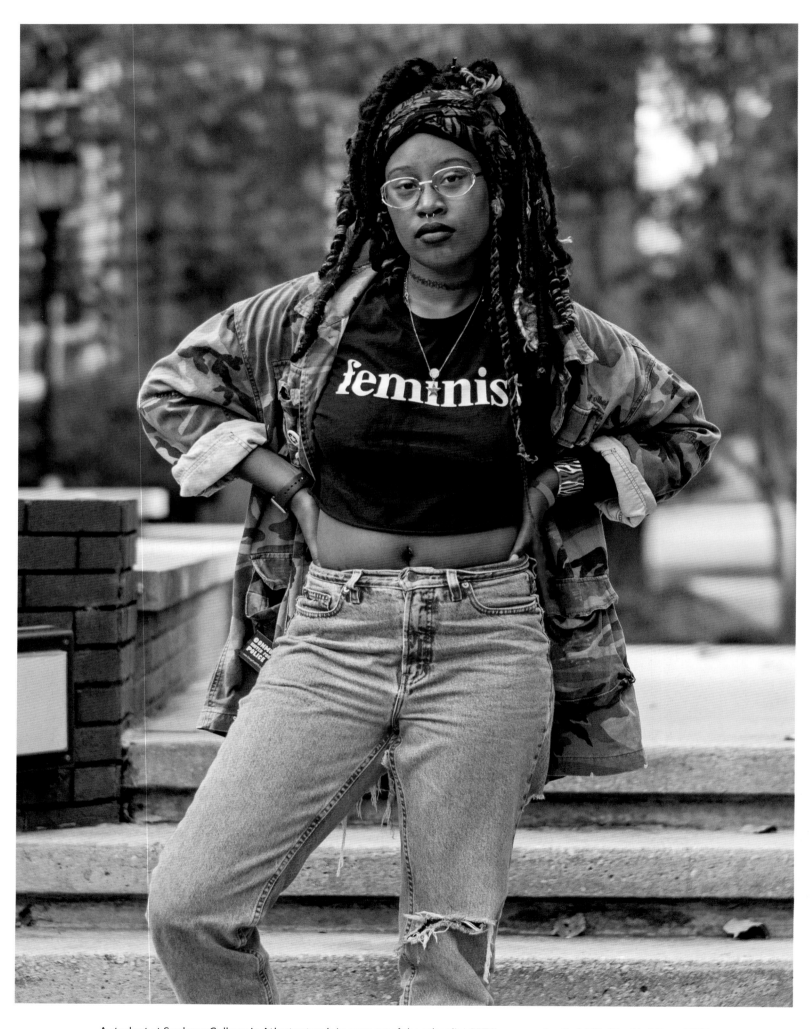

A student at Spelman College in Atlanta stands in support of the school's LGBTQ community. *Radcliffe "Ruddy" Roye, 2017*

INTRODUCTION

BY SUSAN GOLDBERG

T HE FIRST SCENE in the history of National Geographic doesn't have a single woman in it. It occurred on January 13, 1888, when 33 men of science and letters gathered in a wood-paneled club in Washington, D.C., and voted the National Geographic Society into existence. Our archive contains no photographs of the event, as none were made—which does seem ironic, since if National Geographic is known for anything, it's for creating an indelible visual record of life on Earth.

Over time, as archivists acquired photos for what's now called the National Geographic Image Collection, another record unwittingly was formed: a global chronicle of the lives of women. This book was created with those images. They offer glimpses of women through time—how they were perceived, how they were treated, how much power they had, or didn't have—up to the present day. The photos illuminate what used to be called, quaintly, "a woman's place"—a concept that is changing before our eyes.

You can see the shift begin with one grainy picture from the archive, taken August 18, 1920—the day that ratification of the 19th Amendment to the U.S. Constitution gave women the right to vote. That event 100 years ago inspired us to produce this book, and to devote our print, digital, and television platforms to examining women's lives throughout 2020. We expect to find heartening examples of how the world's women have gained rights, protections, and equal opportunities in the course of the past century. And we know we will also come across many cases where women have experienced the opposite: rights denied, opportunities withheld, vulnerabilities exploited, contributions ignored.

Over the course of National Geographic's coverage during its 130-year life span, we've seen women's emancipation move at a halting pace: two steps forward, one step back. And we've witnessed how inequality can become invisibility, until the oppressed hardly can be seen or heard at all. At this anniversary, thanks to the vision of the Image Collection, we aim to bring more women's lives into the light.

I'M THE TENTH EDITOR of National Geographic since its founding. I'm also the first woman to hold this position—an appointment that once would have been unthinkable.

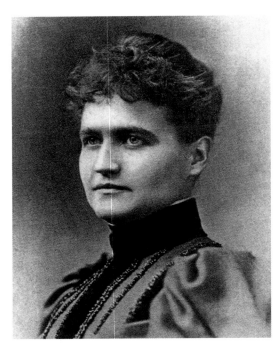
Eliza R. Scidmore, one of National Geographic's
first women photographers

Carolyn Bennett Patterson, who was hired as a research assistant in 1949 and became the magazine's first full-time female editor around 1965, likened the organization then to an elite gentleman's club, governed by "a very, very distinct idea of what ladies did, and what ladies did not do here."

The magazine printed its first issue in October 1888—and, in 1914, what's believed to be the first photo taken by a woman. Eliza R. Scidmore was a globetrotting writer and photographer who did her own hand-tinting of the photographic plates she made. She may have gotten her foot in the door because she knew Gilbert H. Grosvenor, the magazine's first full-time editor, who once wrote: "Women often see things about the life and ways of people which a man would not notice." I could not agree more.

Still, in its November 1910 issue, the magazine devoted six pages to an article about women getting the vote . . . in Finland. We didn't cover the U.S. suffrage movement, even though it was the passionate cause of Grosvenor's wife. Elsie Bell Grosvenor was an officer of the National American Woman's Suffrage Association, hosted meetings in her home, and took four of the family's six children with her to a 1913 march that her father, Alexander Graham Bell, described as a "great parade of earnest-minded women." But though Elsie was in the movement, the movement was rarely in the family magazine.

And when women did contribute to the magazine, it wasn't always obvious. Several used pseudonyms that obscured gender. One was E. R. (aka Eliza) Scidmore; another was Adam Warwick (real name: Juliet Bredon), who wrote and photographed three magazine stories in the 1920s. Sarah Wilkenson, an accomplished writer-photographer who was openly gay, contributed to *National Geographic* under the name Solita Solano. She and her partner, Janet Flanner, were a publishing team, creating content for the leading magazines of the '20s, including the *New Yorker*. But mostly, in *National Geographic* at that time, women were little seen and little heard.

These pioneering women, who came of age long before I did, overcame hurdles much more daunting than the ones I've faced. When I was a young newspaper reporter in the early 1980s, the feminist movement was well established in the United States; women were securing more rights and more professional opportunities. And yet, in 1984, when I walked into a pressroom in Lansing, Michigan, where I'd been sent by the *Detroit Free Press* to cover the governor and state legislature, raunchy *Playboy* cartoons and photos of nearly naked *Playboy* centerfold models were taped to the walls. Did that

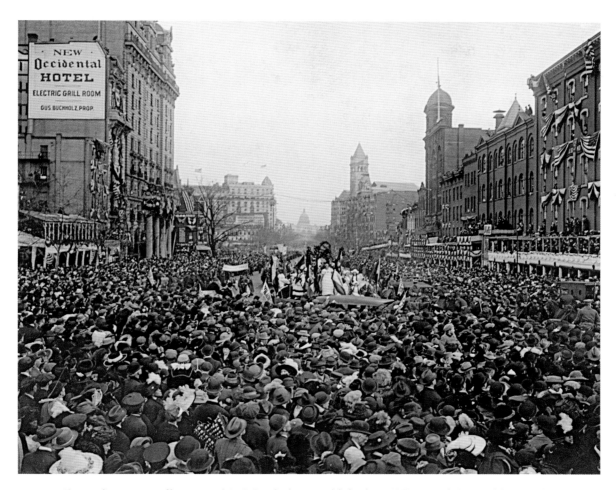

Photo of a woman suffrage march in D.C., which was published in a 1913 issue of *National Geographic*

make it harder for my female colleagues and me to do our jobs, and be taken seriously by the men we worked with and covered? I'll never know: We just silently rolled our eyes, put our heads down, and did the work.

Eight years later, when I was an editor at *USA Today*, we and many other publications wrote stories proclaiming 1992 the "Year of the Woman." Though the number may look underwhelming today—in a body of 435 members, 24 women were elected for the first time—it was the largest number of women voted to the House in any single election. And the 1992 Senate elections resulted in the greatest number of women ever in that chamber: six out of 100 members. *Six!* As naive as it seems now, this was hailed as a harbinger of real change. But, as it turned out, the event was simply my first Year of the Woman. By the time 2018 was given the designation, I'd lost count of how many times it had been declared.

So when there's yet another assertion that women's status is rising, skepticism might be forgiven. But this time, to me, it feels different. It *is* different. Maybe it's because more women are steadily reaching higher positions: in business, the sciences, education. Or that they're being seen and heard, on their own terms, as speed-of-light communications and social media allow them to make an end run around male-dominated systems that

once kept them quiet (#MeToo, anyone?). It is, happily, inconceivable to me that the women at National Geographic today would just go about their business if they walked into an office with a *Playboy* centerfold photo on the wall!

And this time, the numbers really do tell a story of change: The sheer volume of elected women has vastly increased, in developed and developing nations around the globe. In the U.S. Congress seated at the start of 2019, nearly a quarter of the members are women.

LET ME HELP YOU PICTURE the National Geographic Image Collection. The photo archives are stored in the basement of our Washington headquarters. Walk into the main room and you're immediately hit by cold, dry air—65°F, 35 percent humidity: a climate controlled to preserve this visual history. The two-story space contains rows of floor-to-ceiling metal shelves, holding almost 12 million images and pieces of art that date from at least 1870—published photos, unpublished slides, glass plates, negatives, albums. The 15,000 glass plates kept here, with typed caption information glued to their edges, make up the world's second largest collection of autochromes, the first commercial form of color photography.

Add to this the myriad digital images stored on servers, and the collection holds some 64 million images: one of the most significant photography archives on Earth. Even Alexander Graham Bell could hardly have dreamed it when he helped establish a magazine to explore "the world and all that is in it."

It's true that for much of *National Geographic*'s history neither the photographers nor their subjects were a very diverse lot—but we've been making progress. Since 2013, our photography department has been headed by a woman, Director of Photography Sarah Leen. Today, our overall visual staff is three-quarters women. In 2018 about half the story assignments for our website were shot by women photographers—and nearly three times as many of our magazine features were shot by women in 2018, compared with 2008.

Growing these numbers, and the number of photographers who are people of color, is a priority at National Geographic. We want the people writing the stories and taking the photos to be as diverse as the world they cover. In photography circles, Sarah Leen says, there's a concept called "'the female gaze.' It's the idea that women see the world differently than men might." How simple. How true.

PUT ON A PAIR of white cotton archivist gloves and leaf through photographs of women in our collection. I asked Leen to describe what she sees. "In the early eras, it's generally portraiture of women posed in the costumes of their cultures," she said. "And it's nearly always men taking the pictures." While men are photographed in scenes that

show them heroically exploring or on some kind of scientific adventure—say, climbing mountains or digging up fossils—the pictures of the women are, by contrast, very still, very posed, and very pretty. "When photographing women, the focus was more on beauty," Leen observes. "Dancers, beauty contests, bathing beauties, mothers here, there, and everywhere." And yet the archive also documents a series of women-related firsts at *National Geographic* set against the story of women's long march:

In November 1896, the magazine ran its first photo in which a woman is a primary subject. Taken in Witwatersrand in the Republic of South Africa, and captioned "Zulu bride and bridegroom," it depicts a woman and man wearing adornments on their heads and bodies, holding each other's hands and looking directly at the camera. We should also note that this is the first of many photos the magazine published showing women—most often women of color—with their breasts bared. (*National Geographic* earned such a reputation on this front that in a special edition marking our 125th anniversary, we lampooned ourselves with a graphic charting all 539 instances of nudity published up to that time.)

A woman first appeared on our magazine's cover in October 1959. A glamorous-looking diver with goggles pushed up on her forehead, she's examining sea creatures that, like the model's lips, look color-enhanced—something we would never allow today. The caption material names the creatures—sea urchins—but not the woman; archivists think she was the wife of Paul Zahl, the scientist and staff photographer who took the photo. For the next few years, women appeared on *National Geographic* covers as decorative models in costumes of different nations: smiling, dancing, girl-next-door types.

In September 1964, we finally produced a cover featuring a woman at work. Titled "Ambassadors of Goodwill," the article was written by Peace Corps founder Sargent Shriver; the picture shows Peace Corps volunteer Rhoda Brooks hugging a local woman goodbye at the end of Brooks's mission in Ecuador.

We then reach the golden era of pioneering, world-class, female researchers and scientists. Jane Goodall and her chimps were on the magazine cover in December 1965; Dian Fossey and her gorillas in January

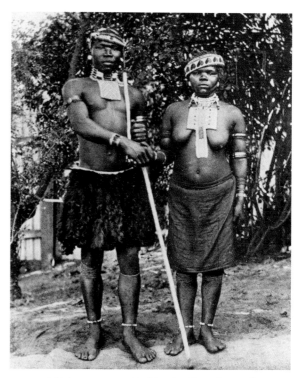

A Zulu groom and bride, the first photo of a woman as the subject published in *National Geographic*.

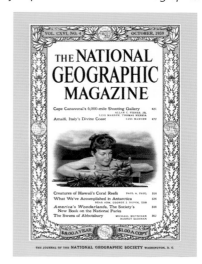

The first woman to appear on the cover, October 1959.

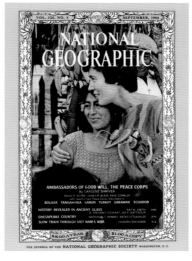

The first cover showing a woman— Rhoda Brooks—at work.

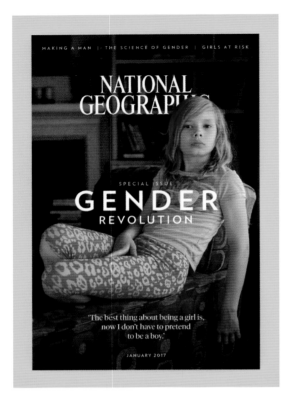

Avery Jackson graced the cover of
National Geographic's 2017 gender issue.

1970; Biruté Galdikas and her orangutans in October 1975. But even these women's fame and success couldn't shield them from sexism: Since all three had a patron in renowned paleontologist Louis Leakey, they were dismissed in some quarters as "Leakey's Angels."

Perhaps the most famous cover photo we have published of a female—and arguably the most famous *National Geographic* cover, period—is the intense, green-eyed gaze of a young refugee dubbed "Afghan Girl" in June 1985 (page 444). Seventeen years later, photojournalists returned to find her and learn her identity; by then, Sharbat Gula was a mother of three, aged beyond her years by a difficult life. She appeared on our cover again in April 2002, eyes wary but still so green.

In January 2017, pink-haired, nine-year-old Avery Jackson of St. Louis, Missouri, looked straight at the camera and became the first transgender female to pose for *National Geographic*'s cover. "The best thing about being a girl," she told us, "is now I don't have to pretend to be a boy." Thousands of people canceled their magazine subscriptions in protest; many others thanked us for acknowledging that what it is to be female has changed.

It's been quite a journey, and Leen sums it up this way: "Today, we're not afraid to look at ourselves. We photograph and address more of the issues of the day, including the challenges for women. And you don't have to be a beauty to be in the pages of the magazine. We show more women in positions of strength and in leadership roles, but also women who are victims of war, disaster, poverty. We don't flinch from showing the world as it actually is."

THOUGH THIS BOOK draws on an archive, it is not just history. Here, we explore the challenges and triumphs women may find in the future, as well as those they've experienced over time. That's why, in addition to the archival photos in these pages, you will find interviews and recent portraits of two dozen accomplished women, most taken by National Geographic photographer Erika Larsen. These images form the archive of tomorrow.

We are delighted to share our conversations with these impressive, insightful women, who come from all walks of life. They are scientists and "social justice warriors" (tech pioneer Ellen Pao's term); attorneys, philanthropists, writers, athletes; a doctor fresh from a war zone, and a seasoned war correspondent. Four of the women are ranked in the top 30 in *Forbes* magazine's 2018 list of Most Powerful Women. One of those four is New Zealand prime minister Jacinda Ardern, who was the second world leader to give birth in office

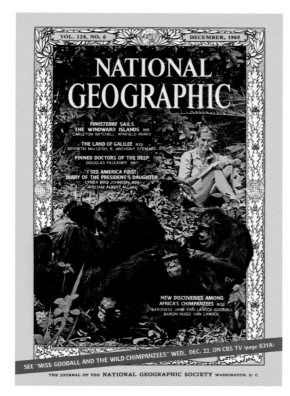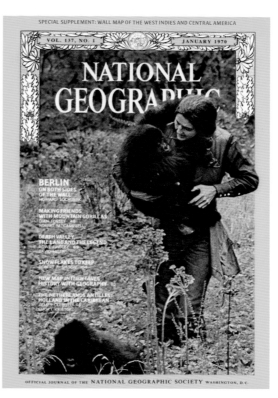

Jane Goodall and her chimps, published in 1965;
and Dian Fossey and her gorillas, published in 1970.

(the first was Pakistan prime minister Benazir Bhutto in 1990) when her daughter Neve was born in 2018—and the first to bring a baby into the United Nations General Assembly hall, when Ardern spoke at a peace summit there.

We put the same questions to all the women interviewed. When asked about their strengths, several mentioned some version of resilience, from plain old stubborn to persistent ("I got an award in high school for being persistent," said lawyer Gloria Allred). Heartbreakingly, nearly all these amazing women talked about their struggle with confidence and insecurity (Black Lives Matter co-founder Alicia Garza called it "imposter syndrome"; Oprah Winfrey labeled it the "disease to please"). And every one of them agreed that women who follow their convictions can overcome almost anything. "Never take no for an answer," said broadcaster Christiane Amanpour. Or as soccer star Alex Morgan put it: "Don't be discouraged in your journey."

Just as no single portrait in the Image Collection could represent the face of womanhood, no single comment in the interviews could summarize all women's strivings and hopes. But conservationist and entrepreneur Kris Tompkins may have come close, so let hers be the parting words before turning the page:

"The unequal role of women in so many societies goes back millennia, and sometimes I despair as to how this will ever right itself. I do believe in speaking up and holding your ground—sometimes at great cost—and not being silenced. It took thousands of years to get to this place, and it will take a long time to get better, more equitable cultures. Equal rights for women is a long-distance run, not a sprint." ■

JOY

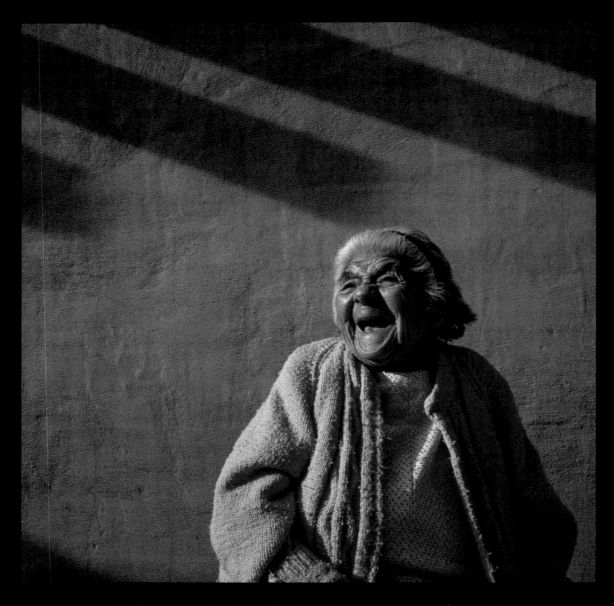

A Hopi woman laughs in the Walpi Indian Village in Arizona. *Lynn Johnson, 2002*

In photos of joyful women, can you trace the joy to its source? Many times, it's obvious: the diploma in the hand of the new college graduate. The red-convertible road trip, and the friend sharing it. In other photos, the delight is clear but its cause is a mystery—obscured, the way demure women's hands obscure their smiling lips.

Some joy is not of this world: a white-gowned pilgrim's bliss as holy water dampens her face; the ecstasy of Holi festival revelers, showering one another in color. But sometimes it's distinctly earthly pleasure: Cokes and potato chips. Sun on surfboards. A walk along the Seine.

Why is the woman on the facing page smiling? Her joy must have its reasons. The key, says oceanographer Sylvia Earle, is to find a reason of your own. "Find something that you love; that really makes your heart beat fast." ∎

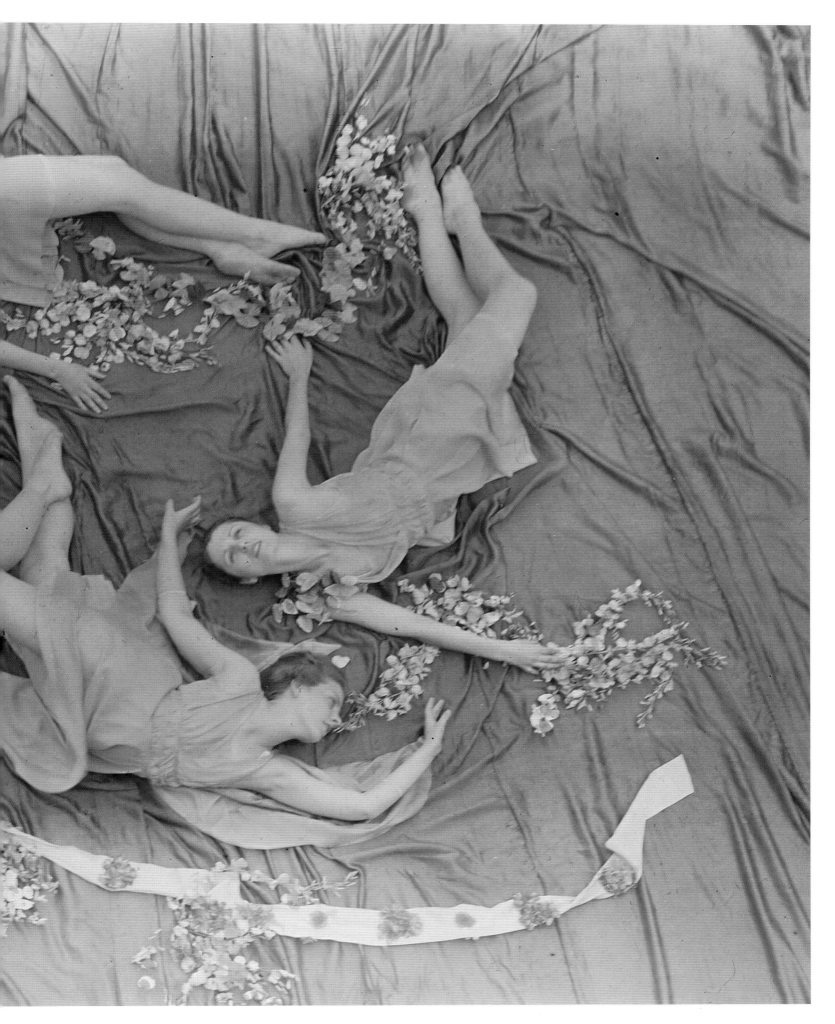

A group of colorful dancers perform at the Mississippi State College for Women in Columbus. *J. Baylor Roberts, 1937*

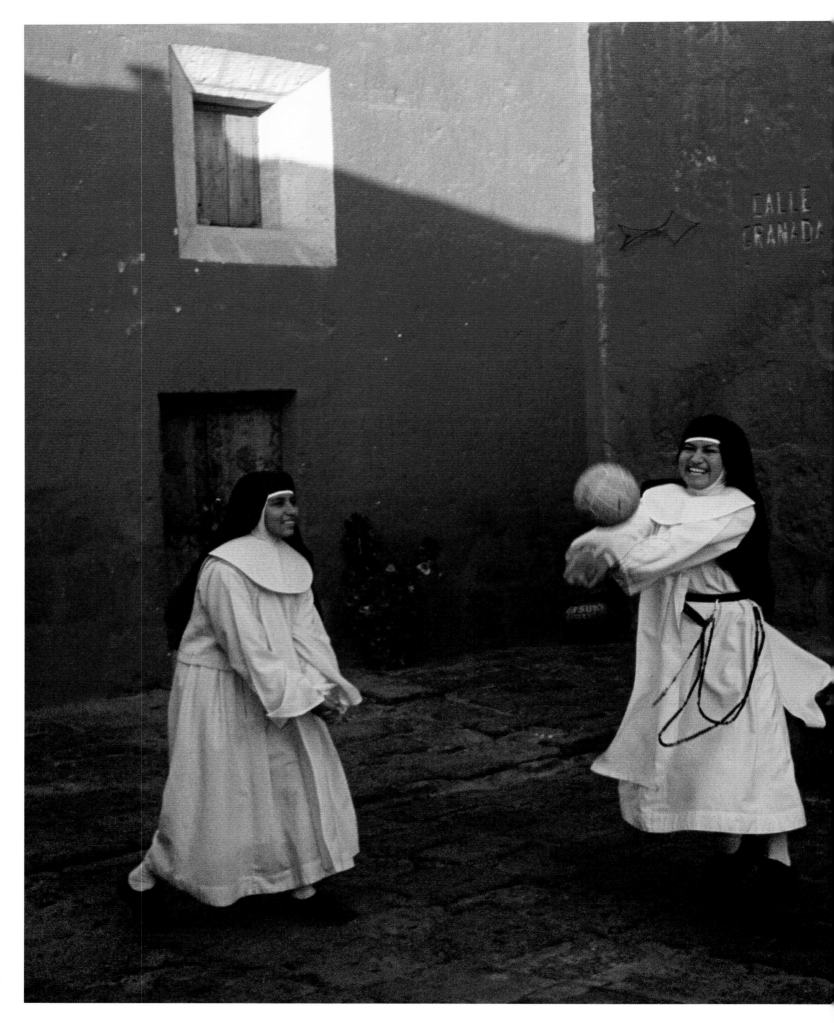

Nuns take time for a game of volleyball at the Santa Catalina Monastery in Arequipa, Peru. *Melissa Farlow, 1998*

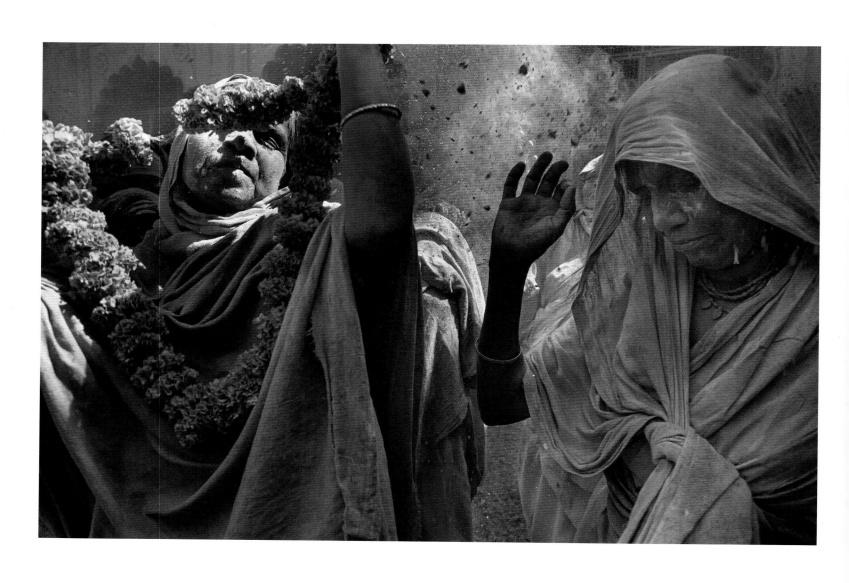

Women participate in the Holi ceremony, the festival of love and colors, which was once considered inappropriate for widows, at the Gopinath Temple in India. *Amy Toensing, 2016*

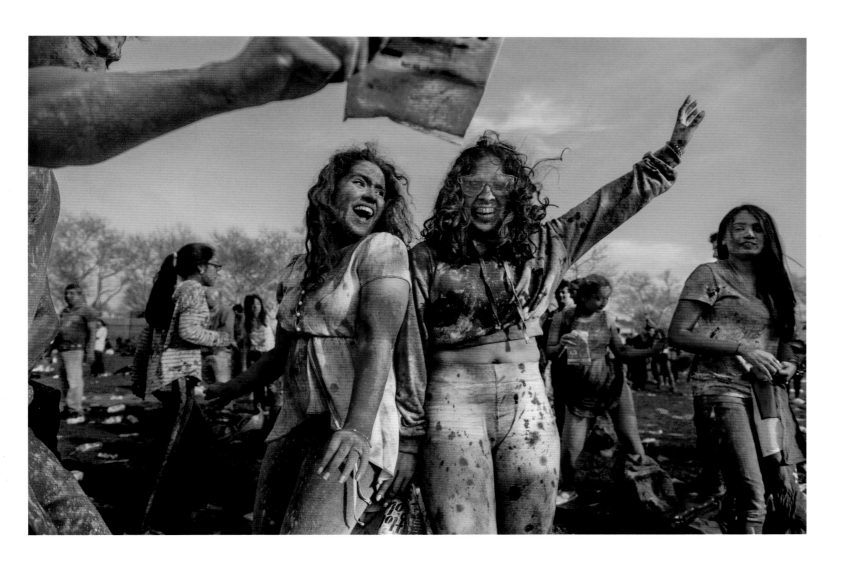

Two women revel in another Holi celebration. This one is in Richmond Hill, a neighborhood in Queens, New York. *Ismail Ferdous, 2018*

Four young women sport polka-dot dresses outside a farm in Bennet, Nebraska. *Joel Sartore, 2015*

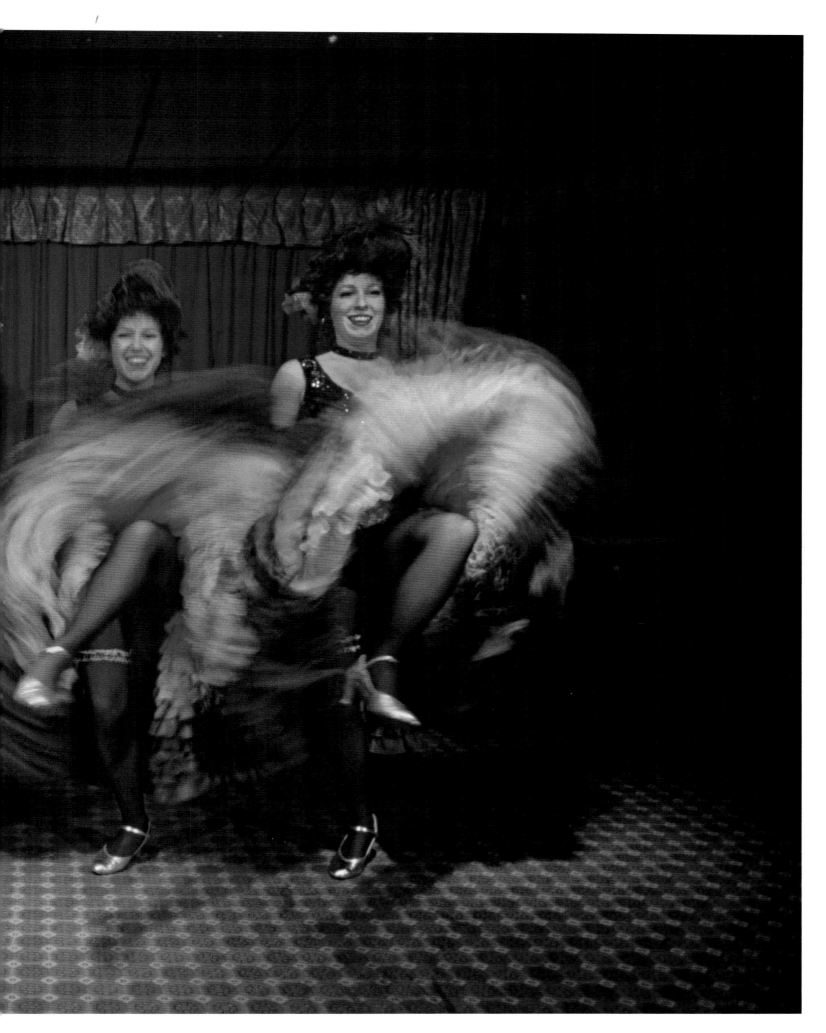

Dancers turn back the clock to the heyday of the Klondike gold rush in Whitehorse, Canada. *George F. Mobley, 1978*

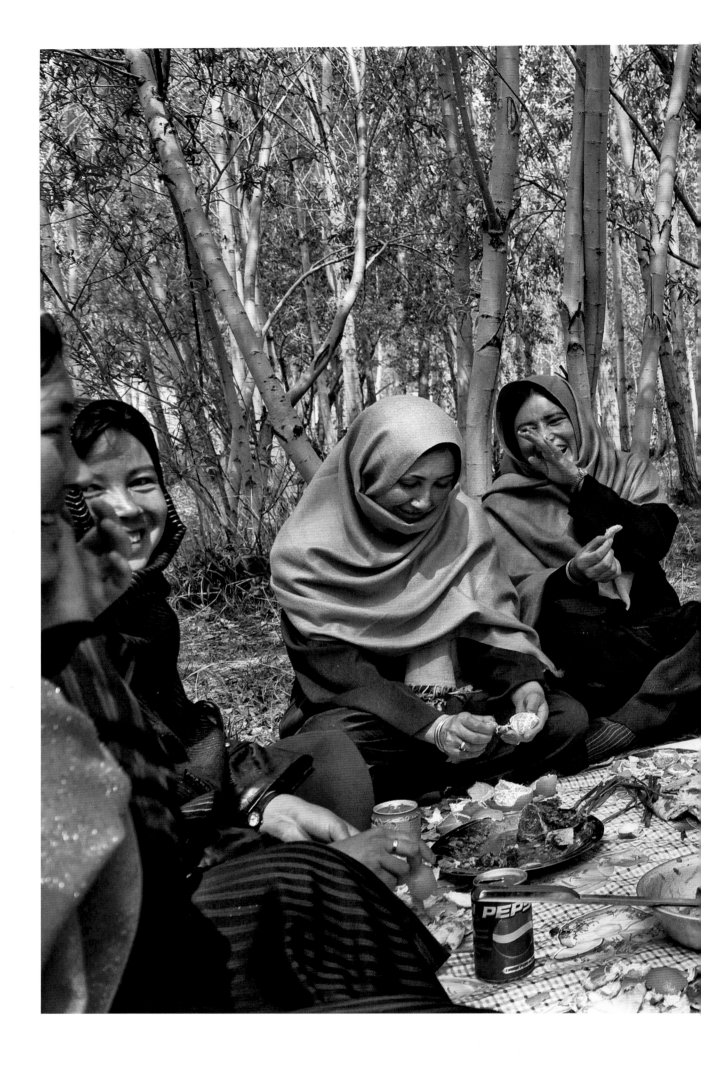

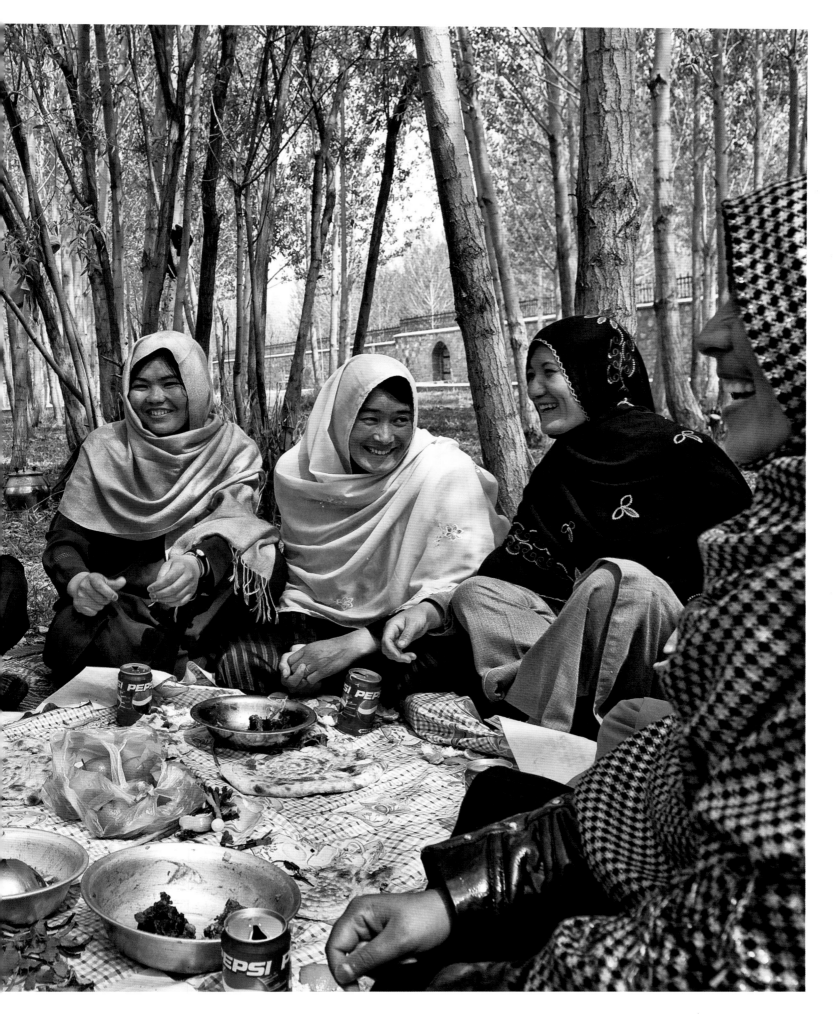

Women laugh and talk during a picnic in the women's garden—a park intended for families—
outside of Bāmyān, Afghanistan. *Lynsey Addario, 2010*

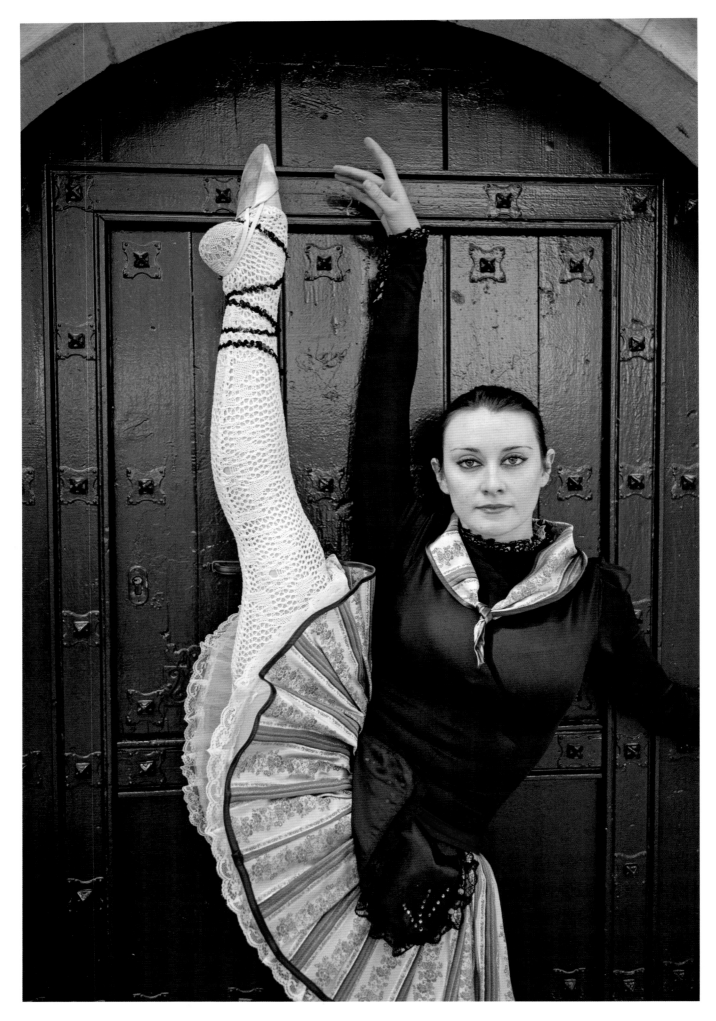

A Spanish contortionist and dancer strikes a pose in an Aragonese Jota-style tutu. *Kike Calvo, 2011*

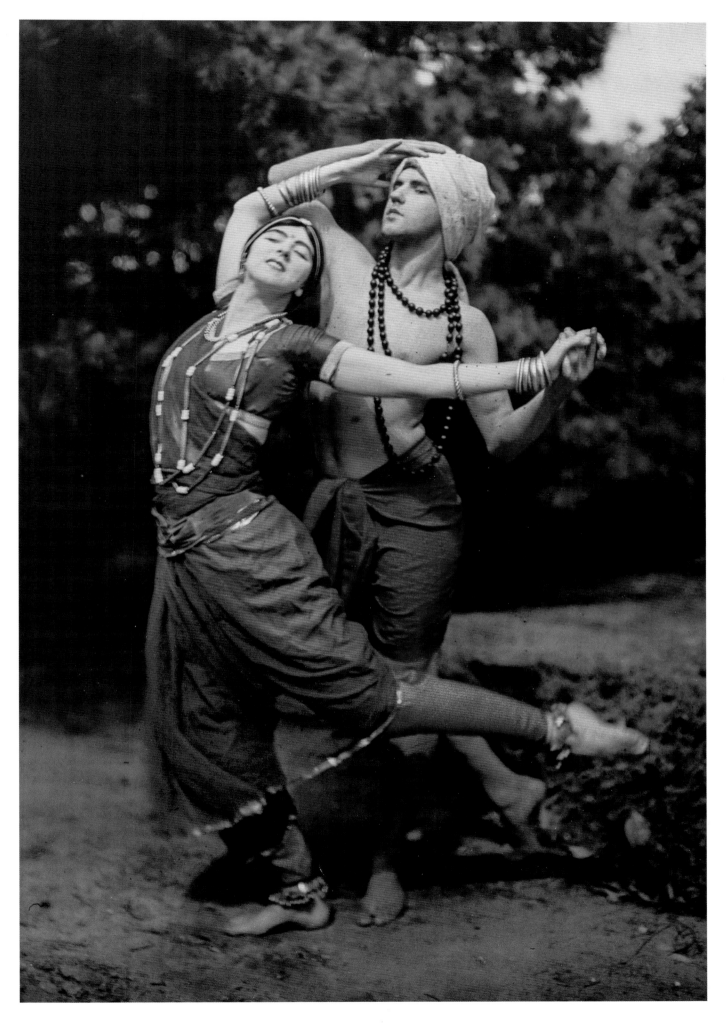

Modern dance pioneers Ted Shawn and Ruth St. Denis perform in costume. **Franklin Price Knott, 1916**

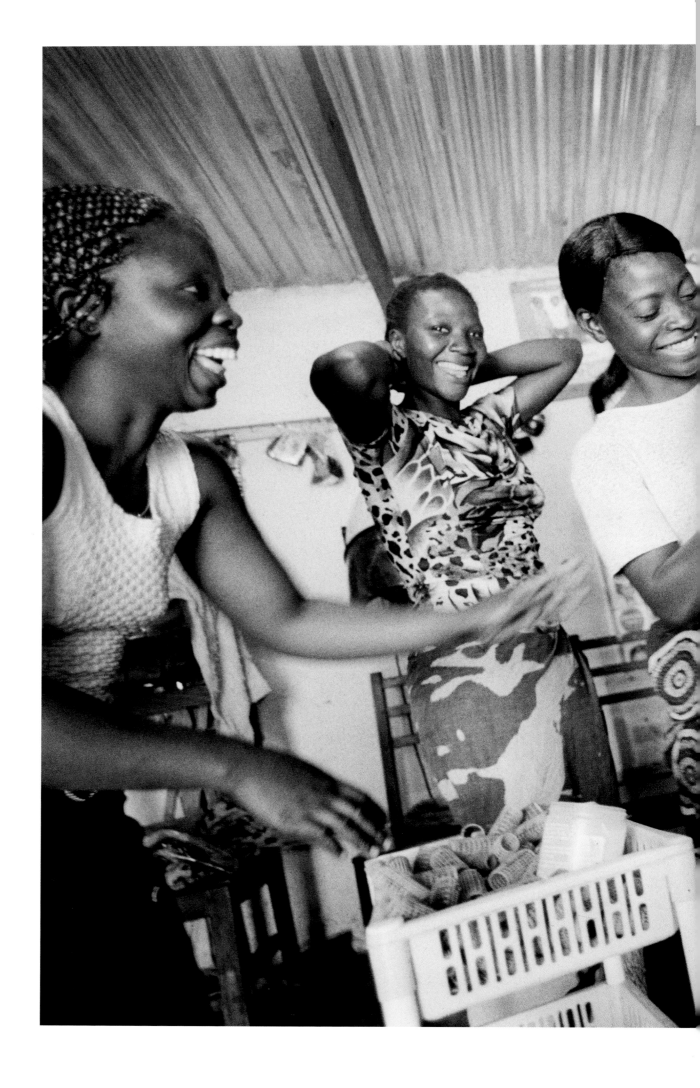

Friends gather for conversation at the Cinderella beauty shop in Mfuwe, Zambia. *Lynn Johnson, 2005*

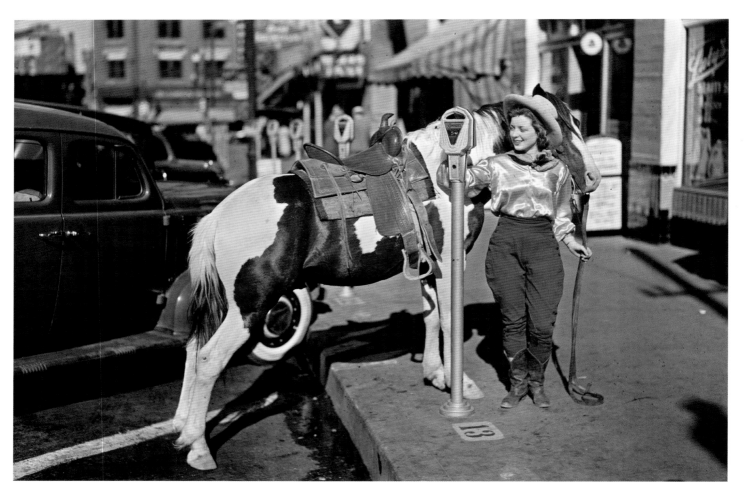

A cowgirl puts a nickel in a parking meter in El Paso so she can hitch her pony. *Luis Marden, 1939*

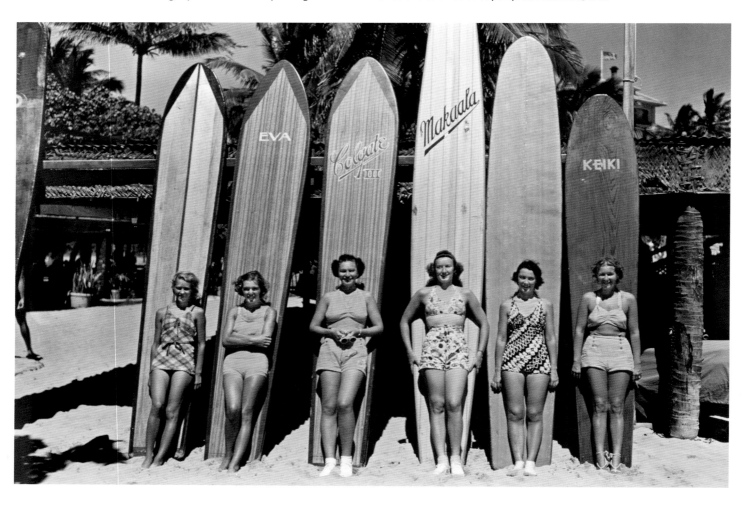

Women pose in front of their surfboards on Waikiki Beach in Honolulu. *Richard Hewitt Stewart, 1938*

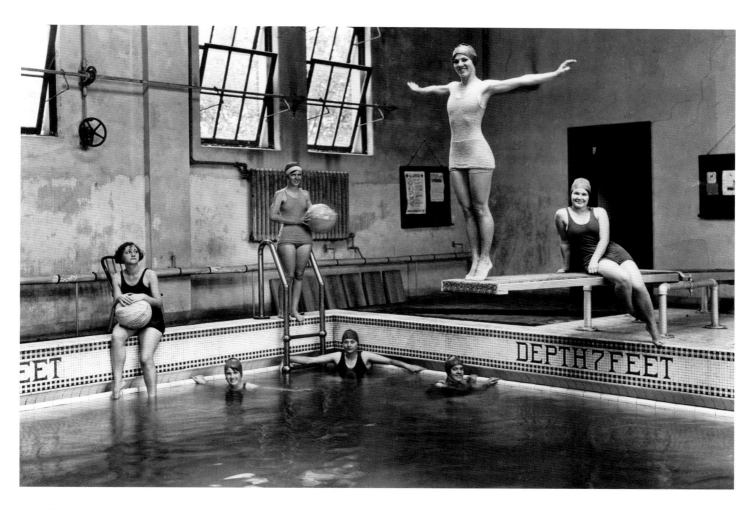

Swimming lessons were once on the curriculum at Newcomb College, part of New Orleans's Tulane University. *Edwin L. Wisherd, 1930*

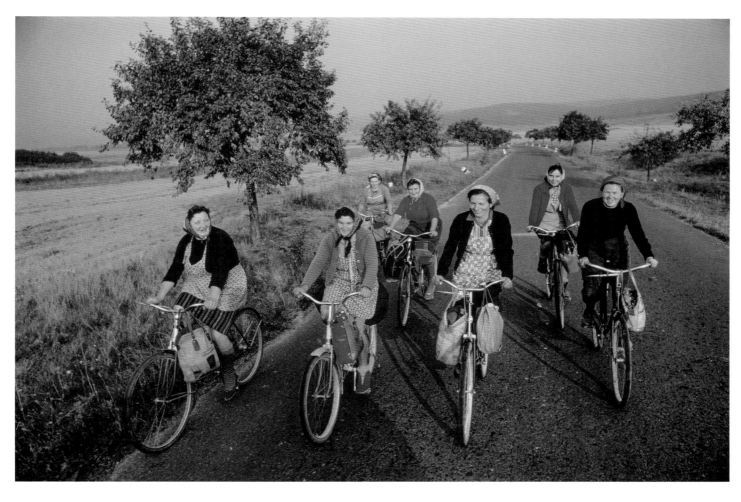

Women ride their bikes home after a day in the fields in the Little Carpathians, which is now part of Slovakia. *James P. Blair, 1968*

Children in Southern California celebrate Eid al-Fitr, which marks the end of Ramadan, on a moon bounce. *Lynsey Addario, 2017*

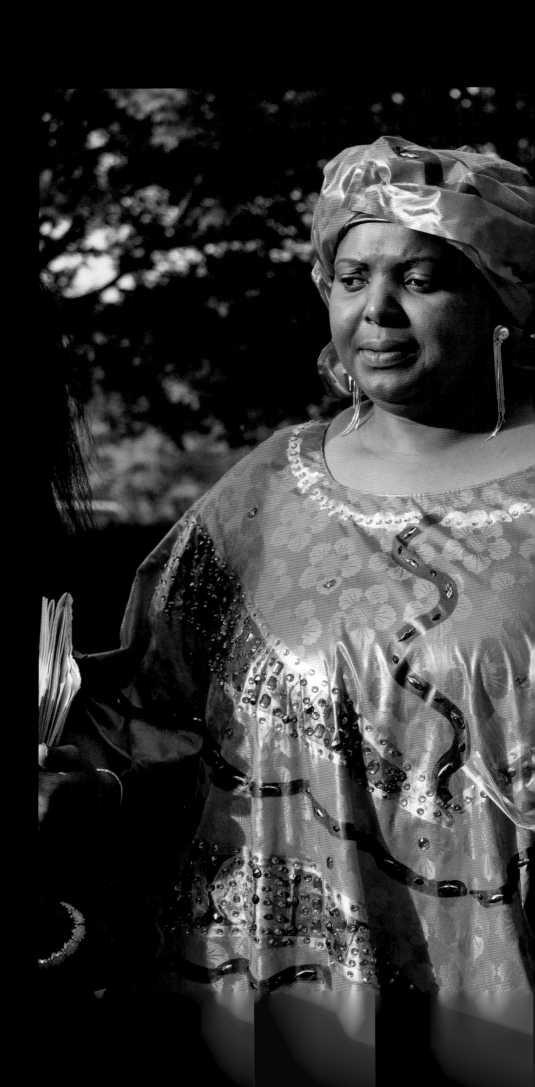

THROUGH
THE LENS

A lot of photographers have legendary role models that they look to as they are coming up. I was so grateful to have someone in my family—my grandfather—to inspire me. He died before I was born, but I got to know him and bond with him through an archive of beautiful black-and-white images he took of his family and his community. I love his photos of black people on the island of Guam, which he shot while he was in the Navy, as well as his portraits of black people in the South.

For this story, I wanted to show how much diversity there is in blackness. Spelman is historically a black university, but as I was walking around on graduation day I saw how much diversity there is, with so many students from all over the world. In this image, three generations of strong black women are celebrating excellence: black excellence. That's what I love about it. At Spelman, the students are protected by their teachers and their peers. Everyone is rooting for them—and I wanted that encouragement to shine through as well. ■

NINA ROBINSON

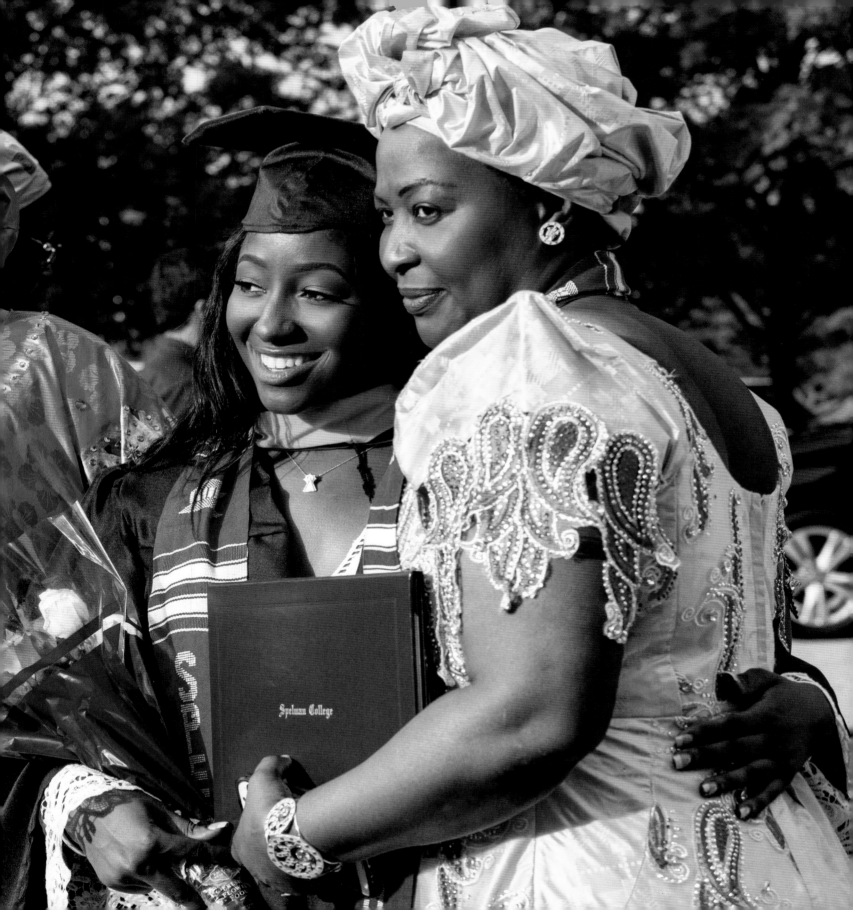

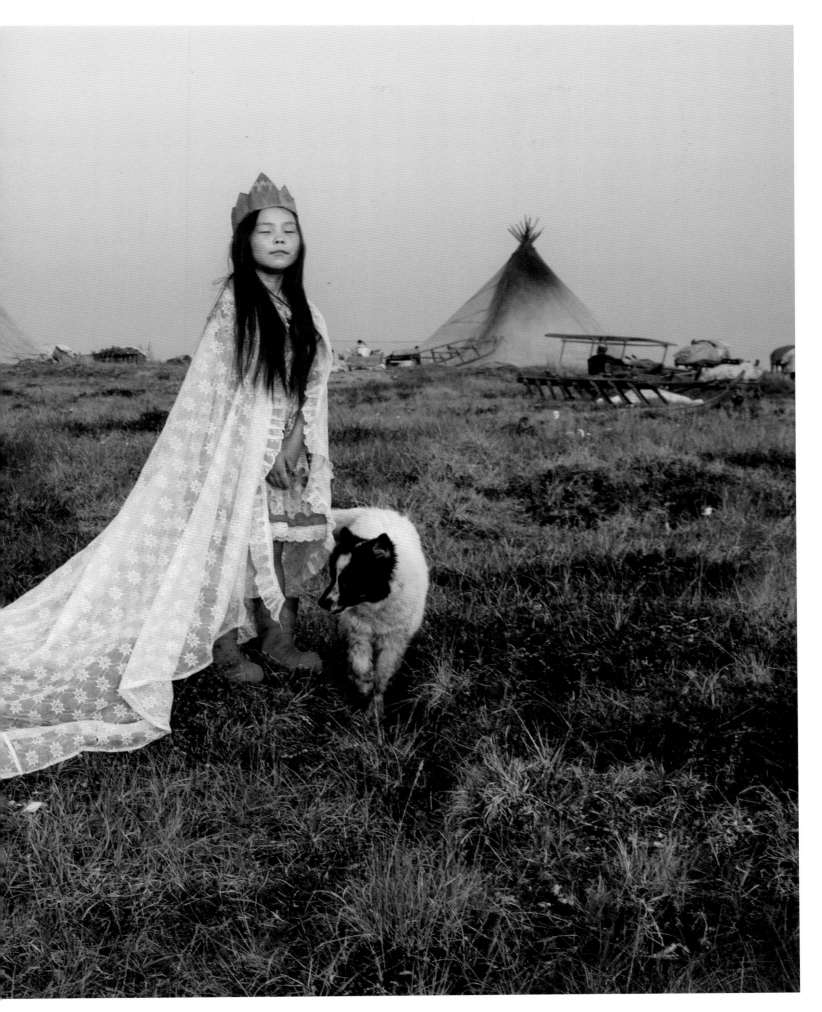

Wearing a curtain and a cardboard crown, a girl becomes the "tundra princess" in the Nenets camp near the Kara Sea in Russia. **Evgenia Arbugaeva, 2016**

A tourist takes a selfie in front of the Barbie dollhouse in Berlin, with its distinctive pink-heel fountain. *Gerd Ludwig, 2013*

Female soldiers take time for photos during the Independence Day Parade in Bogotá, Colombia. *Sebastián Liste, 2016*

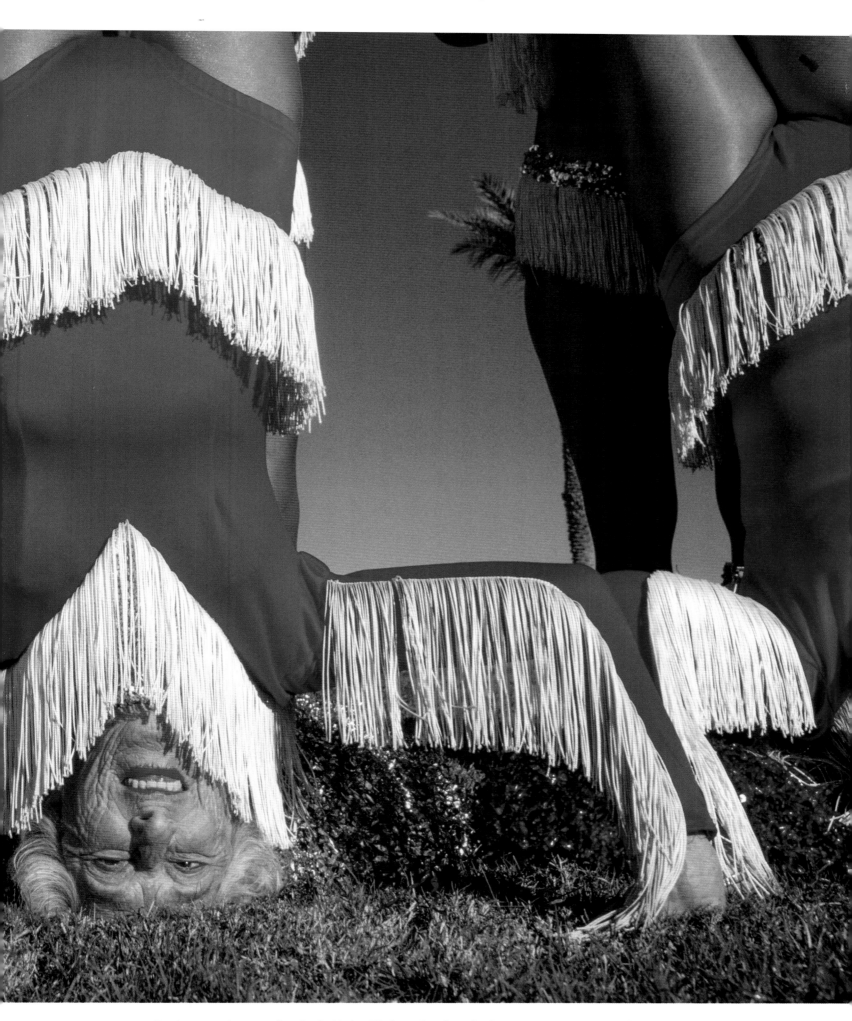

Proving age is just a number, Foofie Harlan, 79, does a headstand as her retirement community dance team performs outside of Phoenix. **Joanna B. Pinneo, 1993**

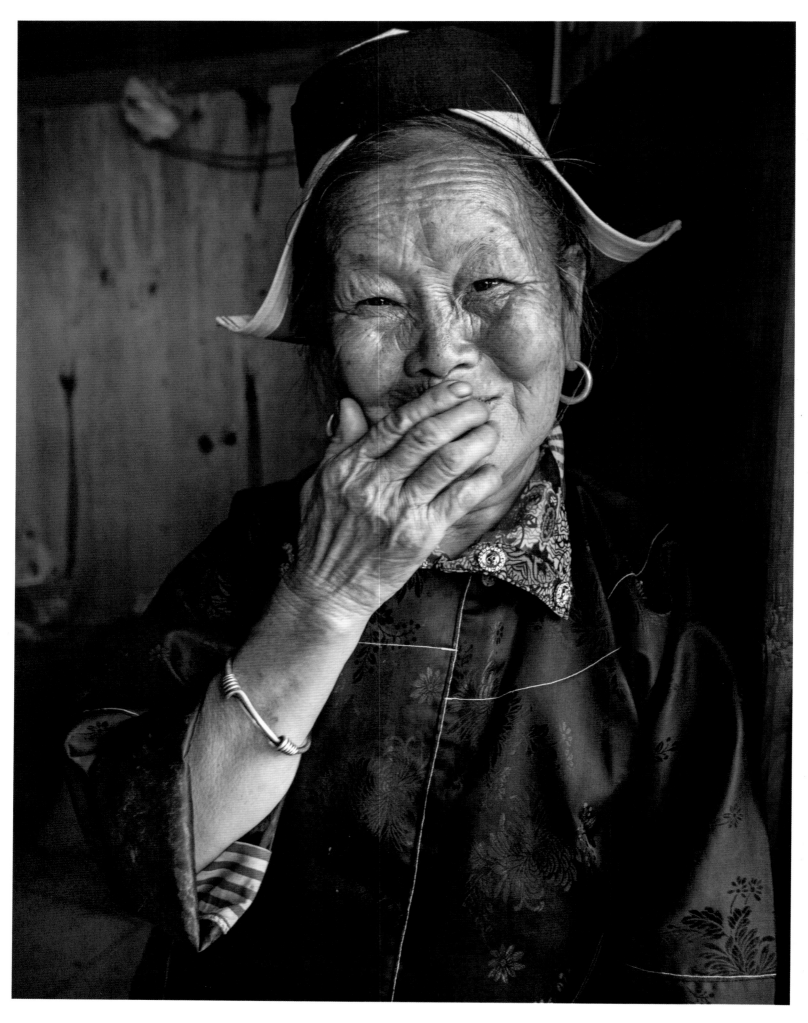

A woman in China tries to hide her smile. **Tino Soriano, 2016**

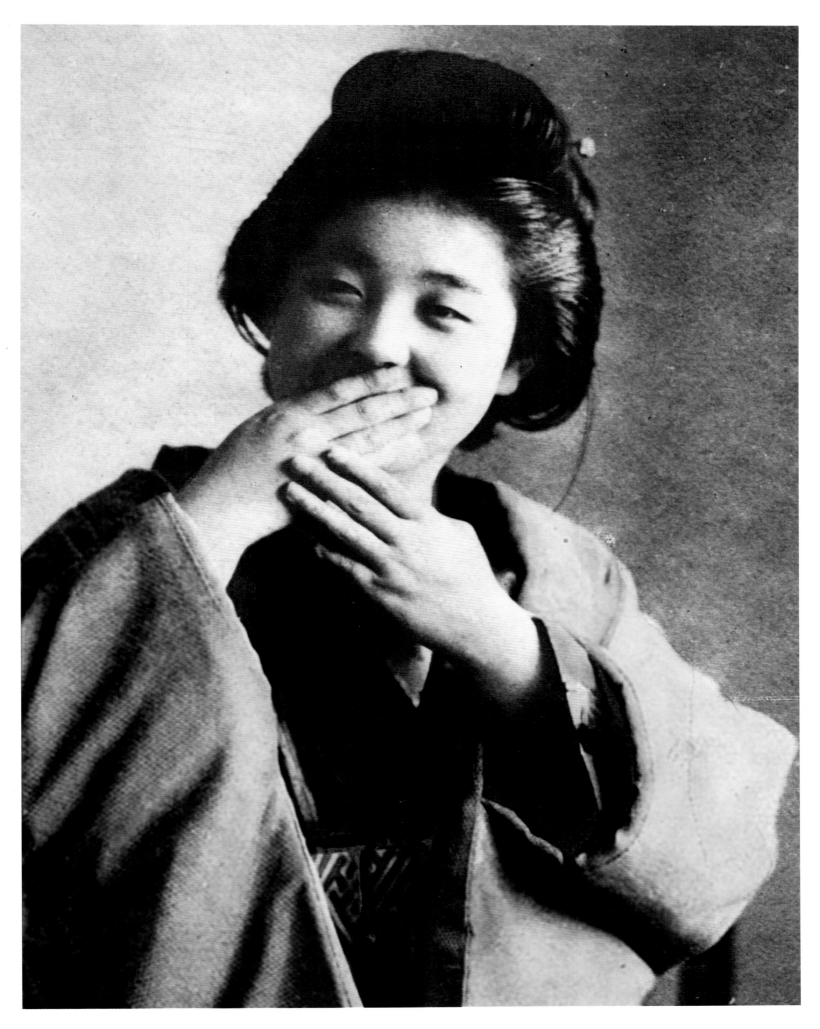

A Japanese woman cannot help but join in the laughter. *Eliza R. Scidmore, 1912*

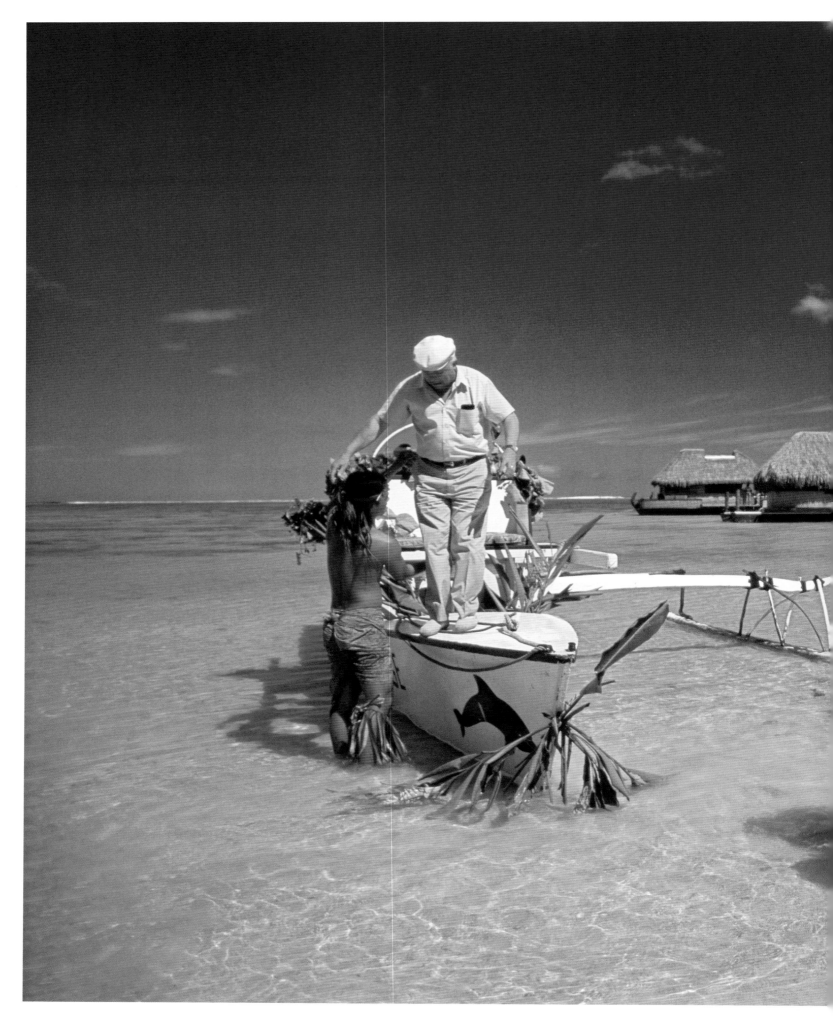

Locals in Tahiti help tourists come ashore after a lagoon cruise in an outrigger canoe. **Jodi Cobb, 1996**

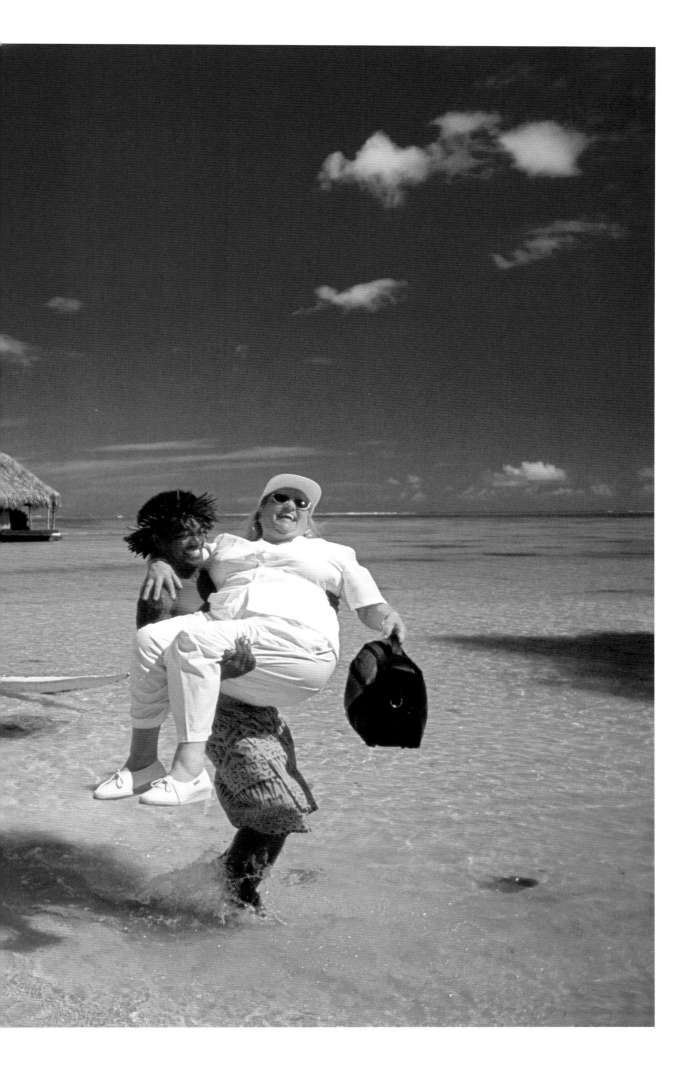

A woman with a striking hat turns heads at the Sizzling Hot Pink Saratoga Hat Luncheon in Saratoga Springs, New York. **Amy Toensing, 2014**

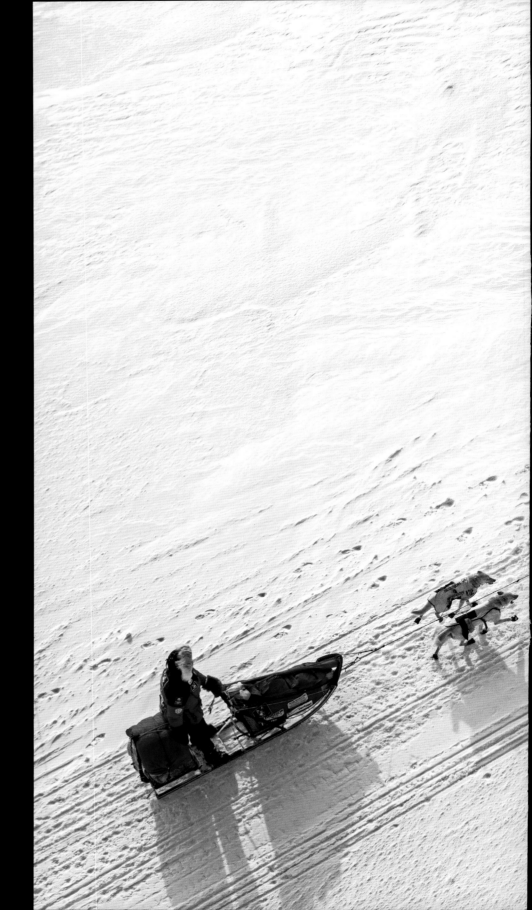

THE LENS

Dogsled racing, or mushing, is one of the rare professional competitive sports that is truly coed. Women made up nearly a third of the athletes in the 1,000-mile Iditarod Trail Sled Dog Race in 2015, considered one of the toughest endurance competitions in the world. Proportionally, top-10 Iditarod finishes between women and men are often an even split.

This is an image of Aliy Zirkle, one of the best and most beloved dog mushers in Alaska, during the 2015 Iditarod. I photographed her from above, while standing on a bridge at the Nenana checkpoint in interior Alaska. From this angle, it's unclear whether the musher is a man or woman—and it makes absolutely no difference. It doesn't matter what gender you are in order to be extraordinary. The women of the Iditarod are my heroes and exactly the kind of role models young girls should see represented. The way that the camera lets you sneak into the lives of extraordinary and inspiring people is a big part of what originally drew me to photography—and the idea that I can use a camera to highlight untold stories and spread awareness about important issues. ∎

KATIE ORLINSKY

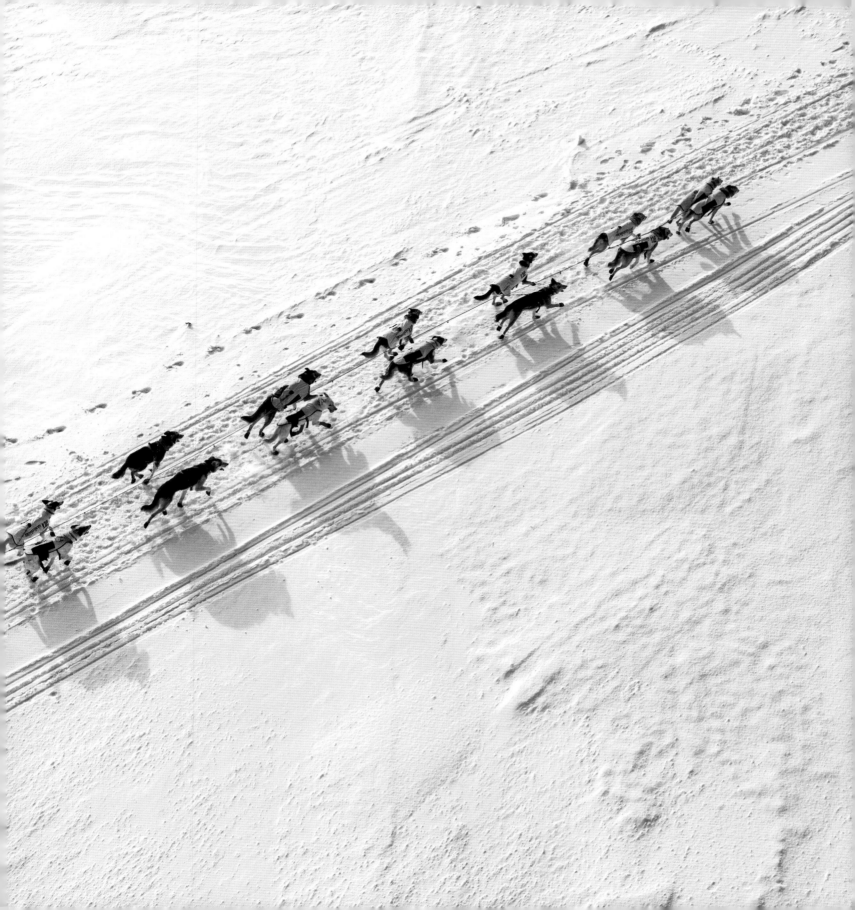

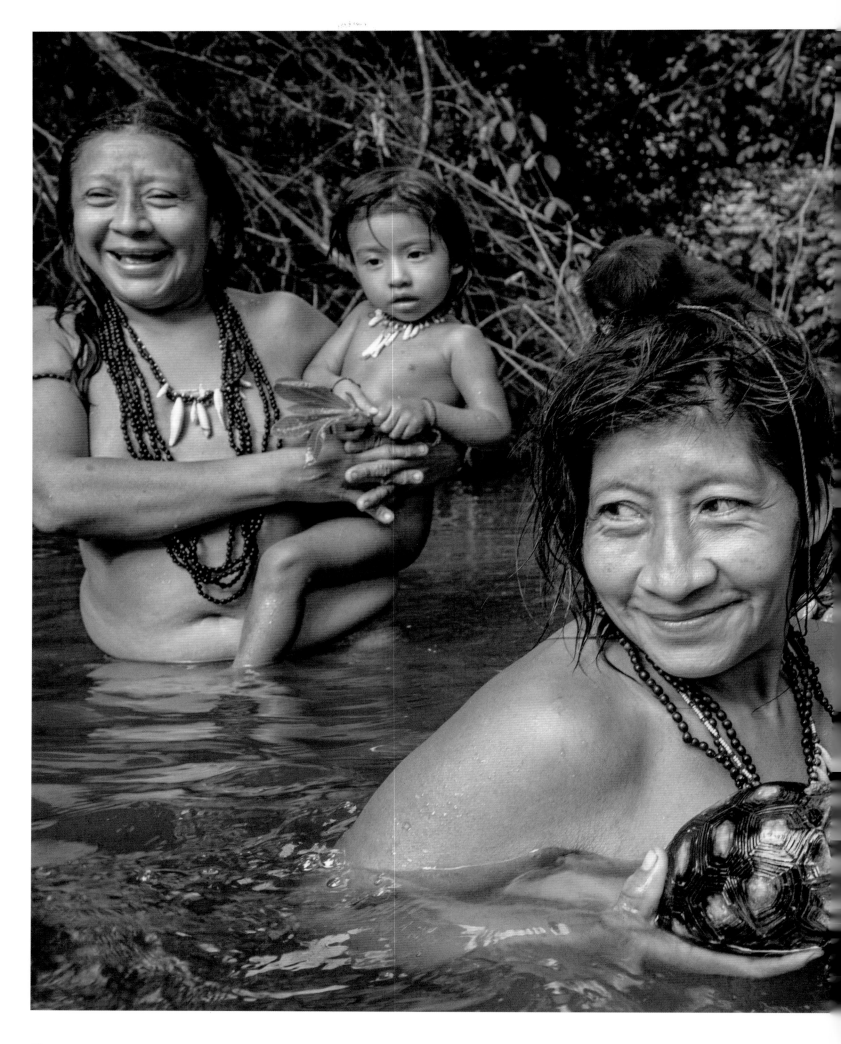

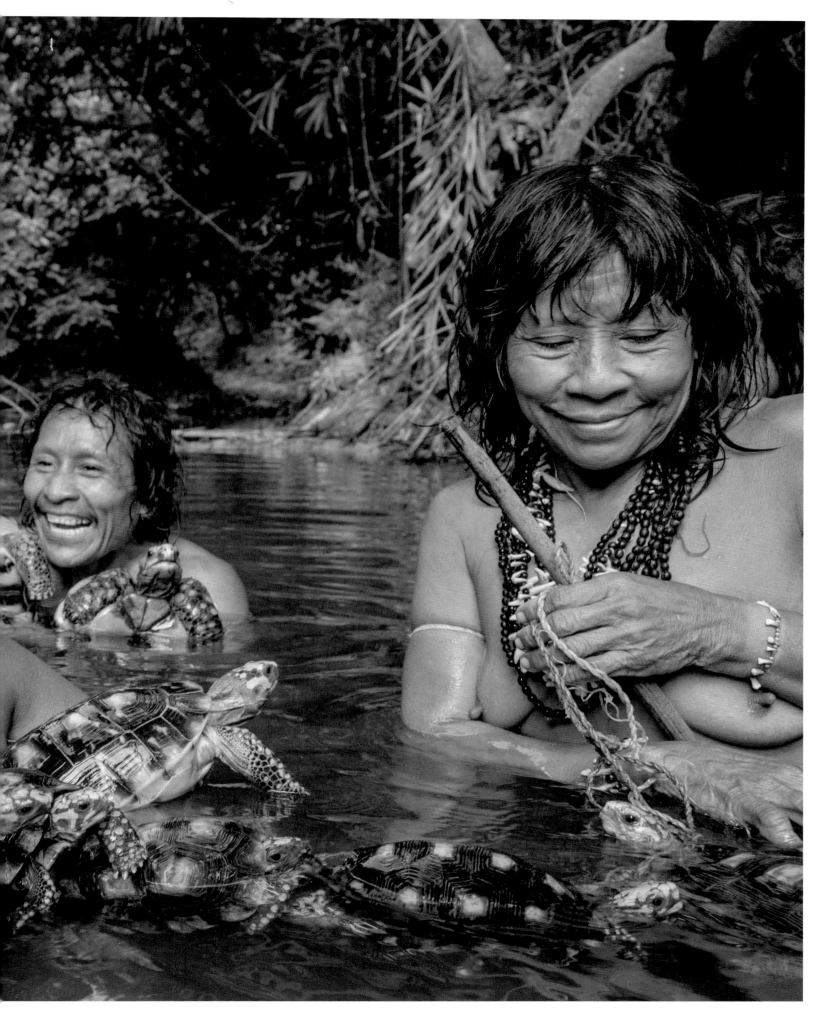

Awá villagers enjoy a morning bath in Posto Awá, Brazil, with red- and yellow-footed tortoises. *Charlie Hamilton James, 2017*

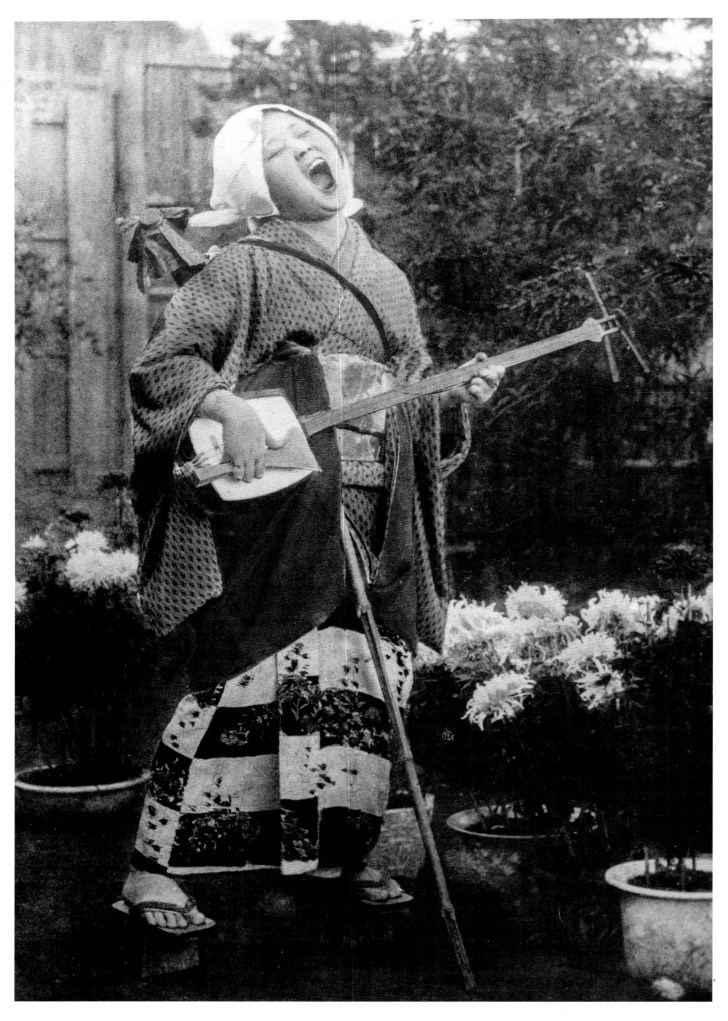

A Japanese woman sings while playing a samisen, a traditional three-stringed instrument. *Eliza R. Scidmore, 1912*

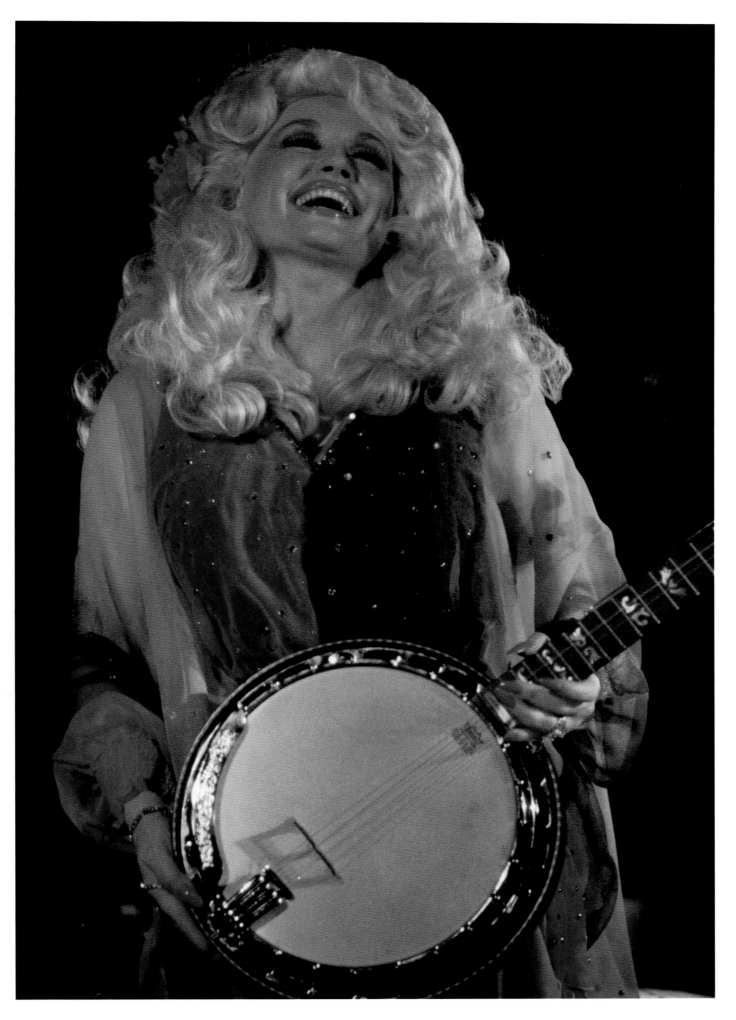

With her banjo in hand, country singer and songwriter Dolly Parton takes the stage in Nashville. *Jodi Cobb, 1978*

Dancers practice in a ballet class in New York City. *Brian Lanker, 2005*

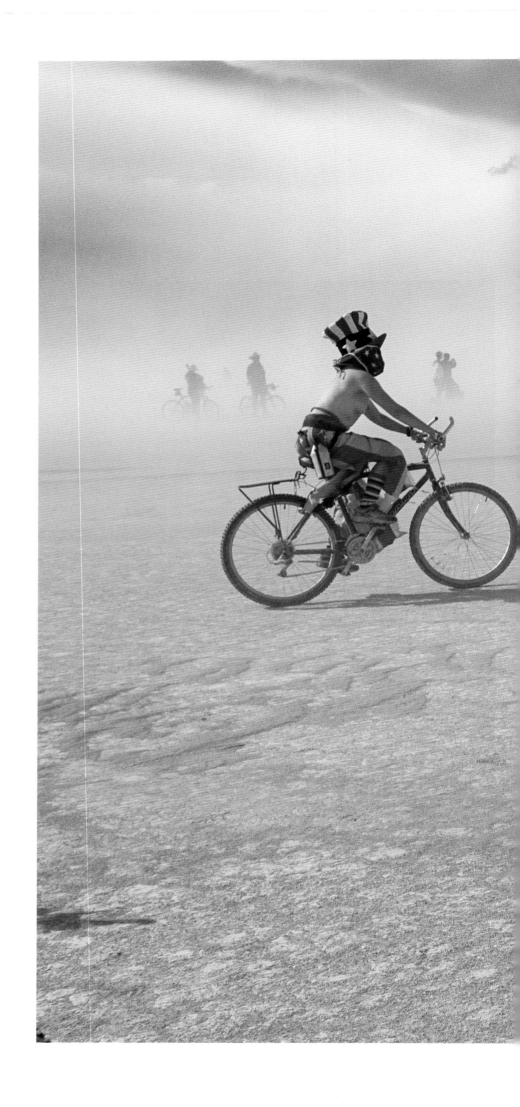

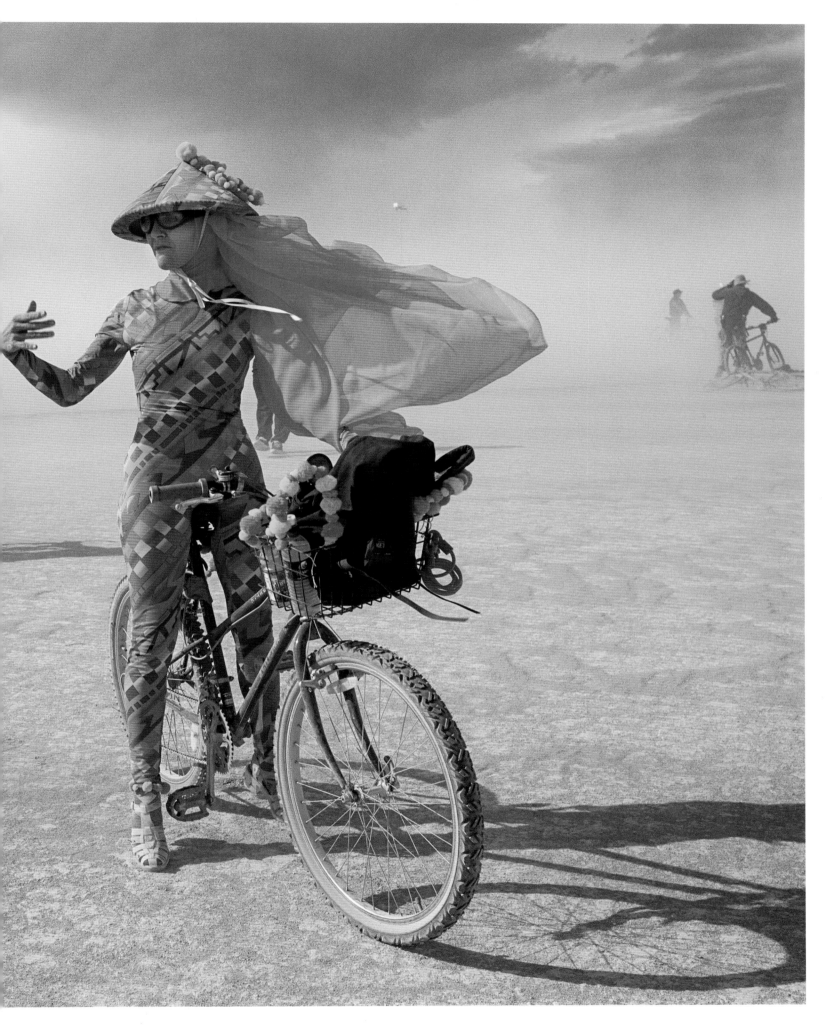

Sporting a colorful costume, a woman rides through swirls of sand at the Burning Man Festival in Nevada. *Melissa Farlow, 2001*

THROUGH
THE LENS

My mother was a prolific painter who inspired me to do something creative, something that I was passionate about. She was also a true feminist; she showed me the importance of education for women. My whole career has been influenced by my mother.

I started covering child marriage around the world 15 years ago. In 2008 this led me to the fundamentalist Latter-day Saints community. While I was there, a group of girls took me on a four-wheeler to visit the gorge where they swim and zipline. In this photo, they're building a tower to free a rope tangled in the zipline.

This is a window into a community at a very specific time: right before the scope of underage marriage in the fundamentalist LDS community was revealed, before families were broken up, before leadership went to jail. In communities I've covered around the world, my work is not just about child marriage, but the larger role of women, who are valued for their bodies, their fertility, their sexuality. The hope is that girls can be recognized for what they can bring—intellectually and politically—to their society. ■

STEPHANIE SINCLAIR

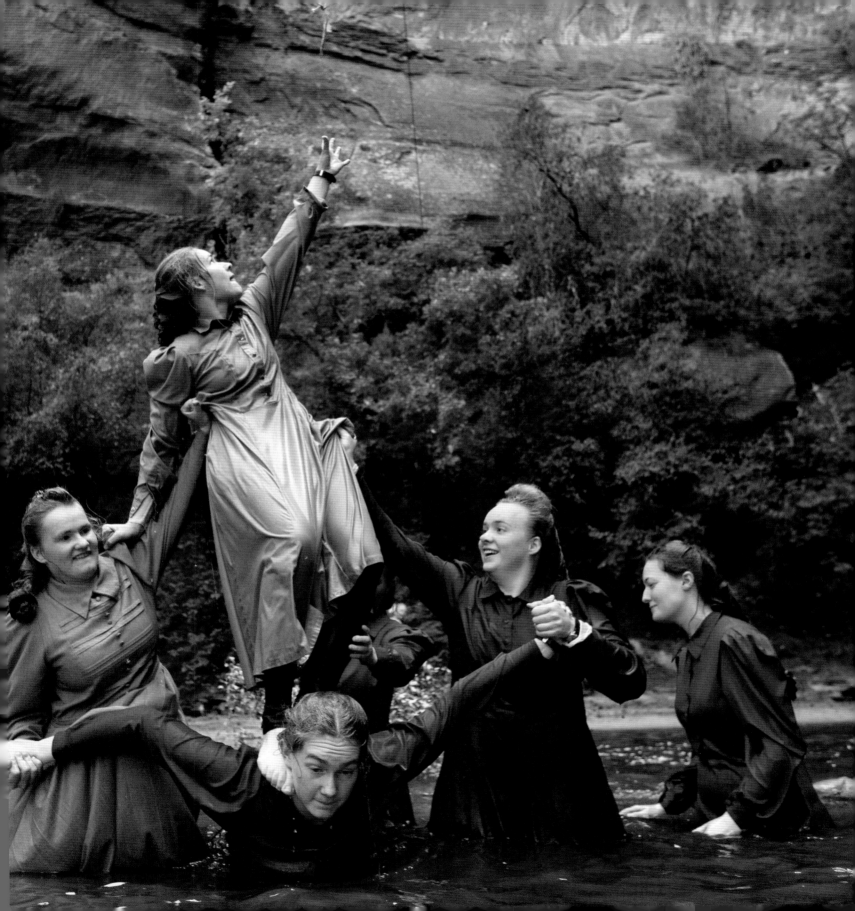

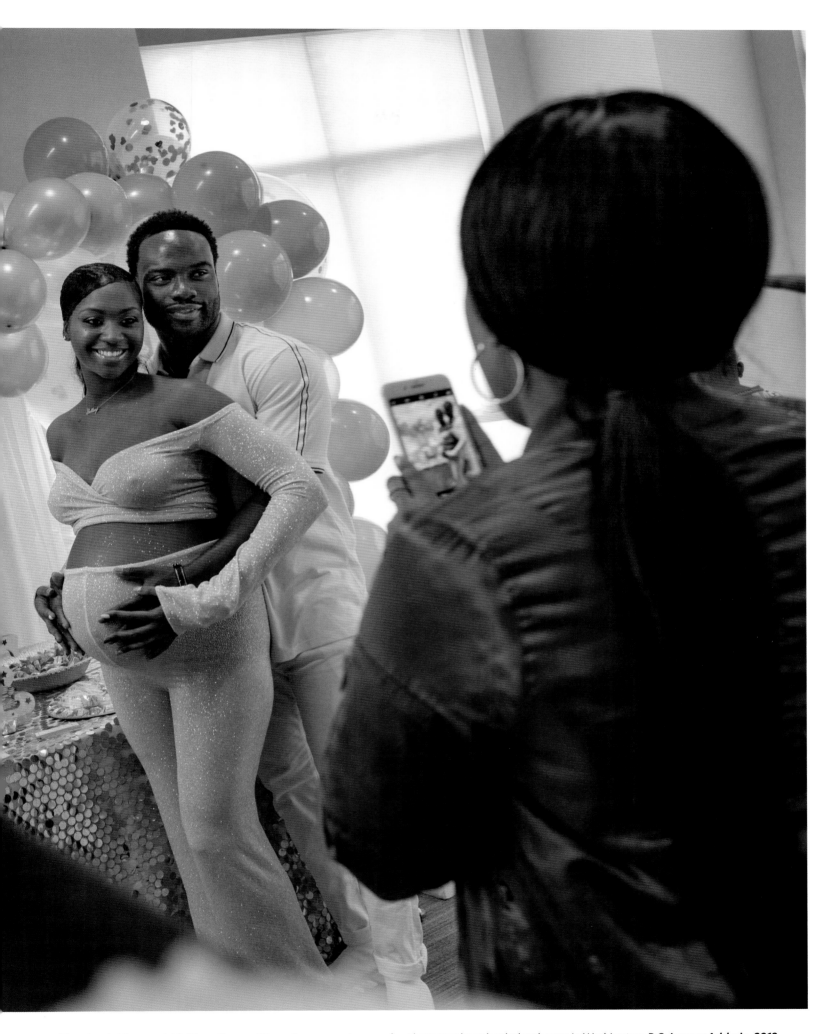

Twenty-eight-year-old Brittany Capers, 34 weeks pregnant, poses for photographs at her baby shower in Washington, D.C. *Lynsey Addario, 2018*

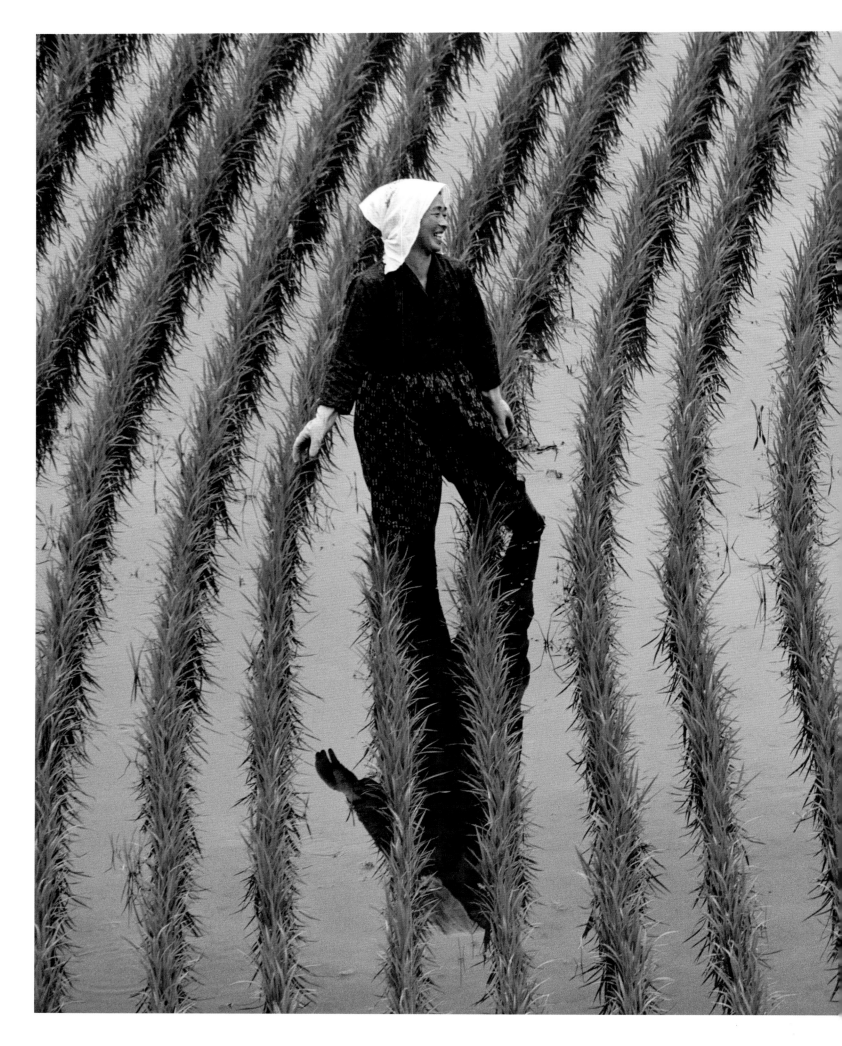

Two women take a break to share a laugh while working in the rice paddies in Honshu, Japan. **Paul Chesley, 1981**

The U.S. synchronized swimming team practices in Indianapolis. **David Bowman, 2012**

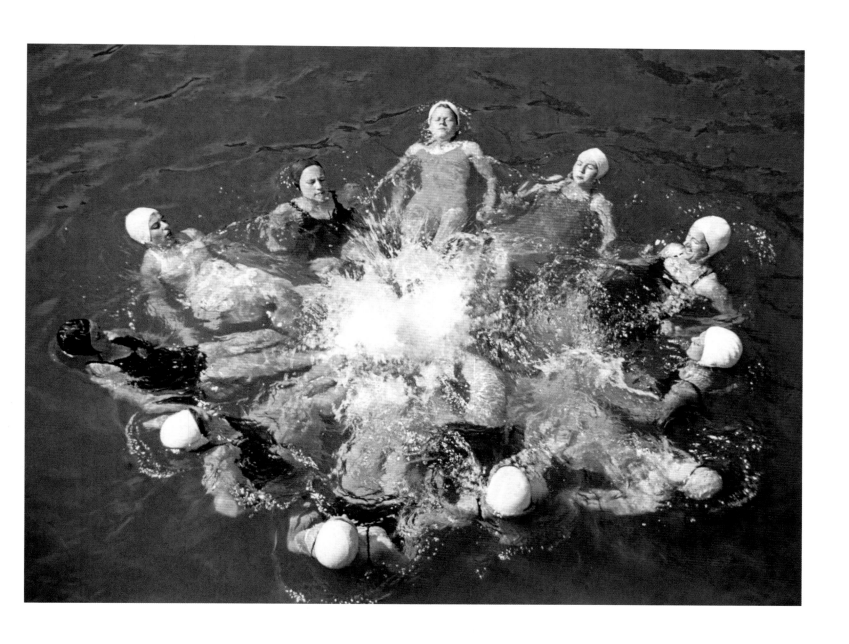

A group of women train to be lifeguards and swim instructors in North Carolina. *J. Baylor Roberts, 1941*

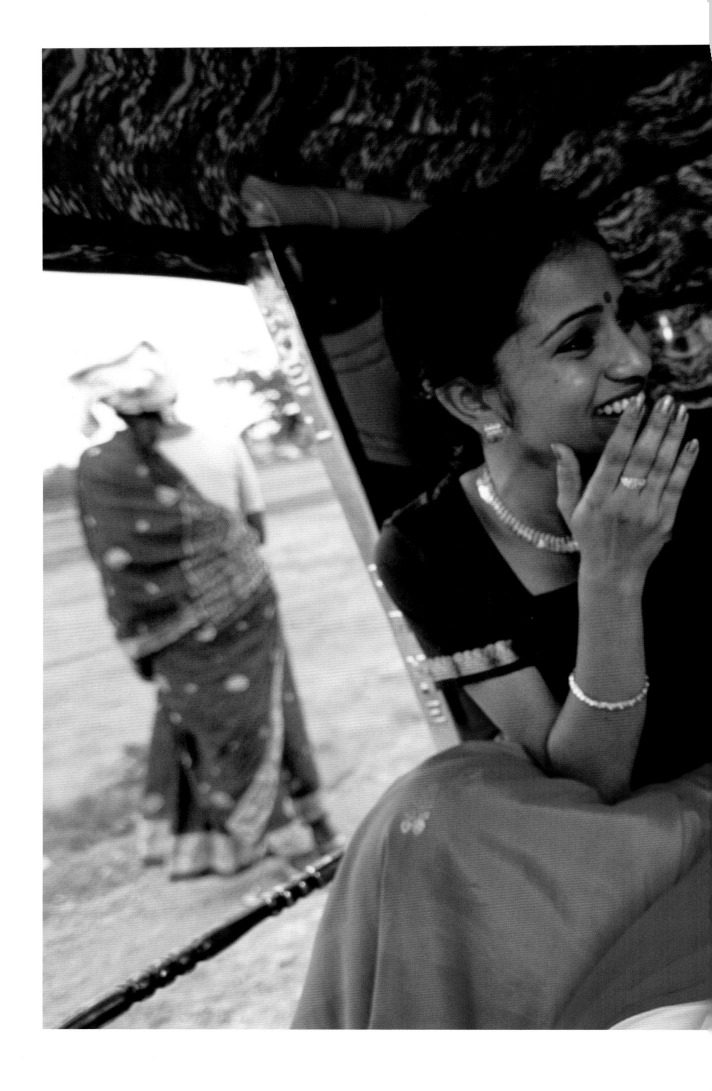

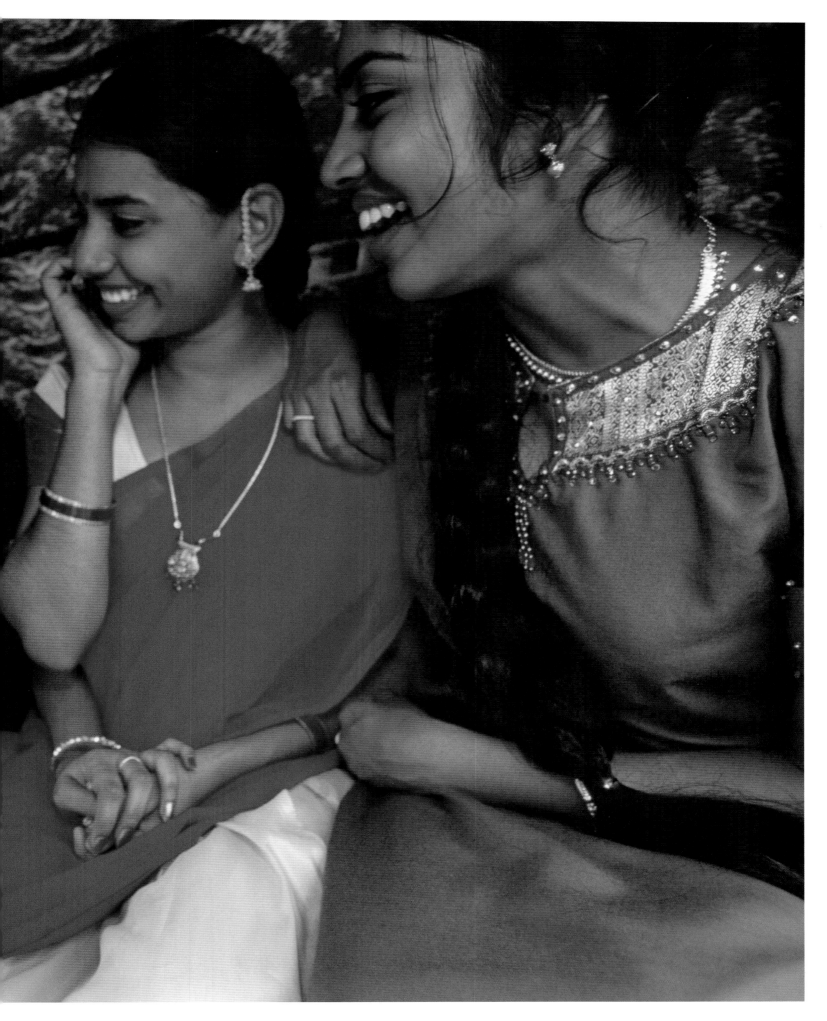

Three friends share a conversation inside a rickshaw in Bangalore, India. *William Albert Allard, 2004*

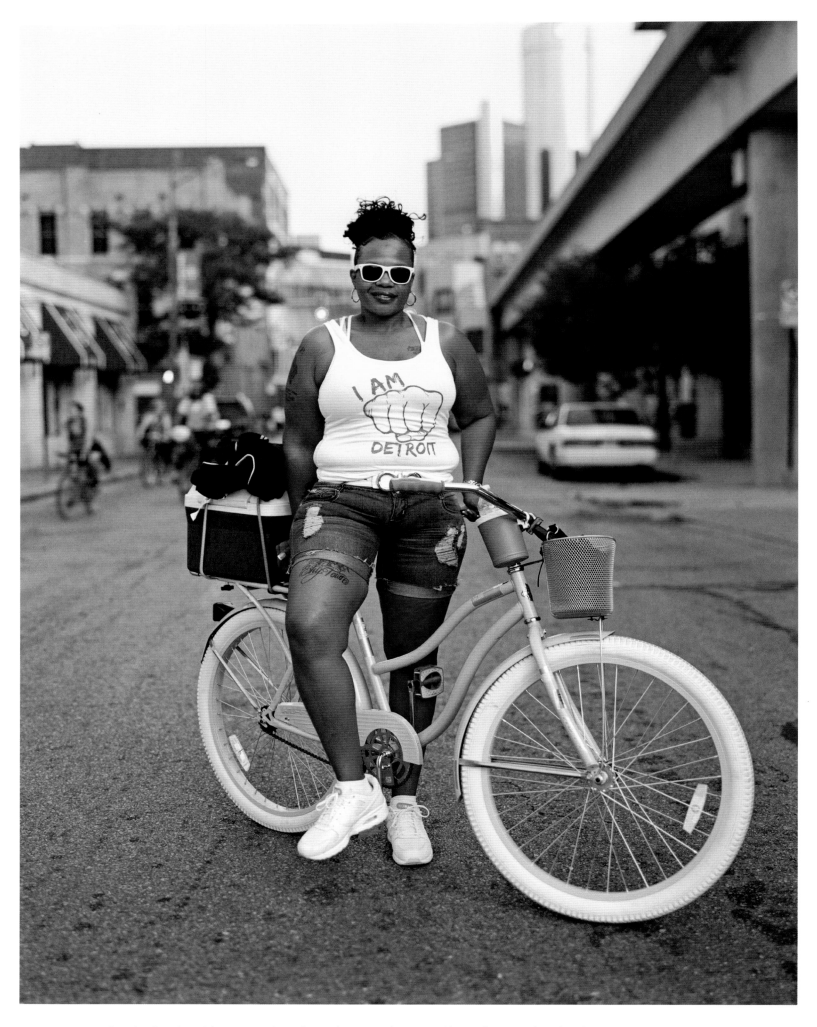

Sporting her city pride, a woman is ready to take part in the Detroit Slow Roll, a group bicycle ride. *Wayne Lawrence, 2015*

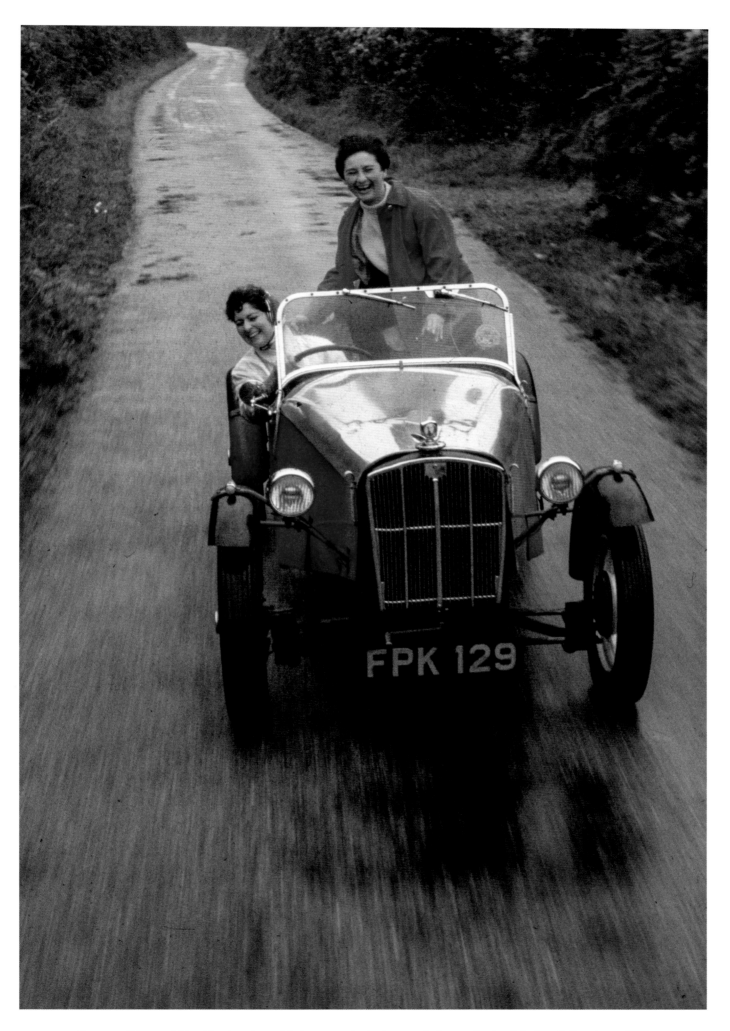

Queens of the road: Two friends enjoy a ride between the hedgerows in Devon, England. **Robert B. Goodman, 1960**

BEAUTY

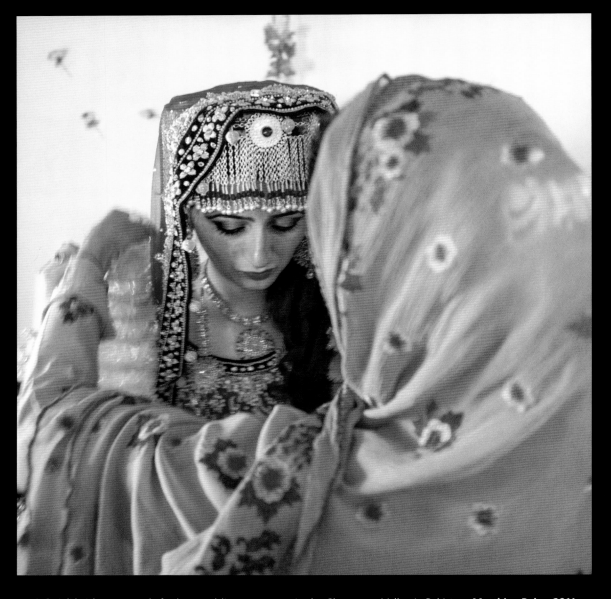

A Gojali bride gets ready for her wedding ceremony in the Chapursan Valley in Pakistan. *Matthieu Paley, 2016*

When compiling this book, we debated devoting a chapter to this topic. Beauty and women share a fraught history; we're judged on our appearance in a way men are not. Many of us grow up in front of a mirror, cataloging how we fall short of conventional notions of beauty. Today's social media ratchets up the pressure, with body shaming and unattainable goals.

In the 1960s, Jane Goodall ruefully recalls, media sent to report on her chimpanzee research "produced some rather sensational articles, emphasizing my blond hair and referring to my legs." The naturalist viewed the experience strategically: "If my legs helped me get publicity for the chimps, that was useful."

Other judgments about looks are more harmful. Author Roxane Gay says she's had to cope with "misogyny and fat phobias. Just dealing with living in a body that this world has tried to . . . discriminate against."

Today, National Geographic's content, including this book, offers a much broader view of what's beautiful. Alongside the traditional— a geisha's red lips, a dancer's graceful pose—we aim to show beauty in its unadorned state, in unexpected places, and in all its multicultural glory. ■

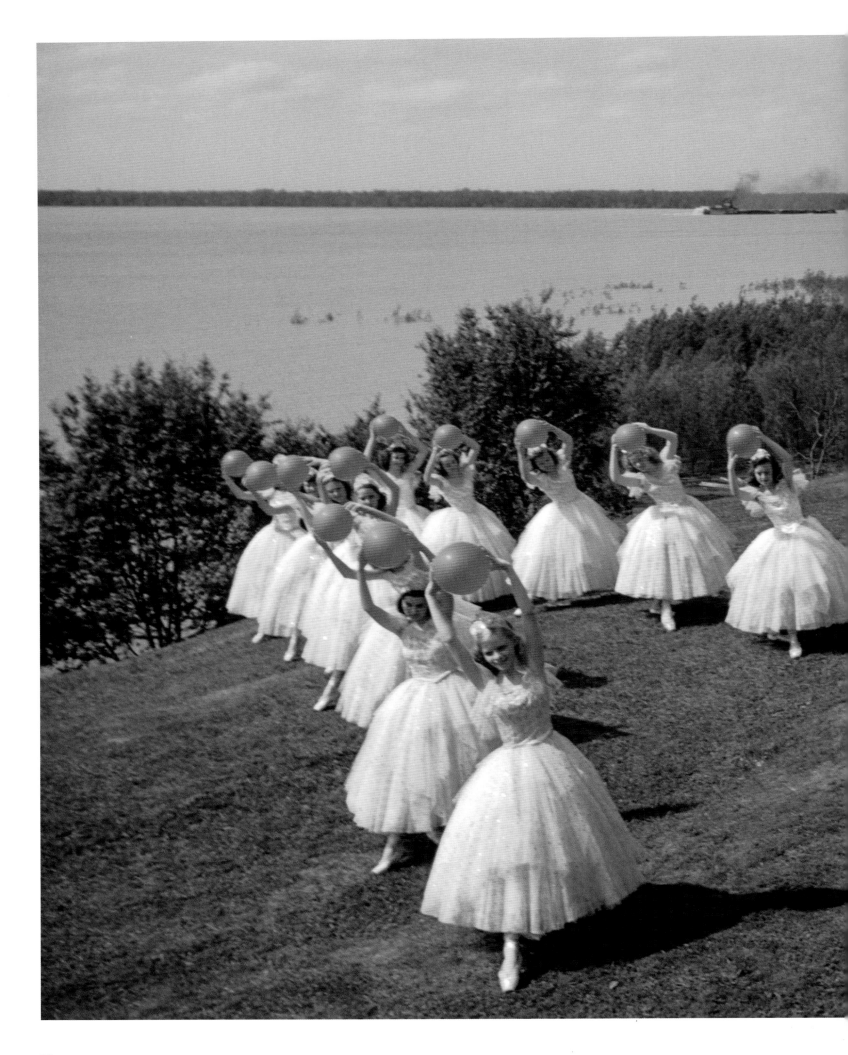

Young ballerinas strike poses, overlooking the Mississippi River near Natchez. *Willard R. Culver, 1949*

There are very few traditional geisha—artists, singers, and dancers for the richest men—left in Kyoto, Japan. **Jodi Cobb, 2008**

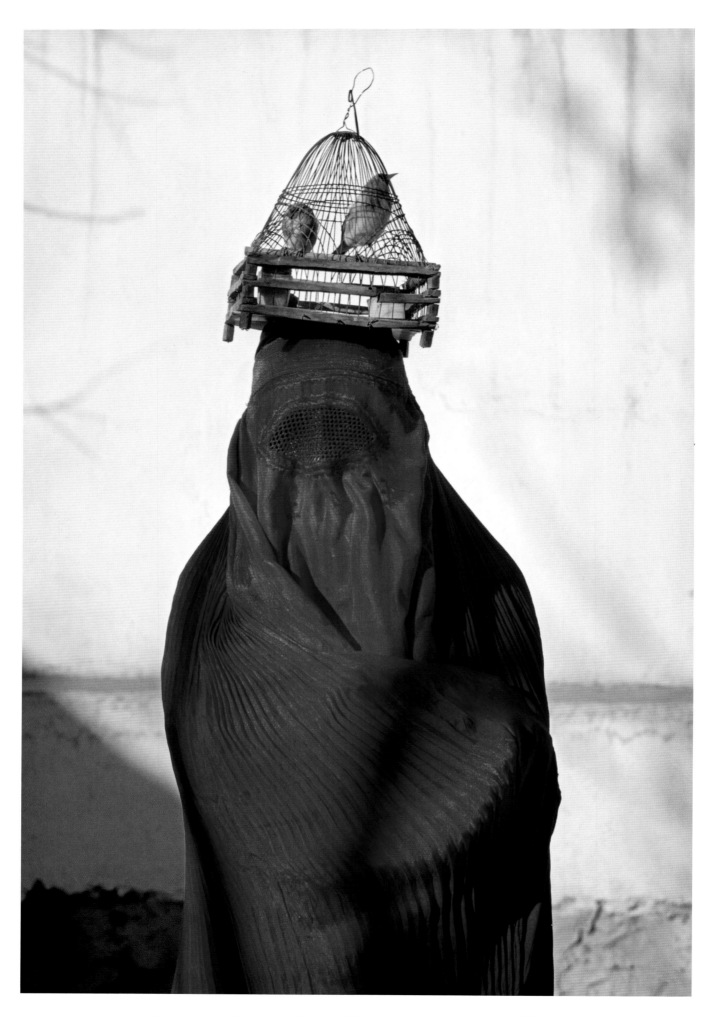

A woman draped in a red chadri—a traditional Islamic covering—carries goldfinches on her head in Kabul, Afghanistan. **Thomas J. Abercrombie, 1968**

A 24-year-old coordinator poses on a smoke break outside
the African Artists' Foundation in Lagos, Nigeria. *Robin Hammond, 2014*

A young woman celebrates her quinceañera, a traditional event marking her 15th birthday, in Richardson, Texas. **Kitra Cahana, 2016**

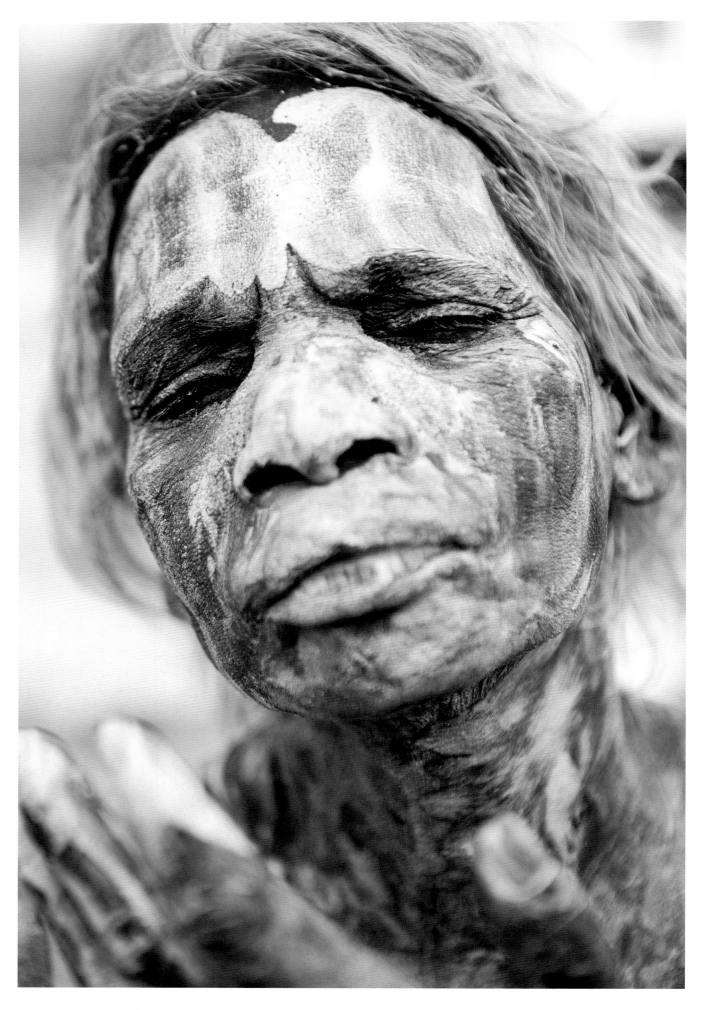

An Aboriginal woman paints her face in preparation for a repatriation ceremony of her ancestors in the Northern Territory, Australia. **Amy Toensing, 2012**

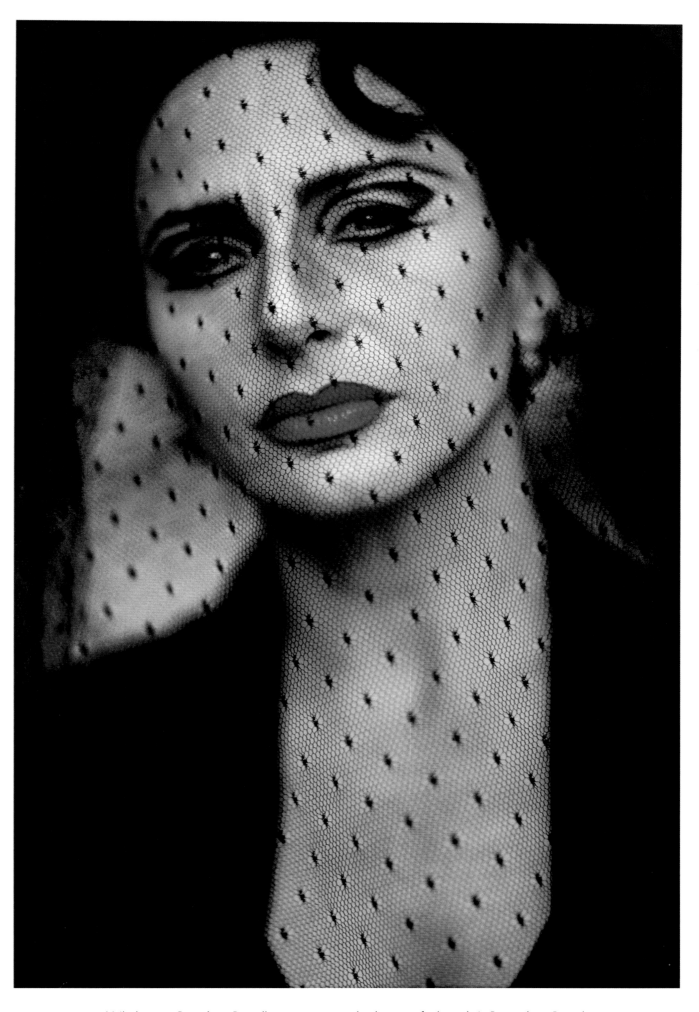

Veiled actress Benedetta Buccellato prepares to take the stage for her role in *Prometheus Bound,* at the Greek Theater of Syracuse in Sicily. **William Albert Allard, 1994**

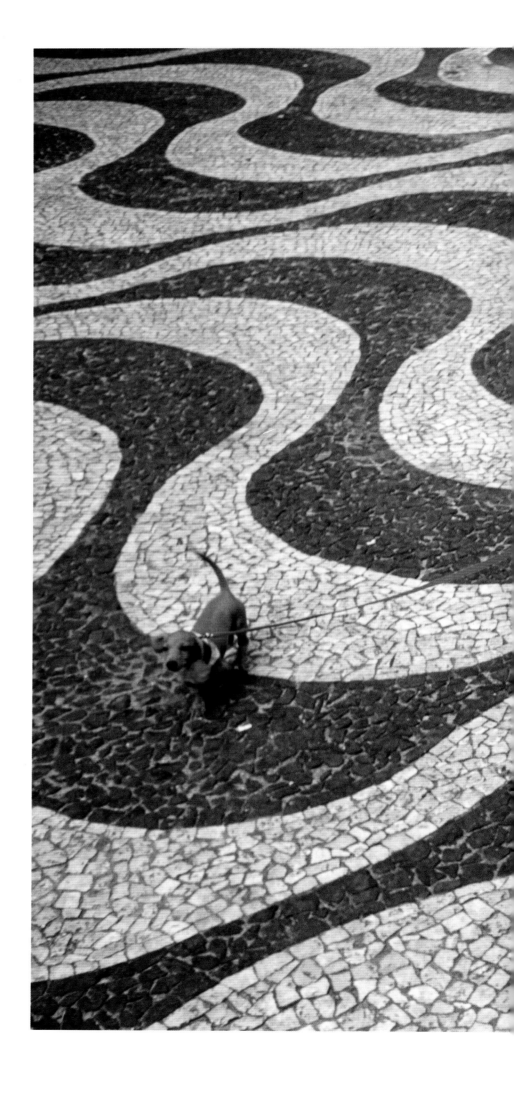

A woman walks her dachshund along the Copacabana Promenade in Rio de Janeiro, Brazil. **Charles Allmon, 1955**

Cowgirl dancers line up at a pioneer village in Scobey, Montana. *William Albert Allard, 2010*

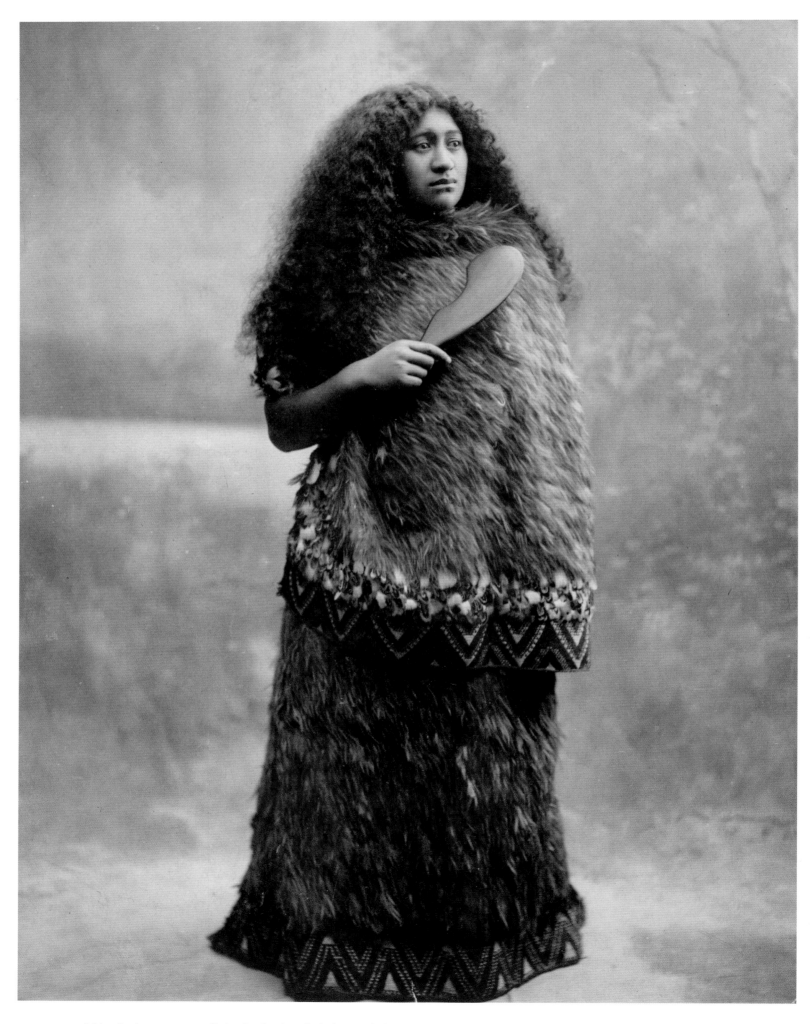

A Maori princess wears a distinctive feather cloak that marks her rank, and holds a weapon made of greenstone. *Tesla Studios, 1921*

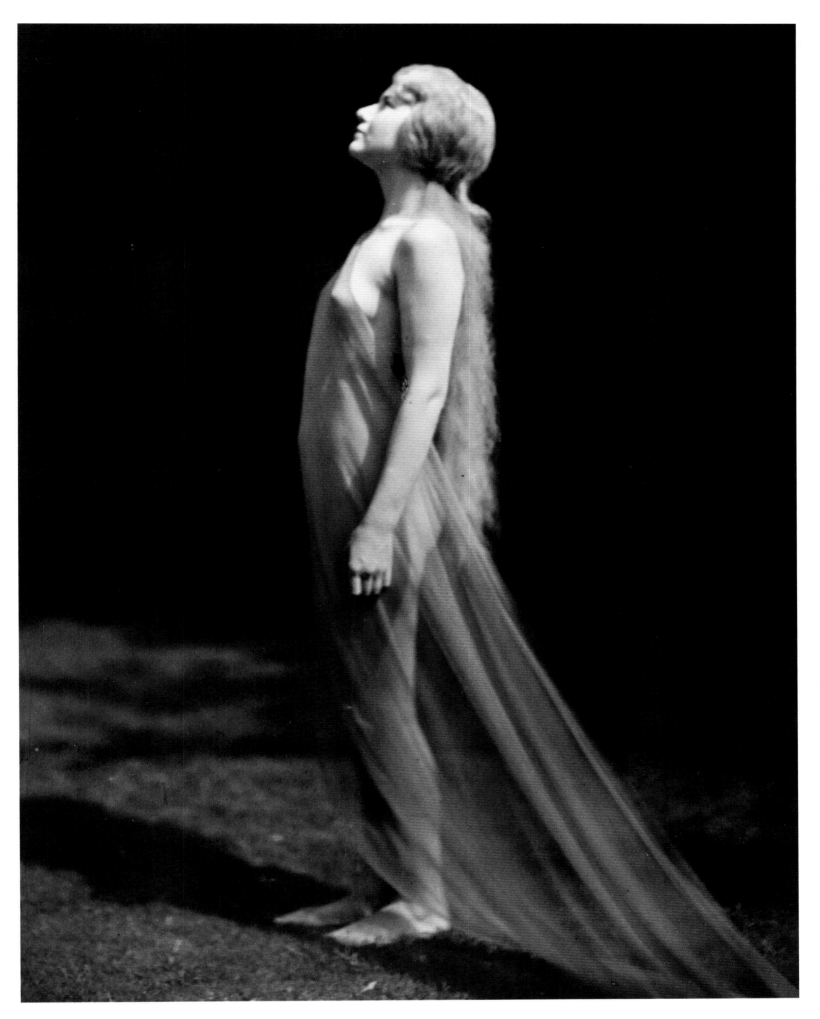

A woman draped in red silk looks skyward. *Franklin Price Knott, 1936*

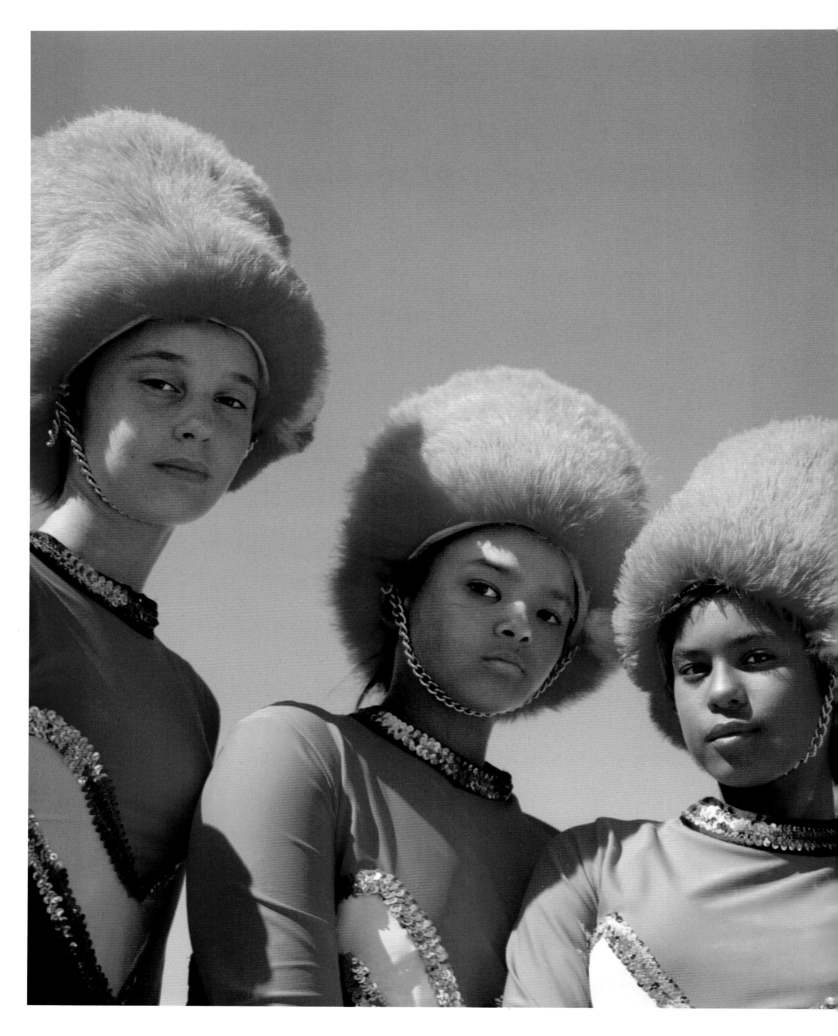

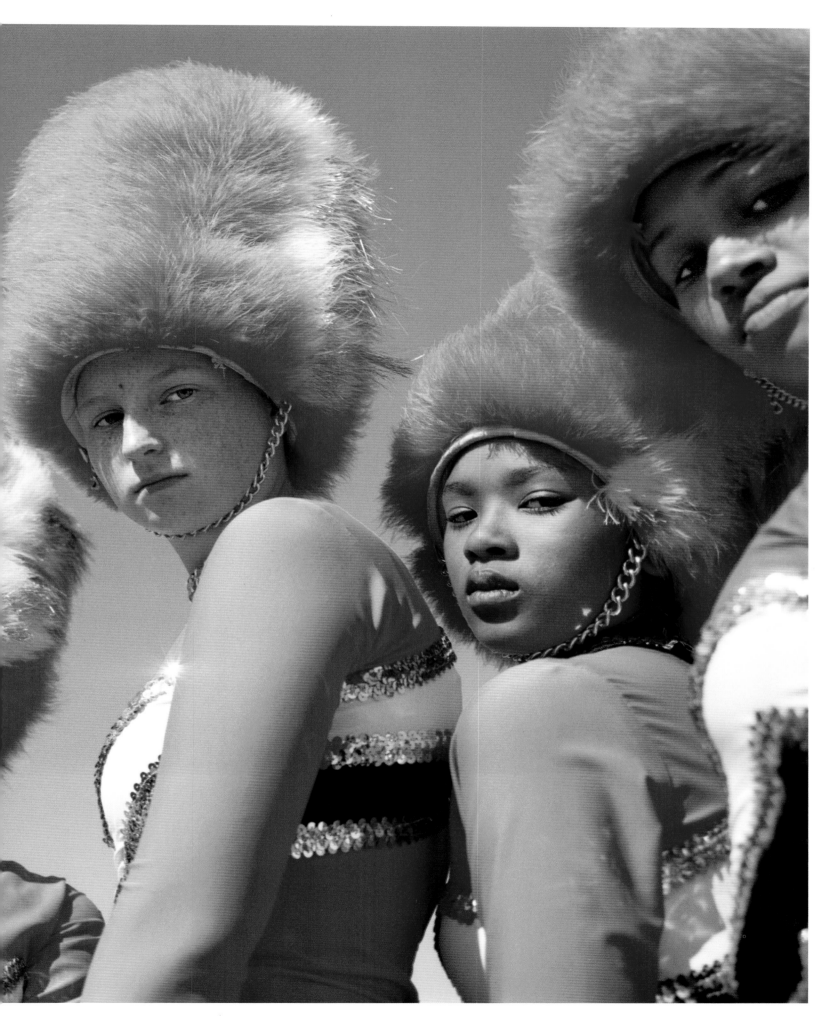

Members of a drum majorette team pose in Cape Town, South Africa. *Alice Mann, 2018*

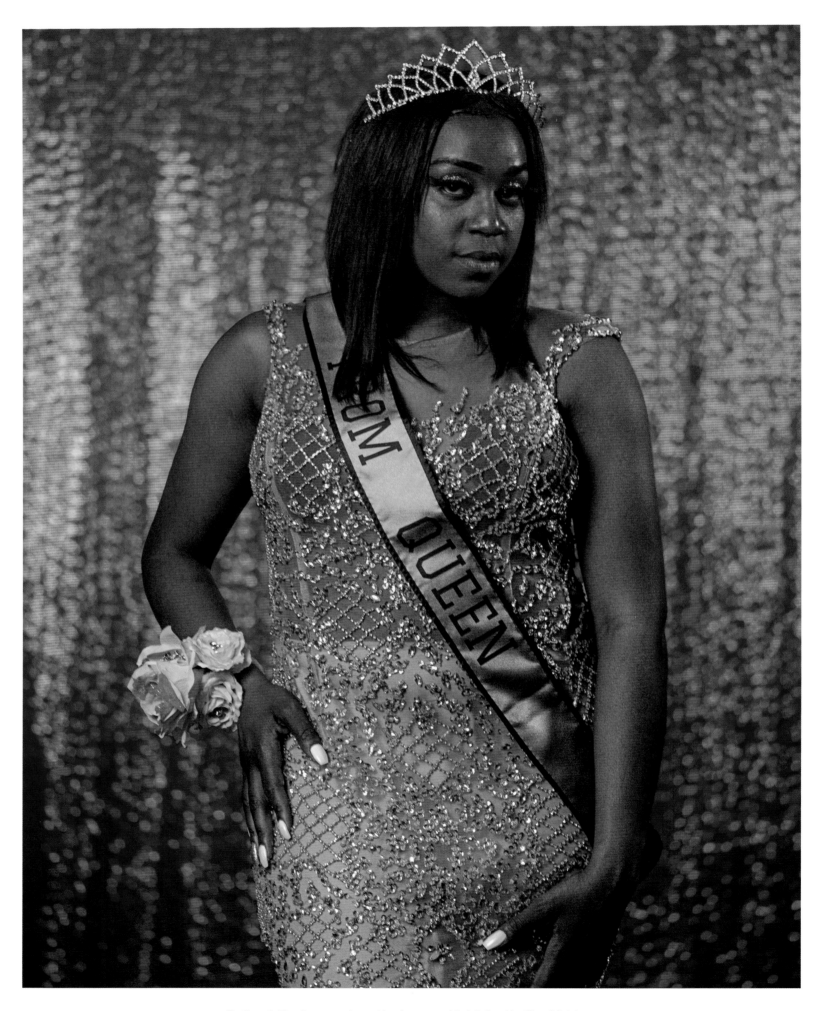

Cha'Leyah Fleming, a senior at Northwestern High School in Flint, Michigan, poses at her senior prom—the last prom before the school closed. *Zackary Canepari, 2018*

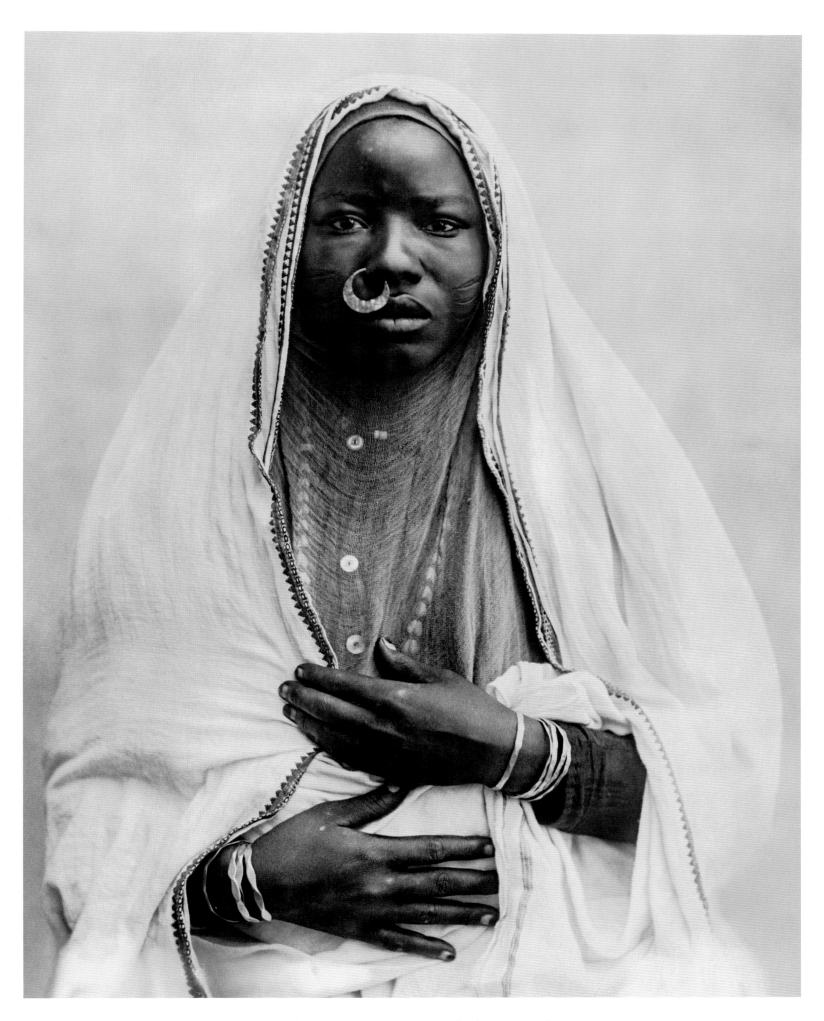

A Sudanese woman poses in Egypt in her home country's
traditional clothing and jewelry. *Photographer unknown, pre-1910*

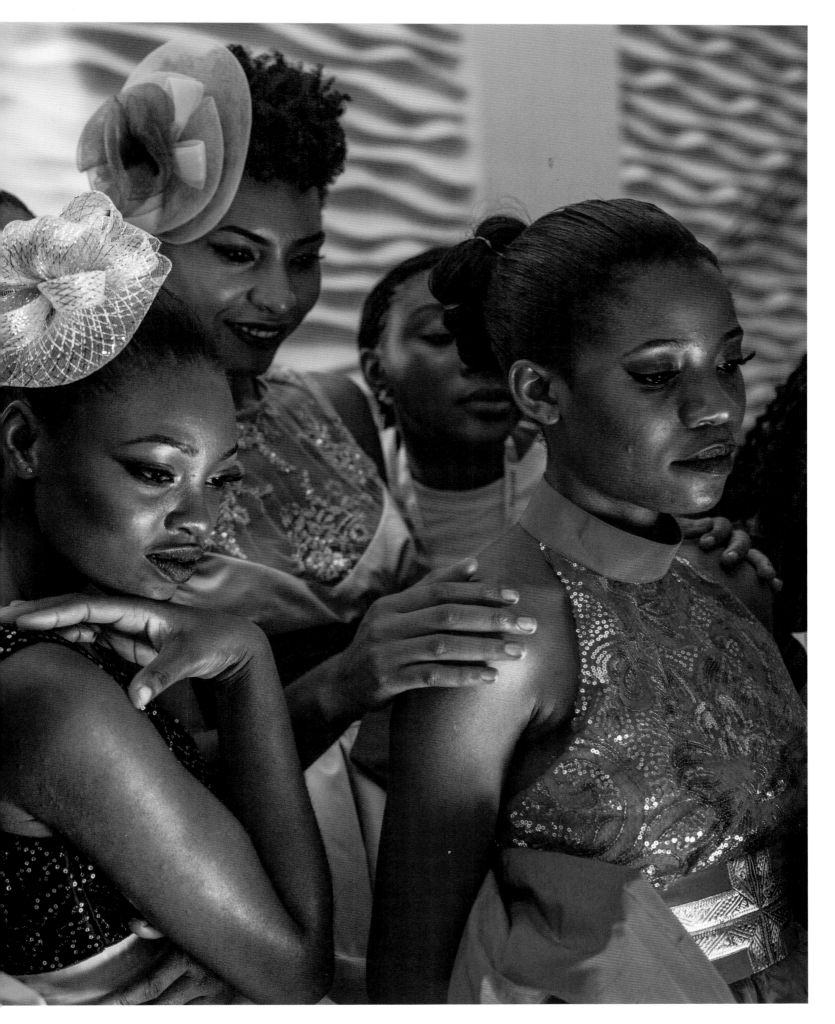

During Africa Fashion Week, models watch the action on a backstage television in Lagos, Nigeria. *Robin Hammond, 2014*

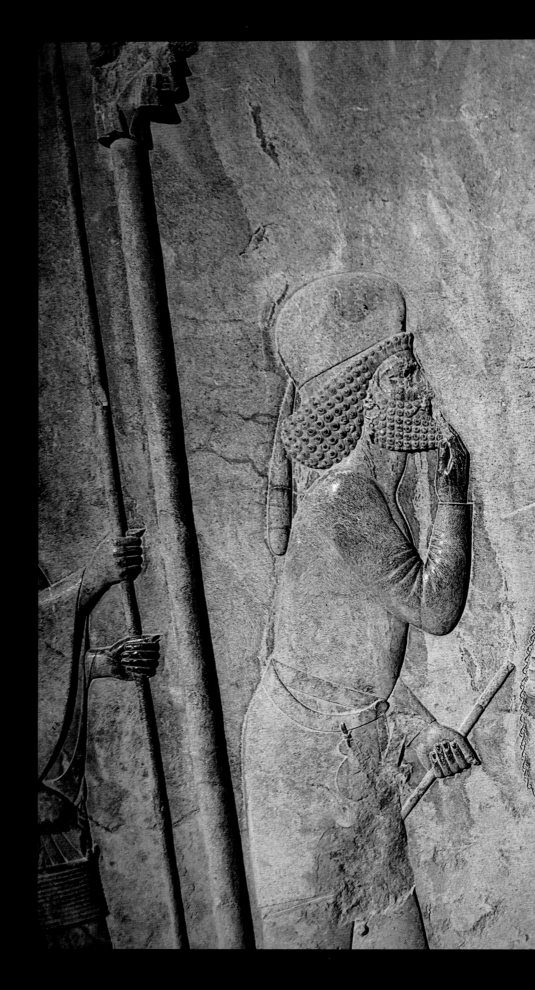

THROUGH
THE LENS

Being a dyslexic teenager, I couldn't express myself the way most of my friends did. Then, I discovered photography, where I could express myself in a visual way. I managed to share my feelings, my thoughts, and my ideas in a more suitable manner for me.

This image was captured as part of a series I took in Iran for *National Geographic* in 2008. In it, an actress is shooting a movie scene in Persepolis, the capital of the Persian Empire and a UNESCO World Heritage site today. It captures the contrast between ancient history and the way Iranians carry on with their daily lives nowadays. It's not that you see a woman or an actress; instead, this photograph illustrates that contrast and offers a certain dose of mystery. ∎

NEWSHA TAVAKOLIAN

A Lakota tribeswoman showcases her distinctive Barbie necklace and pink glasses in Pine Ridge, South Dakota. *Aaron Huey, 2011*

Mina Mahmood, a 19-year-old plus-size model, promotes feminism and body positivity on her Instagram. *Kitra Cahana, 2016*

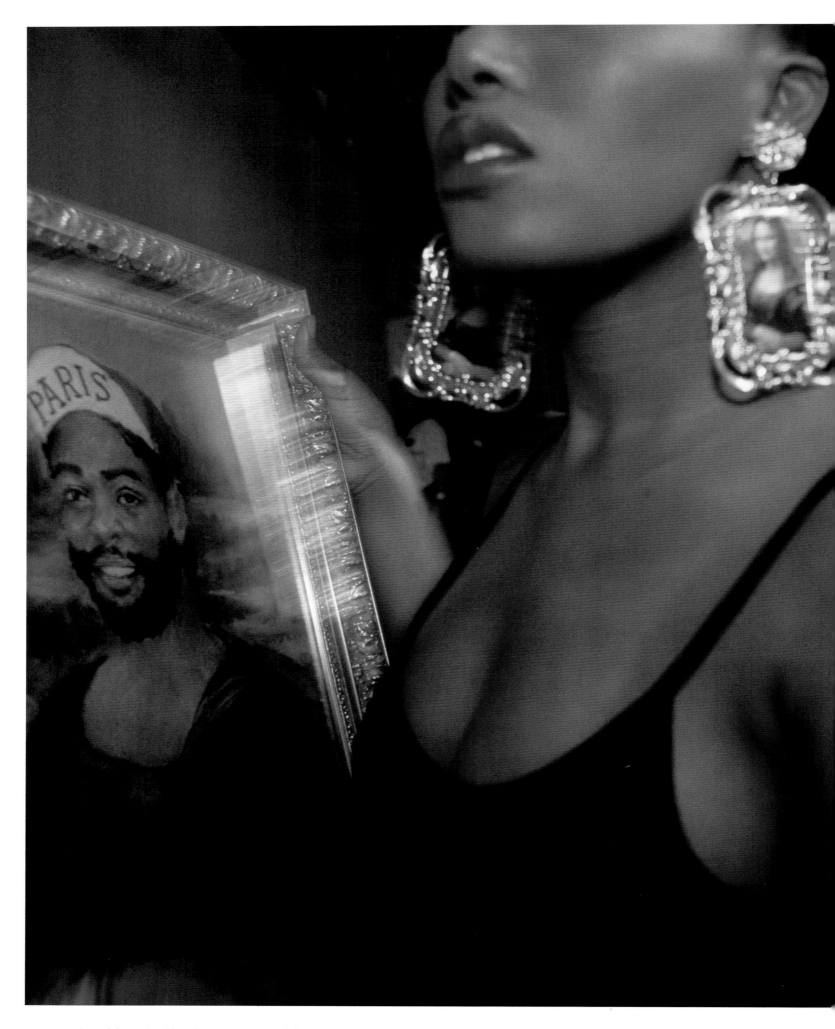

A model wearing Mona Lisa earrings stands by a portrait of Patrick Kelly backstage at a fashion show in Paris. **William Albert Allard, 1989**

Dressed in costume, a tourist takes in the views of the canals and gondolas in Venice. **_Jodi Cobb, 2008_**

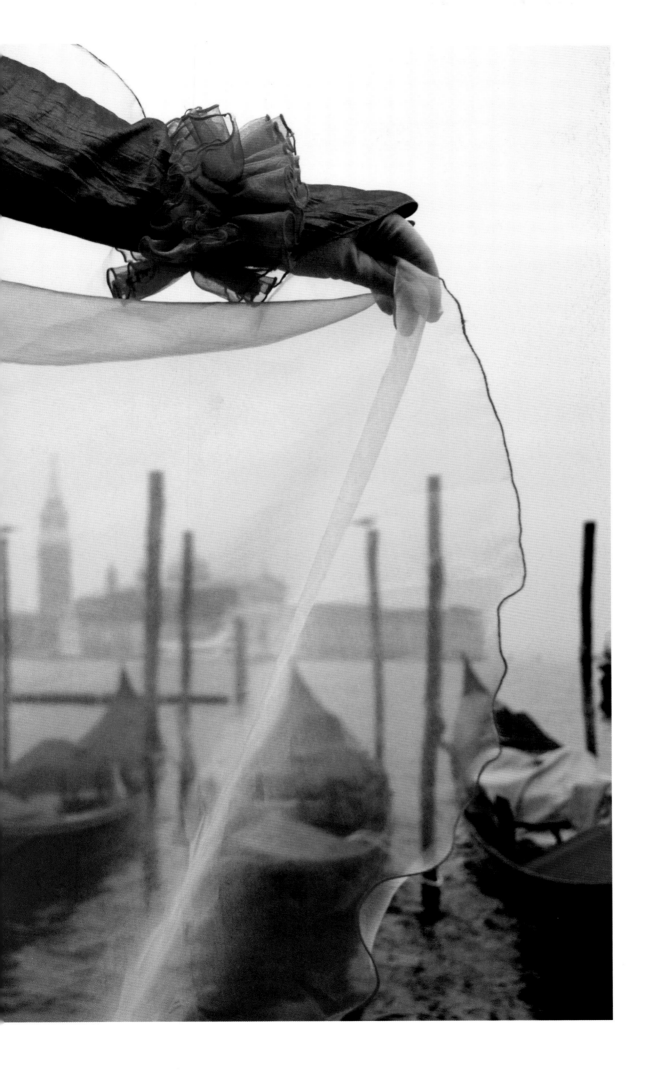

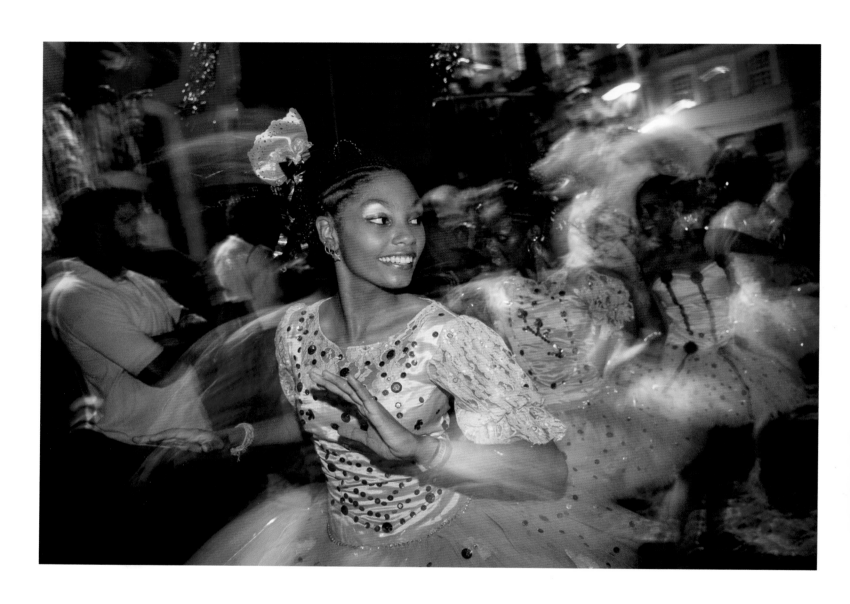

Dancers take to the streets during Brazil's annual Carnival parade. **David Alan Harvey, 2009**

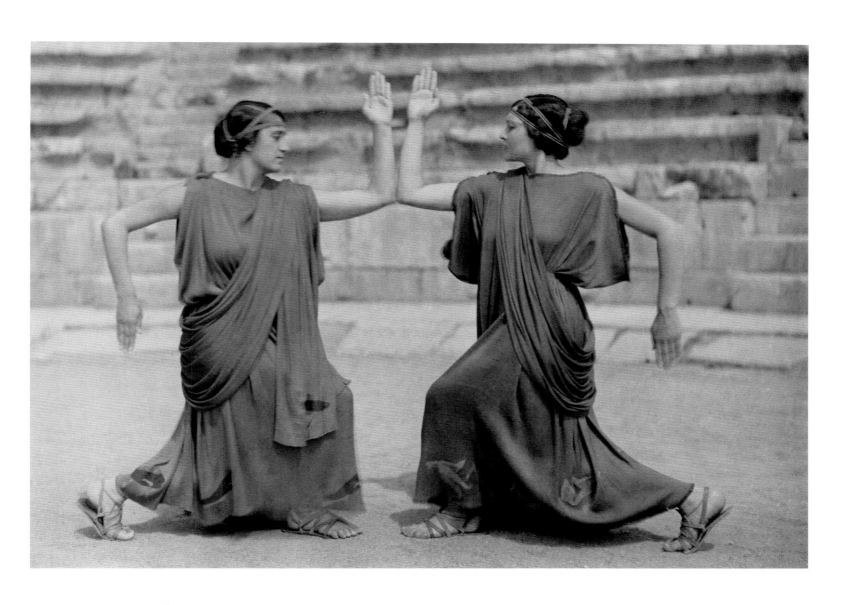

Two actresses strike a pose in ancient Greek costumes during the Delphi Festival. **Maynard Owen Williams, 1930**

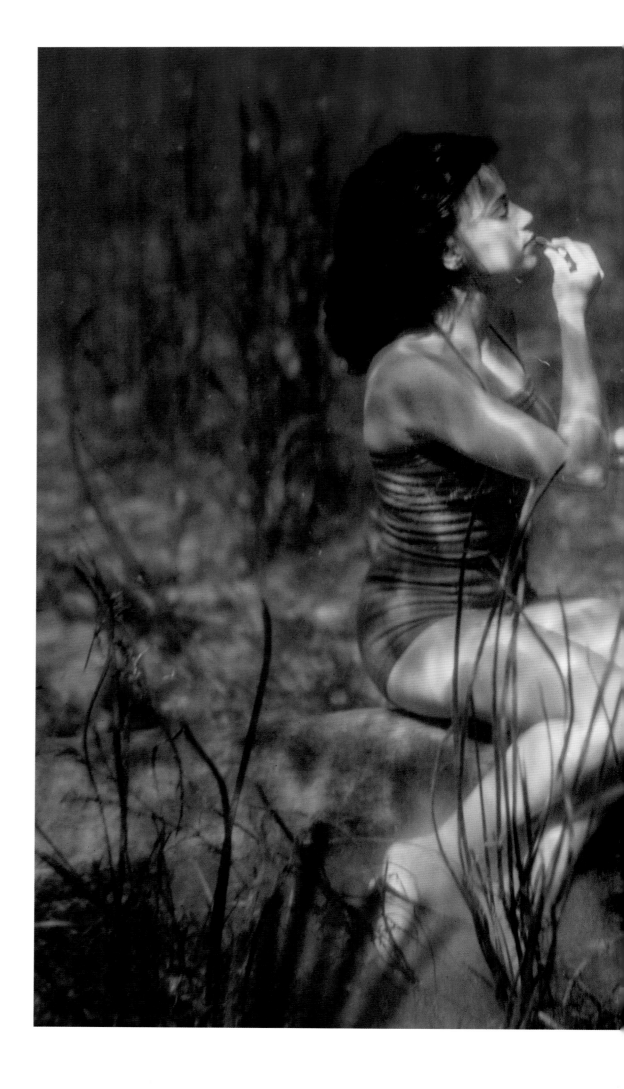

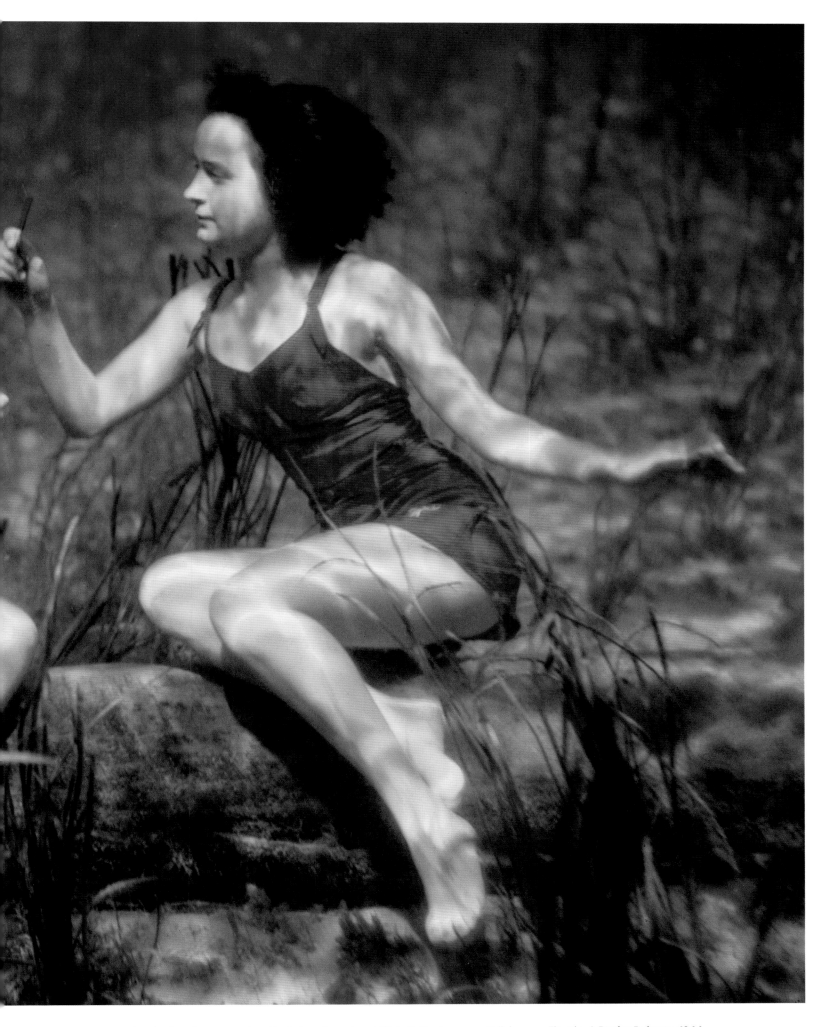

A pair of performers put on lipstick underwater at Wakulla Springs near Tallahassee, Florida. *J. Baylor Roberts, 1944*

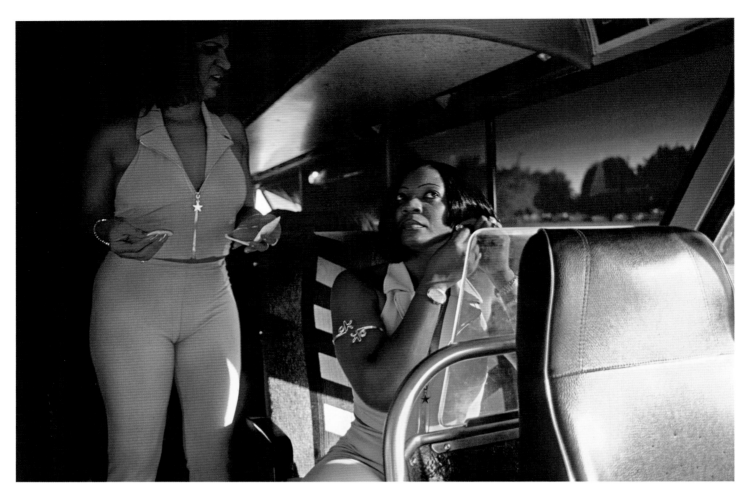

Blues musician Bobby Rush's backup dancers apply finishing touches before a show in Greenville, Mississippi. **William Albert Allard, 1997**

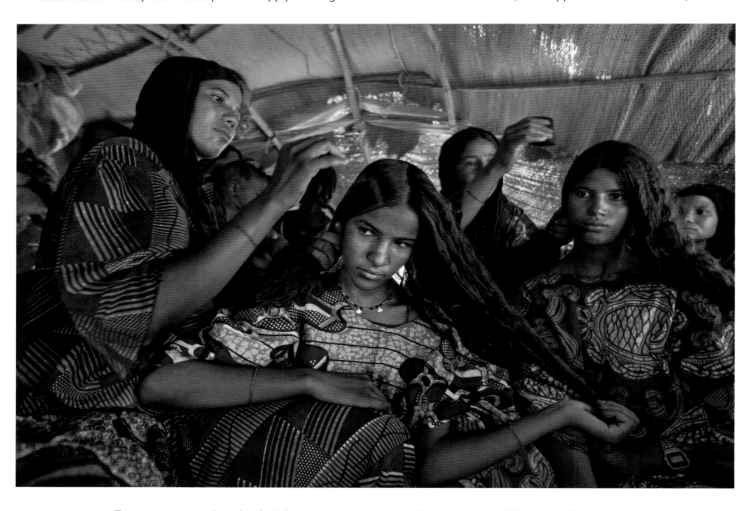

Tuareg women comb each other's hair in a nomadic camp in the Ingal region of Niger. **Brent Stirton, 2009**

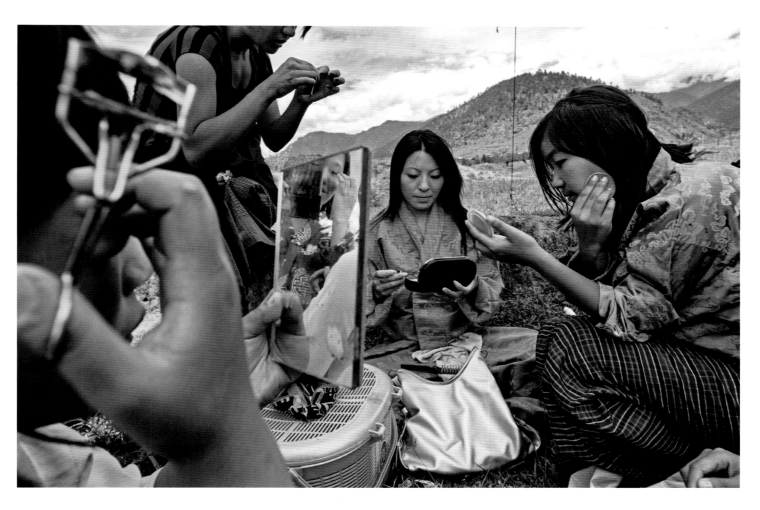

Makeup is applied before taping a dance sequence for a film in Bhutan. *Lynsey Addario, 2007*

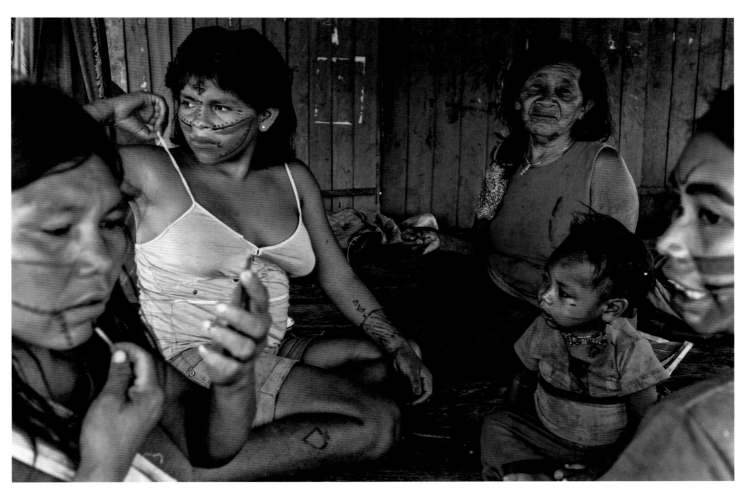

Women in Peru's Culina tribe create striking designs with traditional face paint. *Alex Webb, 2011*

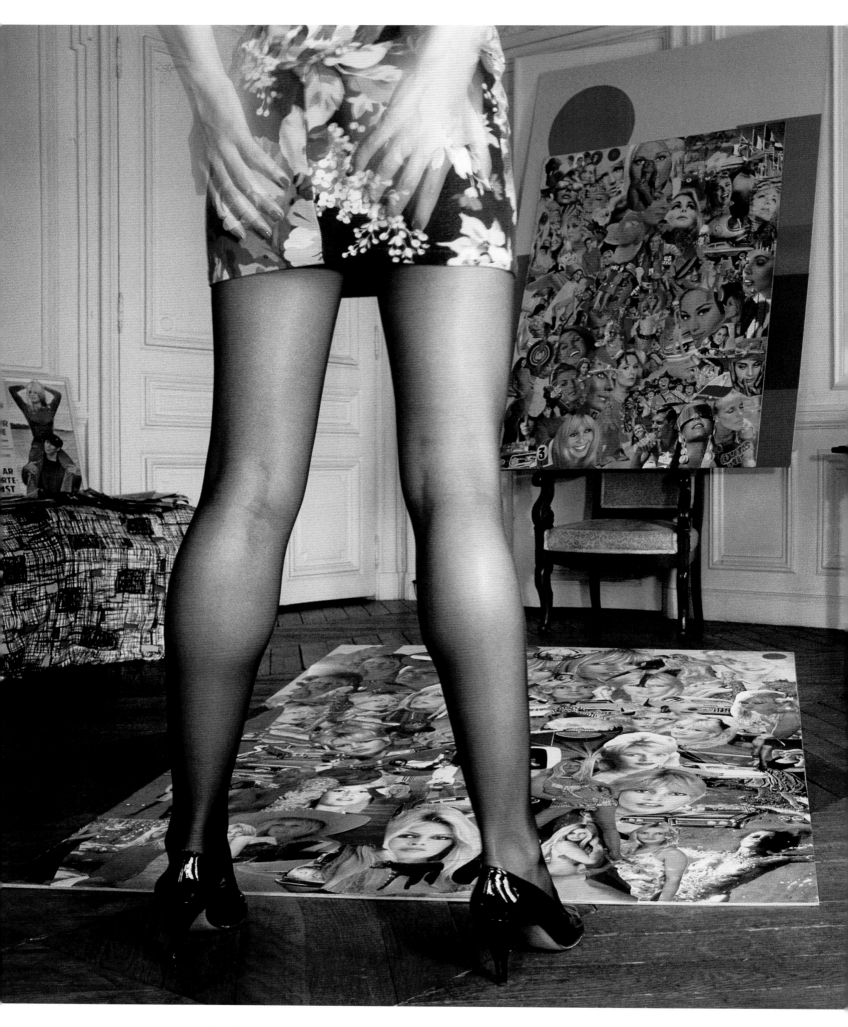

A model, Tanya, stands over a Brigitte Bardot collage in Paris. **William Albert Allard, 1988**

THROUGH
THE LENS

I was working on a *National Geographic* assignment about skin and found a company in London that was using amazing techniques to create lifelike masks and prosthetics. We had a model's face cast, and then I took her into the studio to photograph the mask. I took many shots showing her real face and the mask—but it was when I asked her to hold her own face in her hands that something surprising happened. For me, this is a magical image that is intriguing, disturbing, yet beautiful. It speaks in a language that is not wholly intellectual. All of us, but especially women, are judged on our appearance. Our face is how we meet the world and how the world meets us. Yet, our face is not the whole story of any of us. This image says, "Yes, this is my face, this is me—but it's not all of me. It is only part of me." ■

SARAH LEEN

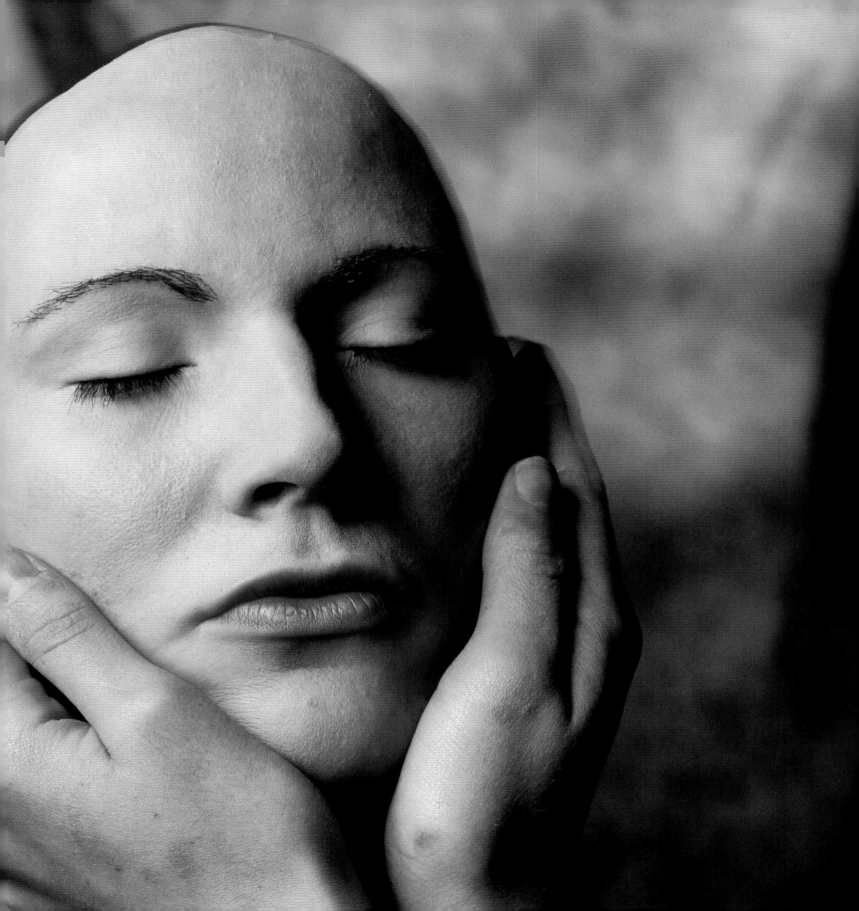

Emmie (right), a transgender teen who came out at the age of 17, talks with her identical twin brother, Caleb. *Lynn Johnson, 2016*

Sisters Carolyn Schear (right) and Cheryl Diggs have a family history of fatal insomnia. *Maggie Steber, 2009*

A woman freshens up in Lima Peaks, Montana, during a Mountain Man Rendezvous. **David Burnett, 2015**

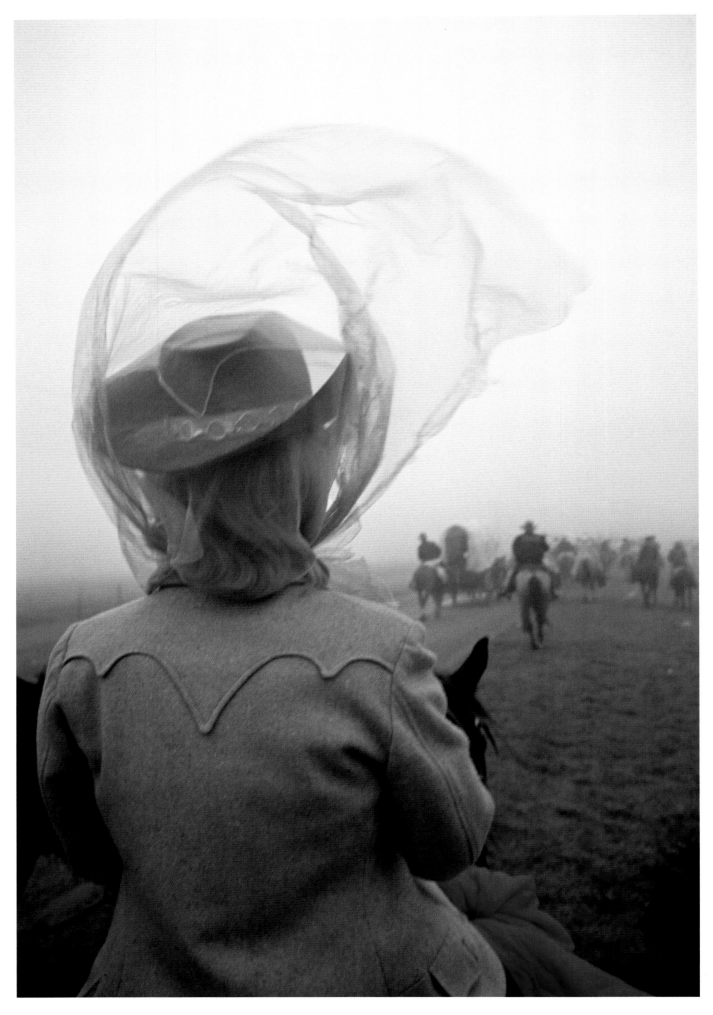

A rider veils her hat to protect it from the wind on a long ride near Houston. **William Albert Allard, 1967**

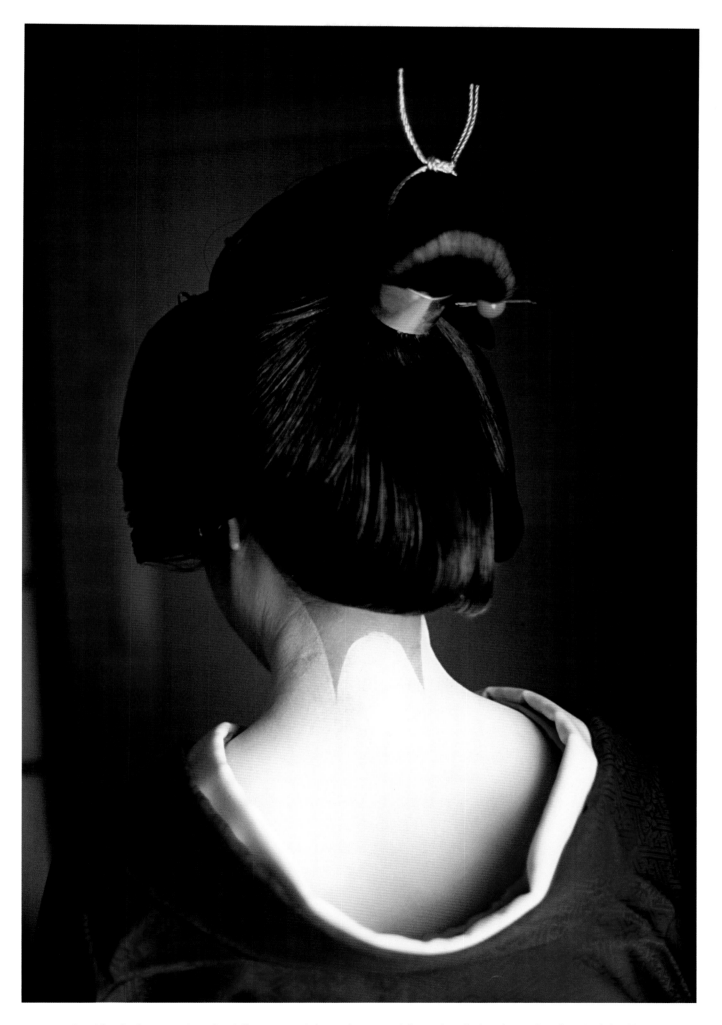

A geisha displays a section of artfully unpainted skin at the nape of the neck, called *sanbon-ashi*. **Alison Wright, 2011**

Two odalisques (members of the Ottoman sultan's harem) play a round of cards in Turkey. *Sébah & Joaillier, ca 1890*

Sébah & Joaillier.

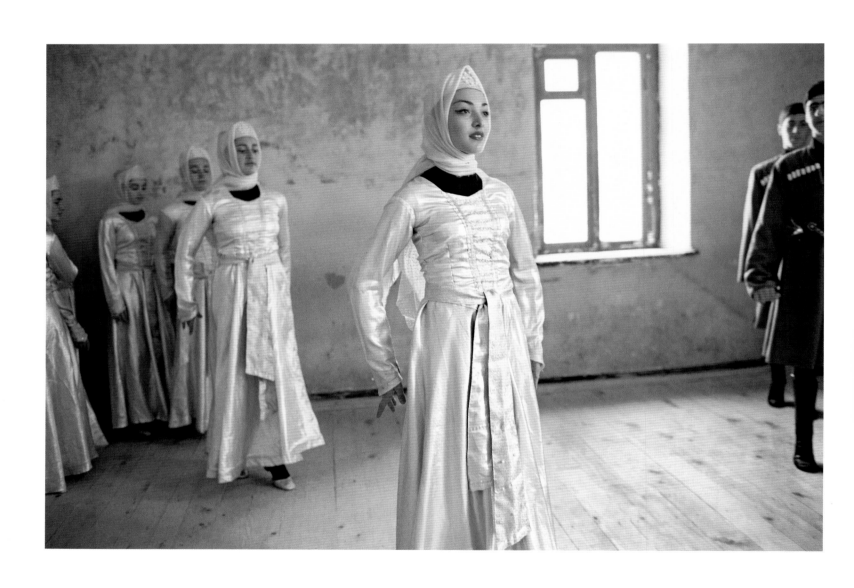

Nana Merlani rehearses traditional dances and songs in the Svan language
with the Lagusheda Folk Ensemble in Mestia, Georgia. **Aaron Huey, 2013**

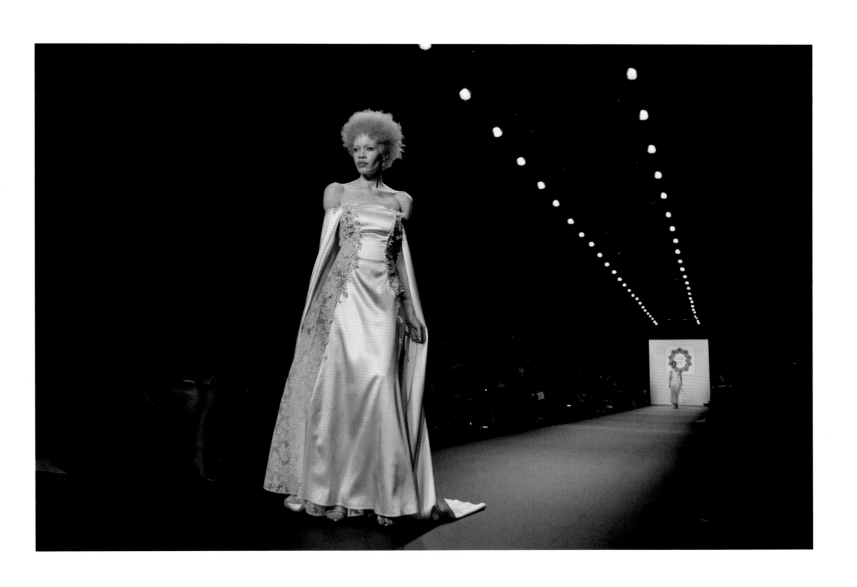

Diandra Forrest, an African American, was the first woman with albinism
to sign with a major modeling firm. *Stephanie Sinclair, 2016*

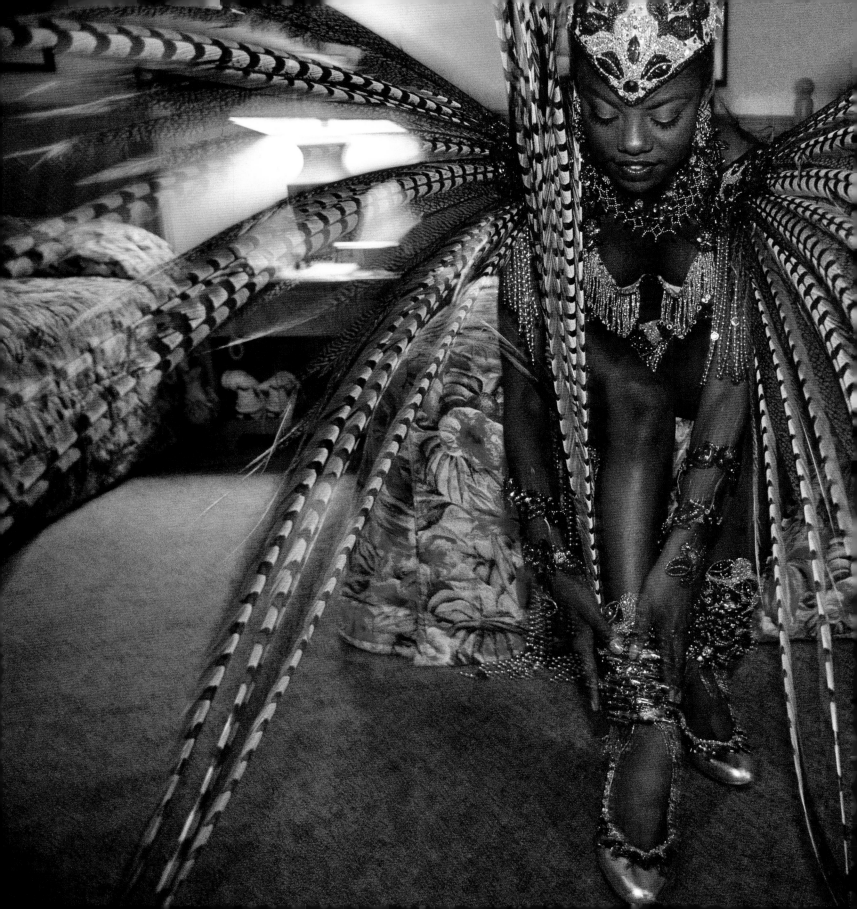

THROUGH
THE LENS

I wanted to change the world. But first I wanted to explore it. My childhood in Iran opened my eyes to the overwhelming diversity of the world, and photography gave me insight and compassion into other people's lives and what it means to be human. It was my passport to the unknown.

How else would I have ended up in the hotel room of Wendy Fitzwilliam, Miss Trinidad and Tobago, who was still in her costume for the "national dress" segment of the Miss Universe competition. The *National Geographic* story was about the science—and complicated history—of beauty. Where better to begin than the controversial competition for "the most beautiful woman in the world"?

Women are as complex as the attitudes that exist toward them. In my travels, I've found that most women want the same things—security, a home, self-determination, an education, respect, dignity, and love—no matter how they look or how people look at them. ∎

JODI COBB

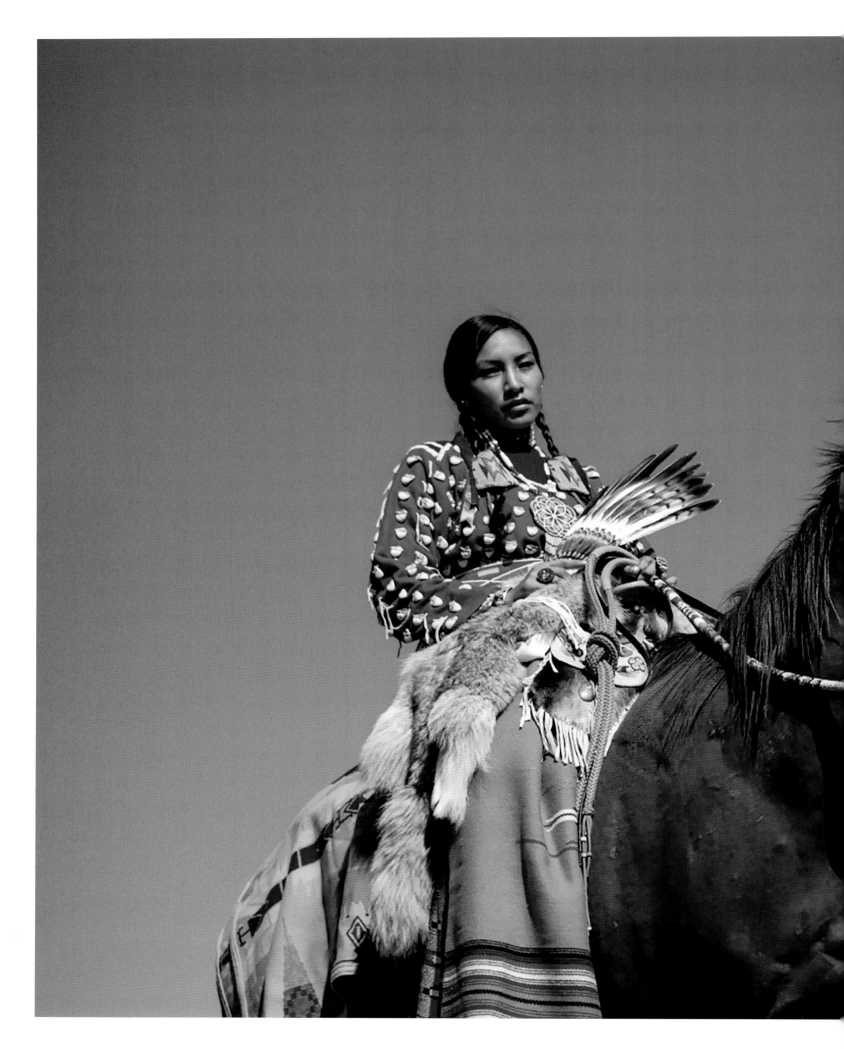

A Crow woman rides her horse at the Crow Fair on her tribe's reservation in Montana. *Erika Larsen, 2011*

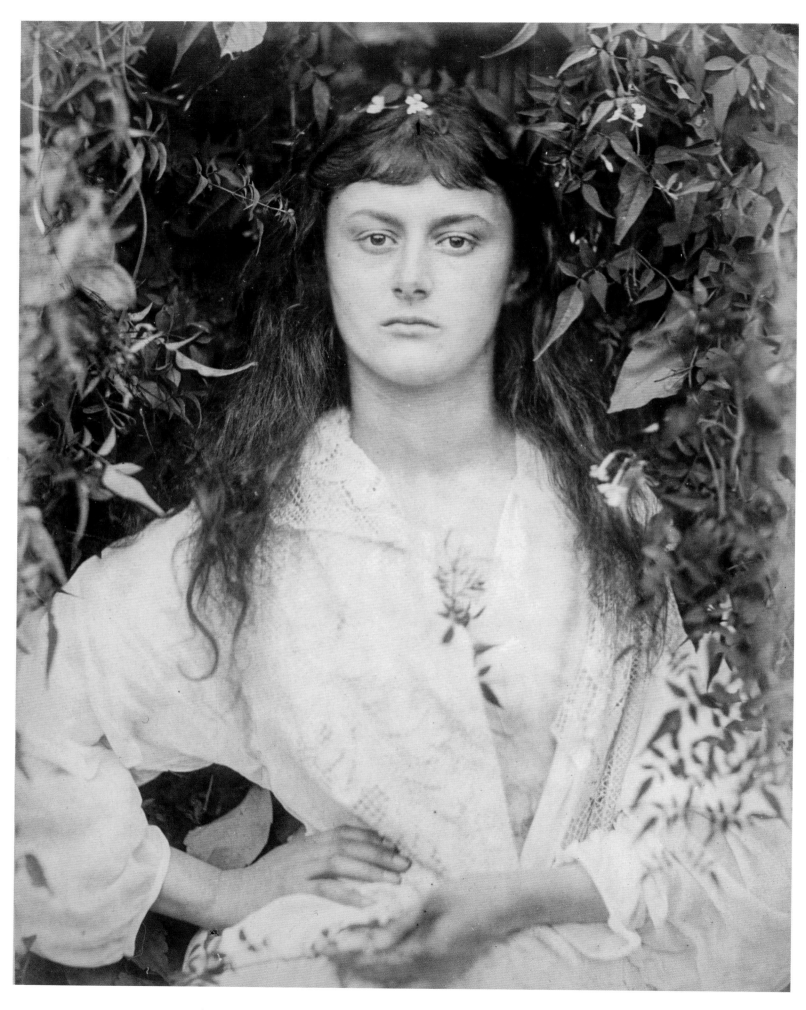

Alice Liddell, 20, the inspiration for Lewis Carroll's *Alice's Adventures in Wonderland,*
appears as a Roman goddess. **Julia Margaret Cameron, 1872**

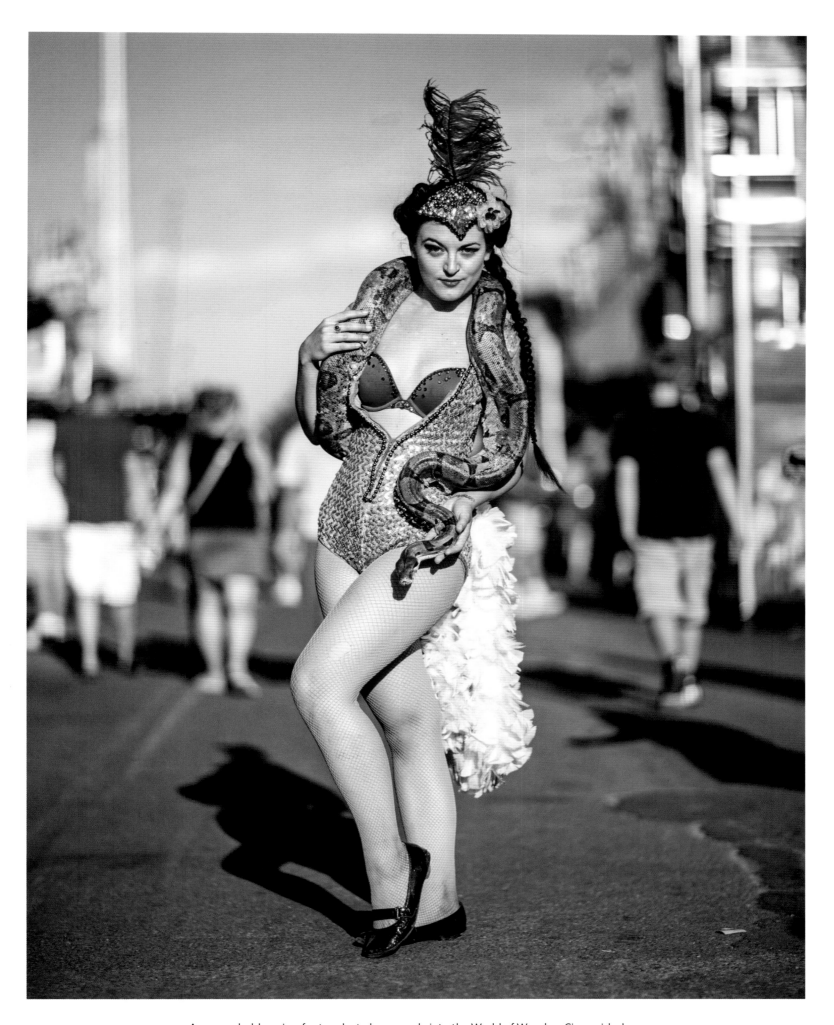

A woman holds a nine-foot snake to lure people into the World of Wonders Circus sideshow at the Minnesota State Fair. **Brian Lehmann, 2012**

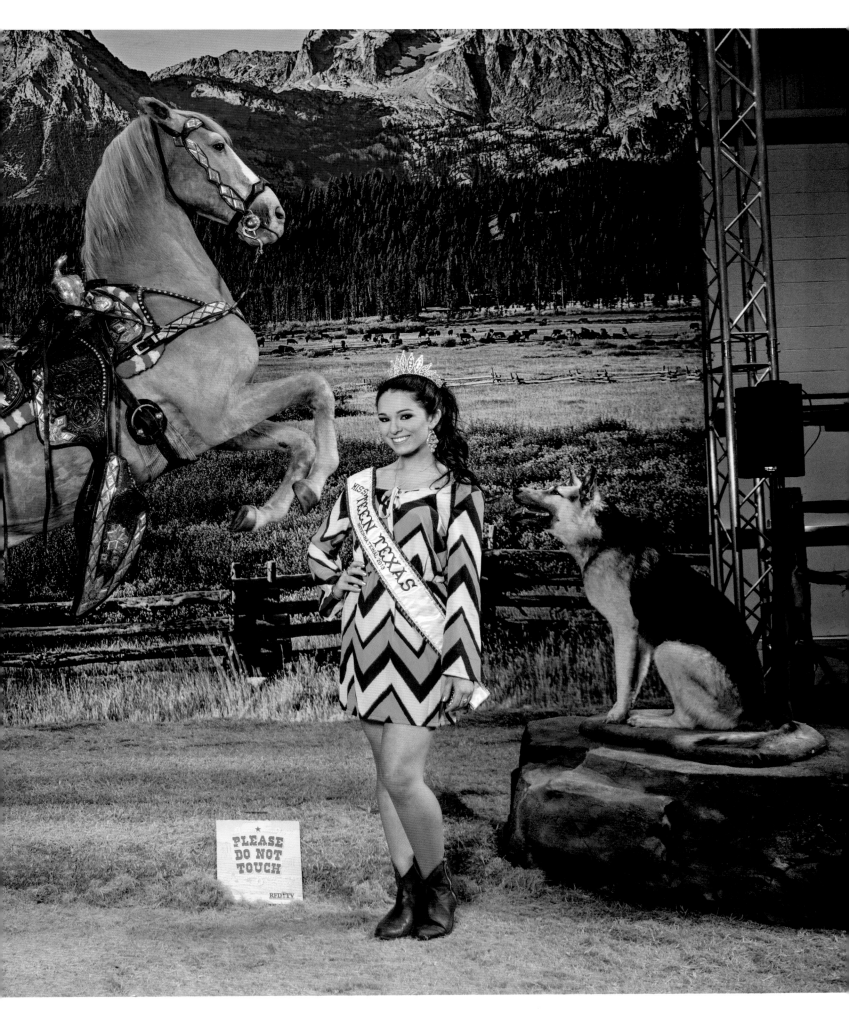

At a Las Vegas rodeo competition, Miss Teen Texas Kylie Boyd has her photo taken with mounted versions of Roy Rogers's co-stars Trigger the horse and Bullet the Wonder Dog. *Robert Clark, 2013*

Ella Eronen, one of Finland's most beloved actresses, studies her reflection in a mirror. **Jodi Cobb, 1980**

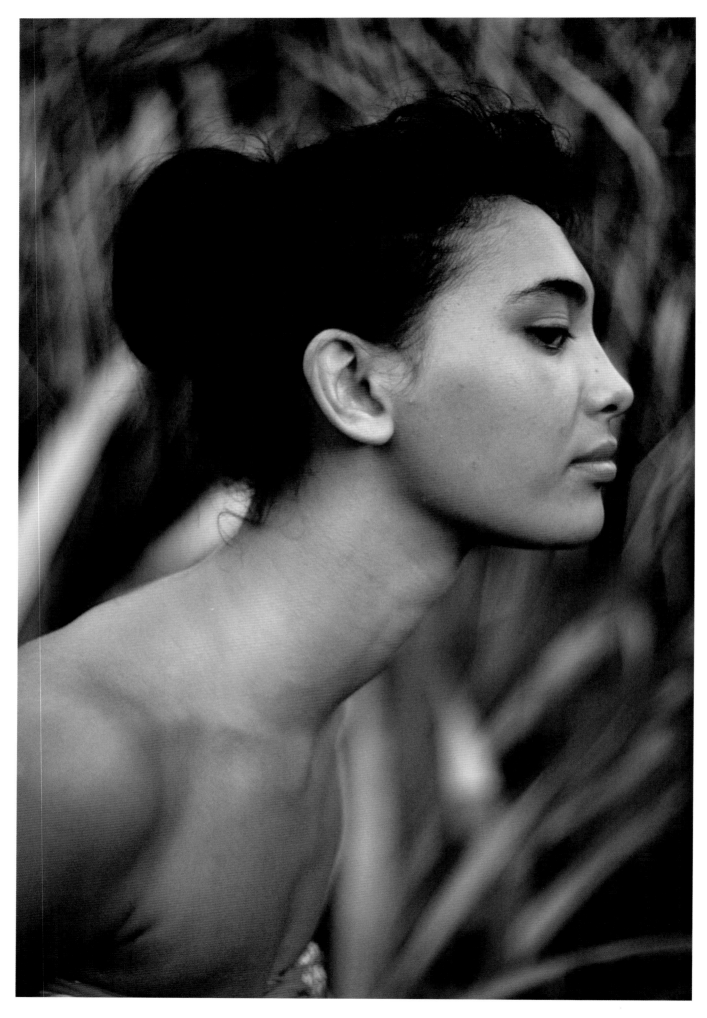

A Tahitian woman stands in profile. **Luis Marden, 1962**

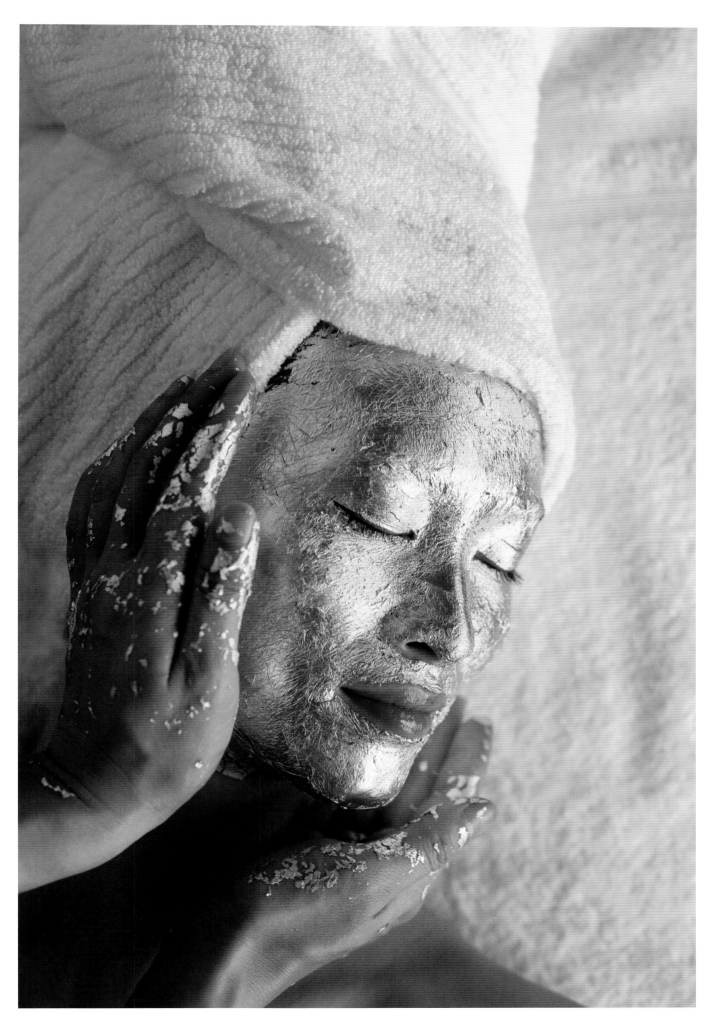

A model in Brooklyn receives a gold facial that costs $300. **Robert Clark, 2008**

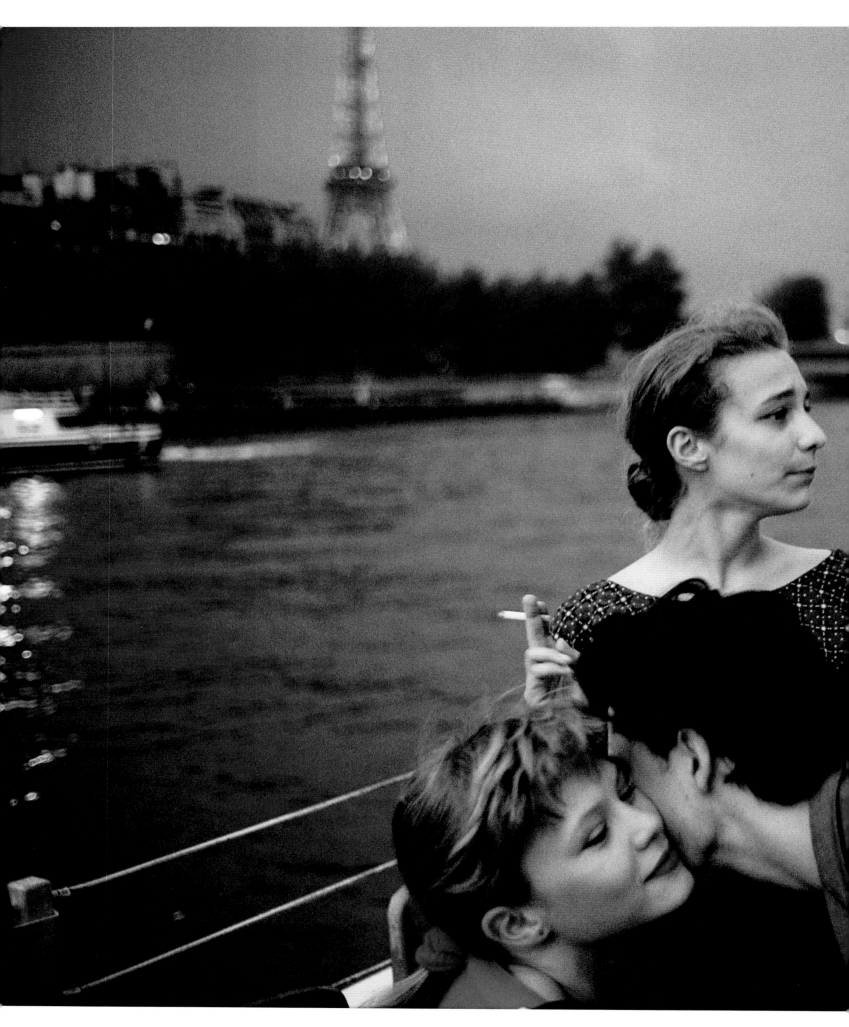

Friends celebrate the end of school with a twilight cruise on the Seine River in Paris. **David Alan Harvey, 1989**

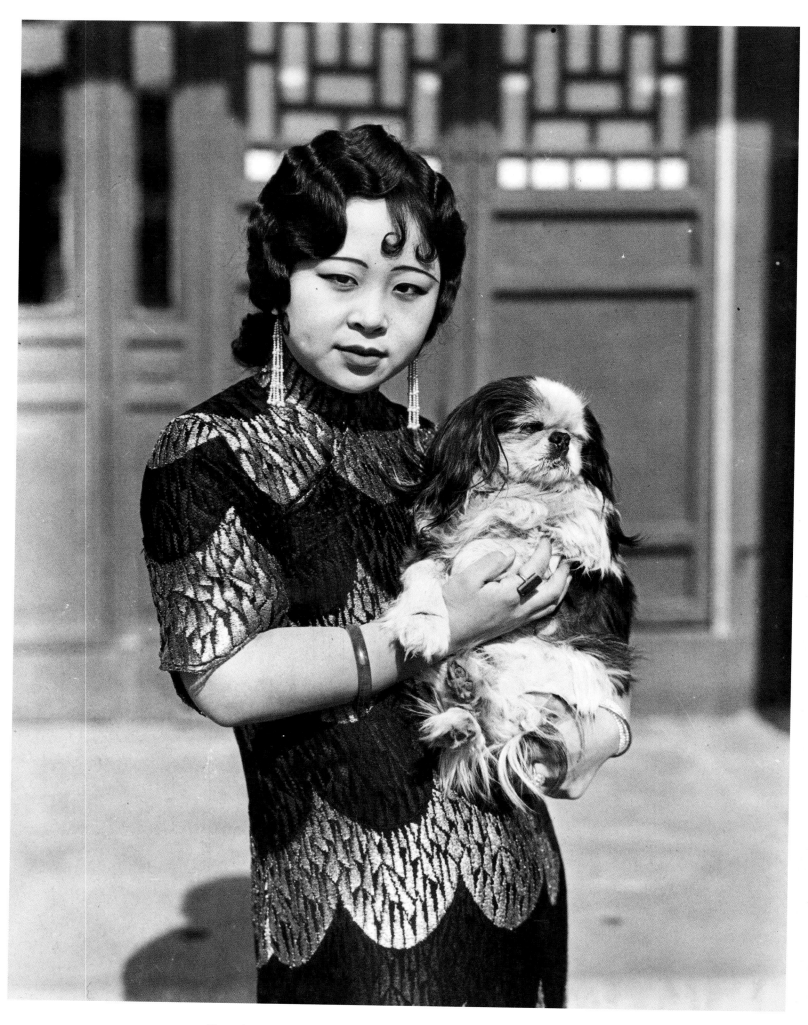

The wife of a Mongol prince holds her dog in Beijing. *W. Robert Moore, 1932*

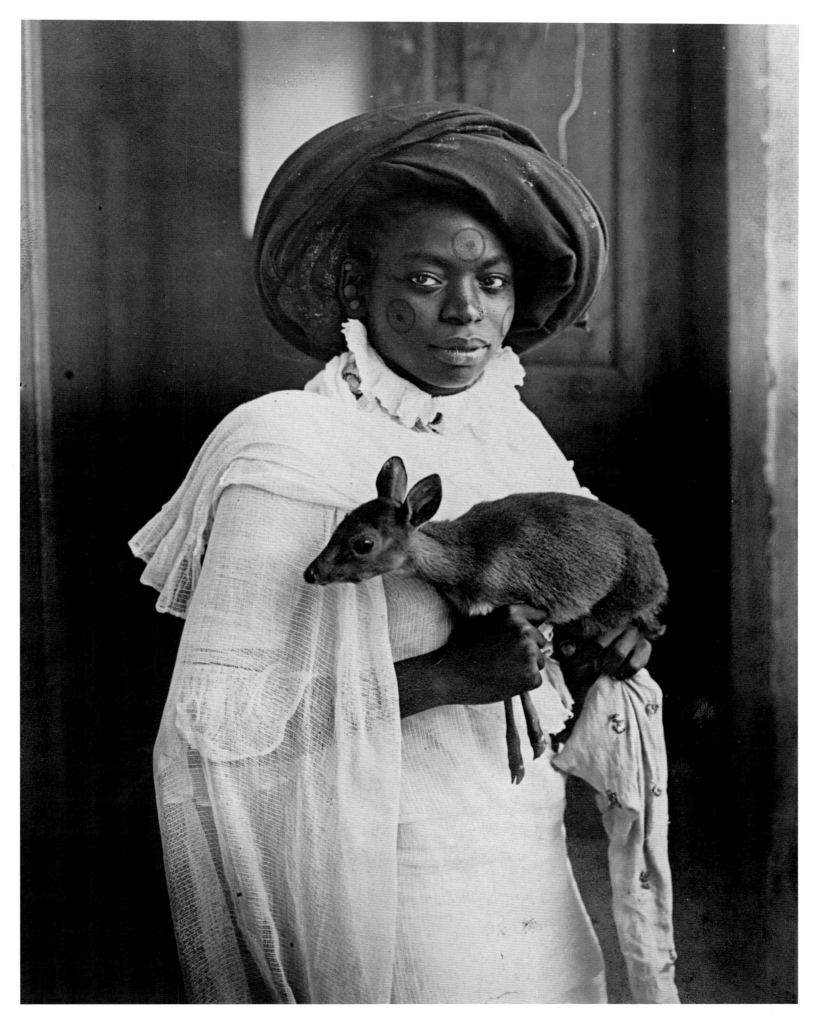

A Kenyan woman keeps her pet deer close. **Underwood & Underwood, 1908**

Travelers find fields of wildflowers in bloom along Route 99 in the San Joaquin Valley, California. *B. Anthony Stewart, 1942*

PORTRAITS

OF

POWER

The education of women and girls throughout the world is the most significant transformation that we can make. It's important for women individually, for their families, for their economies in their countries, and for the societies in which they live.

NANCY PELOSI

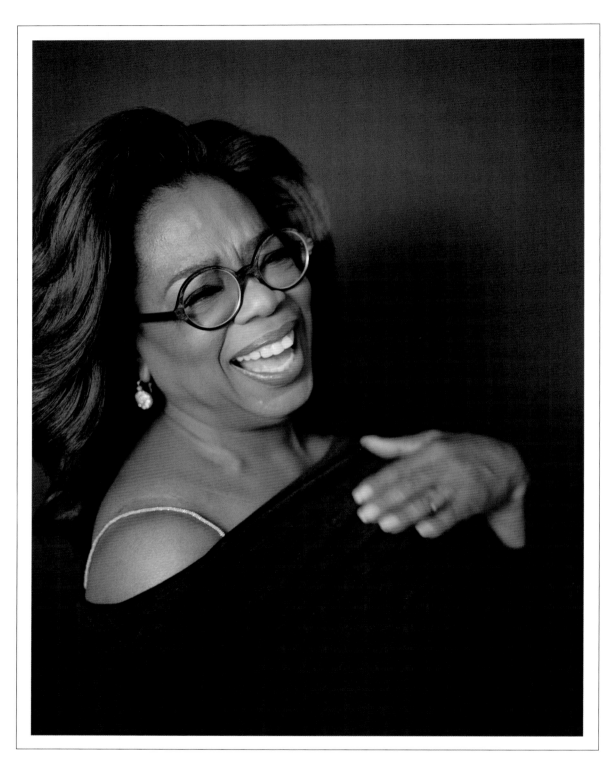

Oprah Winfrey, photographed by Erika Larsen in New York City, December 13, 2018

OPRAH WINFREY

Say only her first name, and the world knows who you mean. For Oprah Winfrey, single-name fame arose from a multitude of projects, talents, and achievements. She's among the most powerful figures in broadcasting; launched her own production company and TV channel; publishes her own magazine; has won numerous Emmy Awards and a Tony; and was honored at the Golden Globes with the Cecil B. DeMille Award. The first African-American woman to make *Forbes* magazine's World's Richest People list, Winfrey has a fortune estimated at $2.7 billion. She uses her personal story—rising from a Mississippi childhood of sexual abuse and poverty to career success and fulfillment—to encourage downtrodden women. And she's a benefactor to young South African women, for whom she built a first-class college preparatory academy in 2007. She's proud of the 100 percent graduation rate of the students, who call her "Mum O."

NATIONAL GEOGRAPHIC: Let's start with the state of women. What do you think is the biggest challenge for women today?

OPRAH WINFREY: Equity and parity continue to be our biggest challenge, and understanding that as an individual born on the planet, as a woman, you have a right to that. Everything in your being should be moving you in the direction of equity and parity in every aspect of your life—the way you move through your daily life, the way you raise your family. When you understand that, you know you belong here and you are not suffering from what I think is one of the most discouraging qualities: not feeling that you're worthy.

NG: Okay. When you talk to younger women, what kind of advice do you give them?

OW: The advice is always the same: The truth is the truth is the truth is the truth, and nothing works better in any endeavor than being the truth of yourself. You know I have a girls' school, I have 191 girls in college right now, all at various stages calling me about one thing or another. Whether it's a boyfriend problem, a money problem, or a trying-to-figure-out-what-I-want-to-do-with-my-life problem, my message is always: Get still enough to understand and hear the truth speak through you. The voices of the world—be it your mothers, your professors, your friends, your bosses—will drown out your true voice if you allow them to. But if you can get still enough, it's always there. Every question that you have, an answer to it is always there.

NG: But it can be hard to hear that voice.

OW: Well, it's hard to hear it because you're listening to everybody else. And it's hard to hear it because women in particular value other voices over their own.

NG: What do you think is the most important change that needs to happen for women in the next 10 years?

OW: I have trouble answering the most important or the best of, because I never think it's just one thing. I also think that everything starts with you. I love this phrase now of people getting woke, because I've been speaking to people awakening themselves for years and I know that everything essentially begins with you—then your connection to other people, and your willingness to use that power for something greater than yourself. I use Maya Angelou as an example all the time, because she was actually my greatest living mother figure, mentor, and teacher. A line in Maya's poem "Our Grandmothers" says, "I go forth alone and stand as ten thousand." For me, that means that you didn't get here alone; that everybody who paved the way for you had dreams bigger than you can imagine, and it's your job to try to fulfill those dreams.

NG: So when you think about yourself, do you consider yourself a feminist?

OW: Oh big-time.

NG: And what does that word mean to you?

OW: It means that I am recognizing and honoring the fierce energy that comes with being a woman on the planet at this time. It means that I am standing for women, that I am standing for myself as a woman, and that I am standing for women throughout the

Equity and parity continue to be our biggest challenge, and understanding that as an individual born on the planet, as a woman, you have a right to that.

world. And I understand that that's part of why I am here.

NG: That leads into this next idea: What do you think is your greatest strength?

OW: No question, it's connection to other people. You know I've interviewed rapists and murderers and child molesters and all kinds of people who have done terrible things—but I can put myself in the space of where they are in that moment and meet them where they are. So my ability to connect to where you are in that moment—not to the thing that supposedly defines you—and just meeting you one on one. That's one of my great strengths.

NG: Where do you think you got that?

OW: I think that had I had the love, the attention, the family surroundings that would have nurtured and supported me in the way that I thought I needed, I wouldn't have it. I think that this connection and yearning to know the heart of other people came from my own sense of loneliness, my own sense of wanting to be understood and know that whatever I'm feeling, somebody else has felt it, too.

NG: Maybe you've just answered this: What do you think is the biggest hurdle that you've had to overcome?

OW: Pleasing other people.

NG: Do you know, I've been interviewing all these amazing women and I have heard that answer so many times, I really have?

OW: The disease to please. It's our curse, and it happens when we are not raised to know our own value and our own worth. You know, one out of four women in this country, by the time they're 18 years old, will have been sexually abused or assaulted. If you are a woman who has experienced that, as I did as a young child, you don't understand where the boundaries are; you can't even control the boundaries of your own body. I was accustomed to letting people do whatever they wanted to. But I believe the world gets fixed when you fix yourself, so I'm in a great position to help other people, because I've done a lot of work on myself. I feel blessed that all of my therapy was done in front of the world so I have nothing else to tell anybody.

NG: All right, last two questions: What living person do you most admire?

OW: Right now, it's Jane Goodall.

NG: She's in the book, too.

OW: Is she? I just think what she's done is extraordinary: her guts, her grit, her presence in the world, her dedication, her commitment.

NG: That's great. When you think about historic figures, is there one you would identify with most?

OW: Sojourner Truth [African-American abolitionist and women's rights activist]. She's my north star. She was able to speak in the slave quarters, and also went to the White House with Lincoln. She was able to use her voice, her presence, her stature as a force for good—for women in particular.

I remember when I came back from opening the school for girls in South Africa, I was sitting at Maya's kitchen table while she was making biscuits, and I said, "That school is going to be my greatest legacy." And she said, "Your legacy isn't some big grand gesture. It isn't a school with your name on it. Your legacy is every life you touch, everybody you encounter." So people emphasize the big things, the joining, and the causes—but it's what you do every day. It's how you live every day as a woman citizen here on Planet Earth at this time. ■

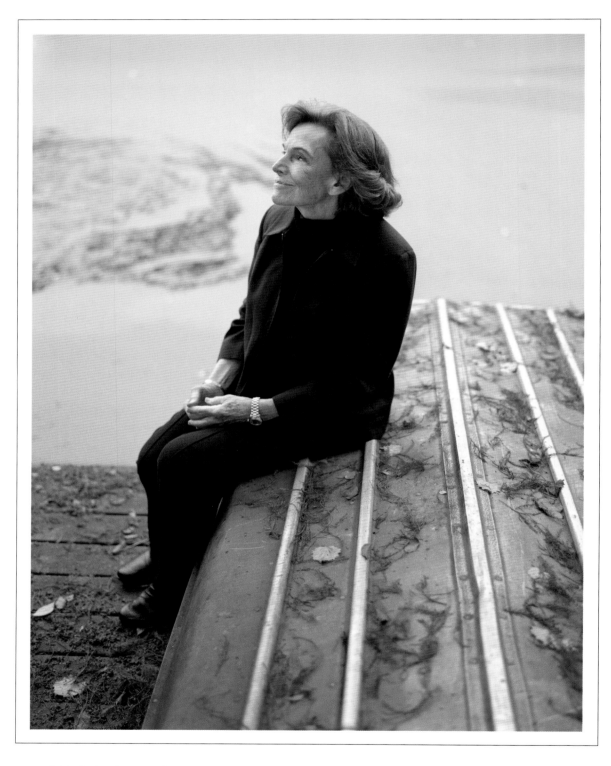

Sylvia Earle, photographed by Erika Larsen, in her parents' garden in Dunedin, Florida, December 21, 2018

IN CONVERSATION WITH

SYLVIA EARLE

She's been called a "living legend" and a "hero for the planet." But the title that seems most fitting for Dr. Sylvia Earle has the ring of marine royalty: "Her Deepness." A marine biologist, oceanographer, and explorer, Earle has spent decades studying the seas and the life within it. She has led more than 100 expeditions, including the first team of women aquanauts to inhabit an underwater lab in 1970. She has logged more than 7,000 hours underwater, including a 1979 descent to an ocean floor depth never before reached by humans. Formerly chief scientist at the National Oceanic and Atmospheric Administration, Earle is a National Geographic explorer-at-large, and founder of Mission Blue, a nonprofit organization that promotes ocean preservation. She has lectured in some 90 countries, authored more than 200 publications, and received more than 100 national and international honors.

NATIONAL GEOGRAPHIC: Do you consider yourself a feminist?

SYLVIA EARLE: I think that depends on how you define *feminist*.

NG: Well, how do *you* define it?

SE: I came along at a time in the '60s and '70s when the idea of being a feminist took on sort of an aggressive tone. Maybe it had to, in order to establish a place in a male-dominated society. But I've never quite thought of myself as first and foremost a feminist. I've thought of myself first and foremost as a person, a scientist with certain objectives. The fact that I was a woman was incidental—never mind that I had to work harder or put up with obstacles that my male counterparts did not. I figured, well, people will tell you you can't do something because you're too tall or too short or too fat or too thin or too old or too young or you're a girl and not a guy, or whatever. Just believe that you can do what your heart says you want to do, and don't let the rest of it get you down.

But now, upon reflection, I guess I am a feminist. Because I think that emphasizing the fairness of being able to engage based on merit—based on what you can do, rather than what package you happen to come in—needs a little help. I applaud women who help women, and I applaud men who help women.

NG: What do you think is the most important challenge facing women today?

SE: Overcoming the habits that we've gotten into culturally—little boys are blue, little girls are pink, little boys do this and play with these kinds of toys, and little girls are encouraged in other directions. It all starts very early. Women need to believe in themselves and realize that if you let others diminish you that's your fault. If you take seriously the statements that you can't do that because you're a girl, then that's your fault. You have to have the courage to say: I do whatever it is and I'm going to do whatever it is, and just do it.

NG: What do you think is the single most important change that needs to happen for women in the next 10 years?

SE: Equal opportunity. To be judged on merit. The change is not just how women are regarded by men, but how women regard themselves. You know, it starts with you.

NG: What living person do you most admire?

SE: There isn't a single individual I most admire. I do admire the characteristics of individuals who think positively and don't get dragged down by adversity—who use adversity as a challenge. Almost everyone who has succeeded in one way or the other has had to make that journey. And often, those who have the most to overcome are the most successful in the end.

NG: Is there a historical figure you most identify with?

SE: Maybe William Beebe. He was an explorer, a scientist, and a communicator. I suppose the high points of his career were in the 1930s, exploring the Galápagos Islands and especially the deep sea. He collaborated with an engineer to come up with a design for a submers-

I've thought of myself first and foremost as a person, a scientist with certain objectives. The fact that I was a woman was incidental.

ible that enabled him and engineer Otis Barton to descend and personally witness life a half a mile beneath the surface of Bermuda for the first time. I read his book when I was a kid and I said, I want to do that! His descriptions of the luminous creatures that flash and sparkle and glow like constellations were poetic but also scientific. That stuck with me. And so did how if he wanted to do something, he had to make it happen. It wasn't that there was a submarine waiting for him to jump into. Many years later I found myself with similar aspirations and began working with an engineer to help develop a submersible that I personally was able to get into—but all by myself, a one-person sub—and go half a mile down. That was very satisfying, and it was all inspired by William Beebe.

NG: All right. What advice would you give to young women today?

SE: The same advice I'd give to young men, I think. Find something that you love, that

really makes your heart beat fast; even if you can't figure out how you could use that [skill] to make a living, make it a life. And be the best you can at whatever that is. Every person has power. At this point in history, we are endowed with superpowers, because we have knowledge that could not exist before right about now. Our predecessors could not know what Earth looked like from afar, could not know how deep the ocean is or that life occurs there. So we've got an edge. My advice is to use that knowledge and to realize that we are at a pivotal point in both Earth history and human history. What we do or fail to do will determine whether we make it as a species on a planet that's currently in serious trouble.

NG: What are your most conspicuous character traits?

SE: Curiosity. Respect for life, all life, humans included.

NG: What is your greatest strength?

SE: Not giving up. Staying the course.

NG: If you've had a breakthrough moment in your life, what was it?

SE: I had a breakthrough about two things during that first time that I lived underwater. It was two weeks; I've done it 10 times now and each time it impresses even more. One was as a scientist, getting to see the individuality of creatures in the sea. We tend to think of fish as commodities; I began to see them as individuals with faces and personalities and distinctive behaviors. And I don't mean that groupers behave differently from sharks or from barracuda; more that this grouper behaves differently from that other one over there. I began to get a greater insight into the way all forms of life are special.

The other thing was, as a woman being expected to do what the male aquanauts, scientists, and engineers did, I found that we were treated in a very condescending way. We were called aqua-babes and aqua-belles and aqua-naughties.

NG: Really?

SE: Oh, yeah. 1970. And I posed the question at the time: Suppose you started calling the astronauts astro-hunks or astro-he-men, what would they think? But in the end, having a sense of humor and just sticking by what we were there to do as scientists and engineers was really what kept us going. And the success of our team helped pave the way for women in space.

NG: Where are you most at peace? I have a feeling I might know your answer.

SE: Under the sea. Surrounded by innocent creatures who are unaware of the problems that we have imposed on this poor planet. I'm at peace—but I'm also driven by the awareness of the responsibility that we as humans have to look for the solutions. ∎

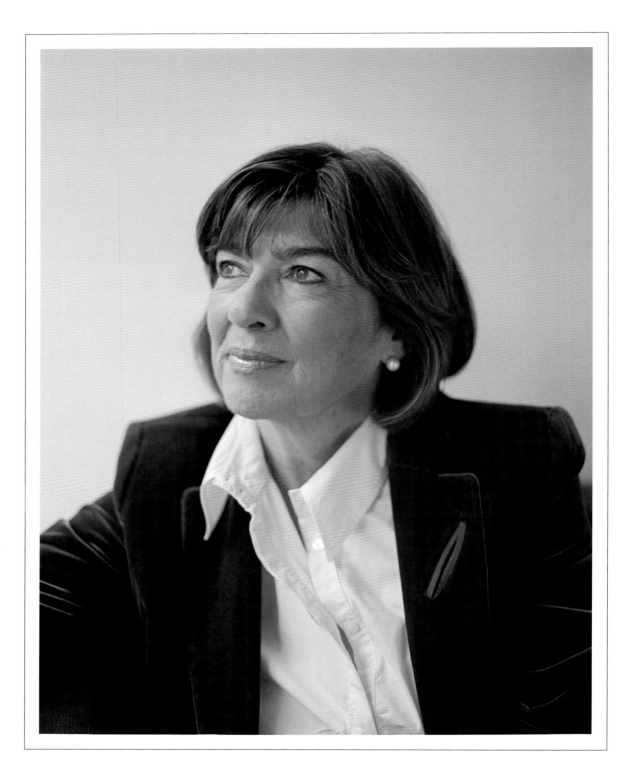

Christiane Amanpour, photographed by Erika Larsen in London, November 29, 2018

CHRISTIANE AMANPOUR

When she was 11 years old, Christiane Amanpour and her family fled their Tehran home ahead of the 1979 revolution. Today, Amanpour credits that experience with firing her passion for reporting on conflicts and their human costs—a vocation that has made her one of the world's most celebrated journalists. Raised and educated in England and the United States, Amanpour started as a news desk assistant at the fledgling Cable News Network (CNN). Within a decade, she was covering the civil war in Bosnia. During more than 35 years at CNN, she has reported on conflicts from Rwanda and Somalia to Pakistan, Iraq, and Afghanistan, and built a reputation for fearlessness, whether interviewing world leaders or broadcasting from war zones. Today, she is CNN's chief international correspondent and also hosts an hourlong global affairs program seen weekdays on PBS stations.

NATIONAL GEOGRAPHIC: Hi, how are you?

CHRISTIANE AMANPOUR: I'm very good. I'm very happy to be part of this, it looks like it's going to be a really good wallop for women.

NG: I'm super-excited. It's going to be a spectacular book. All right, let's go. What do you think is the single most important change that needs to happen for women in the next 10 years?

CA: Women need to get equal pay for equal play. And women need to do what they started to do, and that is turn out in droves for elections—not just to vote, but to stand for office. This is the key that will be the game-changing mechanism for women.

Because many, many, many, many do their utmost and break barriers from the sidelines—but unless it's institutionalized, and until it's institutionalized, it won't have that tipping-point effect.

NG: Good. What do you think is the most important challenge facing women today?

CA: The most important challenge is still being considered second-class citizens, despite the progress. Despite 100 years since some women got the right to vote, despite #MeToo, despite all the personal achievements of women in just about every field you can name, there is still an institutional prejudice against women. An institutional bias. And it's also women who have that unconscious bias against women, so that is a big issue.

I'm afraid that the patriarchy is strong, and the most important thing for us is to get men on our side, period. This has to be something that men help us with; it's not a question of just swapping who's dominant. We're not looking for female dominance; we're looking for equality and to level the playing field—and we can't do that without men's buy-in as well.

NG: I so agree with you. I'm cheering here. Next: What living person do you most admire?

CA: Well, that always puts me on the spot. I'm simply going to say that I admire [German chancellor] Angela Merkel. I admire her because she has been elected multiple times, and she comes from a fact-based environment, an evidence-based background, as a scientist. She was the first woman to challenge for the chancellorship of Germany, and she has been unbelievably successful in every way, whether it's in standing up to aggressors in Europe or welcoming refugees who are feeling legitimate barbarism at home, in war, and as a result of persecution; whether it's in becoming an economic powerhouse in Europe and wanting to carry all of Europe with her, or in constantly standing up—despite the assault of the far right or the populace—for moral values and for the ethics that keep our democratic, independent, free-world order together. She's never compromised those values, so I admire her for that.

NG: When I interviewed Donna Strickland, who won the [2018] Nobel Prize in physics, she said the exact same thing. That Merkel has brought scientific values into what is the often emotional realm of politics. Which historical figure do you most identify with?

CA: I would say Queen Elizabeth I. What a brilliant, fantastic woman. She was an

Of course I'm a feminist. I think it's one of the nicest words. It's not an ugly word. And I think people who recoil at that term simply don't know what it means.

unwanted child. Her father had her mother beheaded because she wasn't a boy. She had to fight not just for her survival as a kid, but for her country and for who she grew up to be. What she achieved at that time is really remarkable. What she did for England and the far-flung reaches of her realm, was unparalleled . . . they called it the Golden Age—the age of so much accomplishment.

NG: Got it. What would you say is your most conspicuous character trait?

CA: Wow, my most conspicuous character trait. Determination, persistence, and having the courage of my convictions. And, I would just add, my tagline is always being truthful, not neutral.

NG: That's a good tagline. All right, what advice would you give young women today?

CA: I would tell young women that there's nothing that they cannot do, but they

mustn't expect things to be given to them. They mustn't have any sense of entitlement; they must simply be prepared to do the hard work, as I would say to any boy as well. Then, not only do you deserve what you achieve, but you become an expert, you become confident—because you've accomplished and mastered all the steps between starting out and getting to a position of influence and success. I think that's really, really important. And to young girls I would simply say what probably women have told them from time immemorial: Never take no for an answer.

NG: What do you think was your breakthrough moment?

CA: My breakthrough moment was the first Gulf War, I would say. Getting my job at CNN as an entry-level desk assistant, but then a series of jobs filling dead men's shoes, to coin a phrase. I took jobs that were left open literally because men didn't want them, so I took them and I made them a success. That includes when I became a foreign correspondent for the first time back in 1990; it was because one of my male colleagues didn't want to be posted where they were posting me. Then the war broke out and I was there to cover it. My break was bursting onto the scene in a very public way at the same time as CNN was doing that.

NG: Do you consider yourself a feminist?

CA: Of course I'm a feminist. I think it's one of the nicest words. It's not an ugly word. And I think people who recoil at that term simply don't know what it means. All it means is equality. If you're for equality, you're a feminist, whether you're a woman or a man, a girl or a boy.

NG: What's the biggest hurdle you've had to overcome?

CA: Like all women, I've had to overcome the subtle and unsubtle bias and prejudice against women. That's a big hurdle. But I've also overcome personal displacement, having survived the Islamic revolution in Iran, and turning that into my way into journalism.

NG: What's your greatest strength?

CA: Strength. And a certain humility—you know, the opposite of arrogance. I refuse to be seduced by the trappings that come with success, and I keep my feet firmly planted on the ground.

NG: And where do you find yourself most at peace?

CA: In my house in France—on the west coast—surrounded by my son and close family. ■

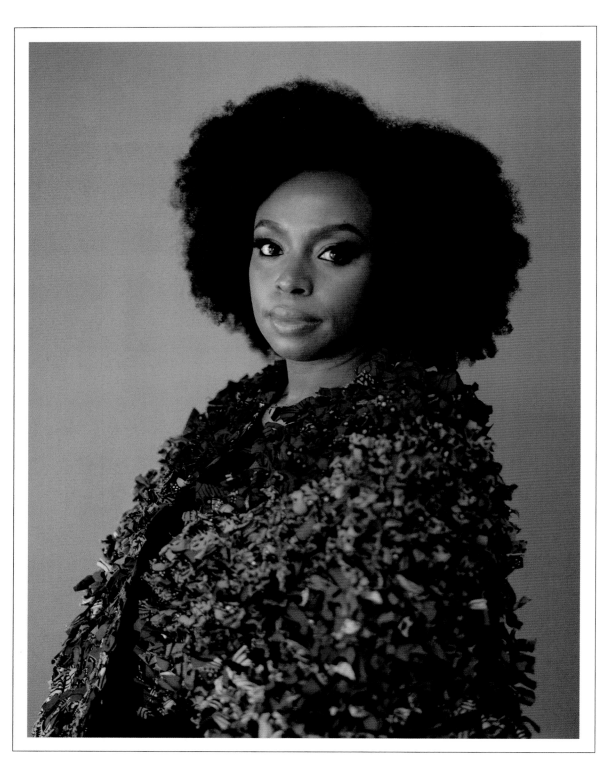

Chimamanda Ngozi Adichie, photographed by Erika Larsen in Ellicott City, Maryland, January 30, 2019

CHIMAMANDA NGOZI ADICHIE

"Unflinching, unswerving, fierce intellectual determination . . . to define the real truth of our lives": That's the high bar that playwright Harold Pinter set for writers in his 2005 Nobel acceptance speech. They are also the criteria for awarding the annual PEN Pinter Prize, which in 2018 went to Chimamanda Ngozi Adichie. The Nigerian novelist and essayist—whose books include *Purple Hibiscus, Half of a Yellow Sun, Americanah*, and *Dear Ijeawele*—has received honors such as the National Book Critics Circle Award and a MacArthur Foundation "genius grant." She's a star to TED audiences; her 2012 TED Talk, "We Should All Be Feminists," was made into a book. In accepting the Pinter prize, Adichie noted that she's been criticized for her stances: championing women's rights, decrying Nigeria's criminalization of homosexuality. A journalist advised Adichie that her fans might prefer that she "shut up and write." To date, she shows no sign of doing the former, and every intention of continuing the latter.

NATIONAL GEOGRAPHIC: What do you think is the most important challenge facing women today?

CHIMAMANDA NGOZI ADICHIE: It's really difficult to narrow it down to just one. I would say women's autonomy over their bodies—and by this I mean a broad range of things. Not just reproductive rights, but including the scourge of domestic violence and also the lack of proper legal protection for women globally.

NG: And what do you think is the most important thing that needs to change for women in the next few years?

CNA: We need to have more women in positions of decision-making—politically, economically, in every way. More women's representation will result in more diverse decisions, decisions that incorporate women's experiences. I don't think having women in positions of power means that the world is going to be perfect or that conflict will be eradicated. It just means that the concerns of half of the world's population will finally be center stage.

NG: What do you think is your own greatest strength?

CNA: I think it's maybe my ability to deal with complexity. That I am comfortable with gray,

I don't need for things to be white or black. I believe in nuance. I look at the world and know that it's complex, and that things don't have to be simple to be understood. And that I am not uncomfortable with things being complex and difficult. I think part of that is because of my socialization as a woman.

NG: Could you say more about that?

CNA: Women are socialized to be care-givers, to find ways to solve conflicts. Women are socialized to be many different things—and, in some ways, to pretend to be different things for different people. Women are socialized to protect male egos. Women are socialized to care for family members. Women are socialized to have a certain kind of emotional intelligence. I really don't think these things are inborn in women; I think that it's because of the way that women are socialized. In some ways, this is bad for women in that they're socialized to hold themselves back and not be too ambitious. But I think that there are ways in which it is good, because it teaches women to be able to deal with complexity and not to be mentally simple. The world is not simple, so if you are familiar with things that are not simple, you're more likely to deal with the world in a constructive way.

NG: When you look back through your life, is there something that you would consider a breakthrough moment?

CNA: I think it was when I was nine years old, in the third grade, and I remember this very clearly. My teacher had said that the child with the best results on the test that she gave would be the prefect. So I got the best result—and then she said, "Oh, I forgot to mention, it has to be a boy."

All humans like to be liked, because we are human—but girls are socialized to think that they need to be liked, and it makes them pretend to be what they're not . . . Young women should just be themselves.

I just thought, "Why?" It would make sense to have said the class prefect has to be the child with the best grades or the child with some sort of useful skill. But the idea that this position of prestige and power in the classroom was reserved for somebody by an accident of being born a particular sex—that was just strange. So my sense of righteous indignation flared up and I said to my teacher, "That makes no sense."

NG: You actually spoke up and said that?

CNA: Oh, yeah.

NG: And what happened?

CNA: Well, the boy still was prefect, and I was made the assistant prefect, which was not necessarily the solution I wanted. But for me

it was really crystallizing: That was the first time that I spoke up about sexism. It didn't work, but it was the moment for me that I don't think I'll ever forget.

NG: I guess that leads to my next question: What do you think are the greatest hurdles that you've had to overcome?

CNA: I think maybe the fear of failure; not wanting to try because I was afraid I would fail.

NG: Do you consider yourself a feminist?

CNA: Yes, I do very much, because I believe that men and women are equal as human beings, and I believe that sex should not be a reason to hold people back. We live in a world that has consistently held women back because they are women, and I feel very strongly that this needs to change. That's what feminism means to me.

NG: What living person do you most admire?

CNA: My father, because he is the best example that I have seen of a certain kind of integrity and decency. He is gentle and kind and he raised his children—the six of us, three boys and three girls—to believe that we could be or do anything. The confidence with which I occupy my space in the world is partly because I was raised by a man like him.

NG: And is there a historical figure—somebody who is not living—that you might identify with?

CNA: There are people that I admire; I don't know about identifying with them, necessarily. I'm also deeply suspicious of stories of people, deeply suspicious of biographies, because I just think that we don't really know

people in the end. But I suppose I could say that I admire Winnie Mandela [anti-apartheid activist and ex-wife of South African president Nelson Mandela] for her resilience, for the way that she managed to hold her own despite a lot of unkindness that she had to deal with. I also admire writers like Rebecca West [born Cicily Fairfield] and Elizabeth Hardwick.

NG: What advice would you give to young women today?

CNA: Don't apologize. Again, back to that idea of socialization: I think women are socialized to be apologetic just for existing, in many ways. And also, don't perform likability. All humans like to be liked, because we are human—but girls are socialized to think that they *need* to be liked, and it makes them pretend to be what they're not. Performing likability makes women diminish themselves; it means that you're often not able to reach your potential because you're not letting yourself really be yourself. I would say to young women, Don't do it, because it's not worth it. Young women should just be themselves. It sounds simplistic, but I think it's quite difficult, considering all the messages that society gives young women.

NG: Last question: Where are you most at peace?

CNA: In my ancestral hometown in eastern Nigeria surrounded by family. ▪

Emma González, photographed by Erika Larsen in Lighthouse Point, Florida, December 18, 2018

EMMA GONZÁLEZ

How can any person be prepared to step into the international media spotlight just days after escaping a mass-murder scene? And yet that's what 18-year-old Emma González did. A senior at Marjory Stoneman Douglas High School in Parkland, Florida, González was at school on February 14, 2018, when a disturbed former student opened fire with a semi-automatic rifle, killing 17 students and staff members and seriously injuring more than a dozen others. The massacre spurred González, her close friend David Hogg, and other students to launch the March for Our Lives movement to advocate for stricter gun control. And three days after the killings, she gave a rousing speech declaring "We call BS" on politicians who say mass shootings can't be prevented. González has said that being an openly bisexual woman, and a three-year president of her high school's Gay-Straight Alliance, has given her both experience and a comfort level in public settings that has helped her grow as a leader. Since graduating from Marjory Stoneman Douglas, she has enrolled in college, and continues to work as a gun control activist.

NATIONAL GEOGRAPHIC: In your life so far, what has been your breakthrough moment?

EMMA GONZÁLEZ: I've been pretty self-aware as to who I am my whole life, but there are definitely things that happened, like the "We call BS" speech when I became nationally recognized, which was a pretty big part of my life. In ninth grade, I started questioning my sexuality and then I came out, and that was a big part of my life, too. But I think I've been pretty comfortable in my own skin for a very long time. There's this story that my mom tells, from when I was in kindergarten, that I

think is quintessentially me. After school one day she asked me, "Hey, Emma, how did kindergarten go today?" And I was like, "Oh, Jonathan threw a pair of scissors at me." And she was like, "What?" And I was like, "Yeah, it was no big deal." And she was like, "What did you do?" And I was like, "I ducked." And that's pretty much quintessentially me.

NG: What would you consider to be your greatest strength?

EG: I don't know, there are so many. Ha! I would say I'm really good at handling things

Kris Tompkins, photographed by Erika Larsen in Pumalin Park, Chile, February 7, 2019

KRIS TOMPKINS

The vocations might seem incompatible: corporate CEO and wilderness adventurer. But those two paths became entwined for Kristine McDivitt Tompkins. An outdoorsy Californian who loved ski racing and rock climbing, she joined her climbing buddy Yvon Chouinard to help grow his business—which became Patagonia, Inc., the environmentally conscious global retailer. After 20 years as Patagonia's CEO, she retired in 1993 and married Doug Tompkins, another nature-loving adventurer who'd prospered (as co-founder of retailers the North Face and Esprit). The couple moved to South America and undertook eco-philanthropy on an ambitious scale, acquiring land in Chile and Argentina and donating it to be preserved as parkland. Tompkins Conservancy projects focus on safeguarding land and marine systems, restoring the habitats of endangered species, and rewilding animals. In December 2015, Doug Tompkins died in a kayaking accident in a Chilean lake. Kris Tompkins is carrying on the couple's plans for the Conservancy, which by early 2019 had permanently preserved more than 13 million acres as national parks.

NATIONAL GEOGRAPHIC: What do you consider to be your greatest strength?

KRIS TOMPKINS: Oh, my goodness. Certainly perseverance serves me well.

NG: I would say so for all women.

KT: Probably for everyone. But also my loyalty and determination. I think in some ways they actually hang together. The things I've done in my life tend to be starting something, or being part of something, that's new and usually difficult; those are the kinds of environ-ments I seem to like. And I think loyalty—whether it's loyalty to national parks or loyalty to friends and family—those attributes are actually all the same thing in a way. They manifest themselves differently at different points in life, but they are always there.

NG: What would you consider to be the breakthrough moment in your life?

KT: I would say meeting Yvon Chouinard—and then a second one, meeting Doug Tompkins, my husband. Yvon, of course, is the founder of Patagonia company; that's all I did

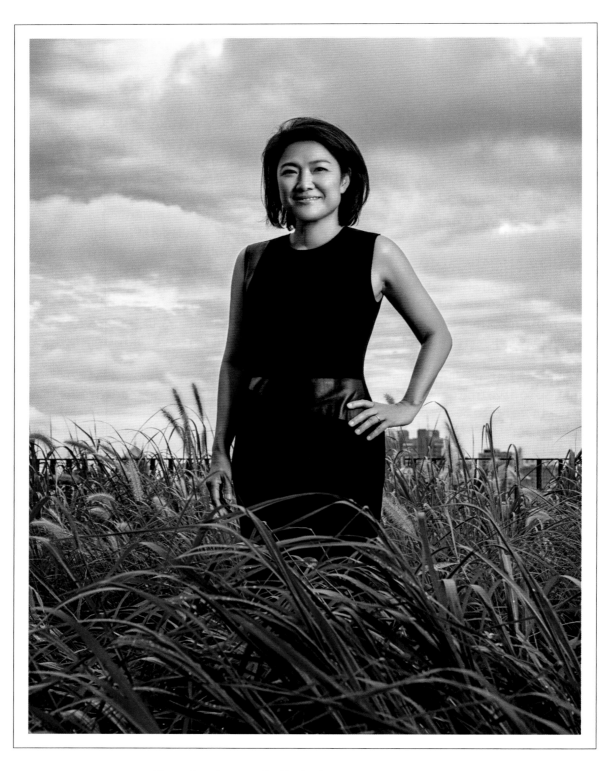

Zhang Xin, photographed by her husband, Pan Shiyi, in China

ZHANG XIN

After moving to Hong Kong with her family at the age of 15, Zhang Xin began working 12-hour days in a textile factory. Today, she has been dubbed "the woman who built Beijing" and boasts a net worth of more than $3 billion. In 1995, Zhang and her husband founded SOHO China, today the largest property developer in the country. In 2007 the company raised $1.9 billion when it went public. Credited as one of the top businesswomen in the world, Zhang is largely responsible for bringing the hottest architects to China. Her mission includes changing stereotypes about women's roles in her country. As one of the few women in a male-dominated industry, she has never kowtowed to men. As she said in a 2017 interview with CNBC: "Women hold up half the sky."

NATIONAL GEOGRAPHIC: What is the most important challenge facing women today?

ZHANG XIN: Women today are still facing the same challenge their mothers once faced. After they have their own children, they are confronting tough choices between staying at home and going back to work. I see many women really struggling when they want to spend the first couple of years with their babies—but they still have their career prospects that can't allow a few years' leave.

NG: What do you think is the single most important change that needs to happen for women in the next 10 years?

ZX: For many women, returning to work after taking maternity leave is a key career transition point. A temporary absence from the workplace can still lead to years of exceptional performance being forgotten. Employers need to support women who take time with their younger children.

NG: What advice would you give to young women today?

ZX: Your careers are for a lifetime, from college graduation to your retirement. Keep in mind that your career is a marathon, not a sprint. You need to pace yourself properly to make sure you will make it to the end in good shape.

NG: What living person do you most admire?

ZX: Barack Obama. He embodies optimism and global vision. And, at the same time, he's such a wonderful father and husband.

NG: Which historical figure do you identify with?

ZX: I've always admired Margaret Thatcher. When I was studying [in the U.K.], Mrs. Thatcher was serving as the prime minister. She was one of the most iconic leaders of the 20th century. When others cowered, she stepped forward. I admire her courage and conviction to stand by her principles. ■

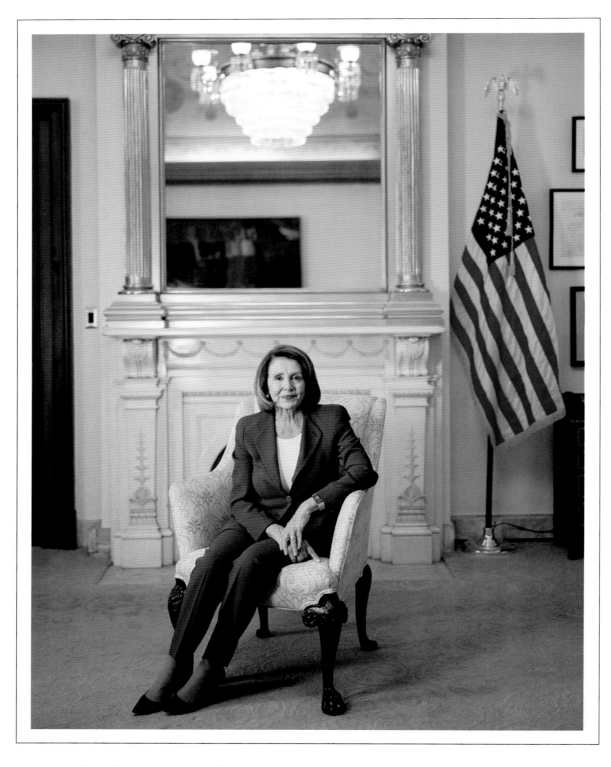

Nancy Pelosi, photographed by Erika Larsen in her office in Washington, D.C., January 31, 2019

NANCY PELOSI

Growing up in the 1940s and '50s in Baltimore, where her father was a popular mayor and congressman, Nancy Pelosi was baptized into politics. Her life has been about political and public service ever since, and she repeatedly has made history. In 2002 she became the highest-ranking woman in congressional history when Democrats elected her minority leader of the U.S. House of Representatives. After Democrats won a majority in the House, in 2007 Pelosi became House speaker; in that role, she led the fight to pass the Obama Administration's health care reforms. When the House changed hands, she became minority leader again in 2011—and after Democrats reclaimed a House majority, in 2019 she was elected speaker for a second time. Pelosi's leadership has made her a lightning rod and frequent target of opponents, while her acumen as a lawmaker and negotiator has helped her party prevail on Capitol Hill.

NATIONAL GEOGRAPHIC: What do you think is the most important challenge facing women today?

NANCY PELOSI: I think a barrier to women reaching their complete fulfillment—many women—is a question of confidence. I just say to them: Know your power, be yourself, there's nobody like you.

NG: How do you get over that confidence issue? Almost every woman I have interviewed has mentioned this.

NP: I started as a mom with five children—all that—and then sequentially, my volunteerism turned into being a member of Congress. I never had a confidence problem because I always knew what my purpose was. I always knew my subject, always had a plan. And I say that to women: Know your why. Know what you're talking about, have a plan, think strategically about how you get something done. And if you do that, you will connect and people will follow you. Have that confidence. It was never about me and my ambition. For me, it was realizing that one in five children in America lives in poverty—that's what got me from kitchen to Congress, from housewife to House speaker. Because it was always about that, I always had confidence in what my purpose was.

NG: When you look at the landscape, what do you think is the most important change that needs to happen for women in the next five to 10 years?

NP: If I ruled the world, I would say—and this

LOVE

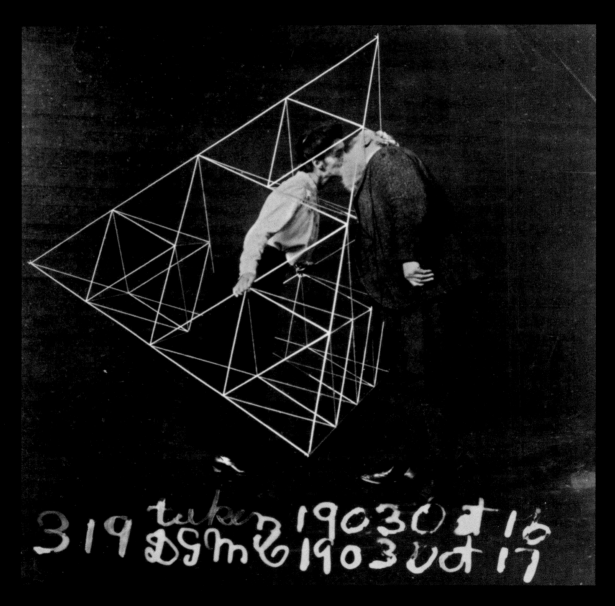

Alexander Graham Bell kisses his wife, Mabel, who stands inside a tetrahedral kite. *Photographer unknown, 1903*

In the *National Geographic* tradition of demystifying arcane topics, our February 2006 cover story unpacked the science of romantic love. It touched on mate choice and evolution, how passion registers on brain scans, and the blood chemistry of the lovesick.

But as almost anyone with a heartbeat knows, feelings, more than facts, influence love. This was readily apparent when, in her 2018 interview, former first lady Laura Bush praised her 99-year-old mother and "how she taught me to love."

The same was true when International Monetary Fund head Christine Lagarde told us how she found surrogate parents after losing her father when she was 16. "Love is an extraordinary engine for confidence," Lagarde says—but faced with "lack of support or love, you have to build that confidence within yourself."

The Image Collection's photographs reveal all kinds of love—familial, romantic, altruistic—across the spectrum of age, gender, kinship ties, and national origin. ∎

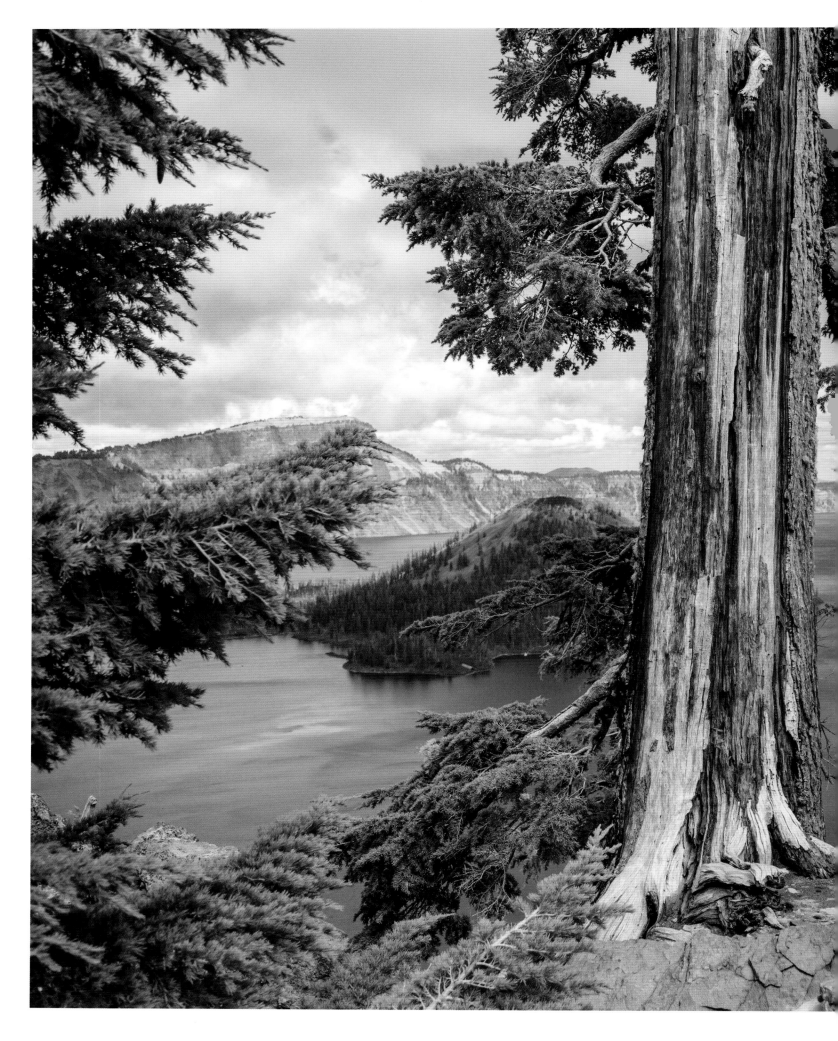

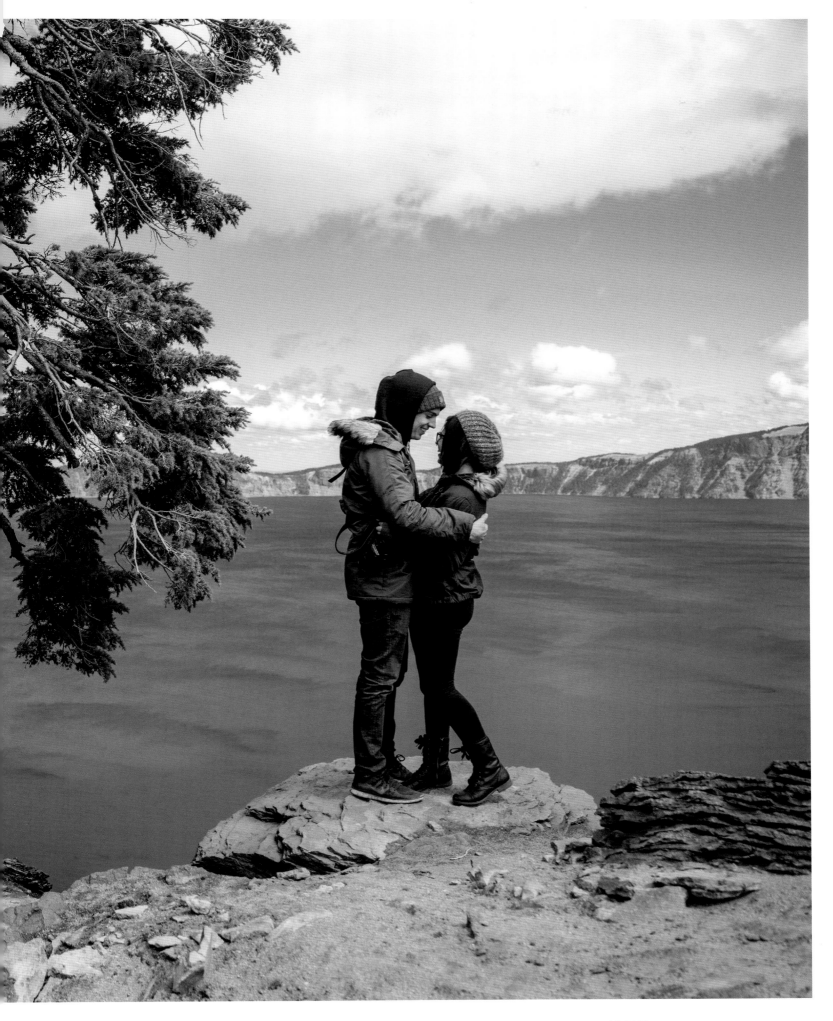

Overlooking Crater Lake in Oregon, a couple shares a tender moment. *Corey Arnold, 2015*

British bridesmaids take center stage at a wedding in Dubai, United Arab Emirates. *Maggie Steber, 2006*

A girl hugs her great-aunt after winning the "Fancy Dress" competition in Taos Pueblo, New Mexico. **David Alan Harvey, 1994**

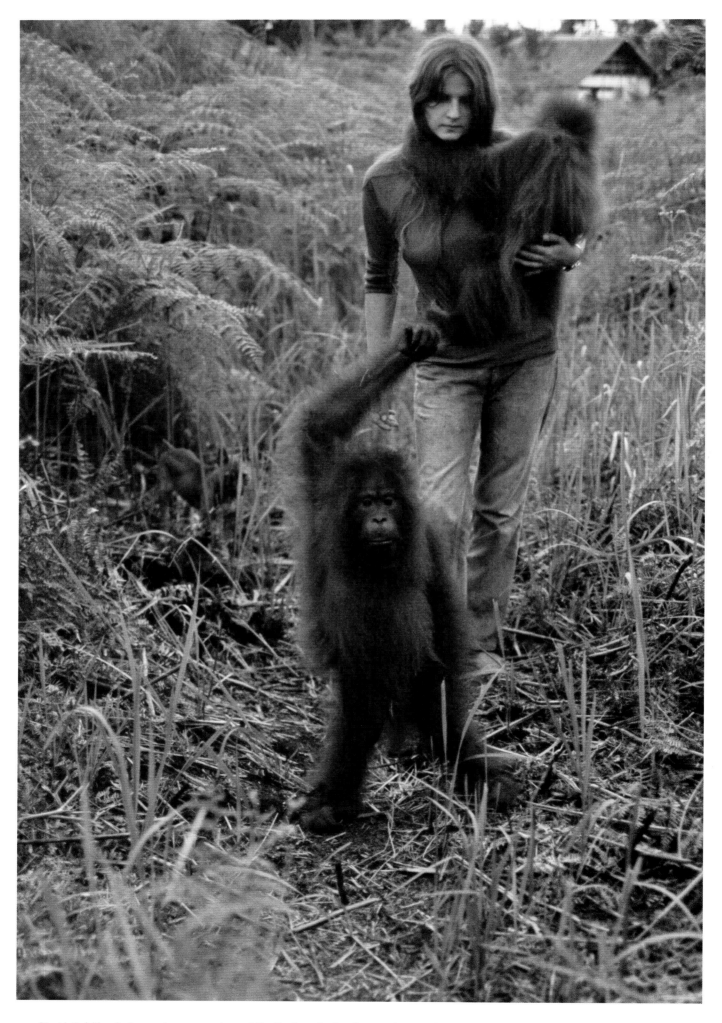

Birutė Galdikas helps orphan orangutans at the Tanjung Puting Reserve learn to live in the forest in Borneo. **Rod Brindamour, 1975**

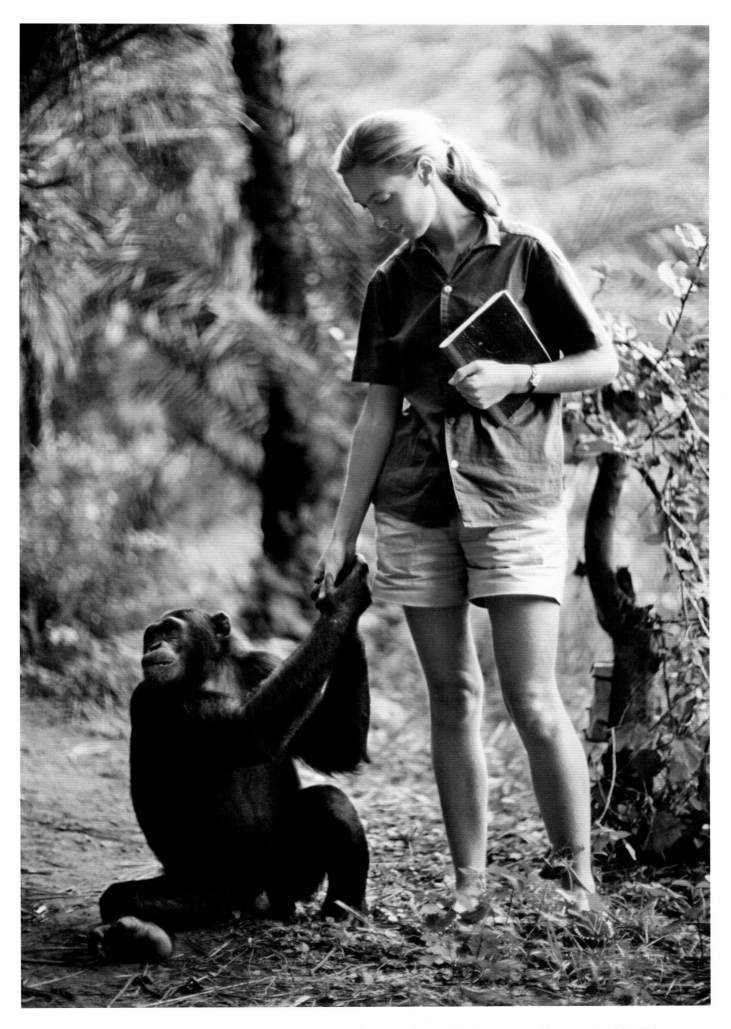

Jane Goodall takes the hand of a chimpanzee in the Gombe Stream National Park in Tanzania. *Hugo van Lawick, 1965*

A servant brings a tray of drinks to a pair of friends talking in a garden in Lagos, Nigeria. **Robin Hammond, 2014**

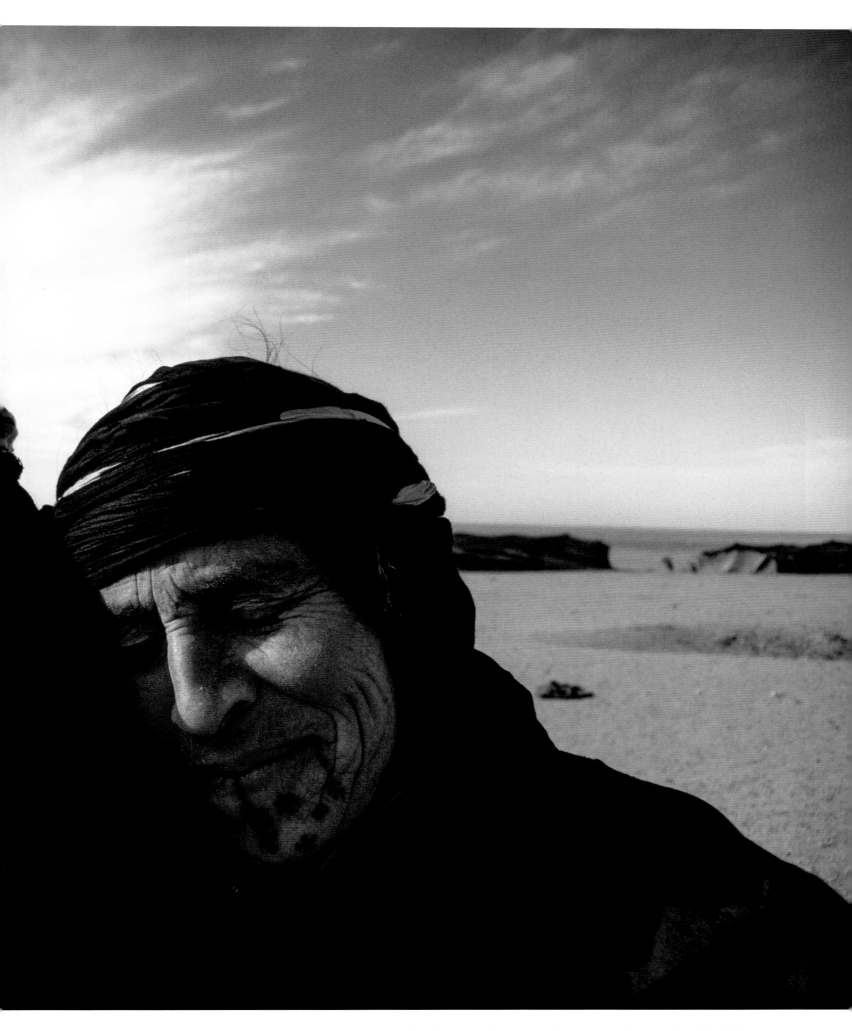

A nomadic Bedouin sheepherder and his wife, wearing traditional headscarves and tattoos, embrace in Syria. **James L. Stanfield, 1978**

Same-sex couples enjoy the day in the Place des Vosges in Paris—a scene that was unthinkable until a few decades ago. *Amy Toensing, 2006*

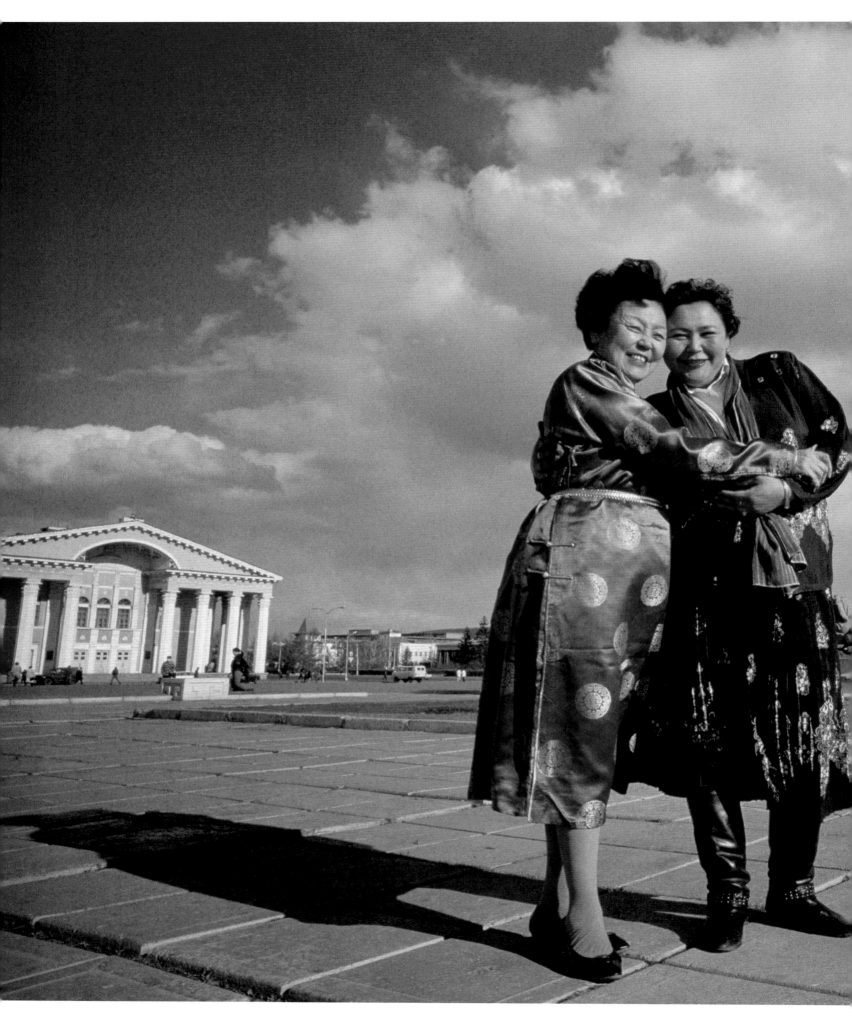

A Mongolian pharmacist (right) meets her hero, a greatly admired actress, in a town square. *Lynn Johnson, 2007*

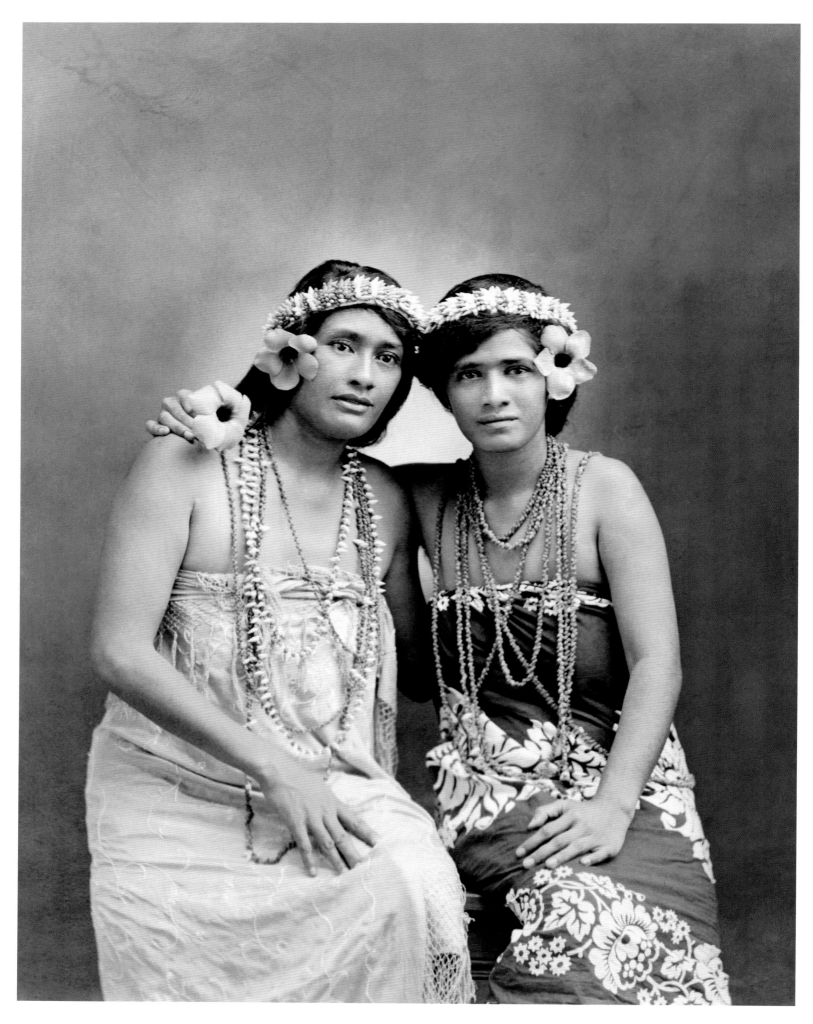

Two women wear flowers of friendship in the Marquesas Islands. *L. Gauthier, 1919*

Cousins from the Cree tribe cool off in Lake Opémisca in Quebec, Canada. *Maggie Steber, 1997*

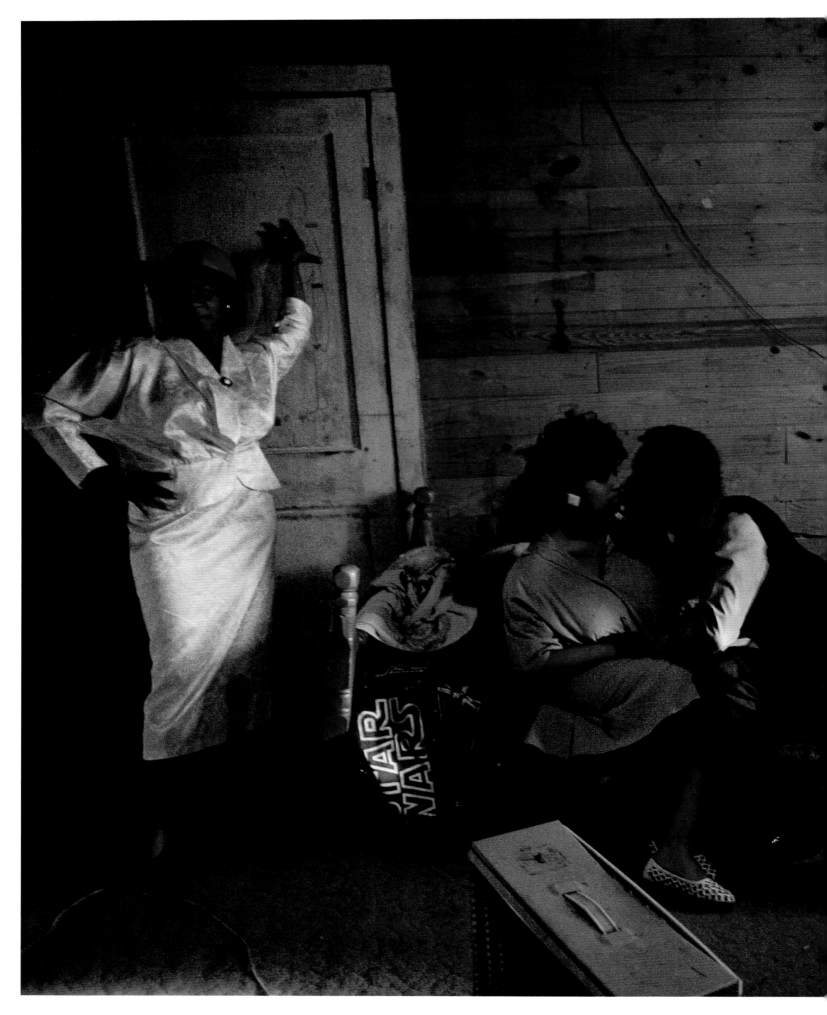

A woman gets a kiss from a bluesman while friends relax in his Mississippi home. ***William Albert Allard, 1989***

THE LENS

Throughout Latin America, women practice *cuarentena,* or quarantine, when mothers rest under the care of relatives for 40 days after giving birth. My mom and grandma took care of my older sister and me after we gave birth to our kids, but I had no idea this was a tradition in other communities. In this photograph, Laura Sermeño and her baby are given an herbal bath and massage as part of a sealing ceremony. This isn't just an image of a mom holding a baby; it's also about women holding each other and creating sacred spaces where they can feel safe and heal. It shows women as nurturers and givers of life. I feel that if women heal and are healed, the whole community remains healthy.

This photograph feels a bit autobiographical—I had just had my second baby when I took it. I remember carrying my camera and breast pump to shoots. I felt like I knew exactly what this woman was feeling toward that little body lying on hers. I was very grateful to be let into such an intimate space. ■

KARLA GACHET

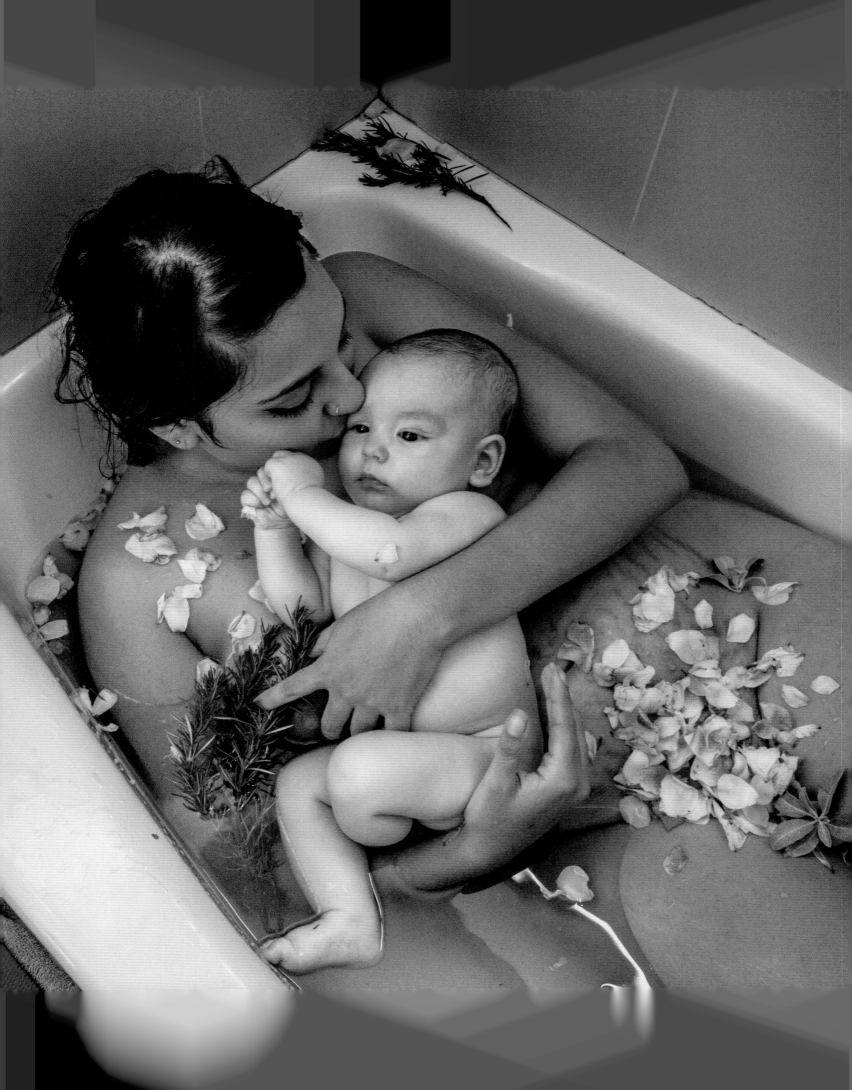

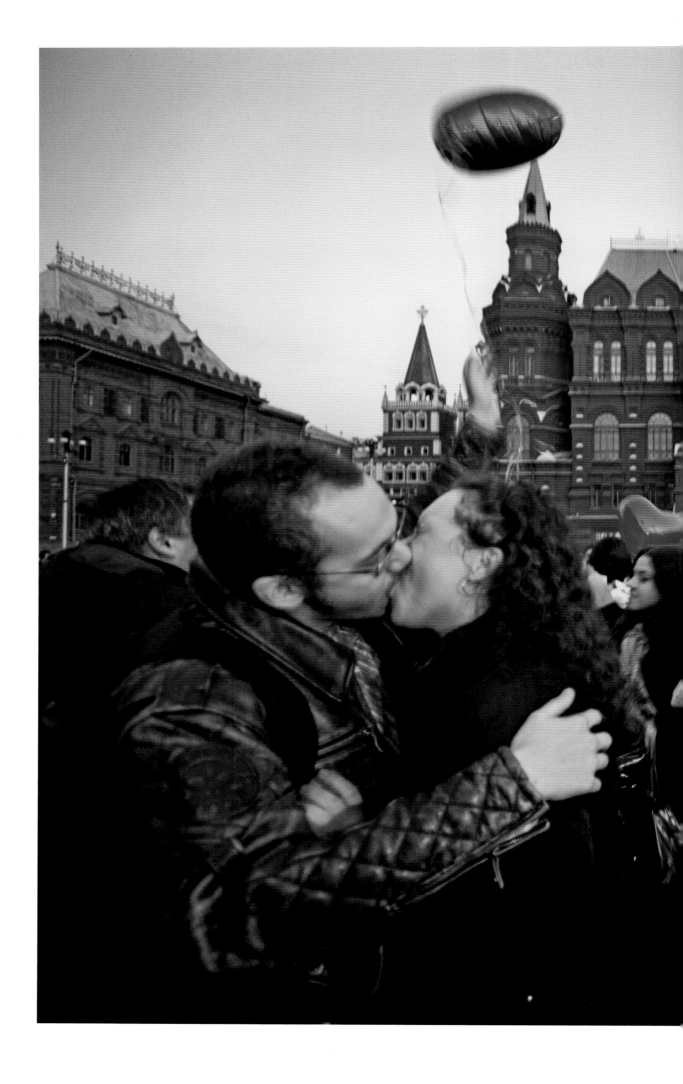

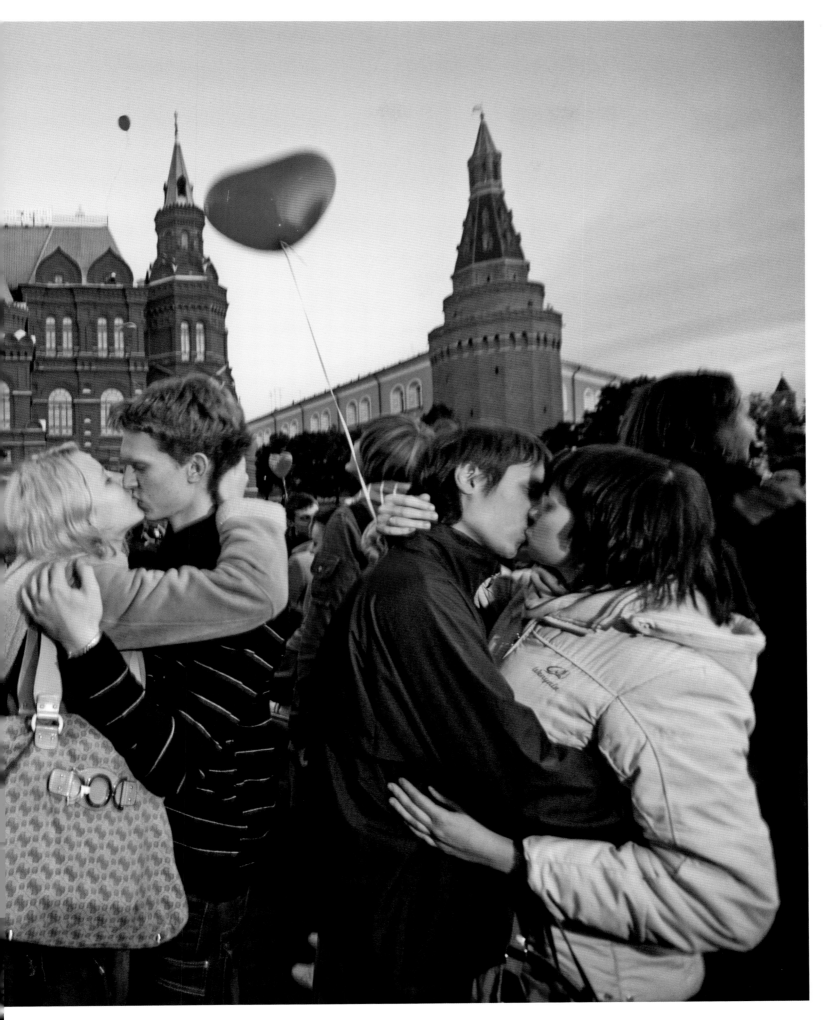

Balloons float above couples as they kiss during a flash mob in Manezhnaya Square in Moscow. *Gerd Ludwig, 2007*

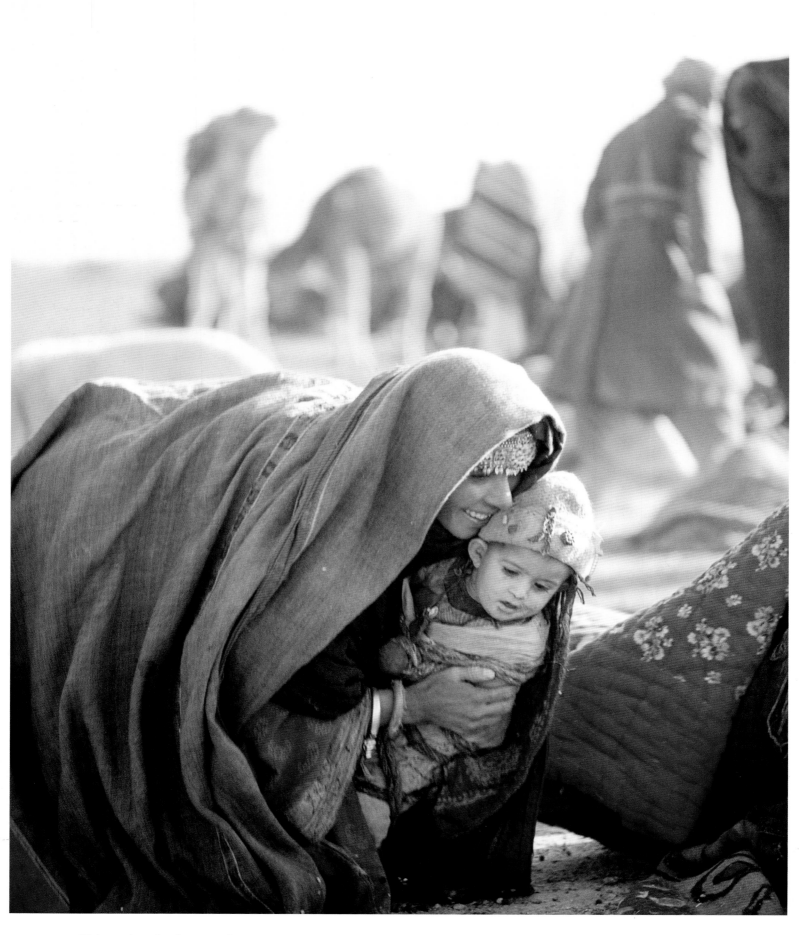

With a smile on her face, a Kuchi woman gathers up a child near the Desert of Death in Afghanistan. *Thomas J. Abercrombie, 1968*

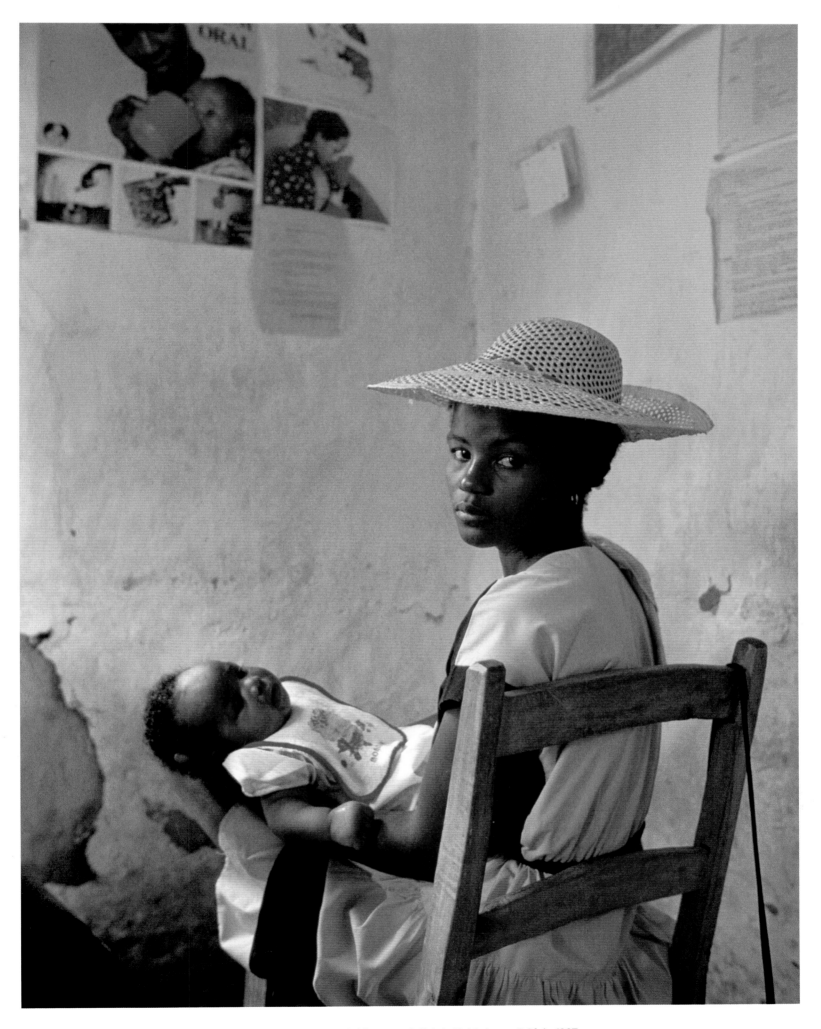

A woman holds her child at a rural clinic in Haiti. **James P. Blair, 1987**

Thenmozhi Soundararajan (standing), from India's Dalit population, its lowest caste, shows off her artwork to a Bangladeshi American. Both women are activists against caste-based discrimination. **Ismail Ferdous, 2018**

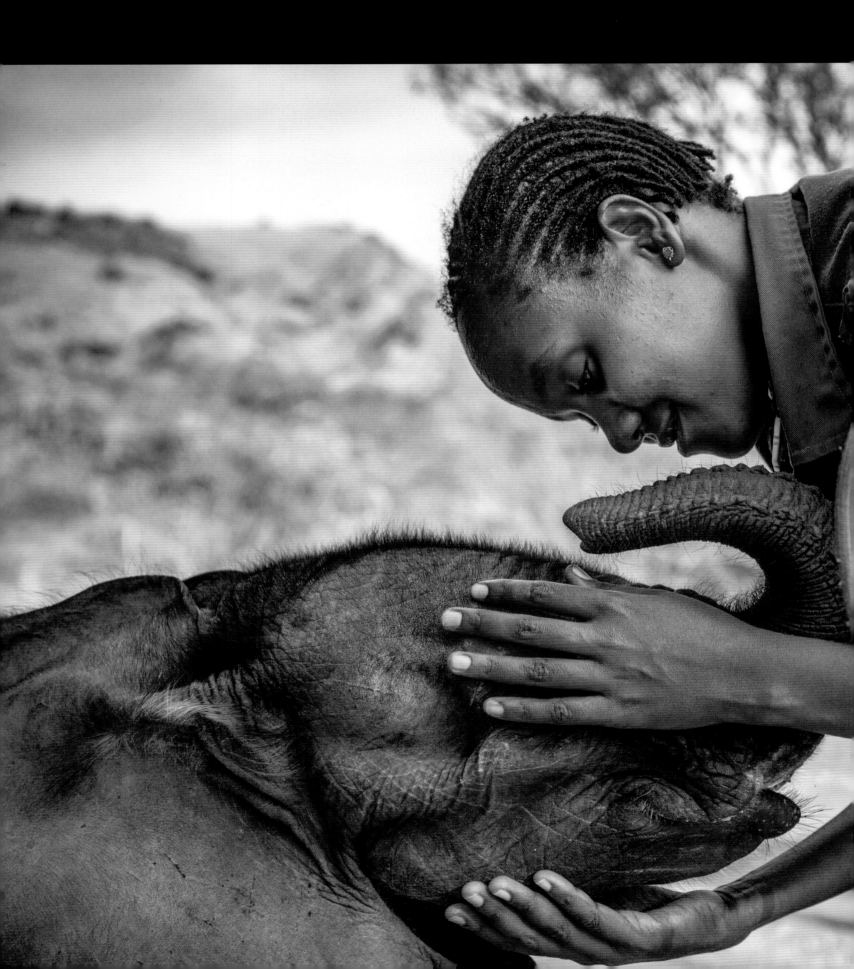

THROUGH
THE LENS

Mary Lengees, one of the first female elephant keepers at Reteti Elephant Sanctuary, caresses Suyian, the first sanctuary resident. Reteti is the first indigenous-owned and -run elephant sanctuary in all of Africa. Their goal is to rescue, rehabilitate, and reintroduce orphaned or abandoned elephant calves into the wild. What's happening at Reteti, without fanfare, is nothing less than the beginnings of a transformation. The sanctuary is breaking stereotypes and pushing the boundaries of women's traditional roles in Kenya; it has become a catalyst for changing the way communities view not just wildlife, but also one another. This oasis where orphans grow up, learning to be wild so that one day they can rejoin their herds, is as much about the people as it is about elephants.

Photography is a powerful medium. It transcends language, creates understanding across cultures, and can make sense of our commonalities in this world we share. After covering conflicts for almost a decade, I realized I can bring that same sensibility into my images—whether they be of people, cultures, wildlife, or nature. Even focusing on issues of security and humanity, everything is dependent on nature for its outcome. ∎

AMI VITALE

A woman in Florence, Italy, takes a moment to herself to read a greeting card designed as a newspaper. **Jodi Cobb, 2005**

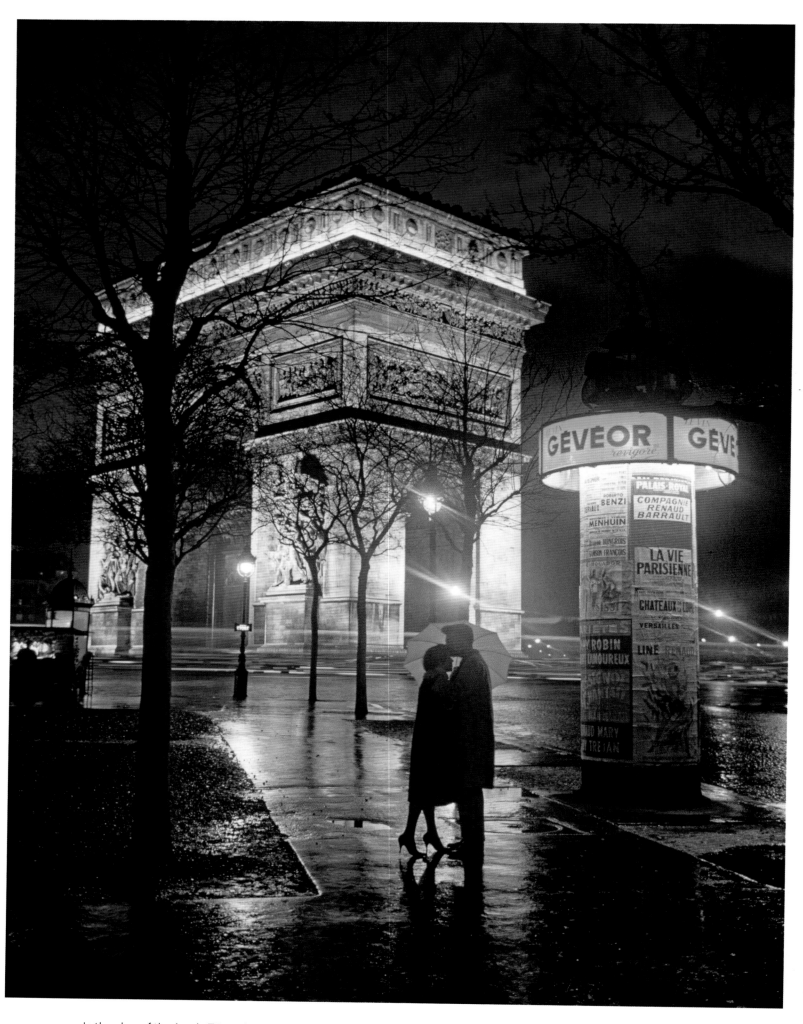

In the glow of the Arc de Triomphe in Paris, a couple takes a moment away from the rush of the big city. **Thomas Nebbia, 1960**

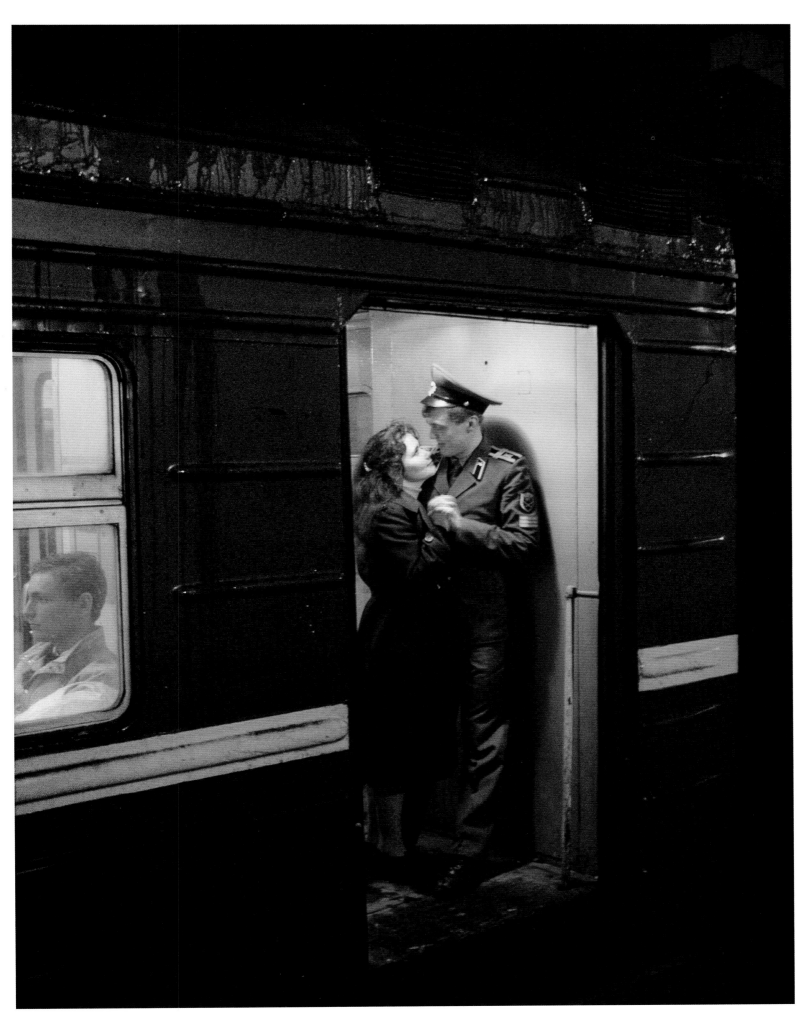

All aboard: Two lovers cuddle as the train to Moscow is ready to pull out of the station. *Gerd Ludwig, 1993*

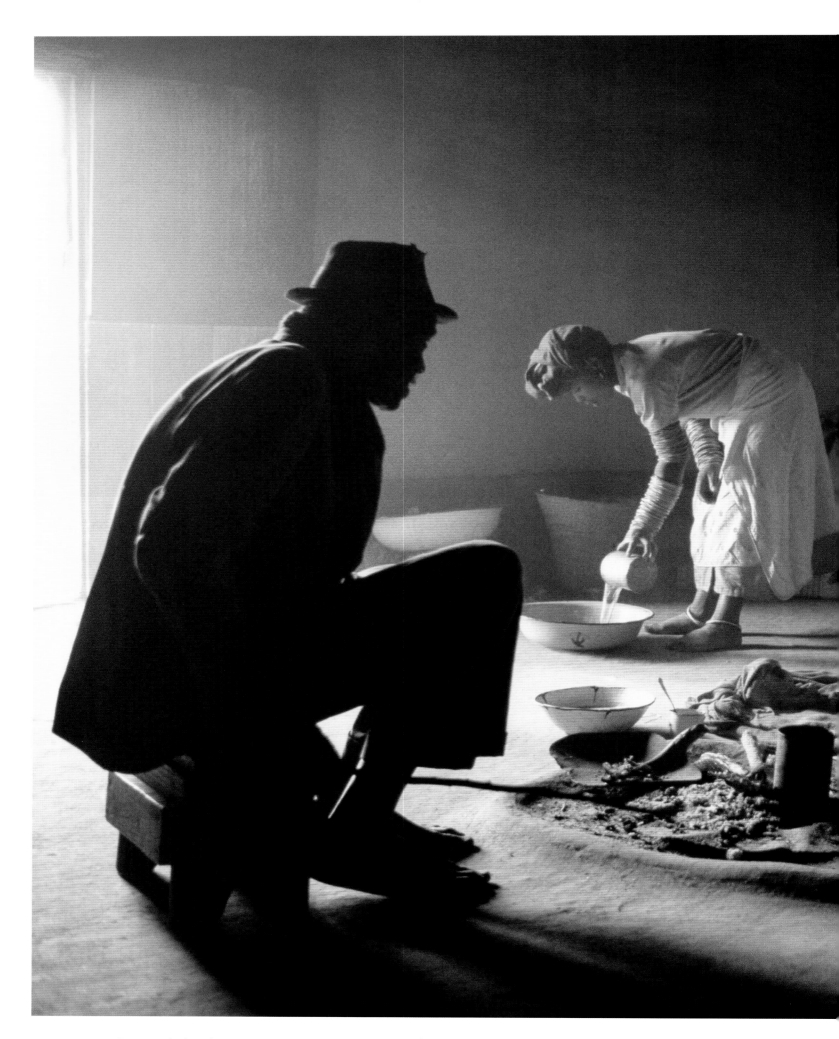

A miner, who lives far away for most of the year, visits with his family in a Transkei village in South Africa. *James P. Blair, 1976*

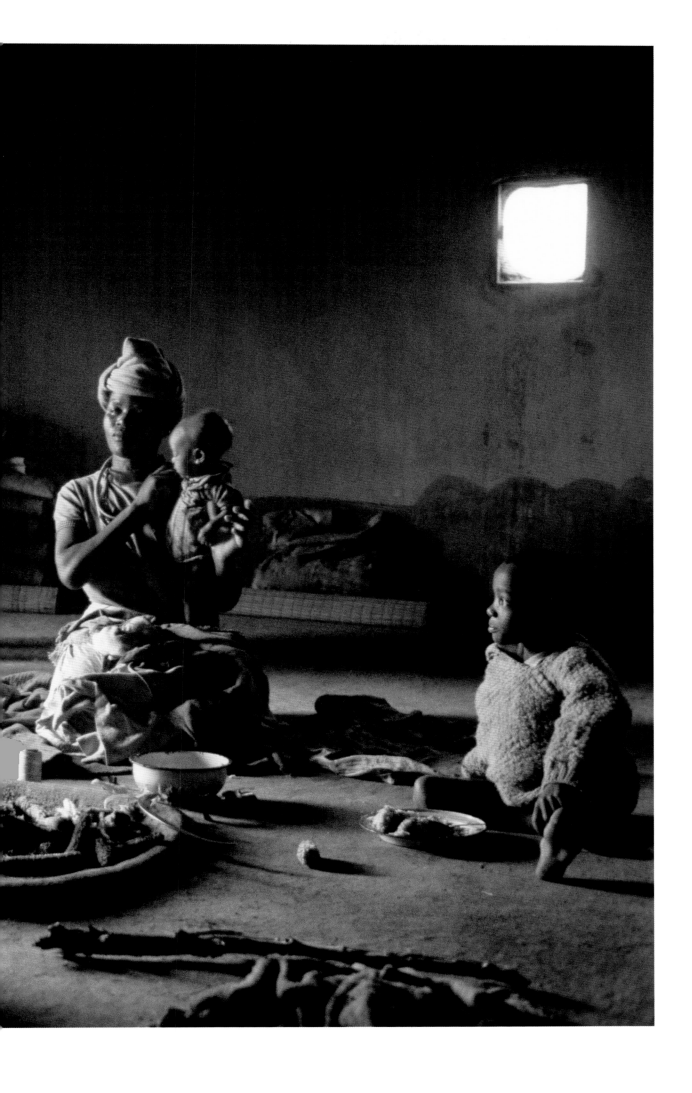

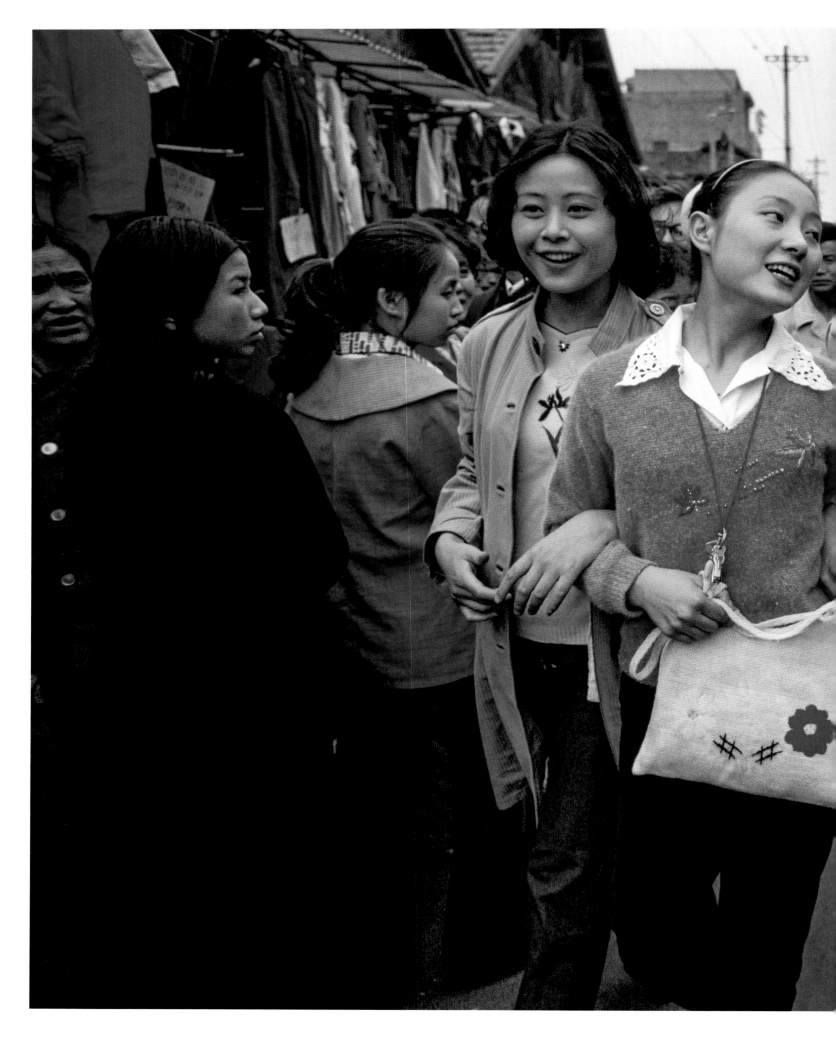

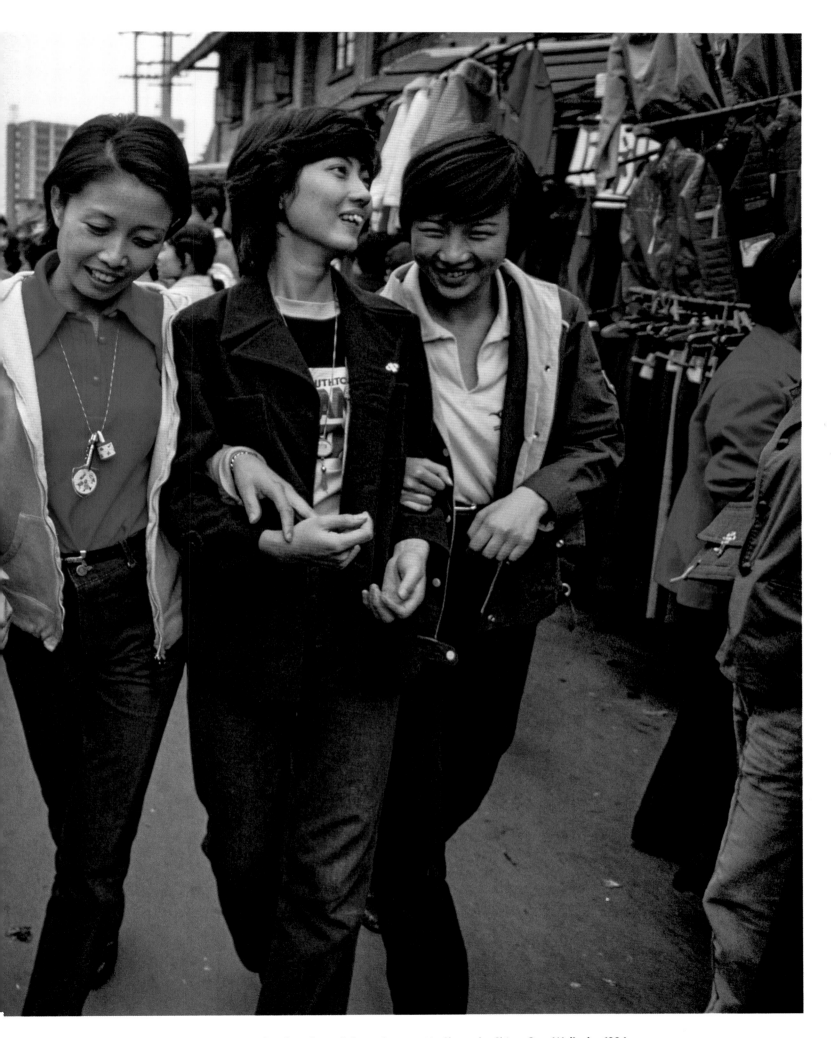

Arm in arm, five friends stroll down the street in Chengdu, China. **Cary Wolinsky, 1984**

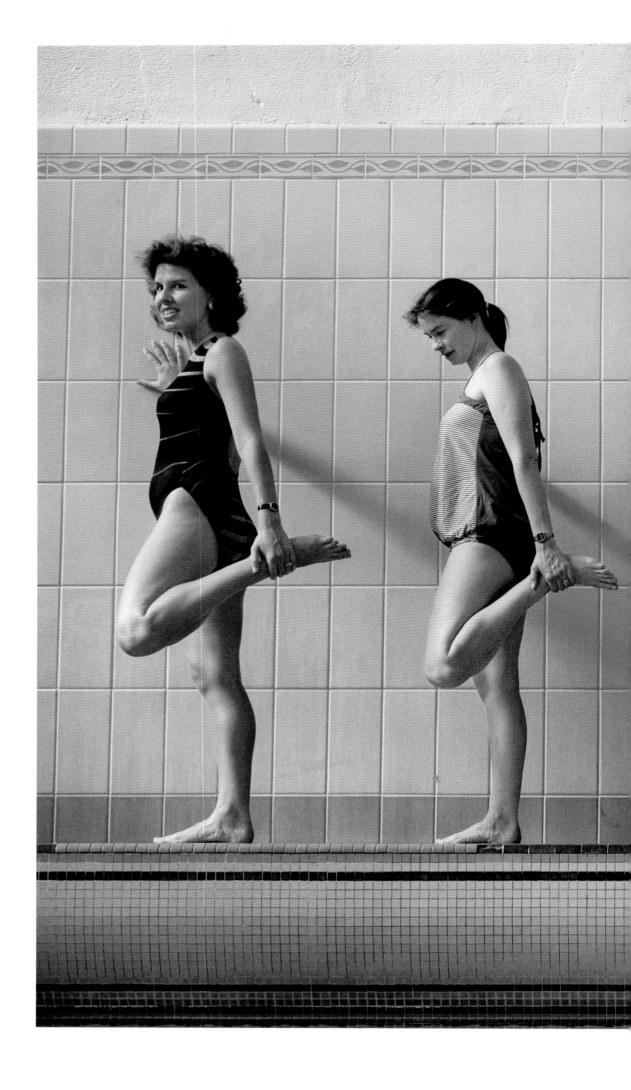

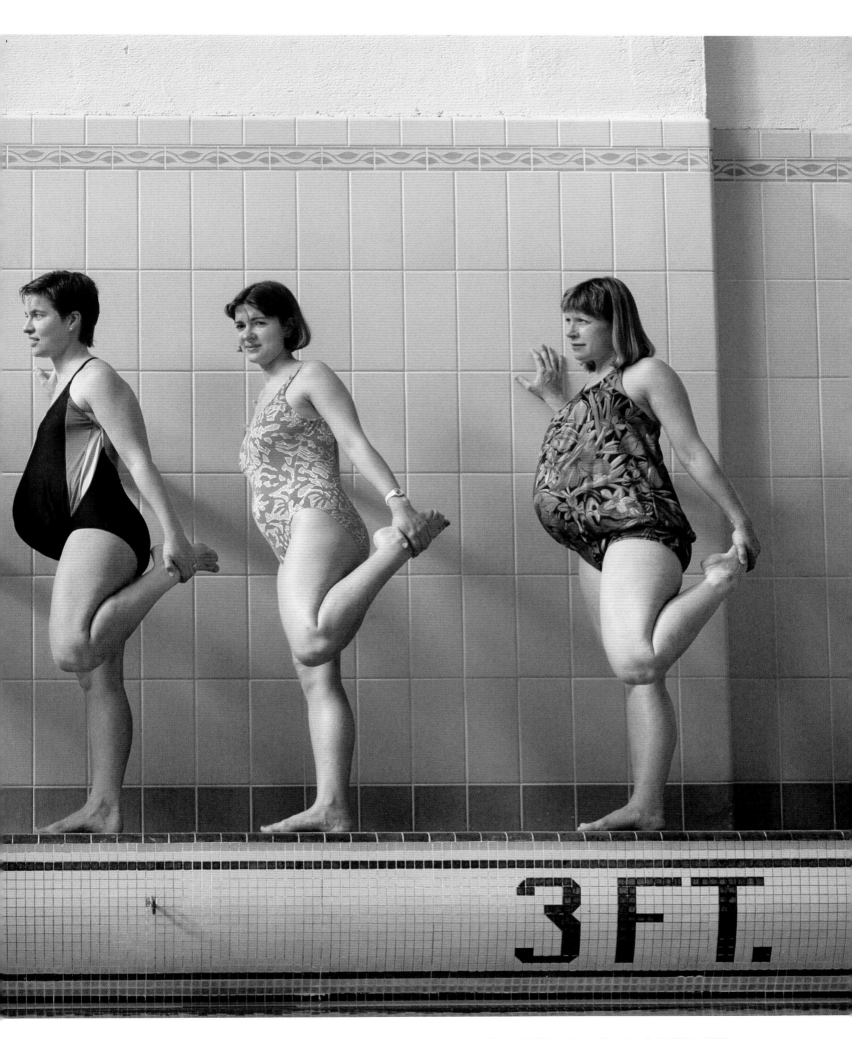

Women in various stages of pregnancy warm up for a water aerobics class in Chapel Hill, North Carolina. **Annie Griffiths, 1999**

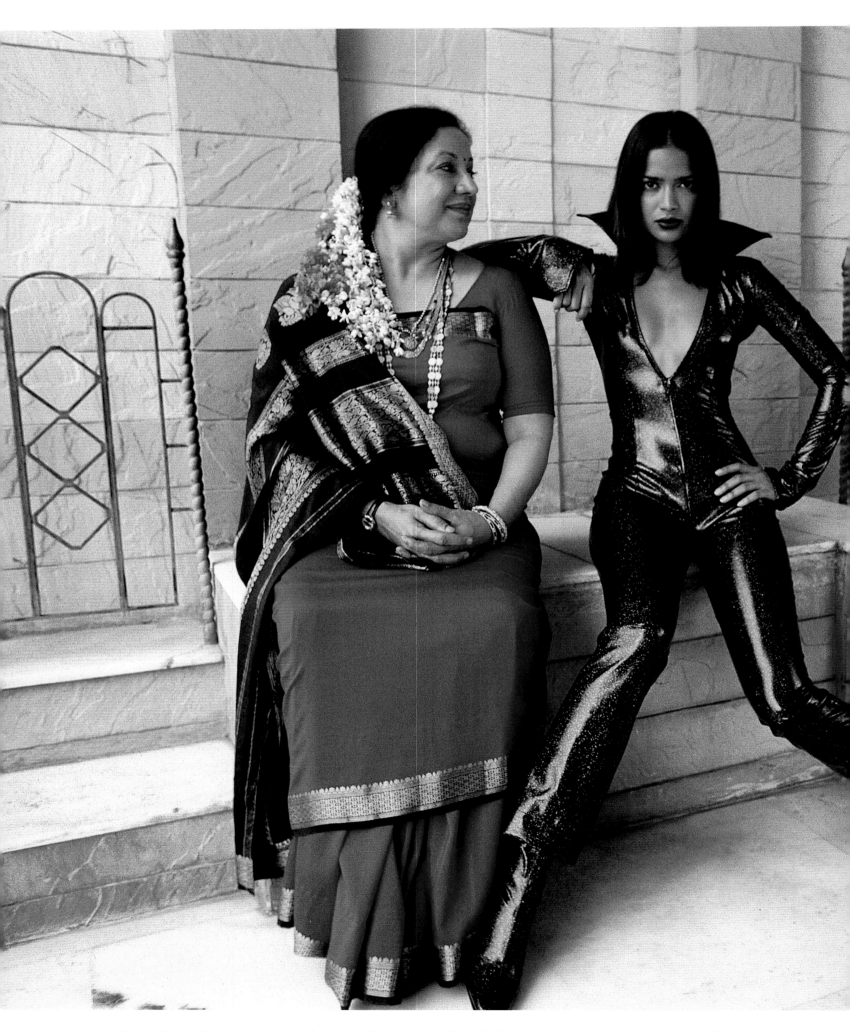

Seemingly a world apart, a fashion model poses with her more traditionally dressed mother in Mumbai, India. *Joe McNally, 1998*

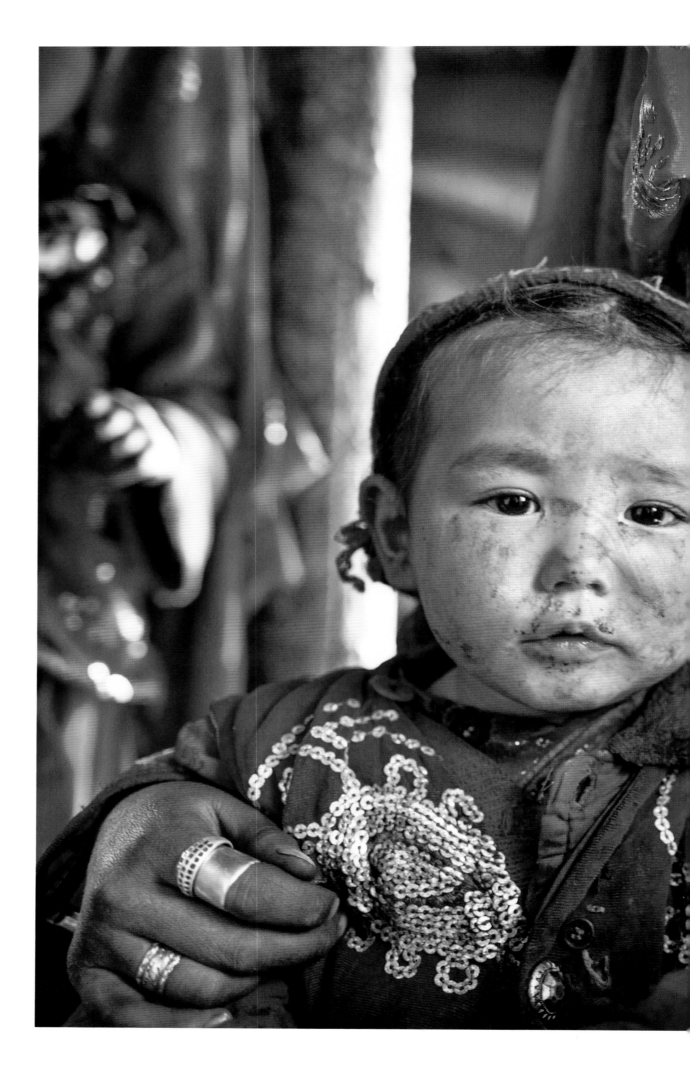

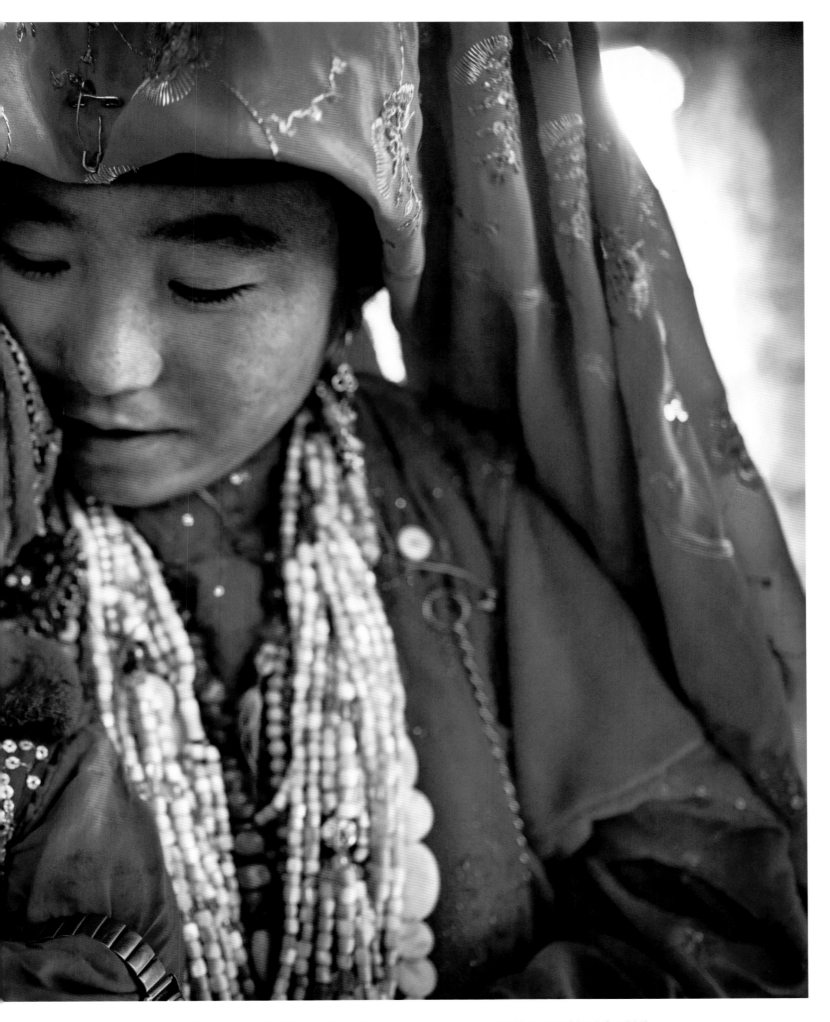

A recently married Afghan girl embraces her younger sister in Wakhan. **Matthieu Paley, 2012**

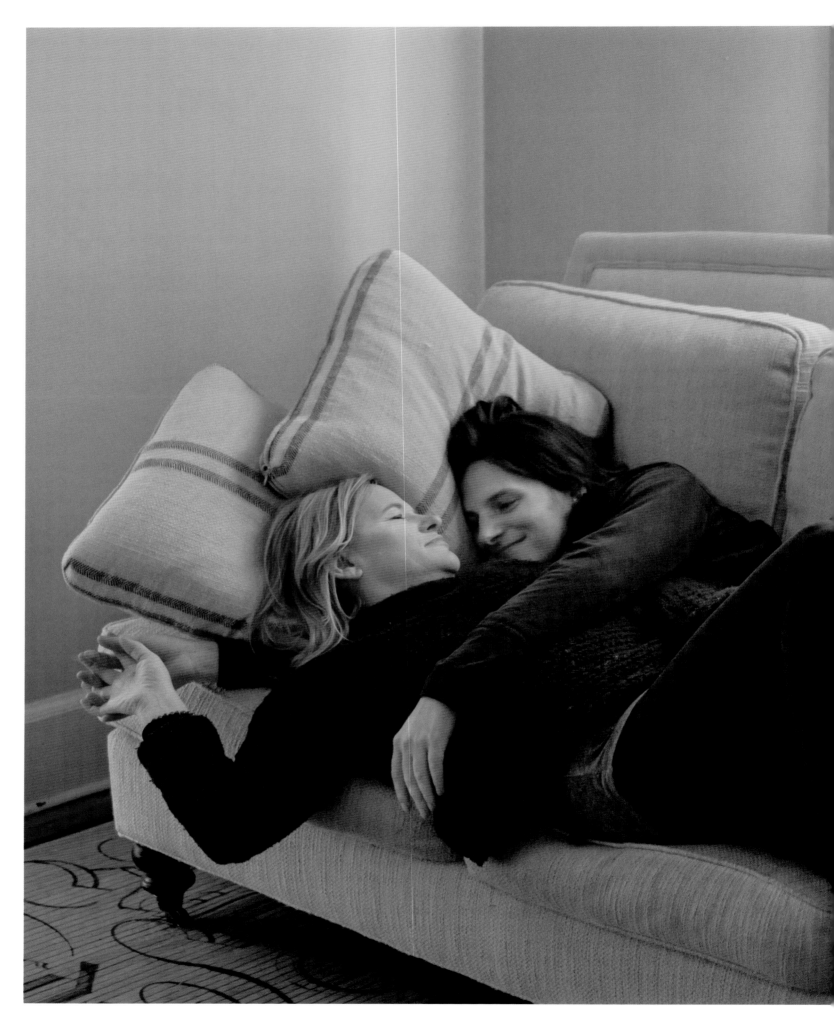

A transgender woman in Derby, Connecticut, embraces her mother after gender-affirming surgery. *Lynn Johnson, 2017*

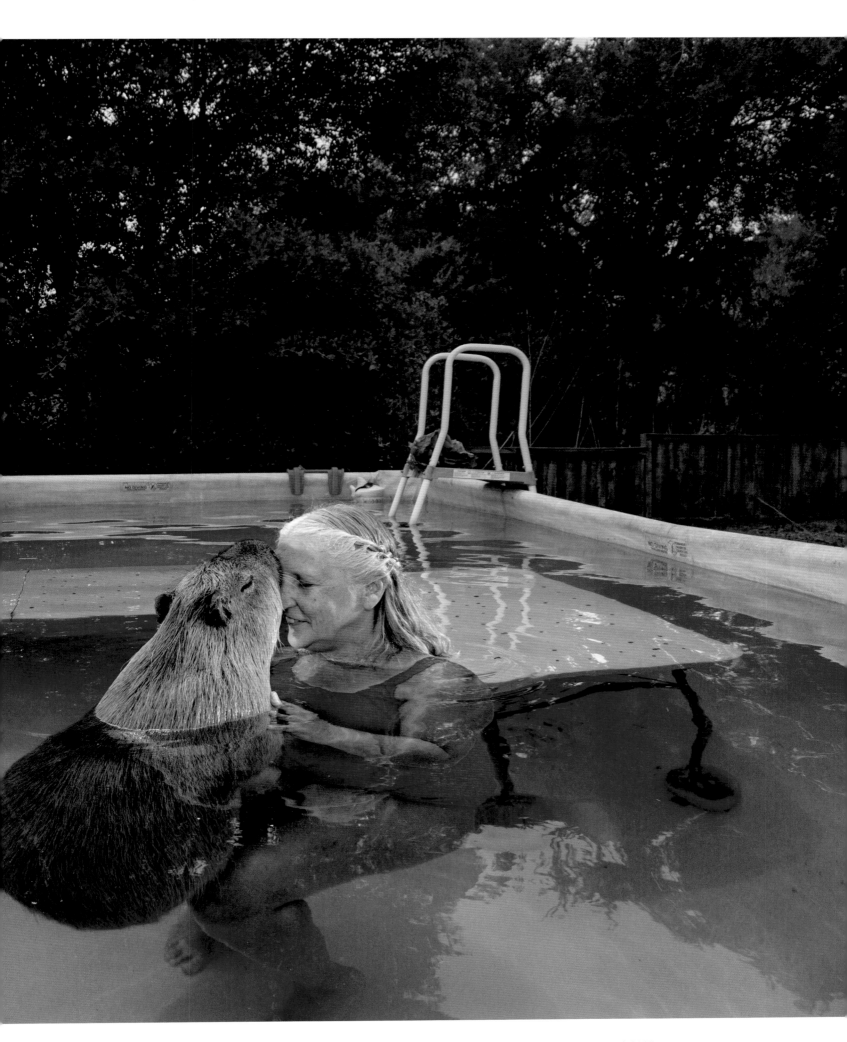

Melanie Typaldos swims with her 120-pound pet capybara in Buda, Texas. **Vincent J. Musi, 2013**

CHAPTER FOUR

WISDOM

A Seri tribal elder sits beneath a cactus arch in Punta Chueca, Mexico. *Lynn Johnson, 2010*

In many eras and cultures, it's been presumed that the wisest people—the most knowledgeable and intelligent—were bound to be male. Consider a prime example from Margot Lee Shetterly's book *Hidden Figures*. During the mid-20th century, the vaunted male scientists of the U.S. space program largely dismissed its female mathematicians—until Katherine Johnson computed the trajectory for astronaut John Glenn's historic orbital mission in 1962.

If any doubt lingers about the force of women's wisdom, the following images should help dispel it. Here, in action, are women of intellect and insight. Leading. Learning. Teaching. Imagining. Preserving ancient truths and discovering new ones.

This wisdom travels much as it always has: passed from one woman to others as counsel, warning, pep talk. Sometimes it's brief and bracing: "Resist, insist, persist," attorney Gloria Allred advises. Other times, it's a heartfelt life lesson: "Fitting in is overrated," says philanthropist Melinda Gates. "Seek out people and environments that empower you to be nothing but yourself." ■

Longa Moala gathers pandanus leaves, soaked in seawater, to weave into traditional Tongan mats when they dry. **Amy Toensing, 2007**

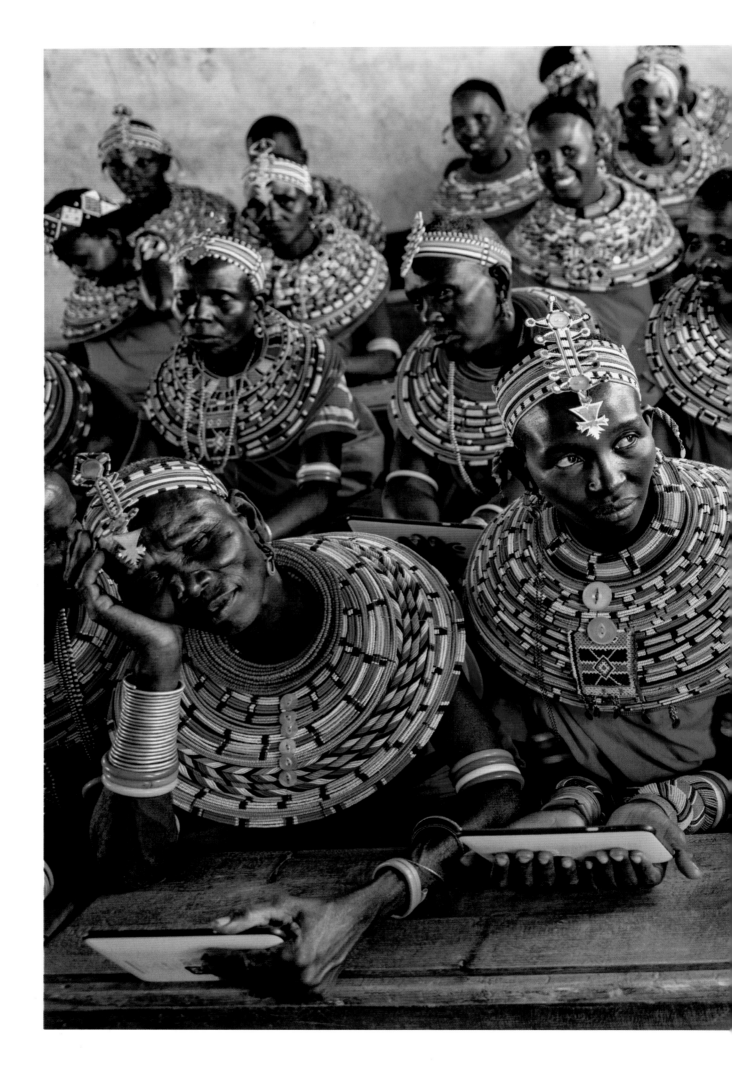

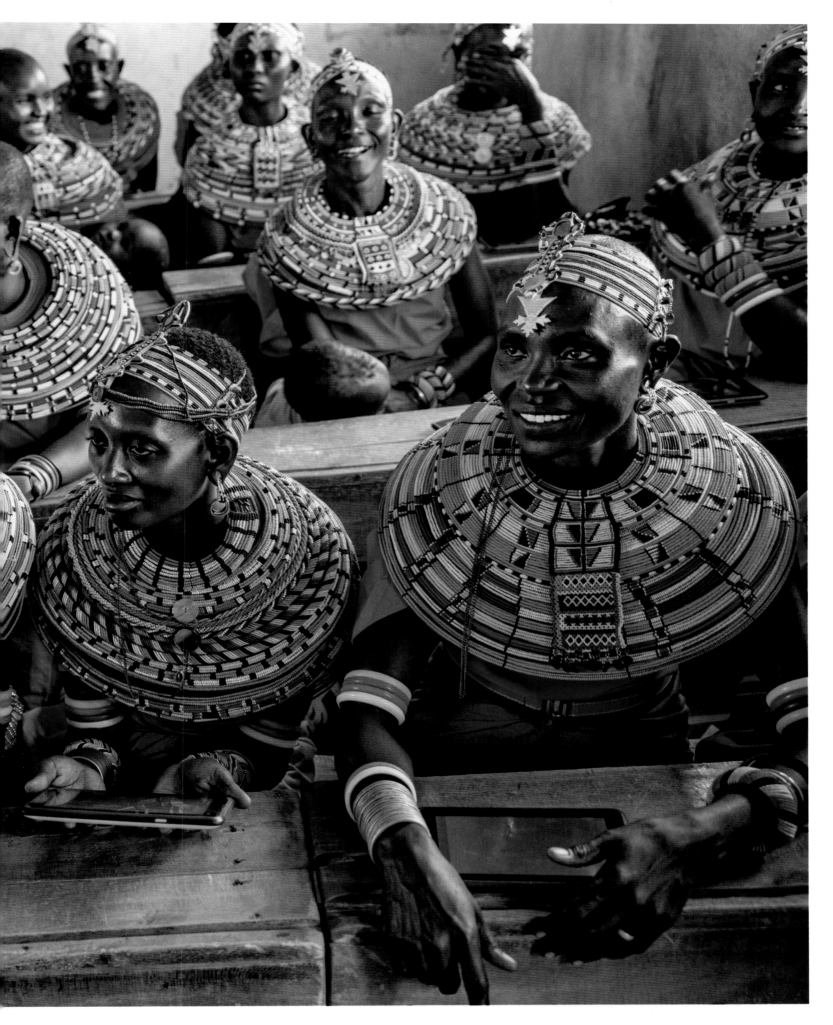

Samburu women in traditional clothing gather in a classroom north of Nairobi, Kenya, to learn more about computers. *Ciril Jazbec, 2017*

A Sherpa woman calls the border region between Tibet and Nepal home. *Cory Richards, 2010*

A wax painting adorns a Ptolemaic sarcophagus in Egypt. *Jules Gervais-Courtellemont, 1923*

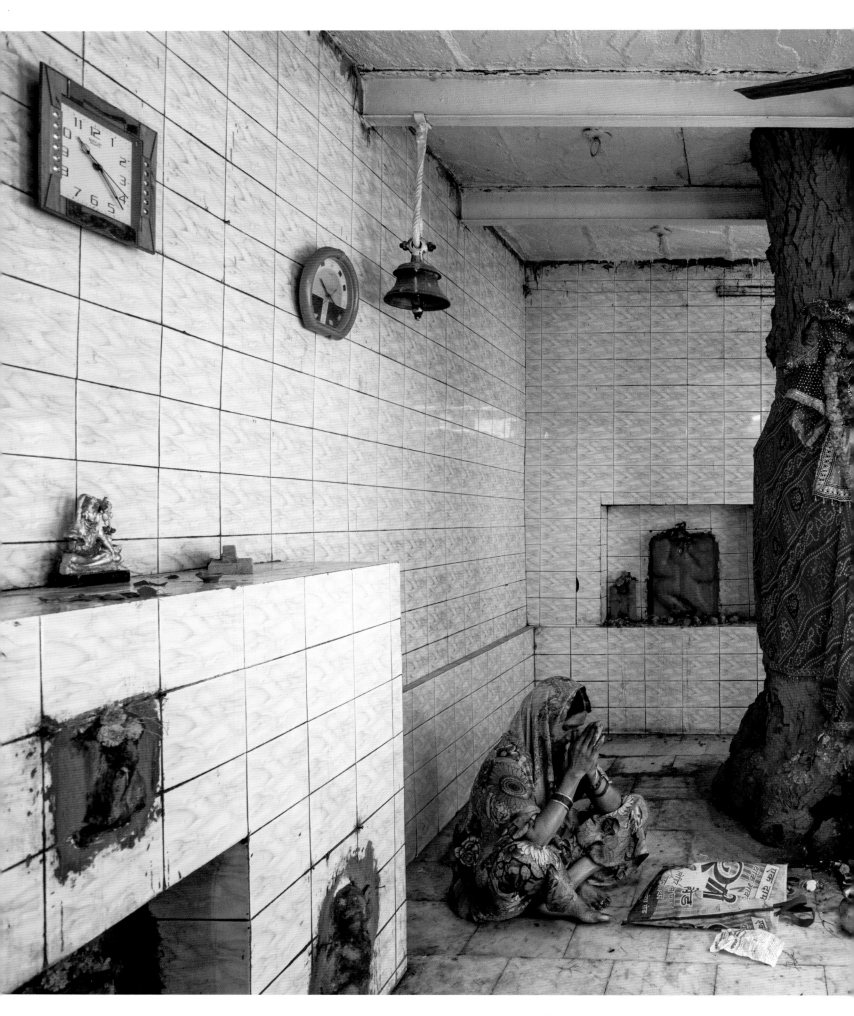

An Indian woman worships at the neem tree, a manifestation of the Hindu goddess Shitala,
at the Nanghan Bir Baba Temple in Varanasi. *Diane Cook & Len Jenshel, 2014*

Students raise their hands in a classroom in the Marefat School on the outskirts of Kabul, Afghanistan. *Lynsey Addario, 2010*

A teacher makes a point in her classroom in Jeddah, Saudi Arabia. At the time, there was just
a two percent literacy rate for women in the country. *Winfield Parks, 1975*

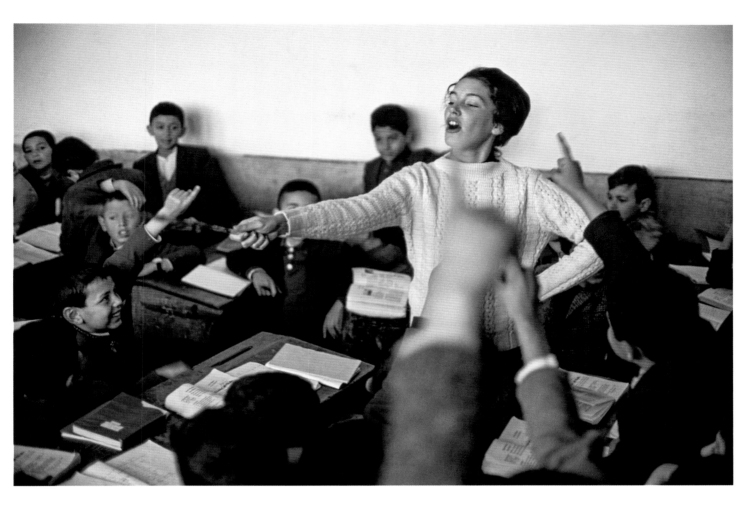

A Peace Corps volunteer teaches English to a classroom of boys in Antakya, Turkey. *James P. Blair, 1964*

Acclaimed distance runner Nancy Kiprop, 39, dances with students at the Kenyan school she founded. *Nichole Sobecki, 2018*

Deb Haaland, one of the first Native American women to be elected to the U.S. Congress, puts in extra hours at her campaign office in New Mexico. **Daniella Zalcman, 2018**

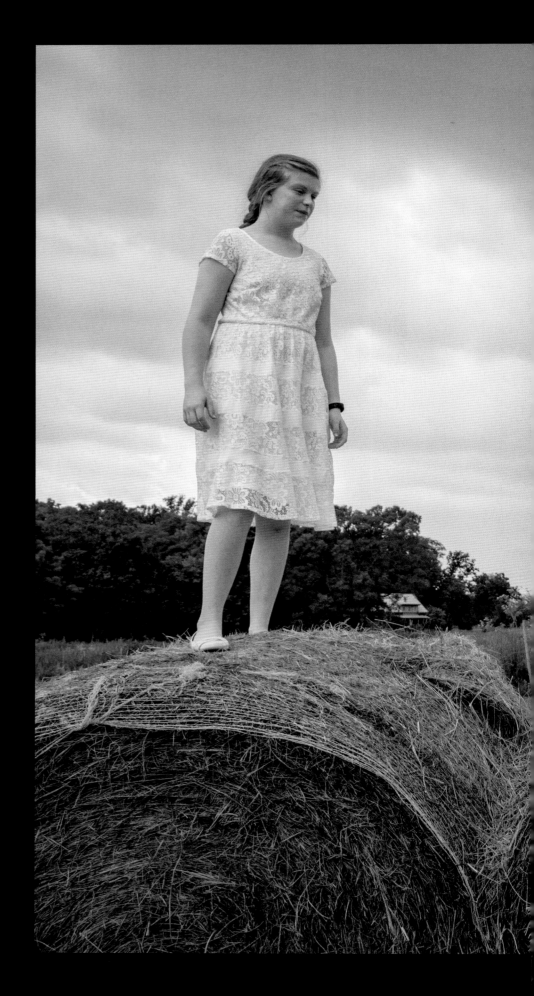

While working on a story for *National Geographic*'s gender issue, I spent a day at a workshop in Kentucky where young girls, along with their mothers, discuss menstruation and puberty. It was part sex ed, part story-sharing, and part ceremony. In our society there seems to be this knee-jerk reaction to the idea that children and their parents would ever sit in the same room and talk about their own bodies. I find this reaction to be so sad; it comes from a place of shame and fear. I didn't sense that any of the girls were there against their own will or too embarrassed to ask questions; rather, there was a lot of love in the room, and I was deeply moved by the courageous acts of vulnerability. I wish more spaces existed to encourage this kind of openness and dialogue between parents and their children.

This photo was taken during a break between sessions, when a group of girls ran outside to play in the haystacks. This image speaks of the openness and freedom I felt that day. And it speaks to the importance of creating spaces where young girls are encouraged to take ownership of their own bodies and are not made to feel embarrassed about something fundamental to their lives. ∎

KITRA CAHANA

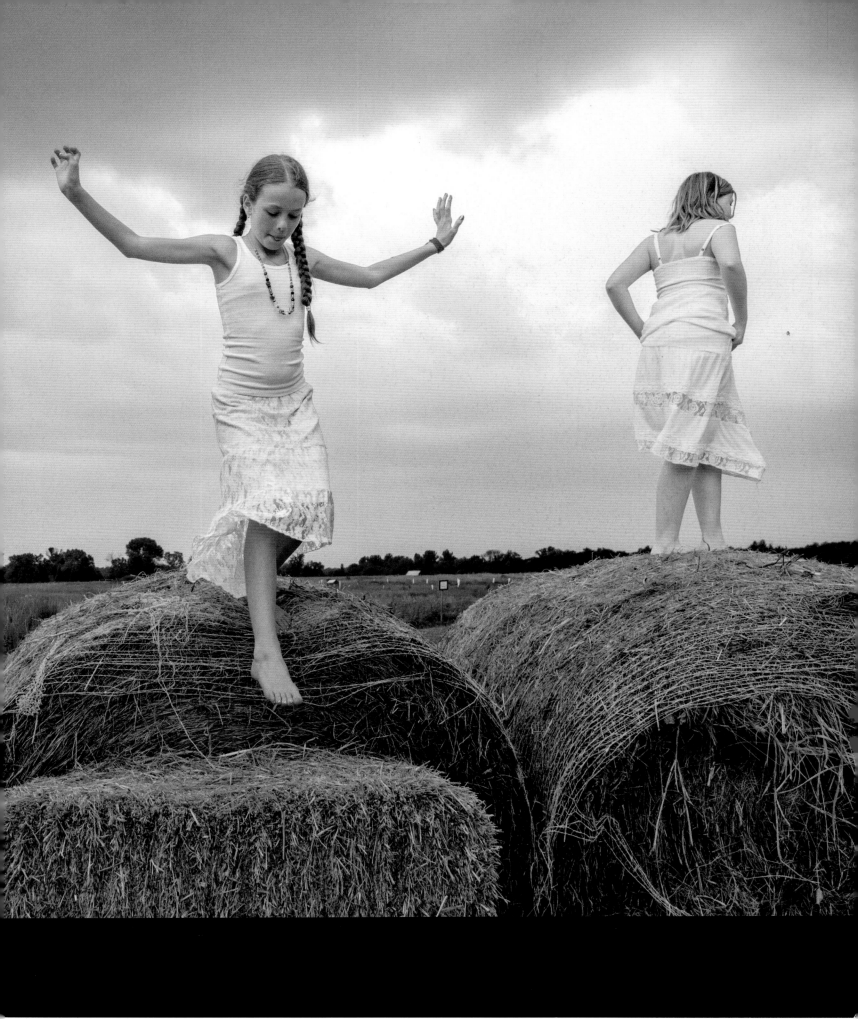

THROUGH
THE LENS

For the last decade, I've immersed myself in the lives of my subjects and their culture, often spending months, if not years, building relationships with them in some of the most remote corners of the world. This image was taken in Poland, while on an assignment for *National Geographic,* in search of the Virgin Mary. It's in the small village of Rutka where I met individuals who were believed to have a direct link to Mary. Known as "whisperers," they use that connection to heal diseases and cure physical pain. Here, Anna, one of the whisperers, is performing a ritual for a patient. There's a certain intensity and vulnerability I feel when I look at this image. It's the same sort of feeling I had upon meeting Anna; she opened herself up to me, revealing a moment so raw, and so intimate. ■

DIANA MARKOSIAN

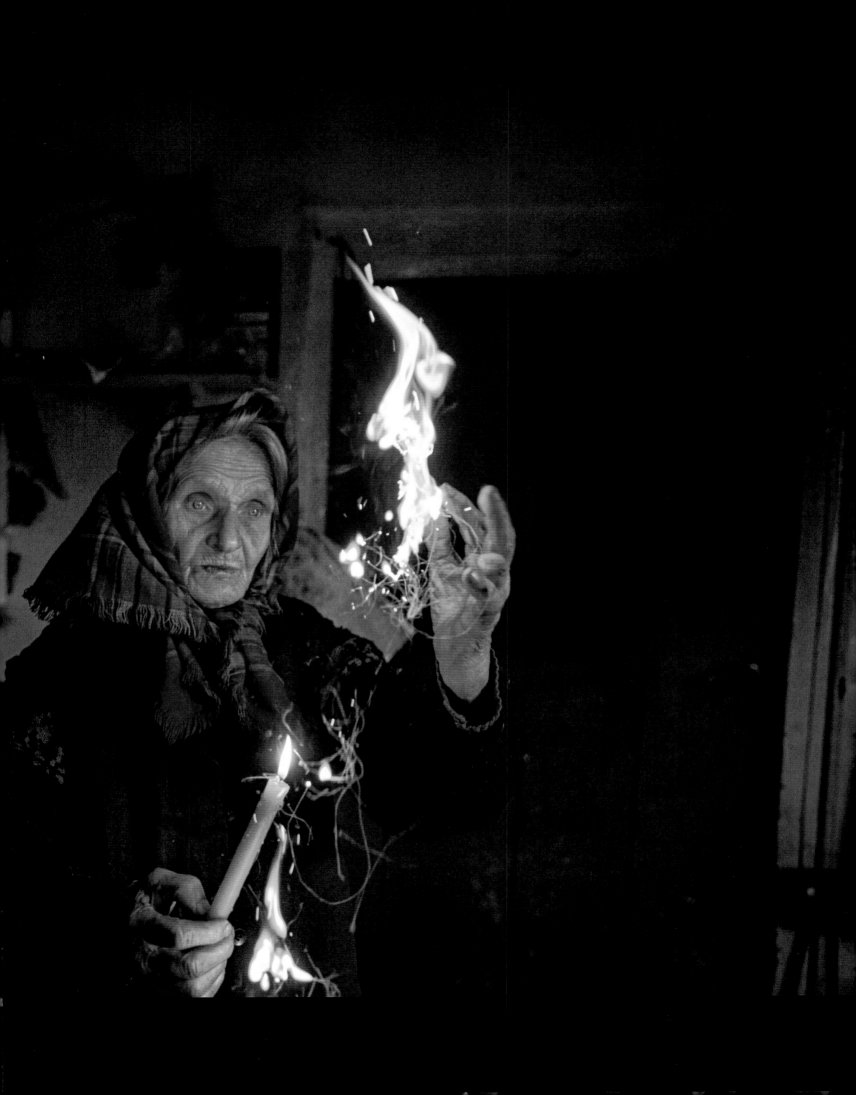

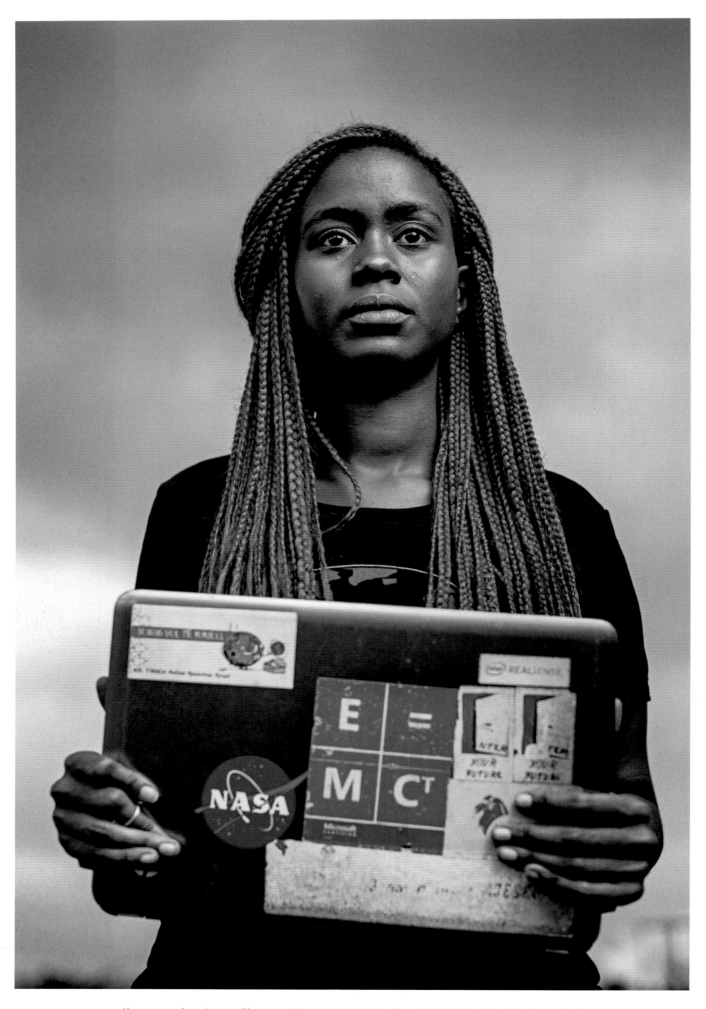

Kenyan student Jessica Chege studies computers at college in Nairobi and aspires to protect the environment through innovative technology. **Ciril Jazbec, 2016**

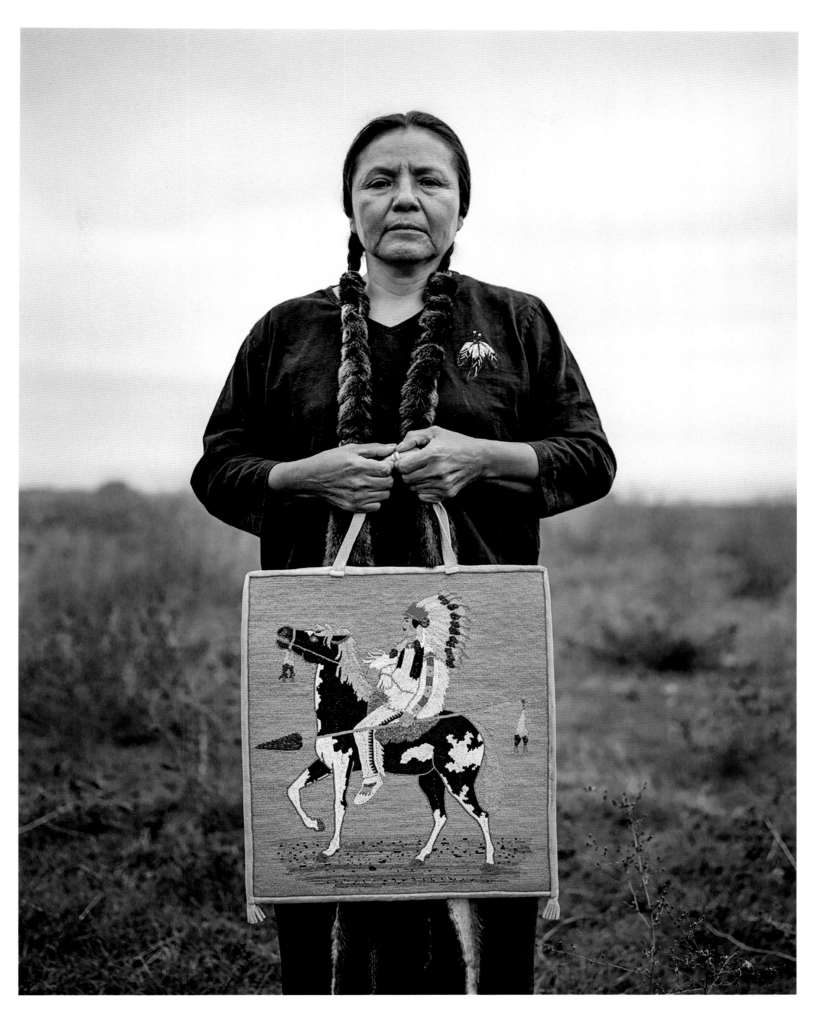

Patricia Heemsah, a Yakama tribeswoman, shows off a bag her mother beaded more than 25 years ago. **Erika Larsen, 2011**

Queen Elizabeth II awards equestrian ribbons to riders in Windsor, England. *James L. Stanfield, 1979*

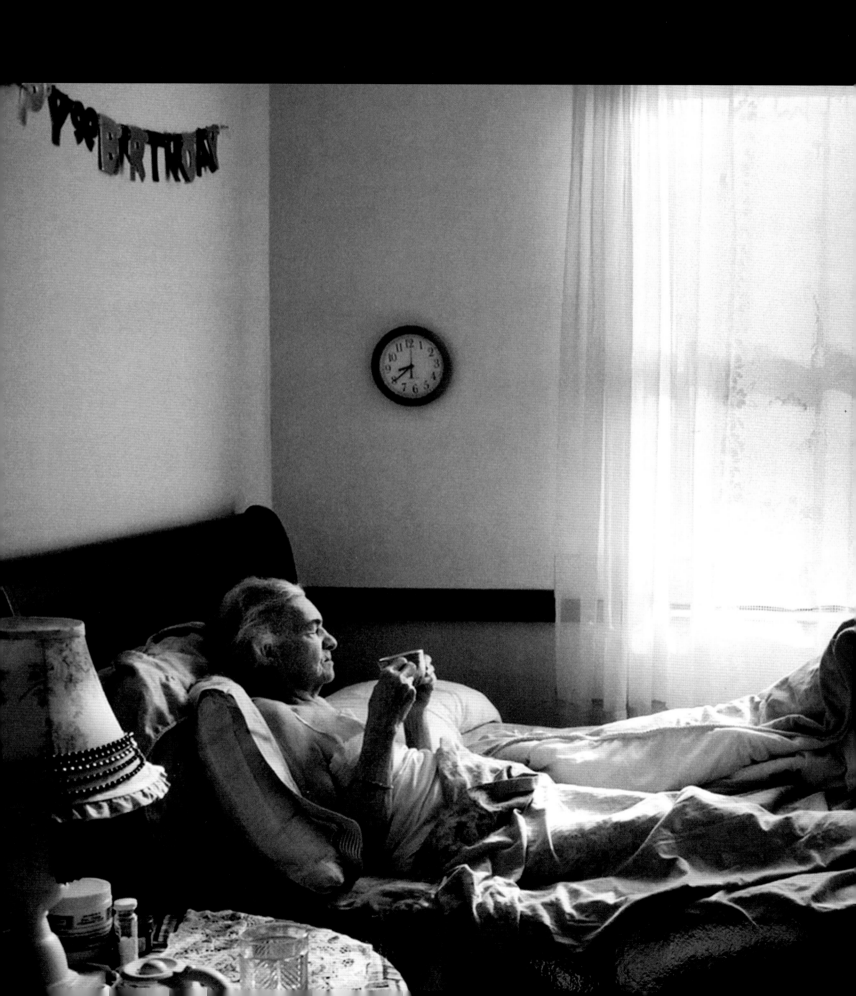

THROUGH
THE LENS

This is my mother, Madje Steber. I photographed her for nine years as she experienced memory loss. I am grateful for this woman who raised me by herself and worked hard to make sure I never felt diminished, since we didn't have a lot. She and I used to read encyclopedias from cover to cover, A to Z, and they were full of pictures. They made me curious about the world and science and theater and music—and ultimately led me to photography.

My mother taught me how to work in a man's world and how to show grace. I'm so glad I could give her a loving end-of-life experience, and that we had so much time together. I'm also grateful to the women who cared for her when I could not. This photograph probably says more about me than it does my mother—that I loved her, that I wanted her to have whatever she wanted or needed, that I wanted to spoil her and to thank her for working so hard on my behalf. This image is about the love between a mother and daughter. ∎

MAGGIE STEBER

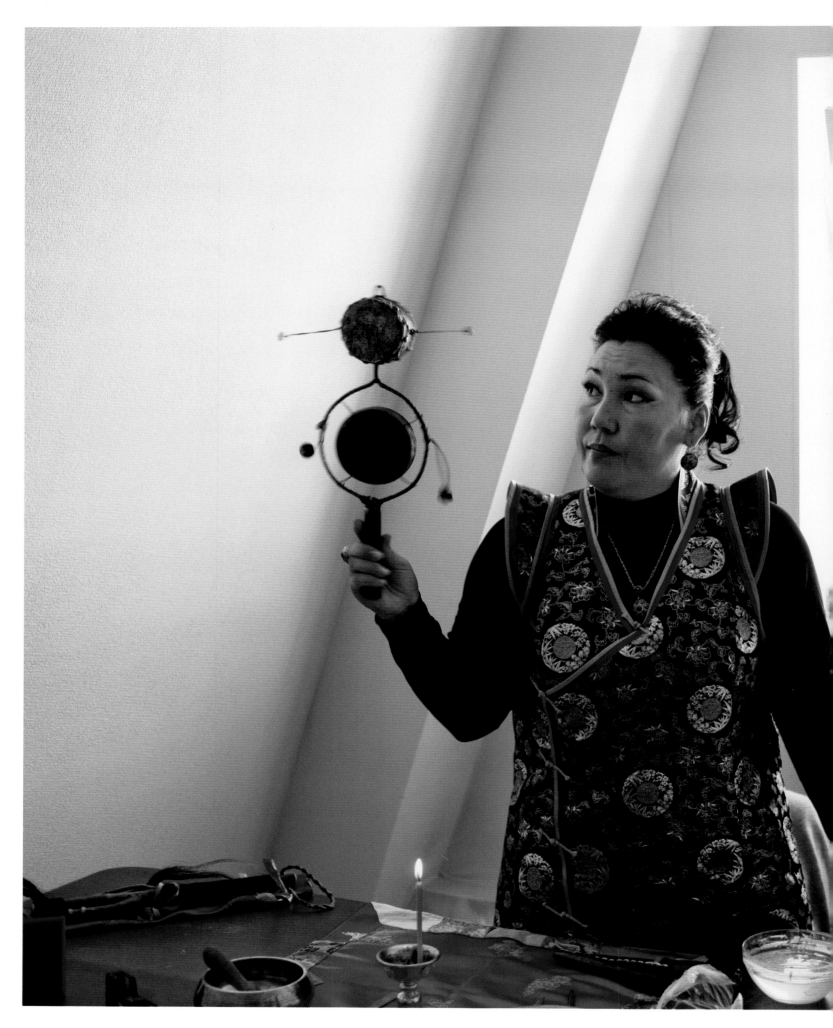

In her office in Irkutsk, Russia, shaman Lyubov Lavrentiyeva wields a mini-drum to help drive out evil spirits. **Carolyn Drake, 2011**

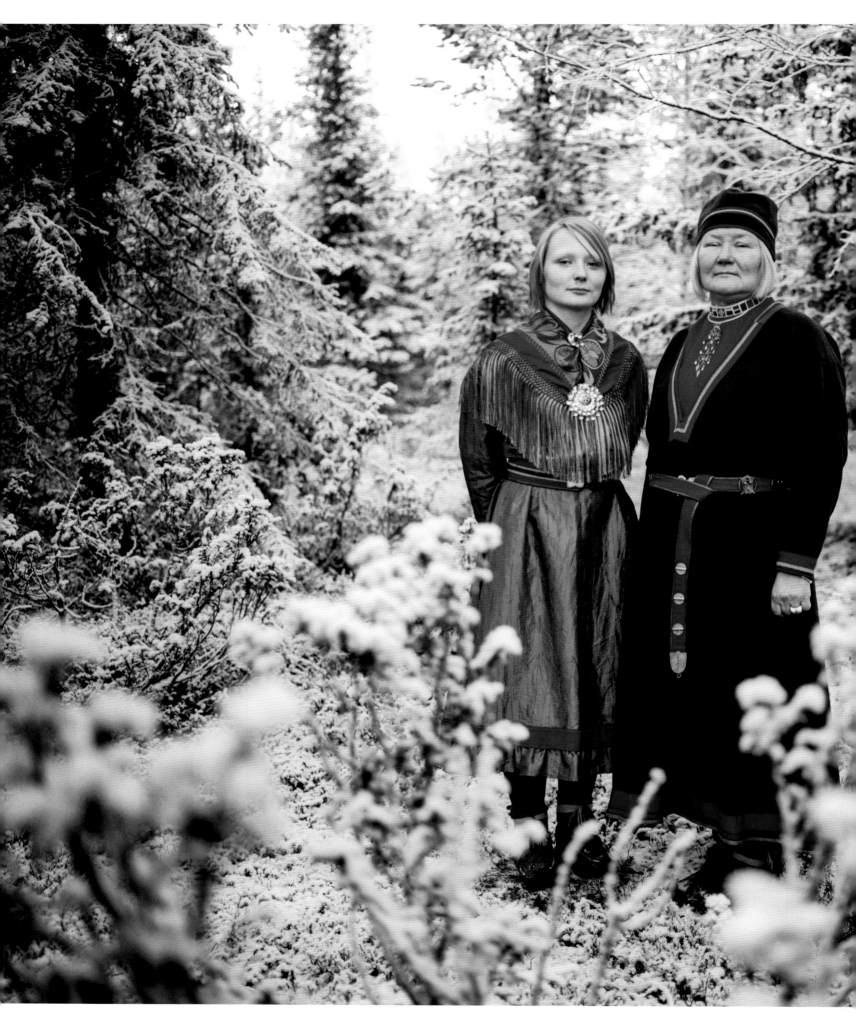

In the Arctic Circle, Sami women in Sweden wear traditional clothing native to the region. *Erika Larsen, 2008*

Director Amora Mautner oversees a rehearsal for *Cordel Encantado,* a *novela* about a fairytale kingdom. **John Stanmeyer, 2011**

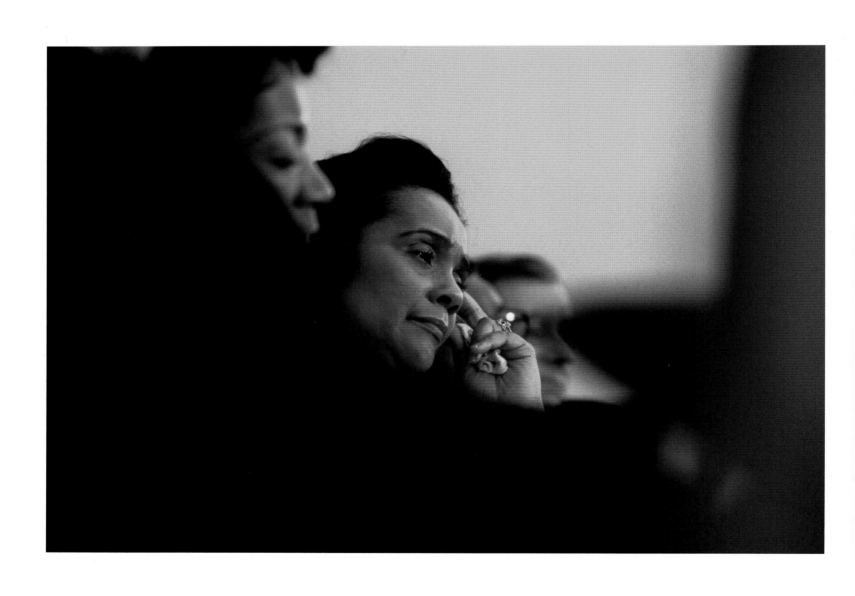

Coretta Scott King, the widow of Martin Luther King, Jr., listens to a service at
Ebenezer Baptist Church in Atlanta. *Jim Richardson, 1988*

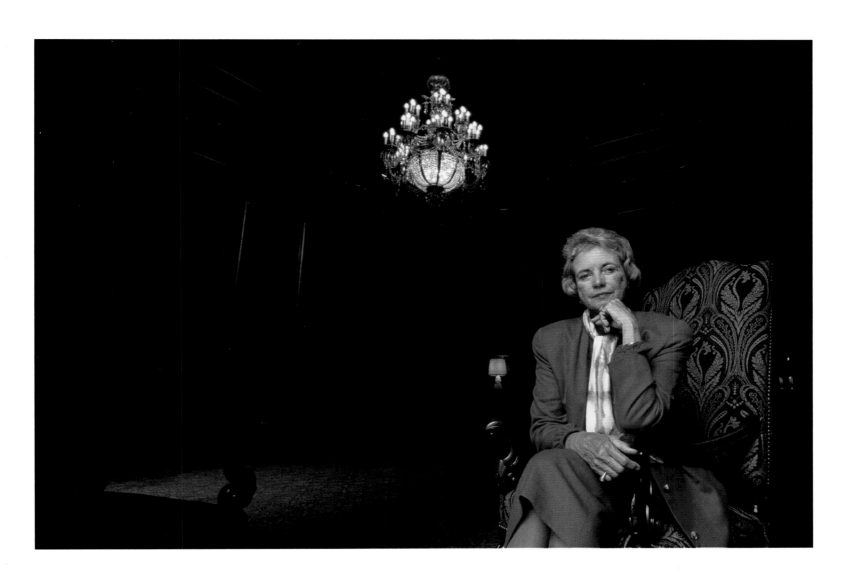

Justice Sandra Day O'Connor, the first woman to serve on the Supreme Court, is photographed in her office in Washington, D.C. **Lynn Johnson, 1987**

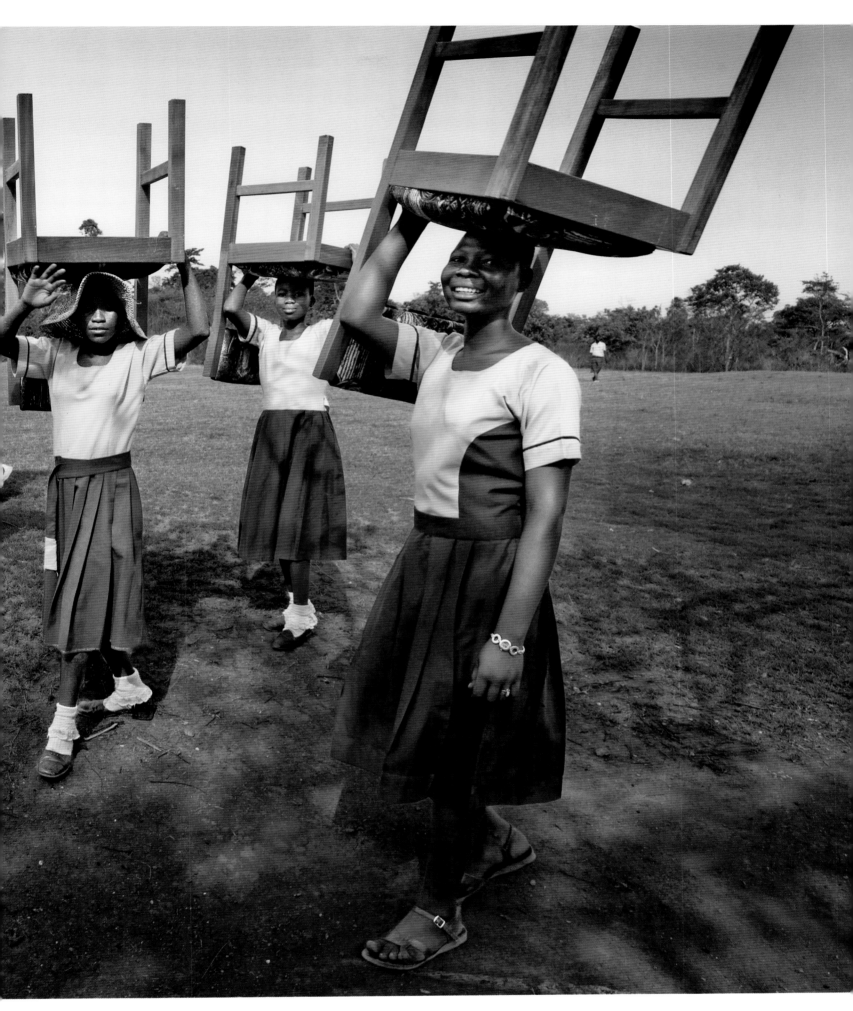

Schoolgirls in Ghana help prepare for the opening of the Maranatha Maternity Clinic
by carrying chairs to the ceremony. **Randy Olson, 2007**

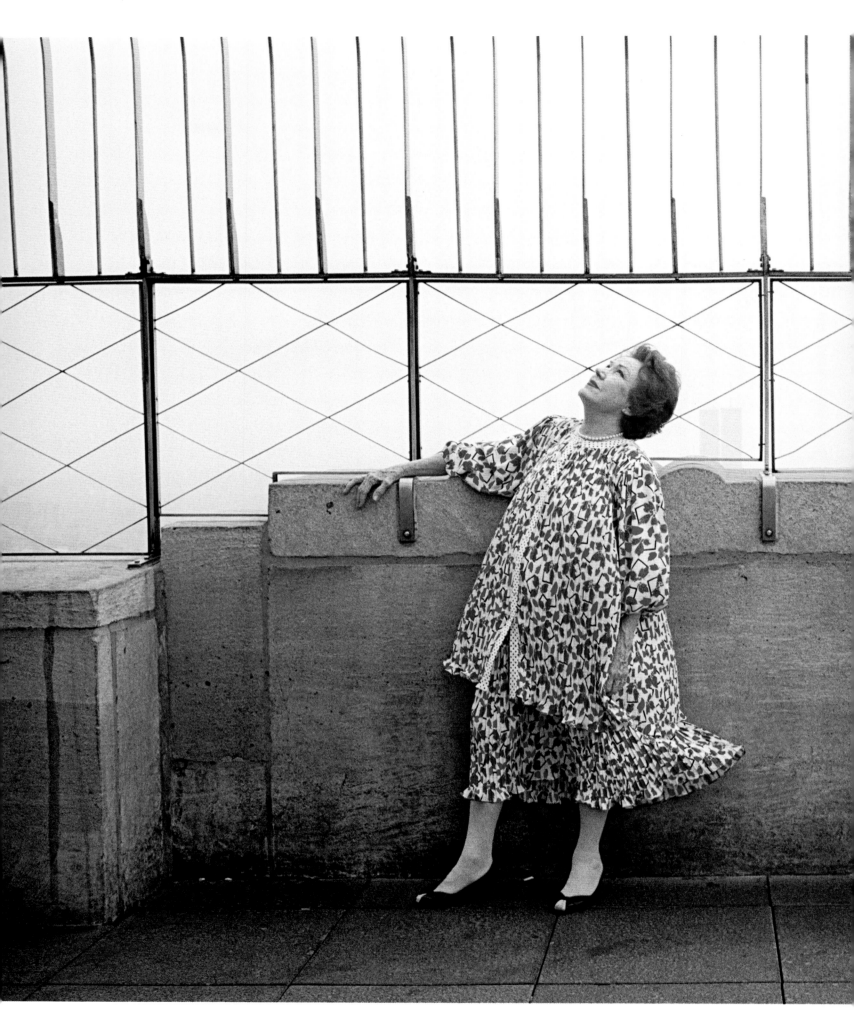

Fay Wray, who played Ann Darrow in the 1933 film *King Kong,* visits the Empire State Building for the first time in 50 years. **Lynn Johnson, 1989**

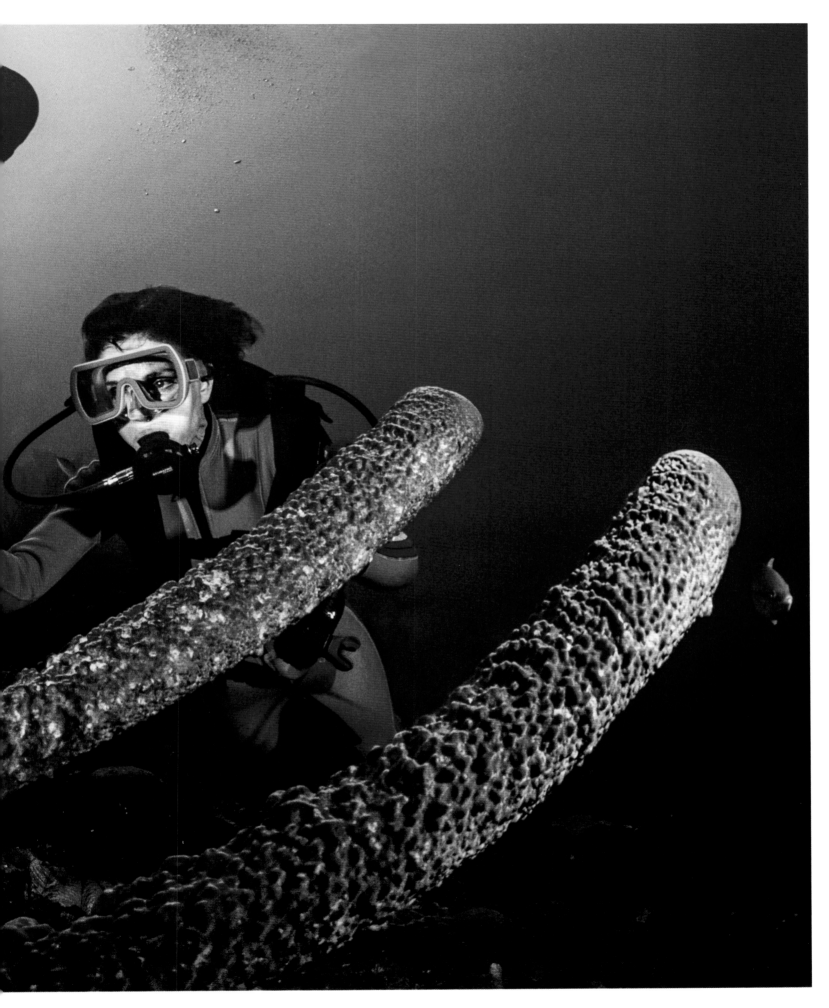

Marine biologist Sylvia Earle investigates a towering tube sponge in the waters off Bonaire, an island in the Leeward Antilles in the Caribbean. **David Doubilet, 2009**

PORTRAITS

OF

POWER

*I think that feminism
should be a default feature
of humanity. Women deserve
equality and equity with men.*

ROXANE GAY

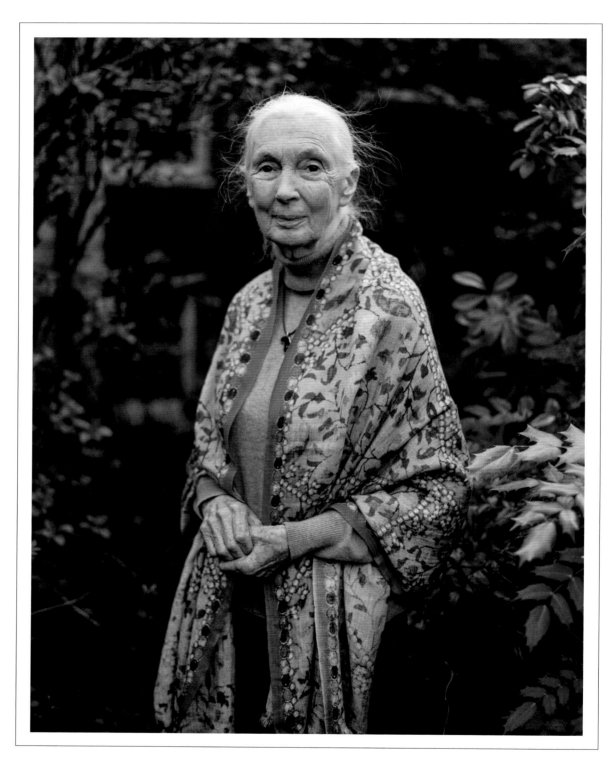

Jane Goodall, photographed by Erika Larsen in London, March 11, 2019

JANE GOODALL

When she was a child in England reading Doctor Doolittle books, Jane Goodall imagined living in Africa, studying its animals. In her early 20s, she traveled to Kenya, where she so impressed paleontologist Louis Leakey that he hired her to conduct chimpanzee research; she began fieldwork in 1960 at the Gombe Stream Game Reserve in what's now Tanzania. Goodall observed never-before-seen behaviors, such as toolmaking and tool use by chimps, including a white-whiskered one she called David Greybeard. Her discoveries revolutionized primate science, prompting the National Geographic Society to fund her work and commission Hugo van Lawick (who would become Goodall's first husband) to capture it on film. Television, magazine articles, and books made Goodall a household name. Her acclaimed work through the Jane Goodall Institute includes establishing chimp sanctuaries and promoting conservation. Now 85, she starred in Brett Morgen's 2017 documentary *Jane*, which depicted her life and work.

NATIONAL GEOGRAPHIC: What is your greatest strength?

JANE GOODALL: I would have to say being determined, open-minded, optimistic; having an innate ability to communicate, and a good constitution (which is genetic!)—but I'll leave it up to you to decide.

NG: Have you had what you'd call a break-through moment in your life?

JG: I've had many breakthrough moments. One was seeing the chimpanzee I called David Greybeard using and making tools. That resulted in Louis Leakey approaching the National Geographic Society, which then agreed to fund the research. Another break-through moment was David Greybeard taking a palm nut from my outstretched hand, dropping it, but then gently squeezing my fingers—that's how chimpanzees commonly reassure each other. We communicated, perfectly. At that moment I knew I was committed to understanding and protecting chimpanzees for my life.

There was the realization in 1986 that chimpanzee numbers across Africa were declining due to loss of habitat, bushmeat trade, and human population growth. And then, in 1990, flying over Gombe and seeing a tiny 35 square kilometers of forest surrounded by *completely* bare hills. The villagers living around Gombe had been struggling to survive and began cutting down trees to try to grow food for family. This caused terrible soil erosion and

poverty, and it hit me that unless we helped the people to find alternative ways of living and improved their lives, *there was no way we could even try to save the chimpanzees.* This led to the birth of the TACARE project, or Take Care: helping people first of all in the ways that they suggested, not that we imposed, such as restoring fertility to the overused farmland without chemicals, helping them grow more food.

Finally, there was the embrace I received from our Tchimpounga sanctuary chimpanzee Wounda when she was released onto her new island sanctuary in the Republic of Congo. She had been rescued from the illegal bushmeat trade and received the first chimp-to-chimp blood transfusion in Africa. The embrace lasted almost a minute; it was the most moving thing that has ever happened to me, and it made all of the hard work worthwhile. I met her for the first time that day. *It was as though she knew who began it all,* said one of the Congolese caretakers.

NG: Do you consider yourself a feminist?

JG: I do not think of myself as a feminist, as I always think of them as rather strident and aggressive, which they were at the start of the movement when it was probably necessary. But now, it seems, the definition has changed. I certainly believe men and women should be treated with the same respect. I love the indigenous people in one of the Latin American countries who say their tribe is "Like an eagle, one wing male and one female, and only when the wings are equal will the tribe fly high." And lastly, I love it that so many girls now believe that "because Jane did it, I can do it, too."

NG: What is the most important challenge facing women today?

[I'd give young women] the advice my mother gave to me, which is, "If you really want to do something you will have to work hard, take advantage of opportunities, and never give up."

JG: In so many developing countries, women have no freedom, no chance (unless they are exceptional) of developing their own careers. In poor communities, families tend to provide money to educate boys over girls. Some girls are forced to stop going to school at puberty as there is no privacy, or hygienic lavatories, or provision of sanitary supplies. There are still cultures where menstruating girls must stay alone in a hut until their period is over. In Saudi Arabia, women weren't even allowed to drive until just very recently. In many cultures women have no access to family planning, have numerous children and are solely responsible for their care and upbringing, as well as having to do the chores and cooking

single-handed (until helped in some cultures by a second, then third wife). For these reasons not only women but children—and thus our future—will suffer.

NG: What living person do you most admire?

JG: There are many people living today I admire greatly. Iain Douglas Hamilton represents those scientists who have devoted their entire lives to conservation; in his case it is the elephants. Vandana Shiva, who fights to protect forests and women's rights in India—and, again, she represents so many people who devote their lives to protecting the environment. Muhammad Yunus, who brought hope to millions of women through the Grameen Bank in Bangladesh, a microfinance organization and community development bank that makes small loans to help lift people from poverty. Then there's Mikhail Gorbachev, the former leader of the Soviet Union who helped to end the Cold War. And Gary Haun, who went blind at 21 in the U.S. Marines and decided to become, of all things, a magician. He does shows for children and they don't know he's blind, and then he'll say, "Things may go wrong in your life, but even if they do, don't give up." He now does scuba diving, skydiving, cross-country skiing, and has taught himself to paint! Almost 25 years ago, he presented me with my mascot, a stuffed monkey (which he thought was a chimpanzee) named Mr. H.

NG: Which historical figure do you most identify with?

JG: Charles Darwin, who was fascinated by wildlife from childhood. In the Galápagos Islands, he worked out a theory of evolution. His suggestion shocked mainstream academia and religion; the suggestion that we are descended from apelike ancestors was heresy. In the same way, when I attributed personality, mind, and emotions to chimpanzees, mainstream science was horrified: Only humans share these characteristics, they said. Darwin did not abandon his theory, despite the criticism. Nor did I.

NG: Where are you are most at peace?

JG: Out in nature by myself.

NG: What do you think is the single most important change that needs to happen for women in the next 10 years?

JG: To be treated with the respect due to us, based on the understanding of all that women have accomplished over the ages.

NG: What advice would you give to young women today?

JG: The advice my mother gave to me, which is, "If you really want to do something you will have to work hard, take advantage of opportunities, and never give up." Also, that you may not achieve your dream immediately, but keep it alive and seize any opportunity to make it reality. ■

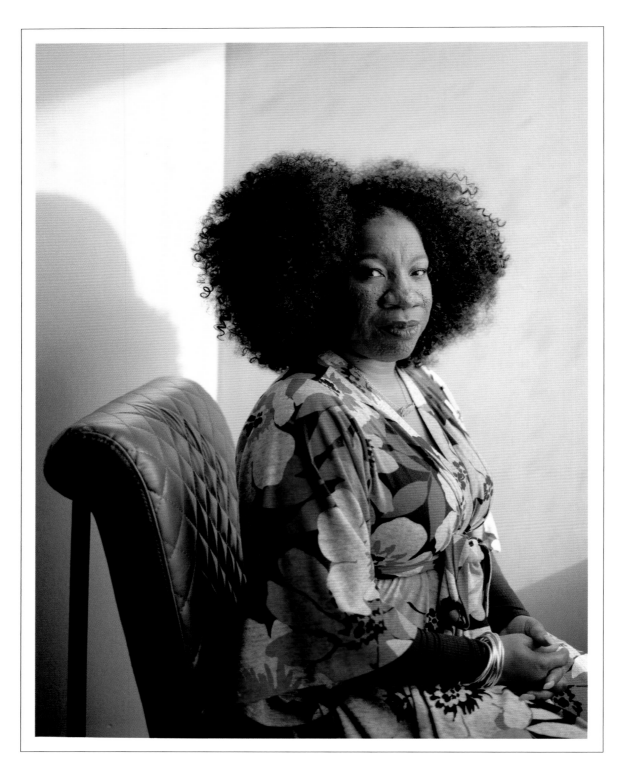

Tarana Burke, photographed by Erika Larsen in New York City, November 19, 2018

IN CONVERSATION WITH

TARANA BURKE

In 2003 Tarana Burke founded a nonprofit that helped girls who had endured sexual abuse, as she had in her youth. The phrase that Burke chose to express solidarity with these survivors—*me too*—has become the rallying cry of a global movement to stop sexual harassment, abuse, and assault. Since #MeToo blew up on Twitter in 2017, Burke has received honors she couldn't have imagined growing up in a Bronx housing project in the 1970s and '80s. To move beyond the trauma of her own sexual assault, she found work serving others through social justice, the arts, and youth groups, including a nonprofit she founded for young women of color called Just Be. At one of her first Me Too workshops for about 30 high school girls in Alabama, Burke announced that anyone troubled about sexual abuse could tell her privately by writing *me too* on the worksheet they were turning in. She was stunned to see "me too" on two-thirds of the papers, and redoubled her efforts on the issue. In 2017, amid sexual abuse scandals involving high-profile men, actress Alyssa Milano urged Twitter users to post their stories with #MeToo—and millions did. Burke, now recognized as a founding mother of the #MeToo movement, is currently senior director of Girls for Gender Equity in Brooklyn.

NATIONAL GEOGRAPHIC: What do you think is the most important challenge facing women today?

TARANA BURKE: I don't know that there's just one challenge that's more important. I think if you ask different people who are passionate about reproductive justice, or economic justice, they would have different answers. Obviously, for me, sexual violence is one of the most important challenges facing women. But all of it comes under the umbrella of patriarchy and the ways that patriarchy affects women economically, physically, professionally.

NG: When you look ahead to the next 10 years, what do you think is the biggest change that needs to happen for women?

TB: It's so many things. If women got pay equity, that wouldn't stop sexual violence. If we interrupted sexual violence, it doesn't mean women would get paid equally. We

have to work on different fronts with the same level of passion and commitment and conviction, to move the needle in these various areas. I wouldn't pick one particular area, because then the other areas suffer. We need to move the needle on all these areas of injustice that women deal with.

NG: You mentioned sexual violence. Looking out 10 years, do you think that we'll be in a different place on that issue than where we are now?

TB: Yes, I do. I think that we have new language and new energy and new understanding around the pervasiveness of sexual violence. For example, as we teach young people now about new understandings of consent, they'll react and respond differently when they're in college; that's the kind of thing that will help us be in a different place in 10 years.

NG: Do you consider yourself a feminist?

TB: I consider myself a black feminist, and I use that distinction because black feminism is rooted in a very particular history. It's inherently intersectional, and it is not to the exclusion of anybody else. The way some white women operate under the guise of feminism has been deeply exclusionary for black women, women of color, trans women, queer women, and others. I draw my understanding of feminism from black feminists who laid a very particular groundwork. From the Combahee River Collective [a black feminist lesbian organization in Boston in the 1970s] to women from the civil rights movement, it's a particular lineage that I would walk in.

NG: Have you had what you would consider a breakthrough moment?

If women got pay equity, that wouldn't stop sexual violence. If we interrupted sexual violence, it doesn't mean women would get paid equally. We have to work on different fronts with the same level of passion and commitment and conviction.

TB: I've had a few. One breakthrough moment, in particular, is when I first started understanding that the things that I experienced as a child—the abuse that I experienced—was wrong. And another was the moment when I realized that I had the option to declare what my identity was: that I didn't have to be a victim of abuse, I could be a survivor. That was a big breakthrough for me.

NG: What would you say is your greatest strength?

TB: I think my greatest strength is being able to take complicated information and make it simple for people to understand. Some of these ideas and theories about social justice—if we make them too complicated, then everyday people feel disconnected from them. One of my strengths is being a bridge between those two places.

NG: Is there a living person you admire most?

TB: There are a few people that I admire very much. Of course there's my mother, and Rochelle Solomon [a Philadelphia educator and community leader], and Carol Zippert [a newspaper publisher and activist in Alabama]. Rochelle is what I think of when I think about being an elder. She has been true to herself and her community her whole life; she's so thoughtful and conscientious and just stately. And I know it's a super cliché answer to give, but I also really admire Oprah—she's provided an example of how to move through the world. The people who I'm naming—Ms. Solomon and Dr. Zippert and Oprah—they've literally taught me about how to make decisions. They're like mentors in my mind; I think about what they would do in a given situation, what lessons they've taught me. But what comes up for me, when I think of those women, is integrity and steadfastness. These people have shown over many decades who they are, and they've been consistent.

And then I think about my mother, who has been a rock for so many people and doesn't even realize it. Whatever people were going through in their lives, they would come to my mother to get straight—whether it's for a place to stay or advice or to get put on the right track. That's something that I admire in all these women: They operate with a lot of integrity and they are who they say they are.

NG: That's great. Is there a historic figure, somebody no longer living, that you identify with?

TB: Yes. I love Ella Baker [an African-American activist who played key roles in forming the NAACP, the Southern Christian Leadership Conference, and other organizations]. She's a civil rights icon. She really believed in grassroots organizing, and she really believed in young people. She didn't believe in having the single, charismatic leader; rather, she believed in leadership development and passing on leadership. She was very much of the people. As an organizer and a movement person, I've tried to pattern myself after her.

NG: What advice would you give young women today?

TB: I'd give the same advice that elders gave me when I was younger, which is: Slow down. Everything doesn't have to happen right now. And, particularly for young people nowadays, I'd say that things don't have to be public, and your work doesn't have to be widely accepted by people in order to be valid. If you want to make a real difference, then just keep your head down and do your work. ■

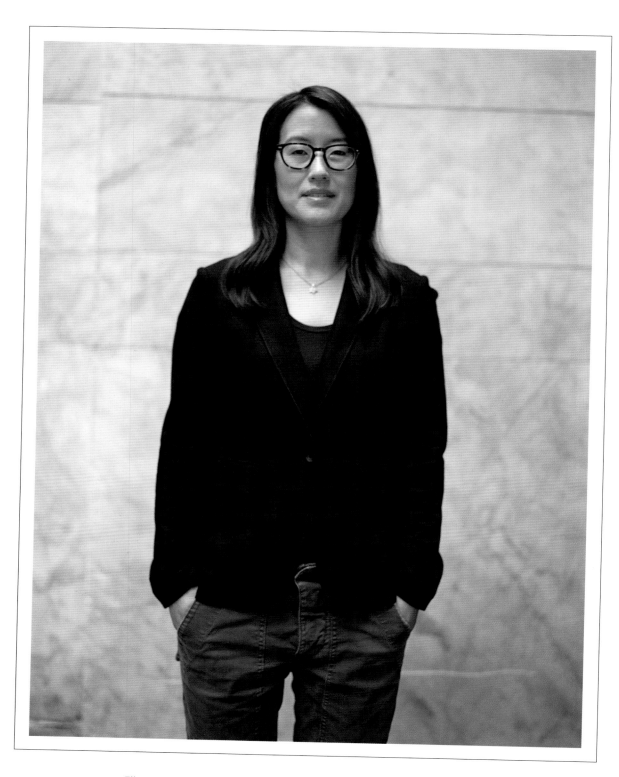

Ellen Pao, photographed by Erika Larsen in San Francisco, January 11, 2019

ELLEN PAO

The nonprofit that Ellen Pao founded promotes diversity and inclusion—matters in which she has hard-won expertise. The daughter of Chinese immigrants, Pao earned engineering, law, and business degrees from Princeton and Harvard before joining the Silicon Valley venture capital firm Kleiner Perkins in 2005. After seven years there, Pao sued, charging gender discrimination and saying she'd been sexually harassed, denied promotion, and retaliated against. Even before it reached court, the case put the tech industry on trial for harassing and biased behavior. In early 2015, a jury ruled against Pao. By then she was interim CEO at the social media site Reddit—but was forced from that job a few months later after banning "revenge porn" and other offensive content. Today, she's founder and CEO of Project Include, which works with tech start-ups to foster inclusion and diversity.

NATIONAL GEOGRAPHIC: Okay. What do you think is the most important challenge facing women today?

ELLEN PAO: Wow, you're coming out with a hard question first. It's a good one. I think the hardest challenge is getting fair treatment and being treated equitably, based on ability to contribute, based on skills. Being accepted as equal. I think that makes it hard for women in the workplace, and in society, to figure out how they need to behave, because they're often not treated fairly when they behave in a natural way that's comfortable to them.

NG: I take it you're basing this on your experiences?

EP: And the experiences I've seen of women in technology, and stories that I've heard from hundreds, maybe thousands, of women about what they have been through.

NG: That's a great answer. What do you think is the single most important change that needs to happen for women in the next, say, 10 years?

EP: I think we need more women in leadership positions, and specifically more women of color, in order to make sure that people are actually seeing women fairly and creating fair workplaces. I think it takes women and women of color at the highest level.

NG: Do you see a gap opening up between white women and women of color?

EP: I think the gap has always been there. I can't tell if it's getting bigger, or it's just that it's becoming more noticeable or being

highlighted more. But I do think there's a set of women who are more comfortable with the existing status quo because they've gotten into positions of power within it. And they reinforce these constructs of power; that's problematic and has to change.

NG: What advice would you give to young women today?

EP: I think it's really important to know what you want and then to find a path to get what you want, and not to be driven by what other people want for you or what opportunities seem available for you. I think that doors are opening and there are more opportunities, but they're not universal—so you do need to do some work to find them. You need to find situations where there is somebody who's willing to help you, show you the ropes, or help you understand what opportunities are there; help you get promoted or help you understand the politics of an organization. You know, that's something that men have had forever and women are starting to get. But finding those people and finding those places isn't always easy because it's not every place and it's not every person.

NG: What are the biggest hurdles that you personally have had to overcome?

EP: I think it's being valued for my contributions and skills versus being judged on my identity. And I think that's true for a lot of people who belong to marginalized groups. They're not given the opportunity to do their best work—and that's a shame for everyone, because we don't get the best answers. We don't get the best products, we don't get the best services, because we're forgetting a whole group of people.

We need more women in leadership positions, and specifically more women of color, in order to make sure that people are actually seeing women fairly and creating fair workplaces.

NG: All right. And what would you consider your breakthrough moment?

EP: There was a point at Kleiner Perkins where I realized that there was no way for me to be successful—and it wasn't just me; it was all women at the firm. There was no way for them to succeed and get to the very top decision-making roles. And that was what took me out of the more narrow focus—How do I do well?—to saying, "Wow, there is a much bigger problem here: How do I get this whole institution to change?" That moment allowed me to step out of my own defensiveness about my performance, and my focus on where I wanted to be in my career, and start thinking about things from a much bigger lens. I had to try to understand what actually needs to happen, what is actually happening, and how do we create change.

NG: Now the questions get really easy. Do you consider yourself a feminist?

EP: I would say yes. I think there's a lot of baggage now to the word, but if by *feminist* we mean all genders are equal and should be treated fairly, yes.

NG: What do you think the baggage is?

EP: I think people have been very effective at making *feminist* into a pejorative term. And that also happens to *social justice warrior*. What's wrong with being a warrior for social justice?

NG: What living person do you most admire?

EP: I think it's Oprah. I've been a huge admirer of hers ever since I saw a biography of her on some cable channel at an airport. She came from such a difficult childhood, and had so many terrible experiences, but continues to be this messenger of hope, of positivity, of empathy. To be able to have had these really bad experiences but to still believe in humanity has always been so impressive to me, and is something that I strive for.

NG: What historical figure do you think you most identify with?

EP: I guess there's more of a fictional figure. I don't know if this'll come out right, but for a long time I felt like I was the boy who cried wolf—where I'm telling you that this is happening and nobody is believing me. That idea that I could see things so clearly, but other people couldn't see it at all for so long.

NG: Okay. What do you think is your most conspicuous character trait?

EP: I don't know if it's a character trait, but I try to be an advocate. Speaking up for others, especially people who aren't able to, is really important to me. The other trait I would say—and I don't think it always comes out—is that I'm actually a strong introvert. I often talk about that because I think there are a lot of introverts out there who feel very intimidated about speaking, or speaking up for themselves. I just want to show them that it is possible, even if you're an introvert, to tell your story and to be listened to.

NG: Finally, where do you feel you are most at peace?

EP: At the end of a tough day, when I get in my bed and meditate to ease my mind. It's like forcing myself to empty my mind in an intentional way. ∎

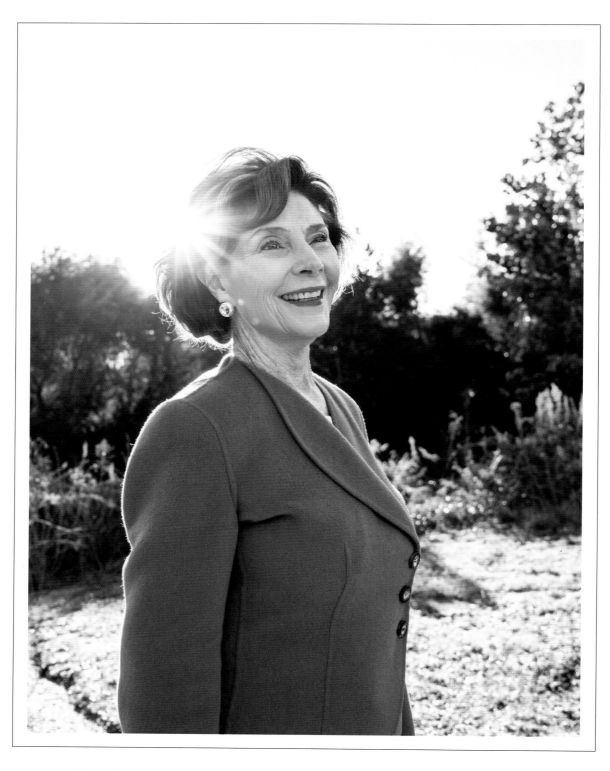

Former first lady Laura Bush, photographed by Gillian Laub in Dallas, Texas, November 1, 2018

LAURA BUSH

For five years she was first lady of her home state of Texas. Then her husband George won the White House in 2000, and Laura Bush spent the next eight years as perhaps the most scrutinized wife in America. Official profiles often simplify her: the one-time schoolteacher and librarian who became the literacy first lady. She was that, but also more. She made repeated visits to Afghanistan, and used her high profile to speak against Taliban oppression and to advocate for Afghan women's rights. She took on women's health issues: at home, raising awareness about women's heart disease risks; and internationally, promoting efforts to achieve early detection of breast cancer. In her best-selling 2010 memoir, *Spoken From the Heart,* Bush confides that once out of the White House, "I could finally exhale." But her work continues: Through the George W. Bush Presidential Center, she remains a champion for women, chairing a global initiative to improve their health, education, and economic status.

NATIONAL GEOGRAPHIC: What do you think are the biggest challenges that women around the world face today?

LAURA BUSH: My interest in Afghanistan, specifically in the lives of Afghan women, showed me that there are serious challenges in some parts of the world for women just to live safe lives. But I also think that in many parts of the world—and certainly in the United States—it's a wonderful time for women. When George was president, I looked at the statistics of girls versus boys in the United States, and realized that boys needed some attention, too. We had focused so much on girls, and girls had become more successful than many boys are in school. We expected

more from boys in a way, without giving them the sort of nurturing that we did girls, and our girls have all succeeded wildly. So it's important that, while we continue to support women at home and around the world, we pay attention to boys, too.

NG: It's funny you should mention that. When I interviewed the woman who won the 2018 Nobel Prize in physics—the third woman in history to win it—she actually said the same thing: that she's quite concerned about our boys getting left behind.

LB: Little girls and little boys need nurturing—both of them do. Obviously, there are certain parts of the world where women still need a

lot of protection and help with health and equal rights. But I think we are fortunate in the United States that both women and men are now succeeding.

NG: Do you consider yourself a feminist?

LB: Yes, definitely. I'm a feminist in the sense that I was a young woman at the height of the feminist movement. I joined a consciousness-raising group and I was an early subscriber to *Ms.* magazine; I did all those things that many girls today, including my daughters Barbara and Jenna, have never heard of. One time, I said to my dad, "You just raised me to be a teacher. Why didn't you raise me to be a lawyer?" And he got out his billfold and said, "I'll send you to law school!" And then I had to admit that what I'd chosen to do—which is what I wanted to do from the second grade, what made me happiest—was to be a teacher and to work with kids.

NG: But you had the advantage of having parents who were willing for you to be anything you wished.

LB: Exactly, anything. They probably thought girls would want to be teachers, that was just the way things were. But if I'd said early on, "I want to go to law school," Dad would of course have said, "Sure."

NG: Can you name a living person you most admire?

LB: She's not living any longer, but of course I admire my mother-in-law, Barbara Bush. I had a huge, huge advantage when I became first lady because I had watched my mother-in-law in that role. And not only did I see what she did and how she responded to things that happened to our country, but I also saw how she

There are serious challenges in some parts of the world for women just to live safe lives. But I also think that in many parts of the world—and certainly in the United States—it's a wonderful time for women.

was as a person, and how she treated others. Just having had her around was a wonderful example for me.

NG: I was also going to ask you which historical figure you most identify with.

LB: Then that would have to be her. Though, I would have never thought I would say that after George first took me to meet her.

NG: Why not? Was she a little intimidating? I know I would have been a little intimidated.

LB: She certainly was intimidating. I don't know if you ever met her or ever talked to her, but I was raised in Midland, Texas, and she was raised in Rye, New York. She had an East Coast

sort of way of being. Plus, she was so quick, and quick to respond, and in some cases those responses were not that encouraging.

When George and I met, people said that the old maid of Midland was marrying the most eligible bachelor. Which is funny because we were the same age. But I grew up in Midland, and George grew up the son of Barbara Bush.

NG: What do you think is *your* most conspicuous character trait?

LB: That's a very difficult question to answer. A character trait I have that I think has been an advantage for me is that I'm interested. I'm interested in people, I'm interested in things that are around me. I'm interested in life. Also, I'm *not* quick to respond nor am I explosive, like my mother-in-law was. I'm patient and interested in what people have to say.

NG: So, is there someone alive today you particularly admire?

LB: Oh, my own mother, who's 99 and still lives in Midland, Texas, where I grew up. A lot of what I'm interested in, and how I am, is because of what my mother taught me. She read to me every single day and loved to read, and we loved to talk about reading. She was very interested in nature and in the outdoors. Many of the things that I've done in my life are the direct result of her: what she liked and what she taught me to love.

NG: Has there been a moment in your life where you realized that you had a voice and that you really needed to use it?

LB: I would say that was right after September 11, when the spotlight had turned to Afghanistan. [White House communications director]

Karen Hughes came in and said to George, "Why don't you let Laura do part of the presidential radio address?" and George said, "Well, why doesn't Laura just *do* the presidential radio address?" I talked about women in Afghanistan and what they were facing. And it was a shock to American women—the very idea that a government would forbid half of its population to be educated. The weekend after the radio address, I went to Austin to visit Jenna, who was a student at the University of Texas. We were shopping at the department store and a woman who sold cosmetics said, "Oh, Mrs. Bush, thanks so much, thank you for speaking for the women in Afghanistan." And that was the first time I realized that people actually heard what I said. I knew it intuitively, I guess, but I didn't really realize the importance of my voice until the woman who sold cosmetics thanked me for speaking out. And after that, we founded the U.S.-Afghan Women's Council. Strangers would call me and say they wanted to do something for Afghan women, and the USAWC gave them the resources they needed.

My roommate from college used to say, "Laura, I'm so glad I don't have to walk in your shoes, being married to the president of the United States." But then she called me after I delivered the radio address and said, "Laura, now I'm jealous, because you can do something to help." ∎

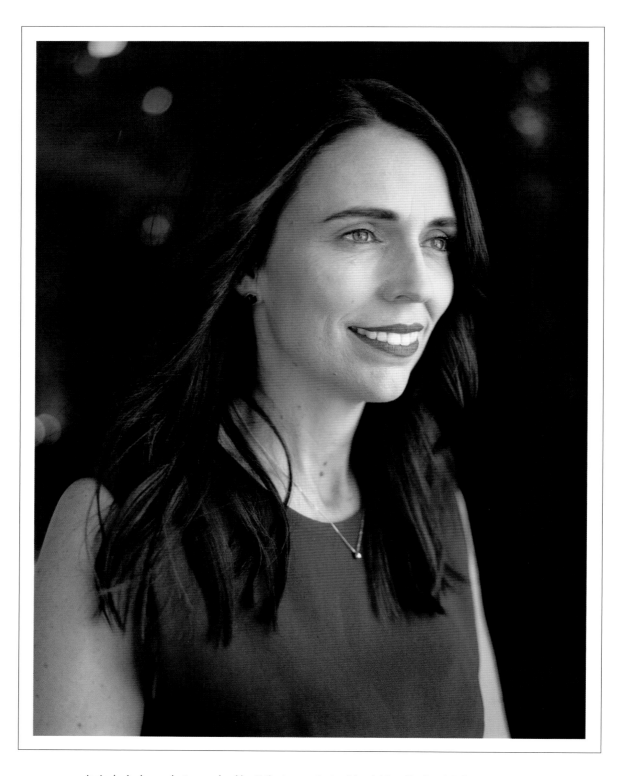

Jacinda Ardern, photographed by Erika Larsen in Auckland, New Zealand, February 15, 2019

IN CONVERSATION WITH

JACINDA ARDERN

As countless parents do on countless workdays, Jacinda Ardern plucked her baby out of the car seat, dropped the child off with the babysitter, and reported to work. Why is this noteworthy? Because Ardern is New Zealand's 40th prime minister, her workplace is the Parliament building, and her mother often meets her there, to care for baby Neve on site. Being just the second global head of state to give birth in office put Ardern in the head-lines—attention she's used to promote family-friendly policies. Not yet 40, Ardern entered New Zealand's Parliament in 2008, became Labour Party leader in August 2017, and prime minister less than three months later on a progressive agenda that includes helping marginalized people. And in March 2019, after a gunman killed 50 people in two Christchurch mosques, the world saw Arden's strength and empathy as she swiftly pressed for gun control and mourned with the Muslim community.

NATIONAL GEOGRAPHIC: What do you consider to be your breakthrough moment?

JACINDA ARDERN: You know, everything for me in politics, and in life, feels so iterative. I'll go and give a speech, give it the best I can, but it won't be until other people start reflecting back that it means something to them that I think, Perhaps that was bigger than I anticipated. I don't think, therefore, that I've had a singular breakthrough moment. I do have to acknowledge that when I told what I thought was just New Zealand that I was having a baby, I never anticipated that it would have such a follow-on effect. I got a letter from a woman in New Zealand who said that she got preg-nant around the same time as me, that her boss had been accommodating and flexible when she told him she was pregnant—and that she did not believe that would have happened had I not made my announce-ment. I don't know if that's true, but I remem-ber sitting there and thinking: If me having a baby has made one employer look differ-ently on a woman, a mother, in his workplace, then that is a good thing.

NG: You having a baby while holding a job: It was made to seem so revolutionary, when in fact, isn't it just natural?

JA: Exactly. Which is why I've never wanted to overstate it, because so many women are jug-gling so many things.

NG: That leads to my next question: What are the biggest hurdles you've had to overcome?

JA: Myself. I am my own biggest hurdle. I've always been open about that.

NG: Why do you say that?

JA: Because no one will be a bigger critic of me than me. Whether or not you're your own worst critic, whether or not you overemphasize your confidence deficit, I do think many women are much harsher on themselves and on their abilities. And I'm one of them.

NG: Do you think you hold yourself back by being your own worst critic?

JA: I think I prevent myself, now that I'm here, from finding more joy in what I do, because I'm constantly focused on the next hurdle. Everything that I want to achieve isn't about checking political boxes; it's because, for example, people need houses, and we need to do better in our education system, and Maori well-being needs to be supported. So because I'm constantly driven by these big aspirations, when we do make a difference I find it very hard to sit back and enjoy those moments. There's just too much to do.

NG: What do you consider to be your greatest strength?

JA: I believe that empathy is the greatest strength that I have. And I think it's a shame that for too long, strengths like that have been characterized as weakness—because in politics, that's exactly what you need. You want people to be able to think of life in others' shoes. We hear from thousands of people from diverse backgrounds. If we only come from our own experiences and view of the world, I think we would poorly serve our communities.

Find what brings you joy and pursue it. That, of course, means overcoming the confidence gaps. If you don't have confidence in yourself to take on a challenge, then listen to those who do until you find your own strength.

NG: What do you think is the most single most important change that needs to happen for women in the next 10 years?

JA: I've answered this a few times, and I jump between what I think are two related issues: financial security and freedom from violence. I jump between the two because actually financial security is one of the ways that we can free women from violent situations and intimate partner violence. But at the same time, women just should be free from those environments, regardless. And at a global level, financial security also links into the ability for women and girls to access decent education, which affects everything.

NG: I'm sure you get this a lot, but would you consider yourself a feminist?

JA: Yes, absolutely. Feminism is about equality. If you believe in equality, you believe in feminism. That for me is really, really simple. If you remove the word *feminism* for a moment and just draw back to the principles and values, it's hard to argue with.

NG: Which living person do you most admire today? Who's your heroine, or hero?

JA: I know it might sound incredibly cliché but for me, it's my mother and my father. You know, your heroes are often the ones that are closest to home and of course I learned all my values from them. My mother sacrificed a huge amount for me and my sister, and continues to do so—she's the one who's two rooms over right now caring for the baby because my partner [broadcaster Clarke Gayford] is having to work. She's the one who's here with me, helping me be a mother. And she's the one who sacrificed her potential career to be a mother for me in a time when women weren't in the position to make the kinds of choices that we can now. She's one of my heroes.

My father was a policeman, a detective, who worked on horrific criminal cases, such as rape cases. The work was never black and white for my dad, and he taught me a lot about the way we view the world and people from varied walks of life.

NG: What historical figure do you most identify with?

JA: This is going to sound ridiculous, but other than female politicians—which is a quite obvious choice—Ernest Shackleton is one of my great heroes.

NG: Ernest Shackleton, the great Antarctic explorer—really? Tell me why.

JA: His adventures captured my imagination. My dad used to read books about his explorations and I started reading them when I was about 14. I admire his persistence and the fact that he demonstrated what leadership was in the face of huge adversity. I just can't imagine what amount of human spirit it takes to endure some of what they went through.

NG: What advice would you give to young women today?

JA: Find what brings you joy and pursue it. That, of course, means overcoming the confidence gaps. If you don't have confidence in yourself to take on a challenge, then listen to those who do until you find your own strength.

NG: This question wasn't on the list, but what do you think is the most important lesson to teach your daughter?

JA: Kindness, and helping others. If we consistently had values of empathy and kindness, we would approach all of the world's challenges so differently—poverty, inequality, even climate change. Simple, simple values that, even when we do teach our children, we kind of forgo in our expectation of leaders and leadership. Why should we forgo that? And so I will persistently teach my child—no matter what her age is, even when she's an adult—I will preach kindness. ■

Roxane Gay, photographed by Erika Larsen in Los Angeles, August 21, 2018

ROXANE GAY

Whether writing fiction, social criticism, or personal memoir, Roxane Gay strives to be open and honest. Where has that gotten her? Into the pages of the *New York Times* as a contributing opinion writer and onto best-seller lists with her books *Bad Feminist, Difficult Women, Ayiti, An Untamed State,* and *Hunger: A Memoir of (My) Body.* It has also won her an ardent social media following, as well as praise in mainstream media for being "a fearless and incisive cultural commentator." A member of the English faculty at Indiana's Purdue University since 2014, Gay writes powerfully from her own history and identity about the intersections between race, gender, and pop culture. The survivor of a gang rape at age 12 who used food as a coping mechanism, she has also been the target of internet trolls and bigots because of her body type and because she is an African-American, bisexual woman. Gay is the author of the *Black Panther: World of Wakanda* comic book series for Marvel, and her writing has appeared in anthologies across several genres. She also has film and television projects in the works.

NATIONAL GEOGRAPHIC: What do you think is the most important challenge facing women today?

ROXANE GAY: I don't think there's just one right now. Things have become complicated for women, in that things have gotten better but with the current administration, a lot of the rights that we had hoped would become inalienable are no longer inalienable. So I think one of the greatest challenges that women are facing is reproductive freedom; another is equal pay.

NG: This is a related question and maybe in a sense you've answered it: What do you think is the single most important change that needs to happen for women in the next 10 years?

RG: I think the most important change is that we need to take reproductive freedom off the legislative table. It needs to be an inalienable right that women can make decisions that they need to make about their bodies without interference from male legislators.

NG: I think I know how you are going to answer this question, but I'm going to ask it anyway: Do you consider yourself a feminist?

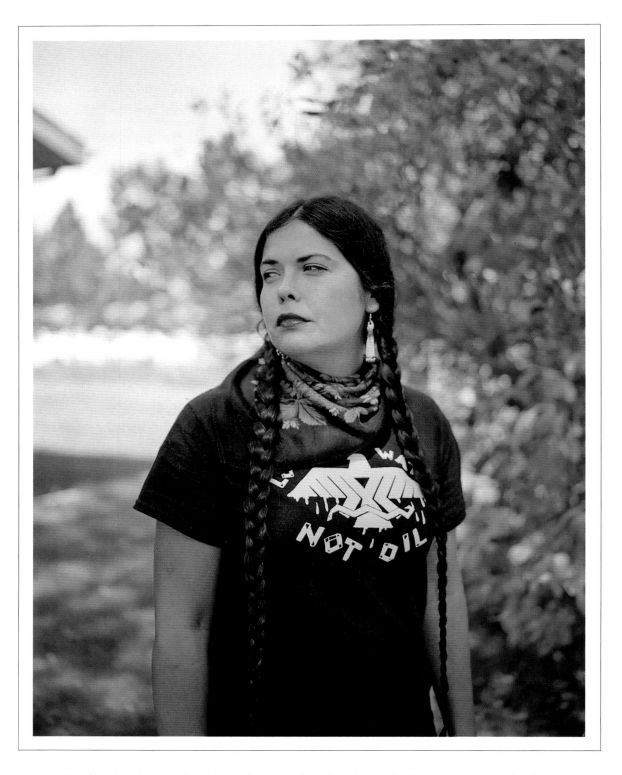

Tara Houska, photographed by Erika Larsen at the Dakota Access Pipeline protest, September 2016

TARA HOUSKA

Many turns led Tara Houska to where she is today. An Ojibwe from the Couchiching First Nation, she was raised in a small Minnesota town at the Canada border by her Ojibwe mother and Norwegian stepfather—and recalls the confusion of growing up off reservation, not belonging in either culture. At college, she drank to mask her pain until an Ojibwe professor at the University of Minnesota–Twin Cities helped her find the "path of light" in native practices. Houska was training to be a patent lawyer when a high-profile fight over an indigenous child's adoption convinced her that native peoples needed more legal advocacy. After several years in Washington, D.C., working on tribal matters with government and nonprofit groups and in private practice, Houska spent six months in North Dakota opposing the Dakota Access Pipeline. In 2017 she moved home to fight the Sandpiper and Line 3, a tar sands pipeline corridor that opponents say will harm the Great Lakes ecosystem and tribal territories and the way of life. Along with her work as National Campaigns Director of Honor the Earth, Houska is also a co-founder of Not Your Mascots, a nonprofit organization that helps fight stereotypes of indigenous peoples.

NATIONAL GEOGRAPHIC: What are the biggest hurdles you had to overcome?

TARA HOUSKA: Not being consumed by experiences of trauma, assault, abuse, and other experiences that were difficult, especially in the formative years. On a personal level it's enabled me to understand the importance of forgiveness, of moving forward and focusing on how we do better. How do we understand one another and create spaces for survivors? How do we do better as a society overall? All those things have a common thread. For example, the Indian Child Welfare Act [the 1978 federal law governing removal and out-of-home placement of American Indian children] was a theft of families. That turns to intergenerational trauma, then cycles of abuse throughout generations. This wasn't 100 years ago. It's my living 70-year-old grandmother. It's still happening. Beyond the internal family and community trauma, there is also a lack of outsider understanding.

Another example: Native folks use Valentine's Day to remember missing and murdered indigenous women and survivors. Many wear red in their honor. Indigenous women are 10 times as likely to experience violence as non-native women; that's one in two women sexually assaulted in their lifetimes, assaults committed mostly by non-native people. Many women in my family have experienced assault or abuse, and we don't have the same access to justice as non–people of color.

NG: Do you consider yourself a feminist?

TH: I think that men and women are owed equality. Whatever gender identity, everyone is owed respect and dignity and equal rights. With white feminism, I've seen a lot of really negative interactions between that group and people of color. There's a tendency to either co-opt the work of others, or disregard those struggles, or wrap it in an overall umbrella of feminism. We can do a better job of intersectionality. Women can and should stand together, but that means understanding each other in a real way. We're getting to a better place, but we have a lot to learn in making sure we're really sitting at the same table together. We're trying as a whole to move forward.

NG: What do you think is the single most important change that needs to happen for women in the next 10 years?

TH: Women across the board need to step into leadership roles; that wisdom and experience is needed in this time and place. We have to raise our children to understand what equality really means, and we need to try to overcome the harmful ideologies that have stuck around. We can do a lot in our

Not being afraid is very important. You may feel like you failed and there's no way to recover, but you can. Life will continue and it will just make you stronger and make you learn something about yourself.

social circles to demonstrate what women's leadership is; to recognize that women are not just your mother and sister; they should be your leader also. Women don't exist in relation to men.

I've been a student of Midewiwin, the Ojibwe medicine society that teaches you a way of being. My longtime teacher has watched me go from a very shy, angry person to this more prominent, outspoken advocate,

and has observed that with other women as well. His position is that it's time for women to step in front.

NG: What is the most important challenge facing women today?

TH: Women need to love themselves and one another in a very real way. We're at a place where you see rhetoric and images and statements of solidarity; the rise of #MeToo, all these names coming together. I still think there's a ways to go in terms of women truly supporting one another. Some of my biggest detractors are women and that's always hurtful to see. When you're among some of the most oppressed people, your tendency is to oppress one another. We'd do better to overcome that. It's more than a T-shirt—there's a real sisterhood that doesn't need to be clichéd. We are women and that means supporting each other.

NG: What living person do you most admire?

TH: Pebaamibines Jones, my spiritual adviser. I was 20 years old when I met him and in a very dark period of my life, drinking myself to death. He was very accepting and non-judgmental; he really wanted to listen and do his best to help me heal from pain I'd experienced. He was a University of Minnesota Ojibwe language professor, and as part of his curriculum, he'd invite the class to come to a sweat lodge or maple-sapping camp or trapping or canoeing. I started going, and learned the language through him. During law school I helped him work on the Ojibwe dictionary online, and I work with him still as an *oshkaabewis*, an apprentice. He pushed me into a path of light that I wasn't on before.

NG: Is there a historical figure you most identify with?

TH: Rosalie Little Thunder, who co-founded a campaign to save the buffalo of Yellowstone National Park. Ranchers don't want the buffalo to get out of the park and onto their property, so Yellowstone started to cull some every year. Rosalie pushed this killing of Yellowstone buffalo into the national spotlight. She made a lot of people uncomfortable. The cull still exists, but what she did helped change how it's done, with some buffalo going to tribes. It was inspiring to learn about a woman who spent decades of her life fighting for this cause.

NG: What advice would you give to young women today?

TH: Not being afraid is very important. You may feel like you failed and there's no way to recover, but you can. Life will continue and it will just make you stronger and make you learn something about yourself. Try to remember the line of ancestors behind you and those to come. Feeling like a link in a chain makes you a lot stronger.

NG: Where are you are most at peace?

TH: In those places where the sun's on your face and the wind's in your nose. When I'm home, on the lakes, in the forest, with my family, with youth: the future. Seeing their faces always gives me hope. ■

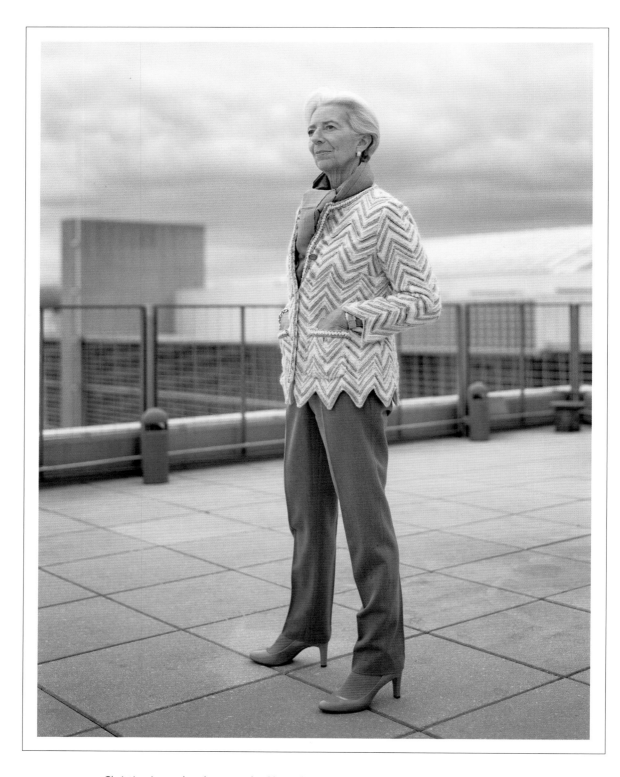

Christine Lagarde, photographed by Erika Larsen in Washington, D.C., January 9, 2019

CHRISTINE LAGARDE

On *Forbes* magazine's 2018 list of the world's most powerful women, only two are ranked above Christine Lagarde: Germany's chancellor Angela Merkel and Britain's prime minister Theresa May. While those two led their nations, Lagarde was shaping the finances of 189 nations: members of the International Monetary Fund (IMF), where she's been managing director since 2011. As a teenager, Lagarde swam for her native France on its synchronized swimming team. In her early 40s, she became the first woman to chair the world's largest law firm, Baker & McKenzie. Under Lagarde, *Forbes* wrote, "The IMF has navigated the eurozone debt crisis, [and] managed emerging market risks and the threat of a U.S. trade war with China." Now in her second five-year term heading the IMF, she is working to maintain a stable European economy amid Brexit. Lagarde has also decried sexism and sexual harassment in male-dominated realms, as well as the gender gap in pay.

NATIONAL GEOGRAPHIC: Let's begin with a look into the future: What do you think is the single most important change that needs to happen for women in the next five to 10 years?

CHRISTINE LAGARDE: I think the most important thing is that there be many more women in positions of authority and power. That will be the conduit of many other things that we all need, such as equal opportunity, equal pay, space, and respect. So, many more women in positions of authority and power in all sectors, public and private alike, in the developed and developing worlds. If you give me a second choice, I would say: at least seven years, if not more, of quality education for all girls, particularly in the least developed countries.

NG: Because women who have education make better choices?

CL: Because young girls with education will find themselves with more parity with boys. We observe, in the economic research that we do, that they will tend to marry later in life, and, as a result, will typically have fewer children in the course of their life. And they'll be able to make better choices in general.

NG: Okay, so that's looking forward. What do you think is the most important challenge facing women today?

CL: I would say lack of access and lack of opportunities, in terms of education, in terms of financing, and in terms of decision-making positions.

NG: Okay, let me switch topics for a little bit and focus in on you. What do you think is your greatest strength?

CL: I would say stamina and a smile.

NG: Would you like to elaborate?

CL: Stamina because, throughout my life, I've seen that it's served me well, whether it was in sports, when I was on the national [synchronized swim] team and grew up to be an athlete, or whether it was in my professional life as a lawyer, as a top manager, as a finance minister, or in the position I'm in now. And also in my personal life, combining a very demanding job as a lawyer in a big international law firm and being the mother of two young kids [sons Pierre-Henri and Thomas], stamina has been critically important to me.

And a smile, that's a way to express two things. One is a positive approach to anything that I face, because you can see the world either as a half-full or a half-empty glass. I typically see it as half full, and I look forward to making the world a better place, rather than commiserating or moaning about how bad a place it is. Second, I think it has served me well in circumstances of hardship, obstruction, discrimination, and all the rest. Sometimes a smile, a joke, a good sense of humor—including a self-deprecating one—has actually helped me out of those situations. And it's the easiest, cheapest gift that you can give to those around you.

NG: That's so true. I never thought of it that way. Now, in your life, did you have what you consider to be a breakthrough moment?

CL: Yeah. I would say that it happened when I was 16, 17: Those were two critical years for me. When I was just 16, my father passed away.

I think there is a shortage of confidence [among women] . . . if only because the role models are few, the path is uncertain, and sometimes you're short on love, support, and encouragement.

And one year later, I got a scholarship from the American Field Service [a student-exchange program] and in 1973 I came to Washington, D.C., and lived a full year with a beautiful American family who have since become my American mom and dad. That really, monumentally helped me in going through that very difficult moment.

NG: Do you still keep in touch with them?

CL: Oh yeah. In 2018 we celebrated their respective 80th birthdays and their anniversary of 50 years of marriage. I owe them a great deal and I never fail to mention that to them.

NG: That's so nice. Maybe you've partially answered this: What are the biggest obstacles you've had to overcome?

CL: I think that difficult time was one. And I think one obstacle is actually myself, you know.

NG: Tell me more.

CL: I think that, over the course of time, the issue of confidence is one I had to struggle with. It's probably closely related to the passing of my father and the sense of loss that you feel as a result. Then, whenever you face that same sense of loss, that lack of support or love or whatever, you have to build that confidence within yourself. I think love is an extraordinary engine for confidence, and when you lack some of it in an early stage, you have to constantly battle against it.

NG: I can't tell you how many women—all of these incredibly accomplished, amazing women whom I've spoken to—how many of them have talked about this very same thing, a lack of confidence. It's making me a bit heartsick, I have to say.

CL: You know, maybe it's too much self-observation, which we tend to do—girls more than boys, as I've observed when my kids were growing up. But if we're honest with ourselves, I think there is a shortage of confidence, sometimes a bit and sometimes a lot. If only because the role models are few, the path is uncertain, and sometimes you're short on love, support, and encouragement.

NG: What living person do you most admire?

CL: Pope Francis, without a doubt. First of all, we share the same faith. Second, in spite of his position, he has managed to remain completely focused on the issues of fighting against poverty, changing people's hearts, and transforming the environment within which he operates, which is incredibly difficult. He's managed to be so deep and yet so simple.

NG: Okay, great. One more question: Where are you most at peace?

CL: Under the sea. I'm a scuba diver, and it's an extremely peaceful environment where you have to really rely on yourself and yet be part of the team. But I would say there is a little field of olive trees in the south of Corsica where I feel very much at peace as well—because of the seclusion, the silence, the communion with nature. And I might equally say that my rose garden in Normandy gives me that same feeling—so I'm lucky. I'm very, very lucky. ∎

Interviews have been edited for length and clarity.

STRENGTH

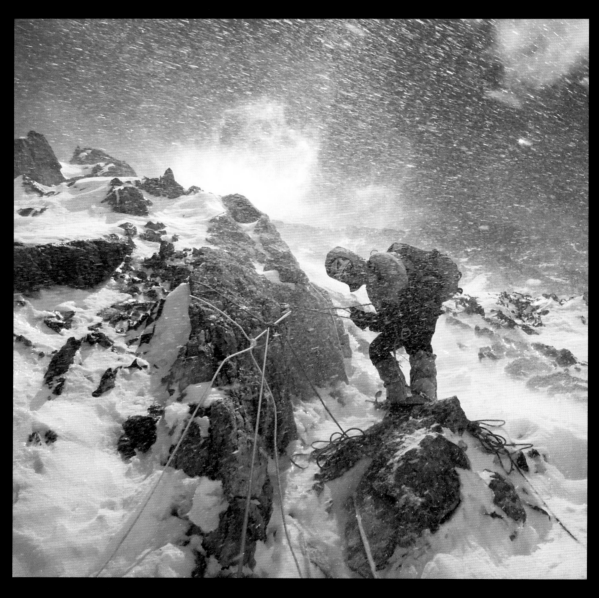

Climber Gerlinde Kaltenbrunner checks ropes fixed along a route on the
Karakoram Range in China. *Ralf Dujmovits, 2011*

It's become a popular saying: "Adversity doesn't build character; adversity reveals character." In these National Geographic images, documenting women's lives across more than 130 years, both the character and the adversity are palpable.

Our acclaimed archives display women pursuing risky and record-setting adventures—or complicated, everyday lives—with fortitude, grit, and grace. Women experiencing oppression, deprivation, and conflict—as well as opportunity, triumph, and renewal—all while caring and sacrificing for loved ones and homes.

It's so common for women to doubt their abilities that psychologists gave the tendency a name: "imposter syndrome." But it's also becoming common for women, at all points on the globe, to recognize their strengths and assert them.

That's the fierce resilience expressed by Alicia Garza, a co-founder of the Black Lives Matter movement: "When people tell me it cannot be done, it must not be done, it has never been done, there's something that goes off inside me that says, 'Okay, watch me.' " ∎

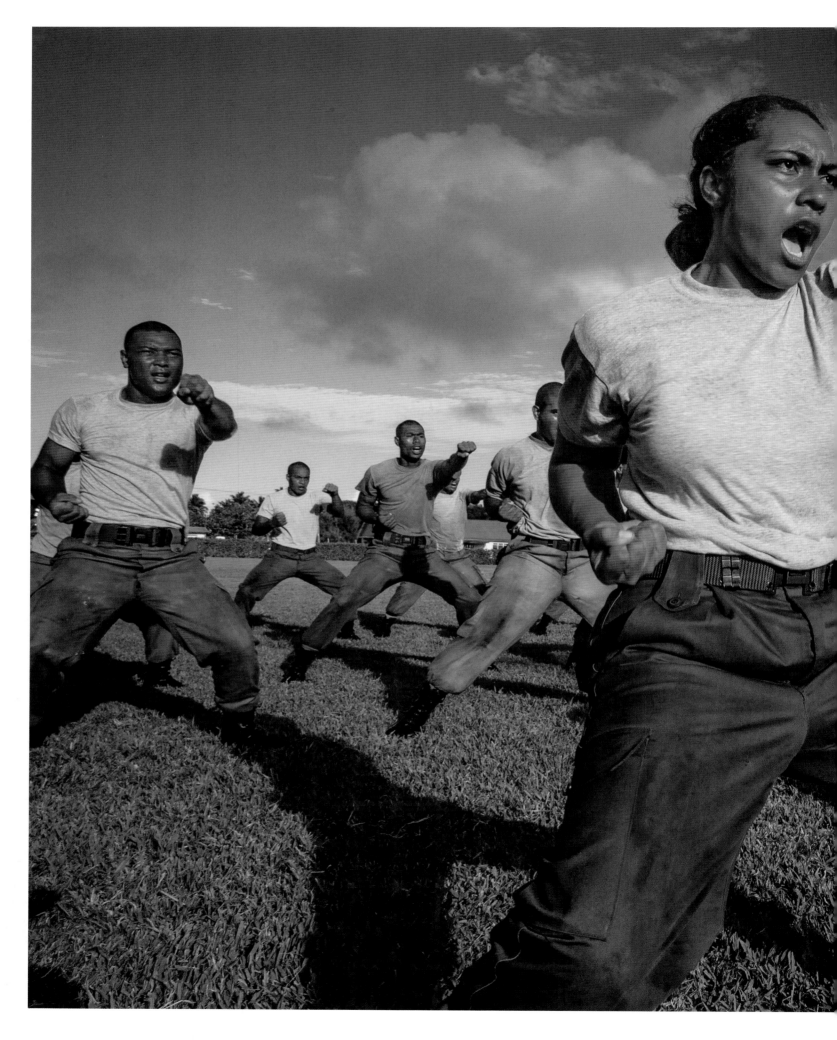

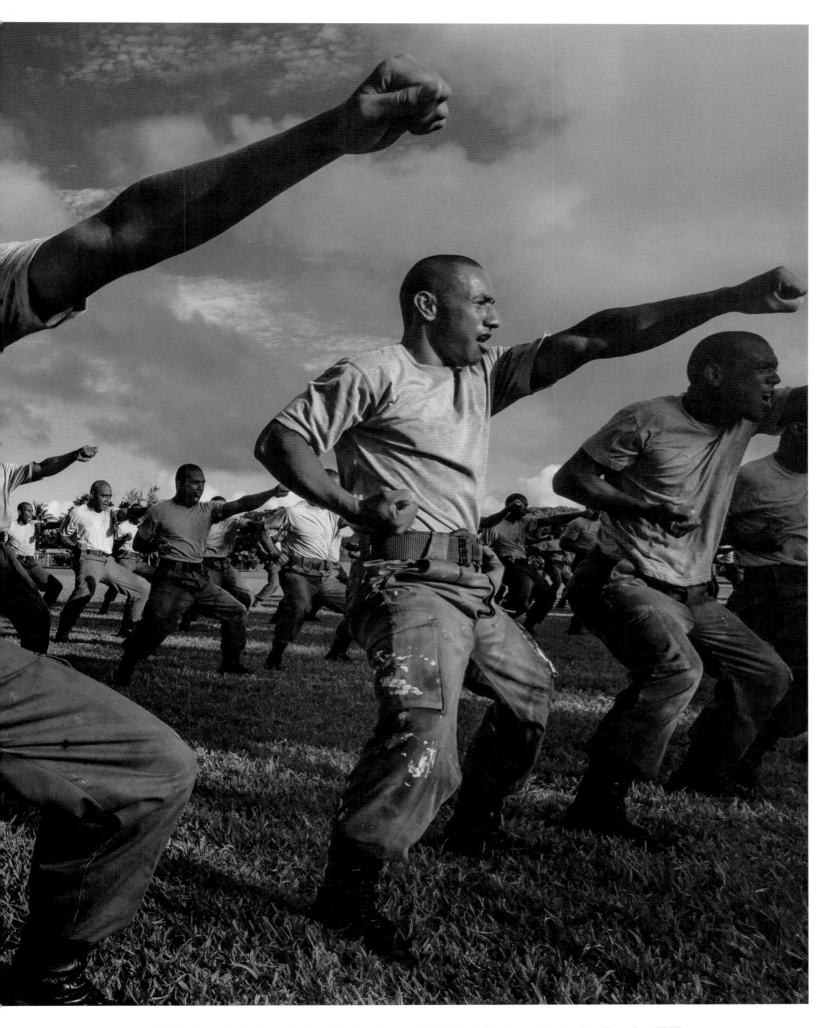

Spirited recruits for Tonga Defense Services demonstrate their ability in martial arts. *Amy Toensing, 2007*

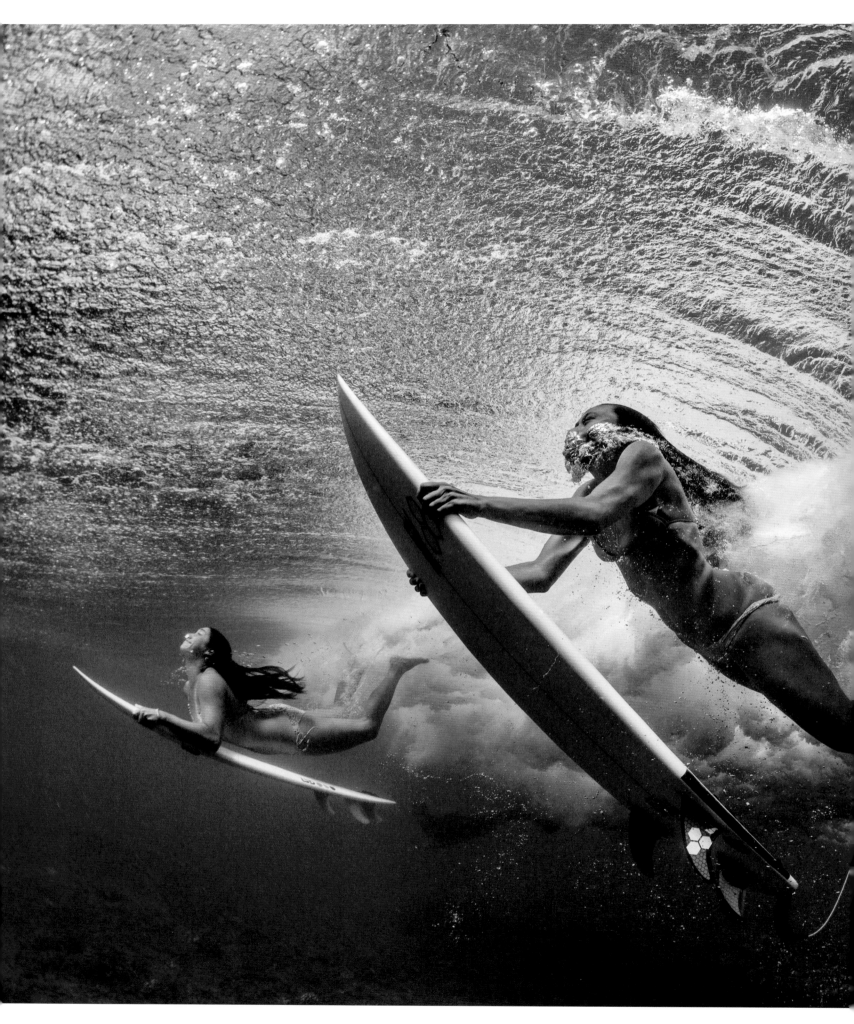

Two friends dive under a wave as they head toward a surfing spot near their hometown of Makaha, Hawaii. **Paul Nicklen, 2013**

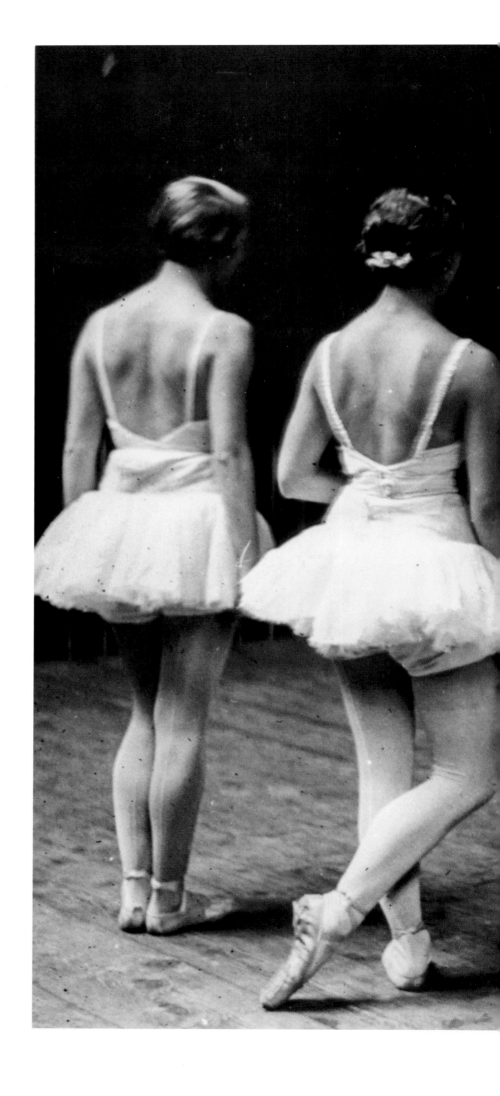

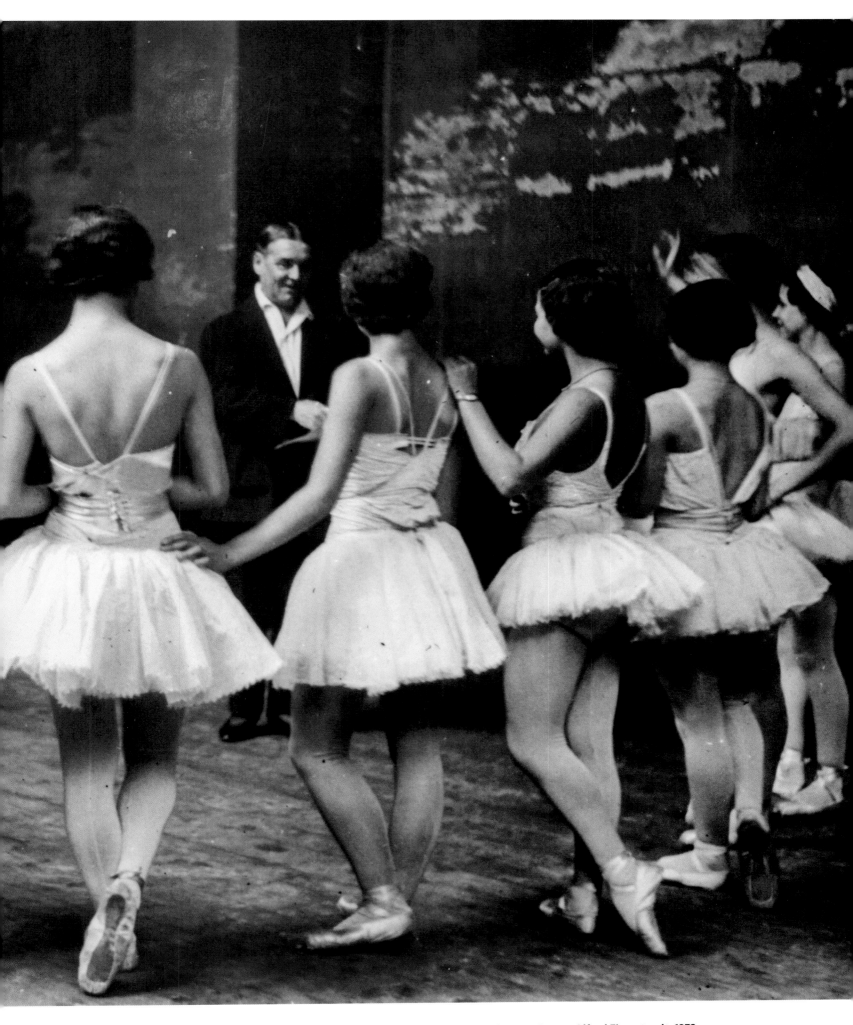

A ballet master gives advice to ballerinas rehearsing for *Swan Lake* at the Paris Opera. **Alfred Eisenstaedt, 1932**

Author Sasha Taqseblu LaPointe explores surviving sexual violence, her mixed heritage, and finding strength in her lineage through her writing. *Kali Spitzer, 2018*

A woman raises her fist in protest at a peaceful demonstration on the state capitol lawn against the Dakota Access Pipeline in Bismarck, North Dakota. *Erika Larsen, 2016*

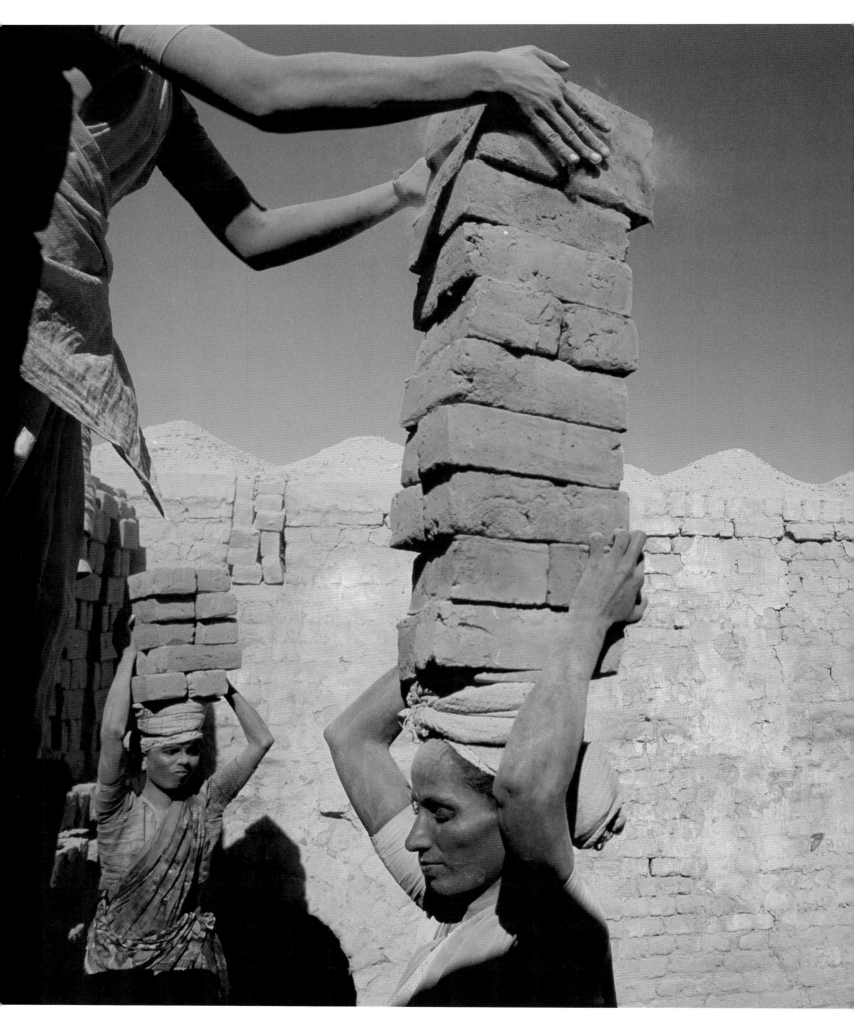

A family of debt laborers stack and haul bricks on their heads in Madras, India, to pay off loans. *Jodi Cobb, 2003*

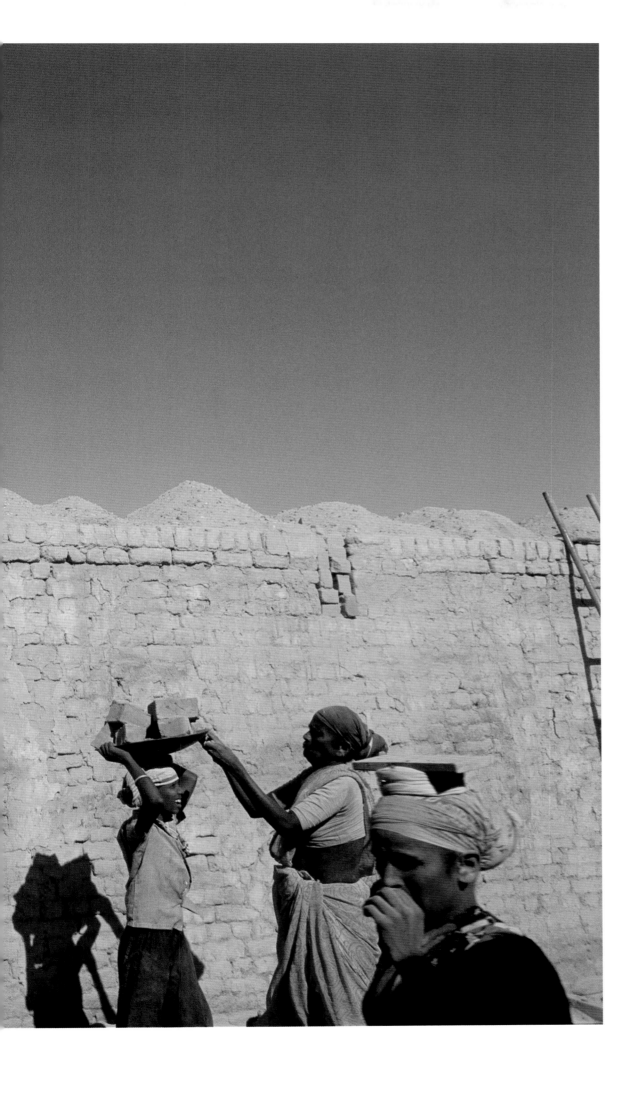

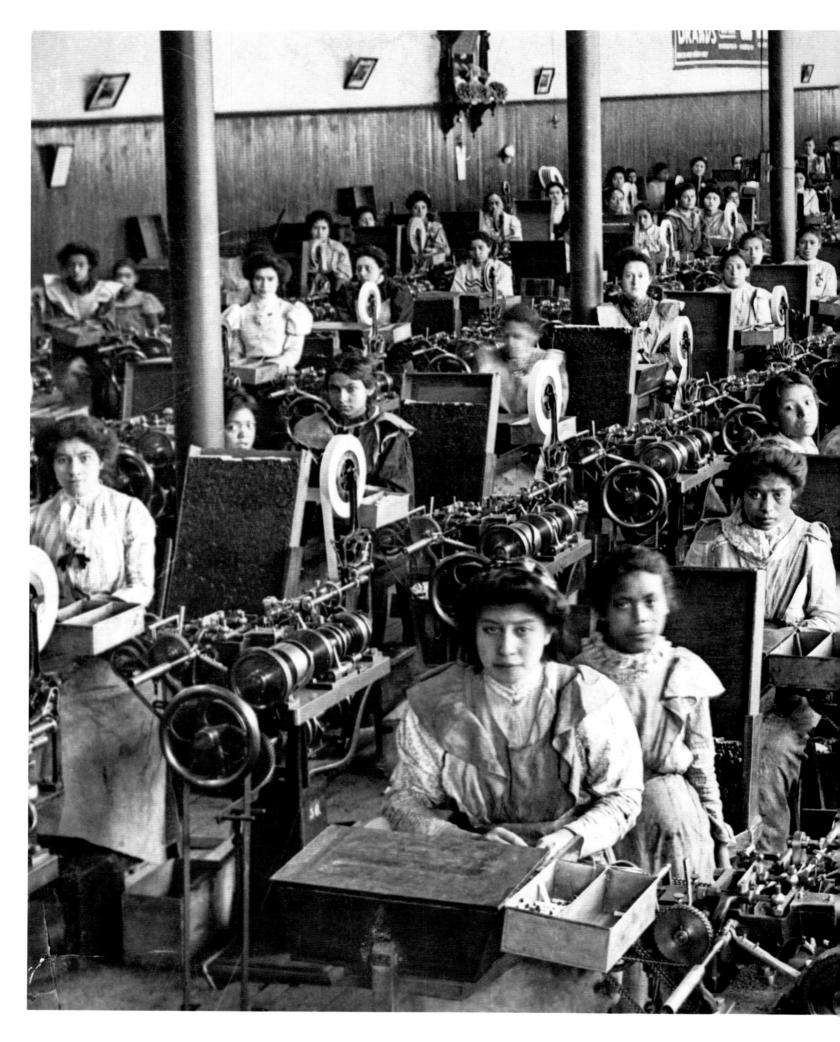

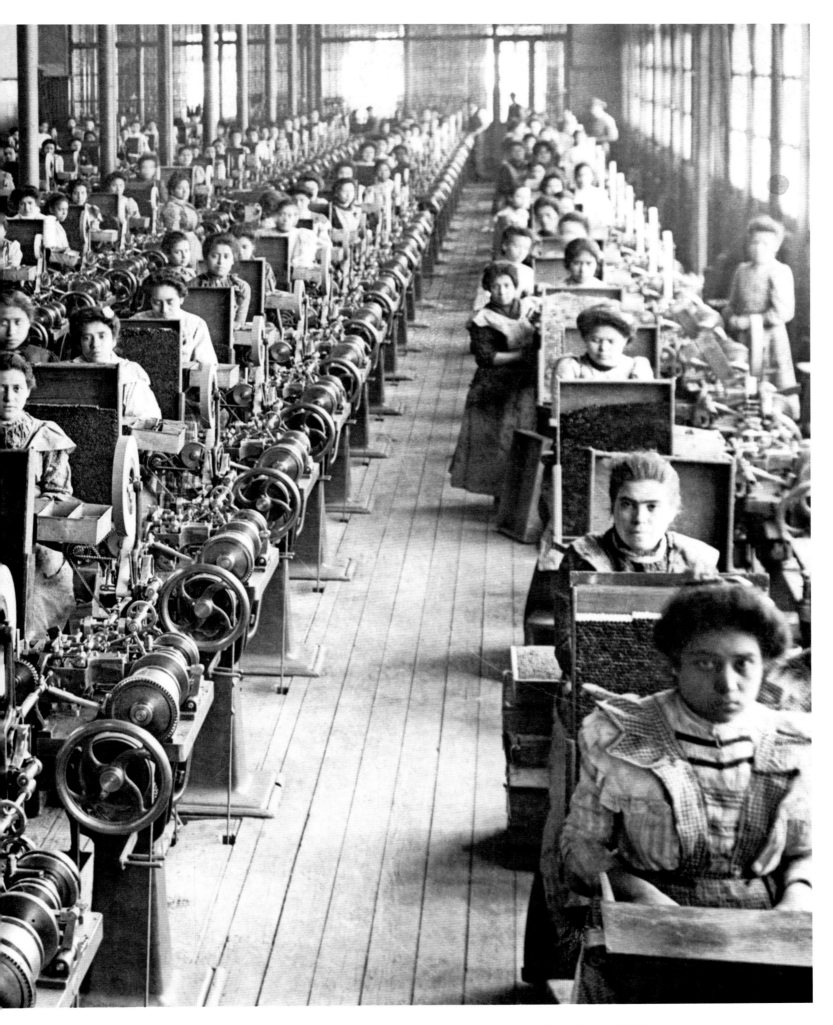

Hundreds of women workers roll cigarettes in Mexico City. *Underwood & Underwood, 1911*

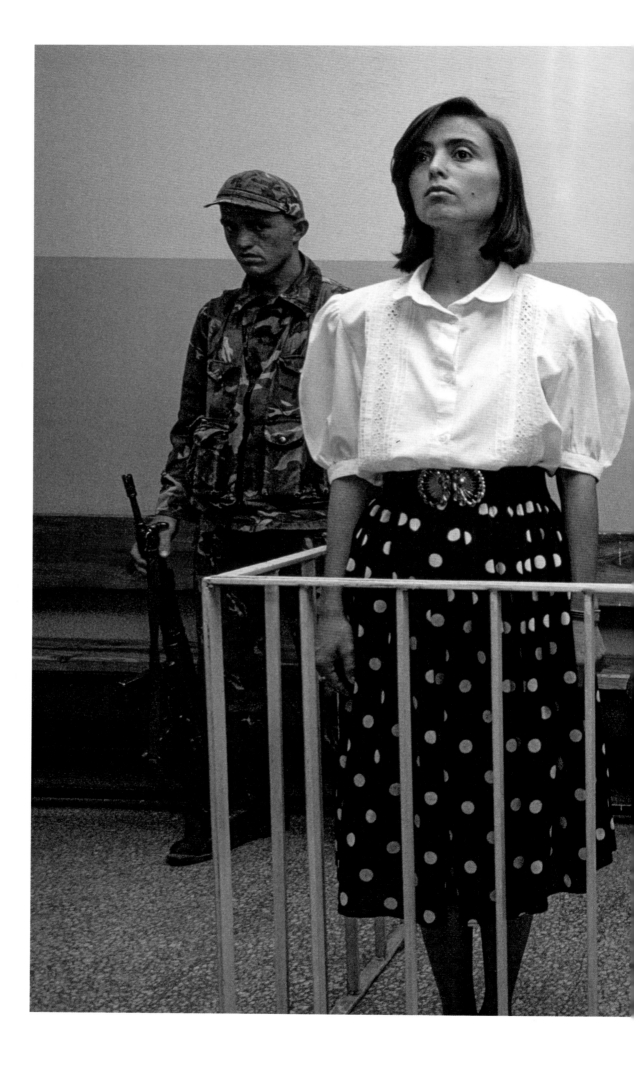

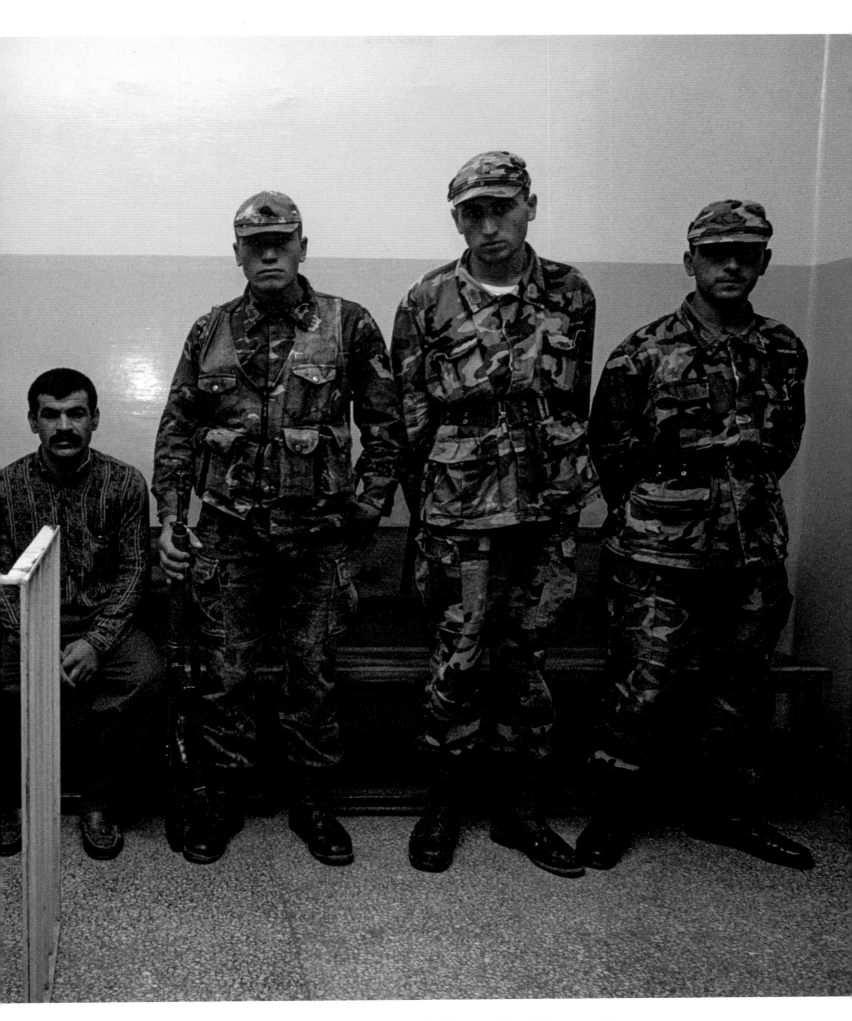

Yildiz Alpdogan was sentenced to 12 and a half years in prison for being a member of the Kurdistan Workers Party—a charge she denied. *Ed Kashi, 1992*

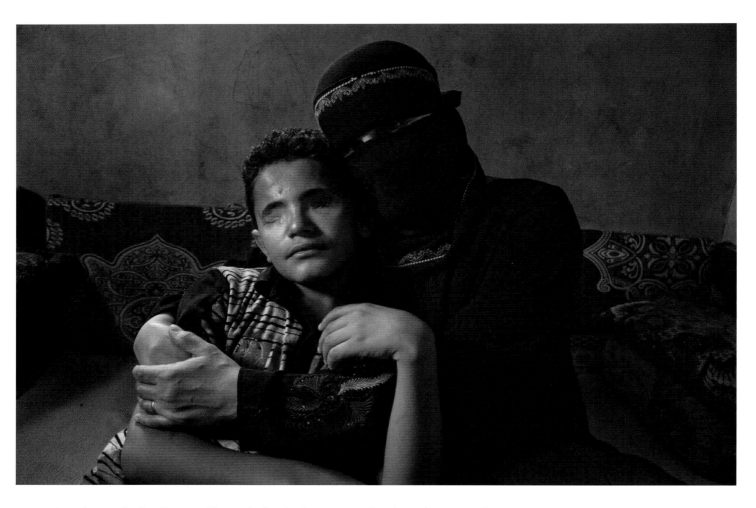

A mother cradles her 12-year-old son, who lost both eyes to gunfire during a protest rally in Sanaa, Yemen. *Stephanie Sinclair, 2012*

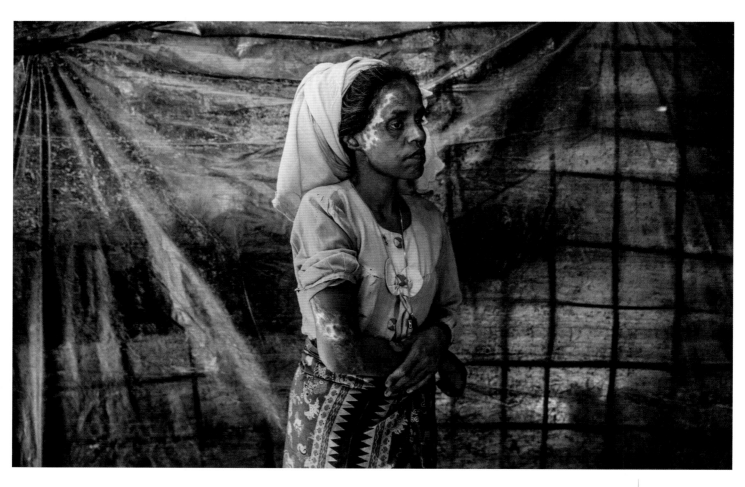

A Rohingya woman, a member of the Muslim minority in Myanmar, was burned on her face and arm when the Burmese military torched her home. *William Daniels, 2017*

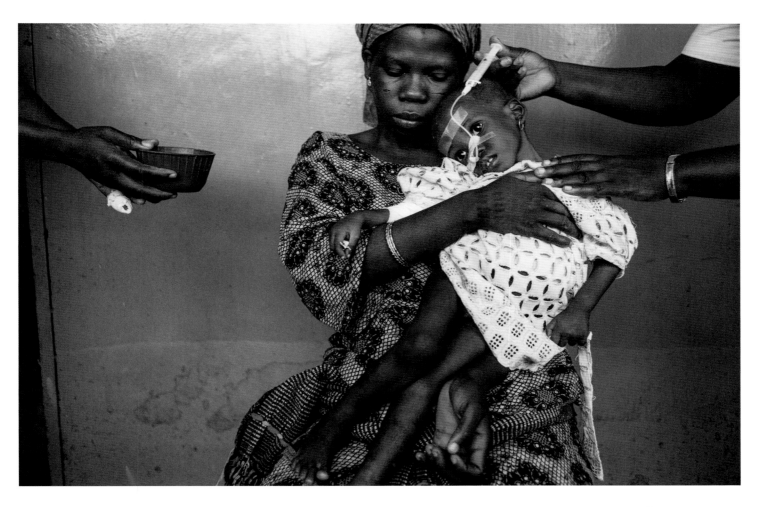

Cradled by her mother, a starving girl receives syringefuls of soy milk at the Kersey Home for Children in Nigeria. *Lynn Johnson, 2008*

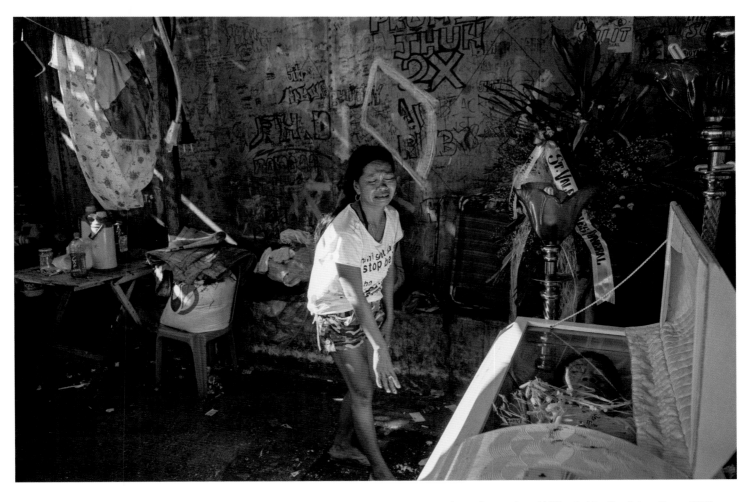

A Filipina woman weeps before the coffin of a man who was abducted and executed in a drug-related killing in Manila. *Adam Dean, 2016*

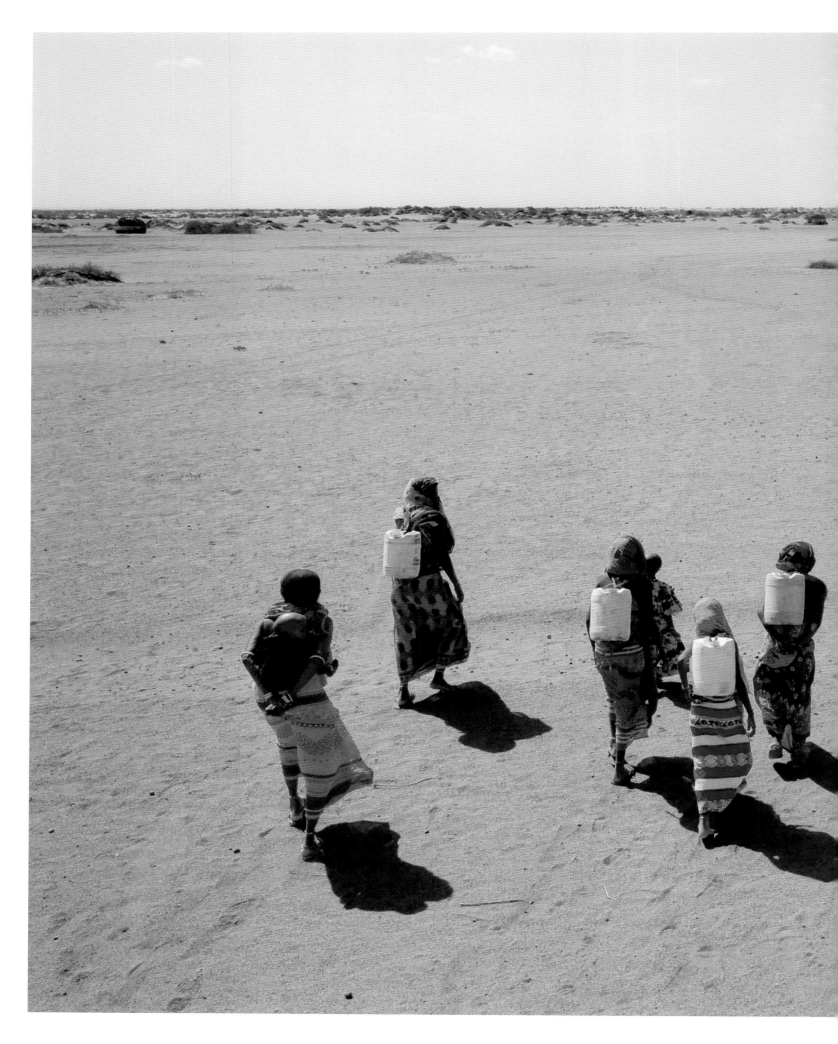

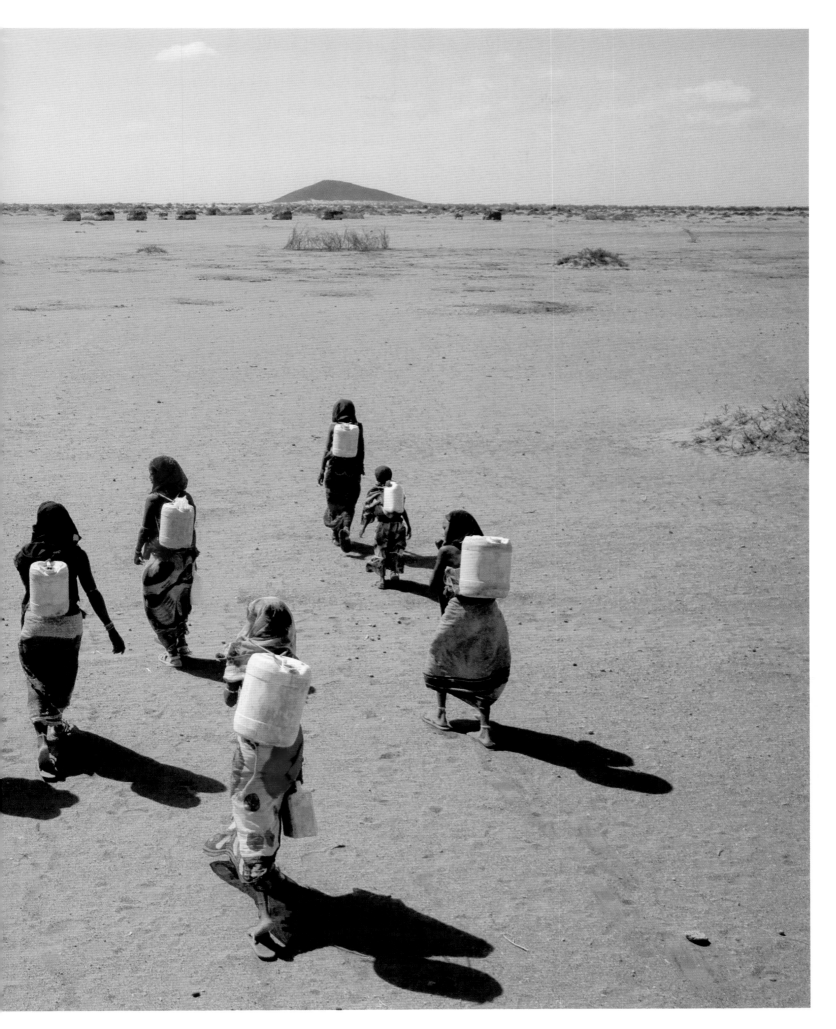

Gabra women carry jerry cans filled with murky water through desert plains in Kenya. *Lynn Johnson, 2009*

A Virginia coal miner lights a cigarette as she discourages her 15-year-old daughter from getting married at such a young age. *James L. Stanfield, 1986*

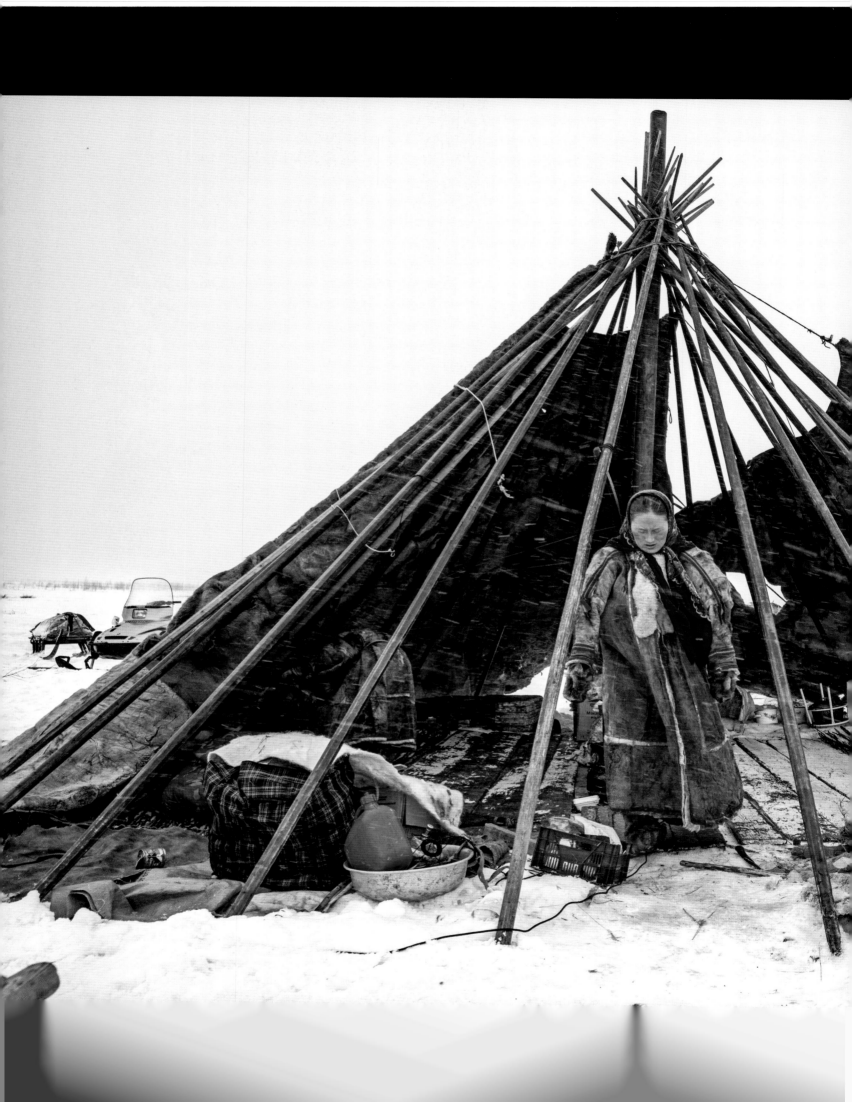

THROUGH
THE LENS

I took this image while following the Nenets reindeer herders in Russia's Arctic as they migrated through modern obstacles, including giant natural gas fields. What struck me is how hard women in this community work; their lives are difficult and physically demanding. While men herd the reindeer, it is the women who assemble the *chum*—or tent—with heavy poles, fur, and leather, often weighed down by snow, while also caring for the children and cooking. In terms of strength, Nenets women are as strong as men.

For these women, there is not even a question about what they can or cannot do. They have been living like this for centuries, and it's how their culture survived. I look at my own work now and believe I can overcome difficult situations. And I feel lucky that in the course of my work for *National Geographic*, I have never been questioned about how I can do something—trek long distances with a heavy backpack, take pictures from a helicopter—because I am a woman. It's a relief that there is no need to prove or explain myself. ∎

EVGENIA ARBUGAEVA

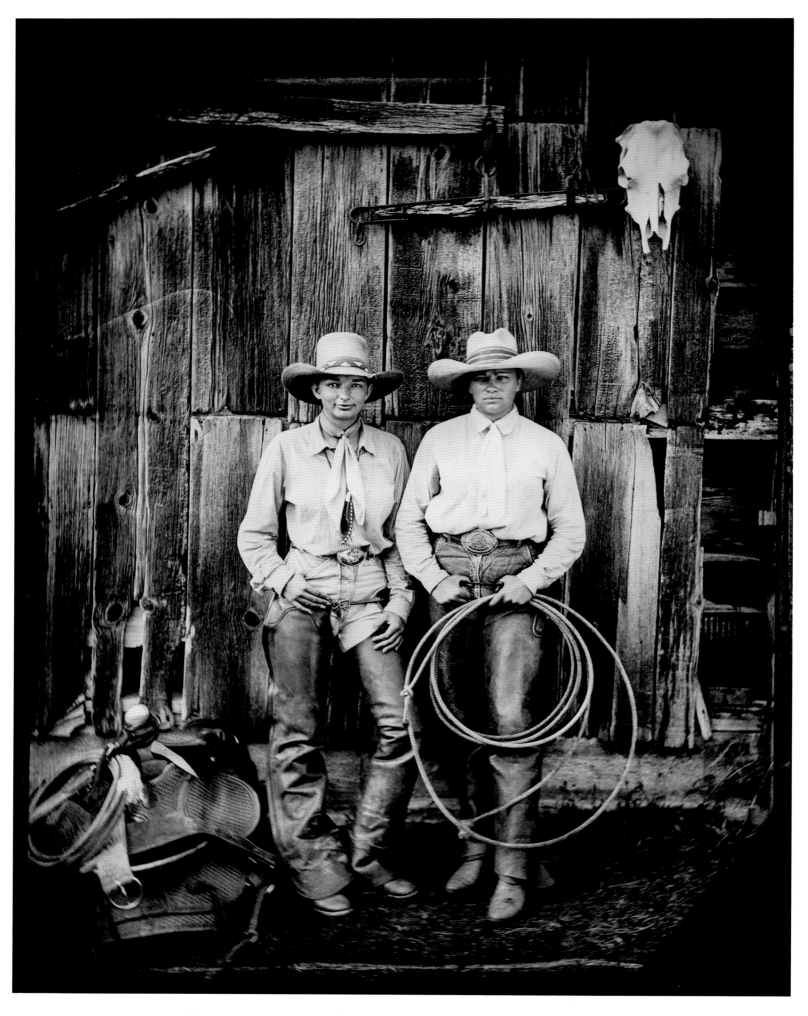

A tintype portrait of two cowgirls who work on a ranch in Nebraska. *Robb Kendrick, 2005*

A woman looks from the porch of a farming commune in Middlebury, Vermont. *Nathan Benn, 1973*

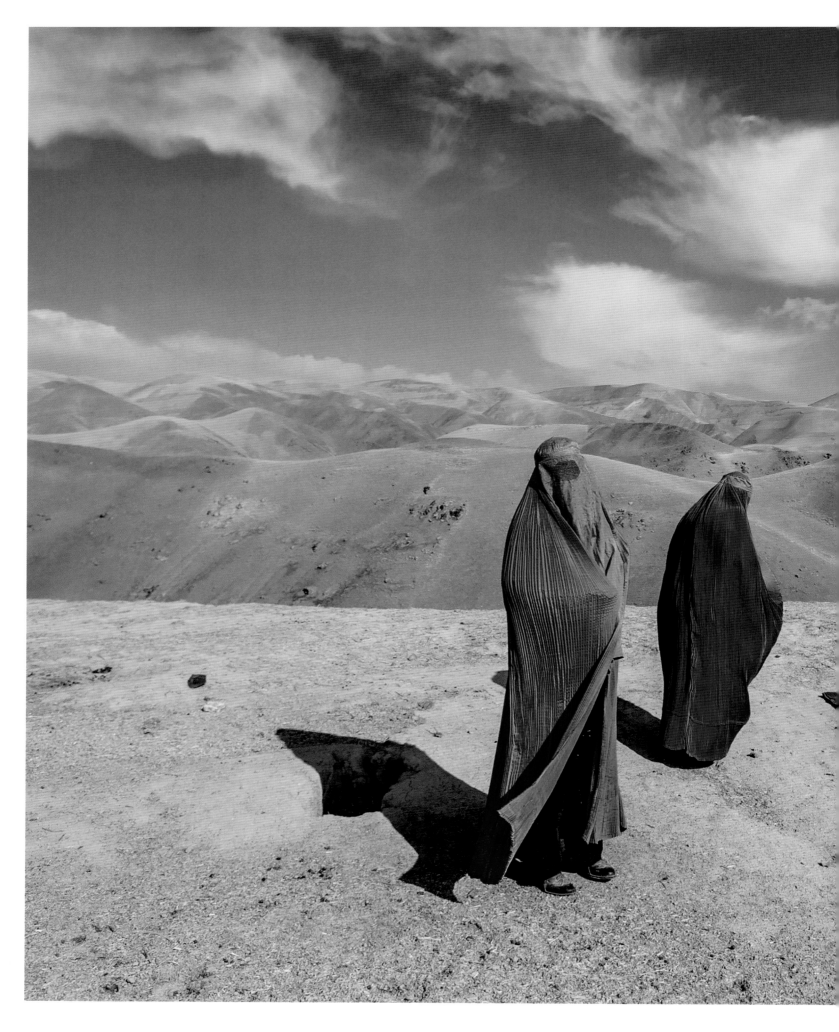

Pregnant Noor Nisa, in labor, is assisted by her mother after her car broke down on the way to the hospital in Afghanistan. *Lynsey Addario, 2010*

Cholitas, part of the Aymara indigenous group, wrestle in traditional dress in El Alto, Bolivia. *Ivan Kashinsky, 2007*

THROUGH
THE LENS

Even in relatively progressive Kabul, Muslims glared, honked, and screamed at Trena, the actress pictured here, who fled her abusive husband, leaving her three sons behind. I had never been in a car with an Afghan woman behind the wheel, and wondered about the reaction from the passersby. Not surprisingly, it provokes men here to see strong women; it symbolizes a freedom they just aren't comfortable with. But, as we drove, Trena blasted her favorite music and danced behind the wheel. It was one of the most carefree moments I have ever witnessed among women in this country. I started working here in 2000 when the country was under Taliban rule, and this was one of the few times I was simply in a car full of women, having fun, and letting go in a public space. Despite immensely different backgrounds, women can always find a point of connection, have fun, and collapse in laughter. I am still so inspired by the people I photograph—and am continually reminded of how diverse, yet similar, people around the world truly are. ∎

LYNSEY ADDARIO

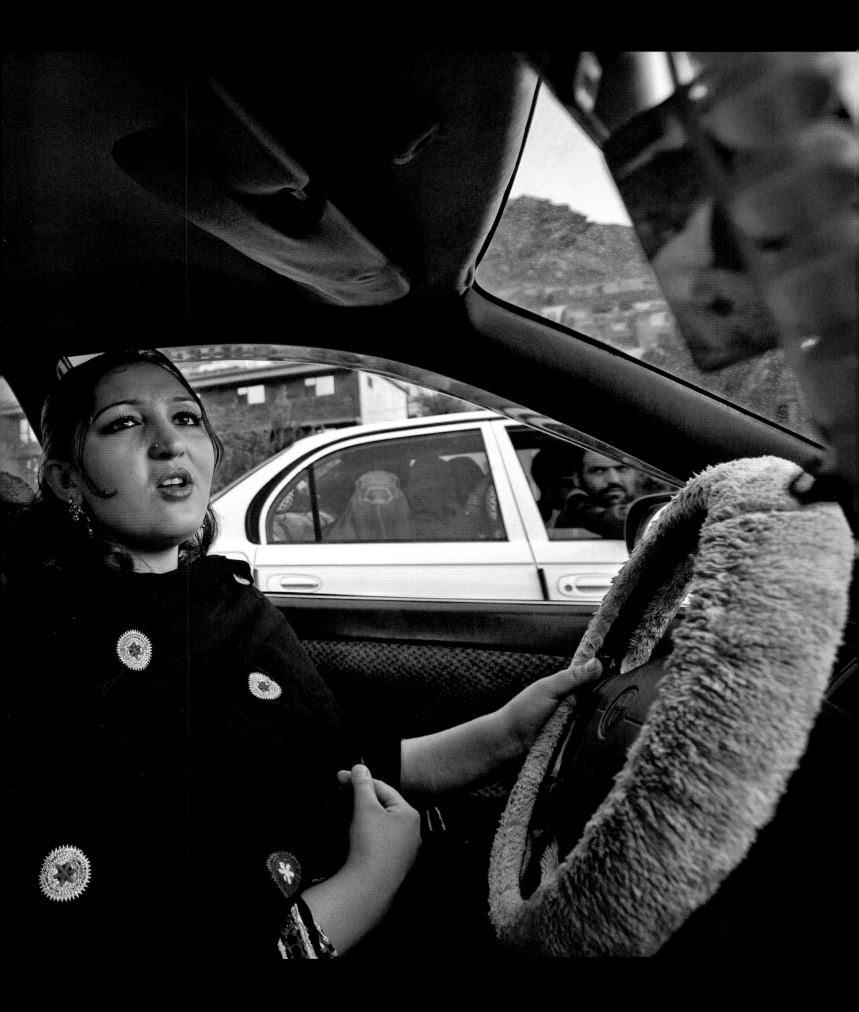

Amaiya Zafar (left) trains inside a gym in St. Paul, Minnesota, as she seeks to officially participate in events while wearing a hijab. *Kitra Cahana, 2016*

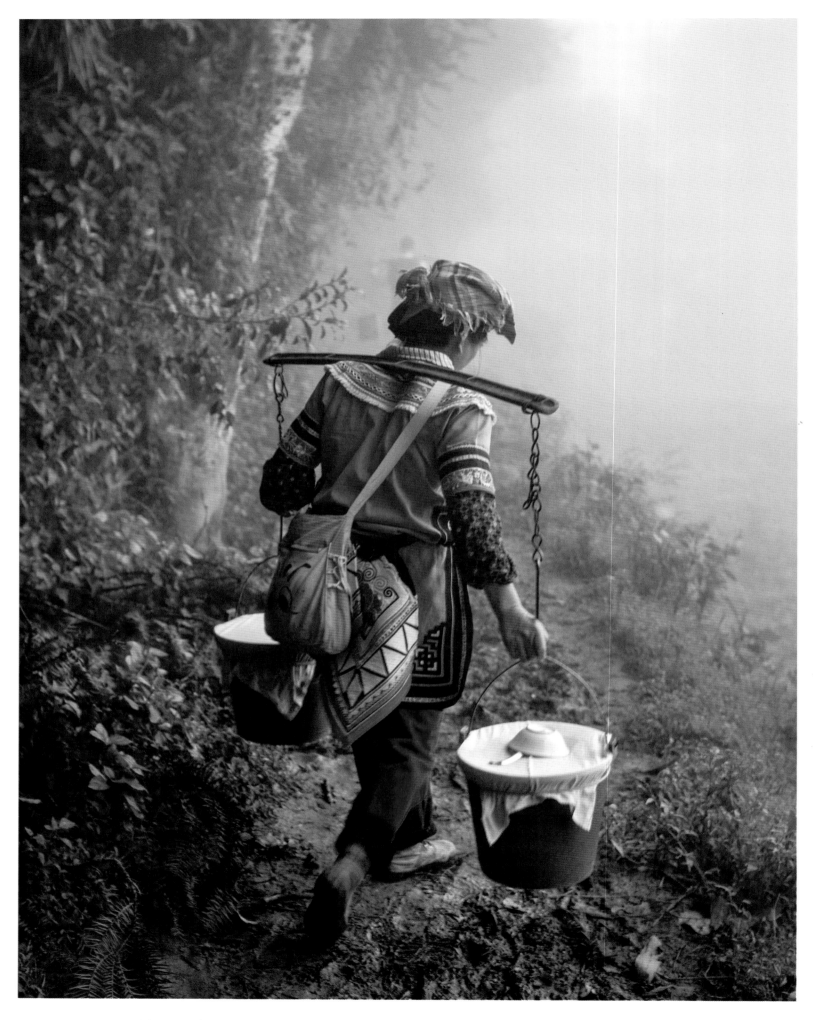

A farmer in Sheng Cun village, China, carries pots of food to those working in the fields. *Jim Richardson, 2007*

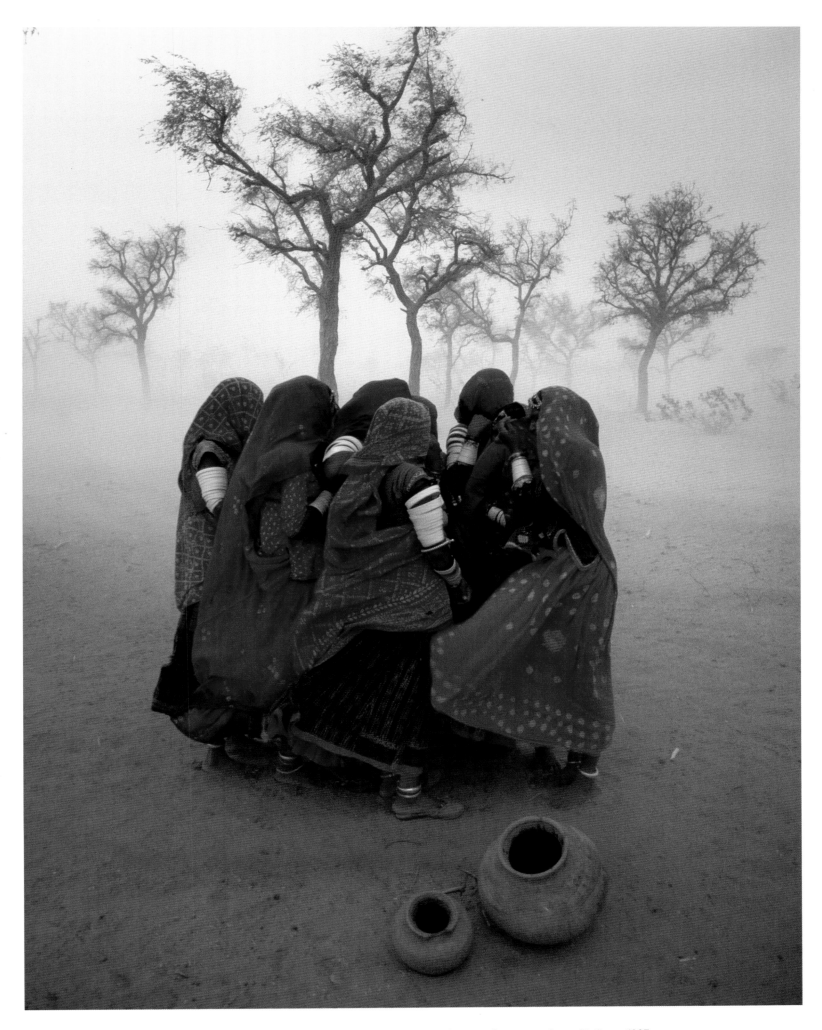

Women in India huddle together as they seek shelter during a dust storm. *Steve McCurry, 1983*

Workers take a break from their jobs at a salmon-canning factory in Poronaysk, Russia. **Natalie Fobes, 1990**

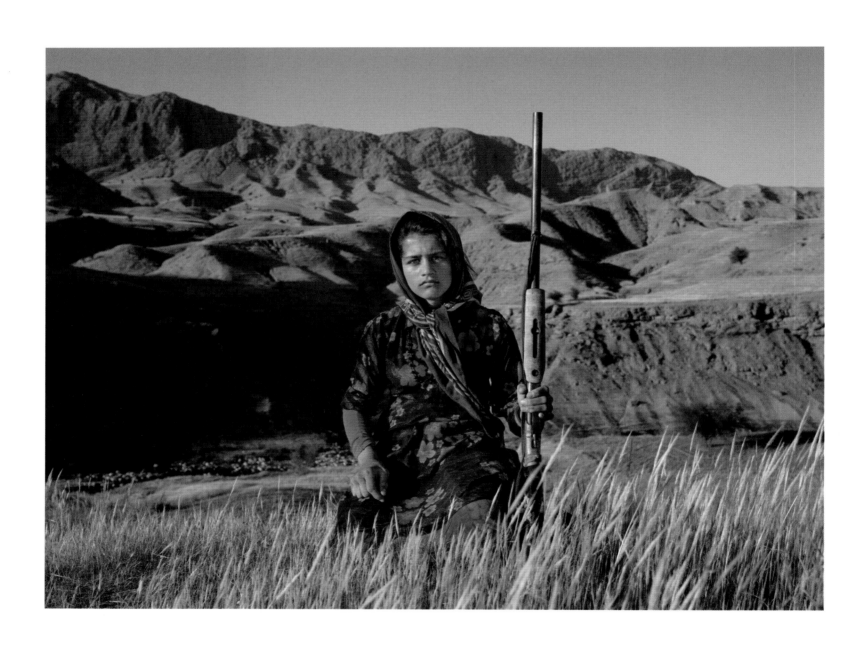

Iranian teen Masoumeh Ahmadi holds her mother's rifle,
a traditional gift from husbands after the birth of their first son. *Newsha Tavakolian, 2018*

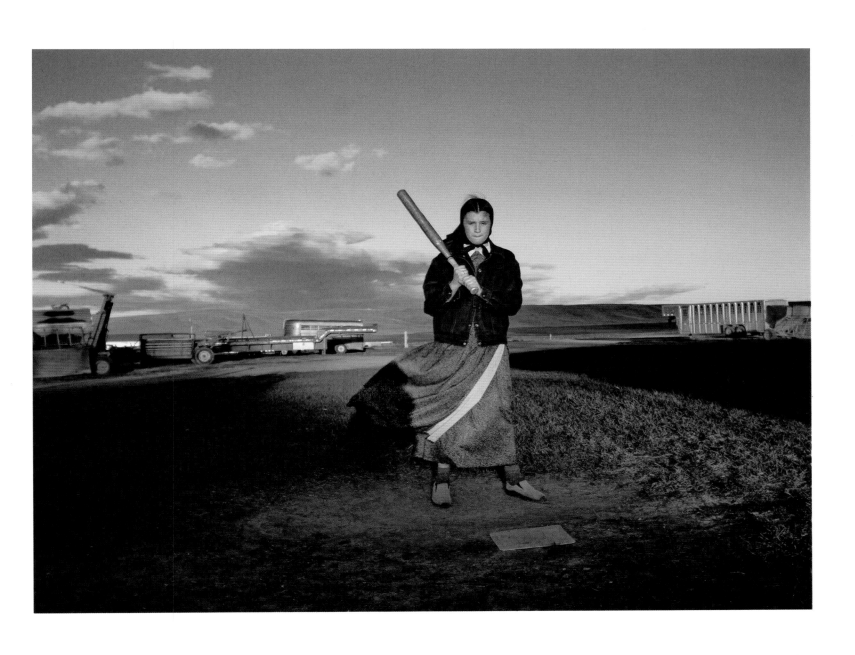

Stephanie Stahl from the Hutterite colony in Montana is ready to swing for the fences. *William Albert Allard, 2006*

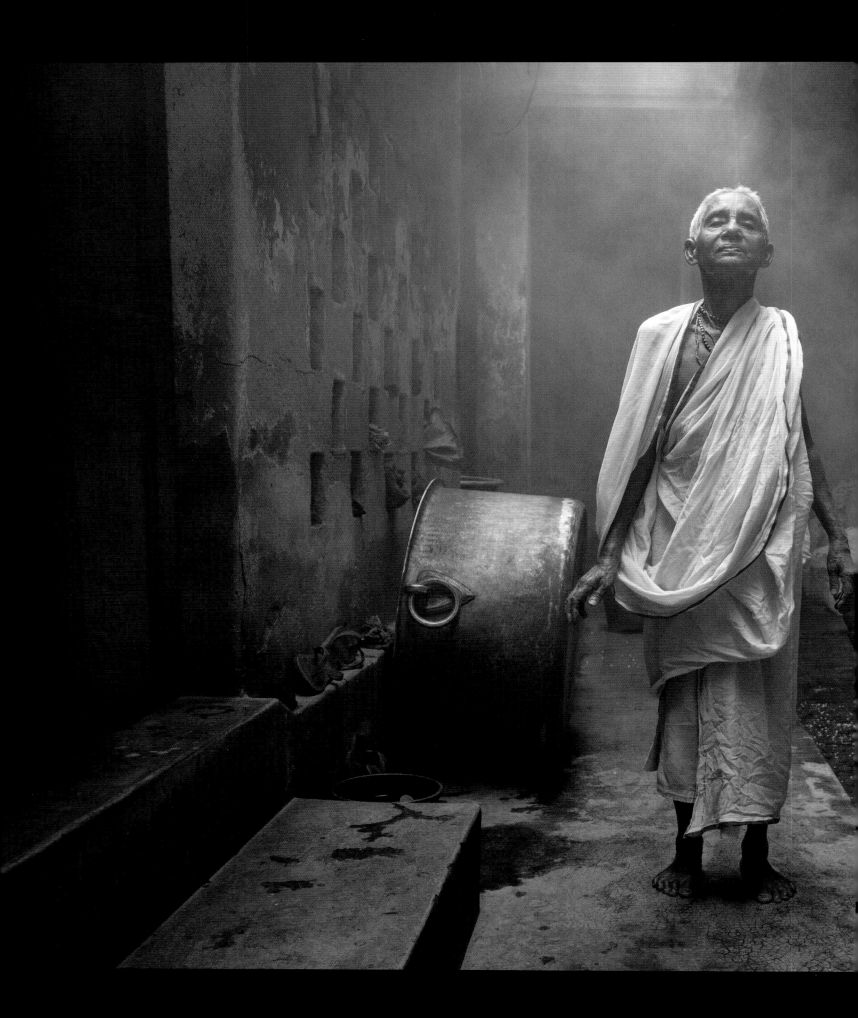

THROUGH
THE LENS

I met Bhakti Dashi in an ashram in Nabadwip, India, where she had been living for 25 years—ever since her husband died. She was moving through her morning chores as the wood-fired stoves boiled rice for the day's meals and filled the air with smoke. I asked her to pause to make a portrait. I had been returning to the ashram for days and I wanted an image that revealed the person I was beginning to know. She stopped and turned toward me, her hands dripping from the pans she had just been scrubbing. When her sari slipped down around her shoulders she didn't try to cover her head again. She exuded dignity, beauty, and sensuality.

In many regions of the world widowhood marks a "social death" for a woman—often casting her and her children out to the margins of society. In these cultures, a woman is usually defined by her relationship to a man: First she is a daughter, then a wife. When her husband dies she becomes an outcast. Commonly uneducated and without the ability to support themselves, widows are often targeted with abuse. In India, thousands of widows seek refuge in holy cities where they carry out a life sentence: shaving their heads, wearing white, and never remarrying. However, younger generations are rejecting these expectations and one can see a shift taking place. ∎

AMY TOENSING

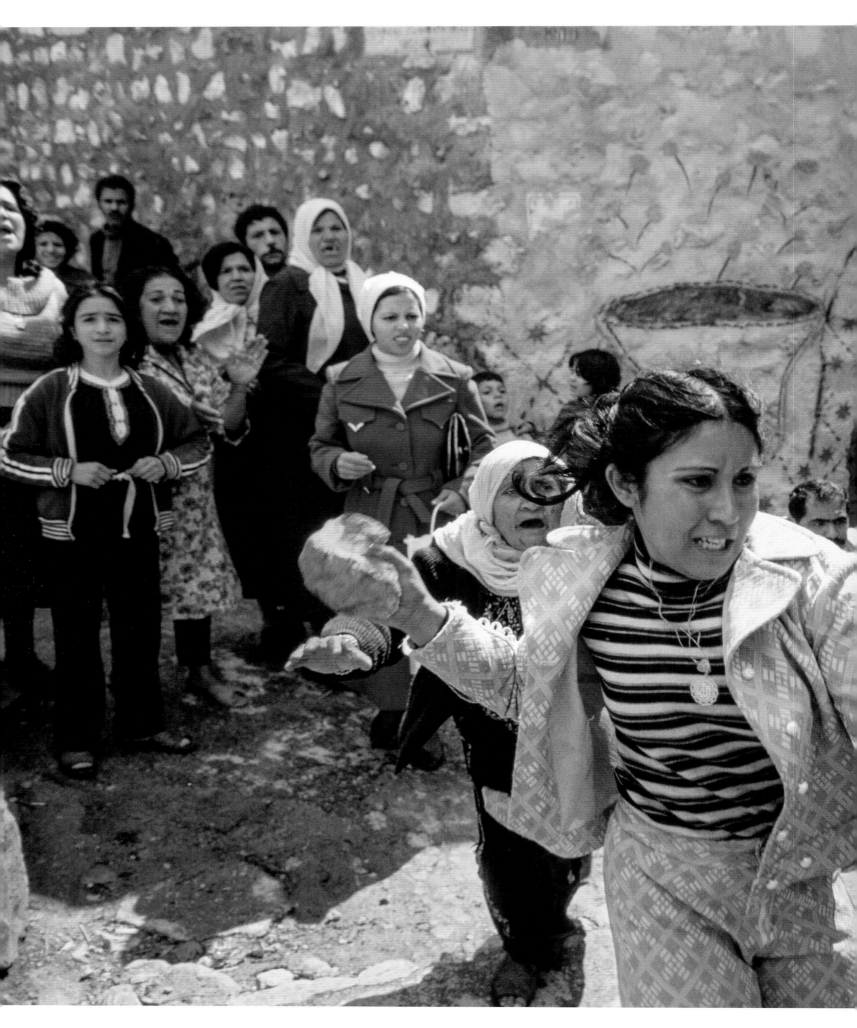

A Palestinian woman turns to violence after a member of her community is arrested. *Jodi Cobb, 1982*

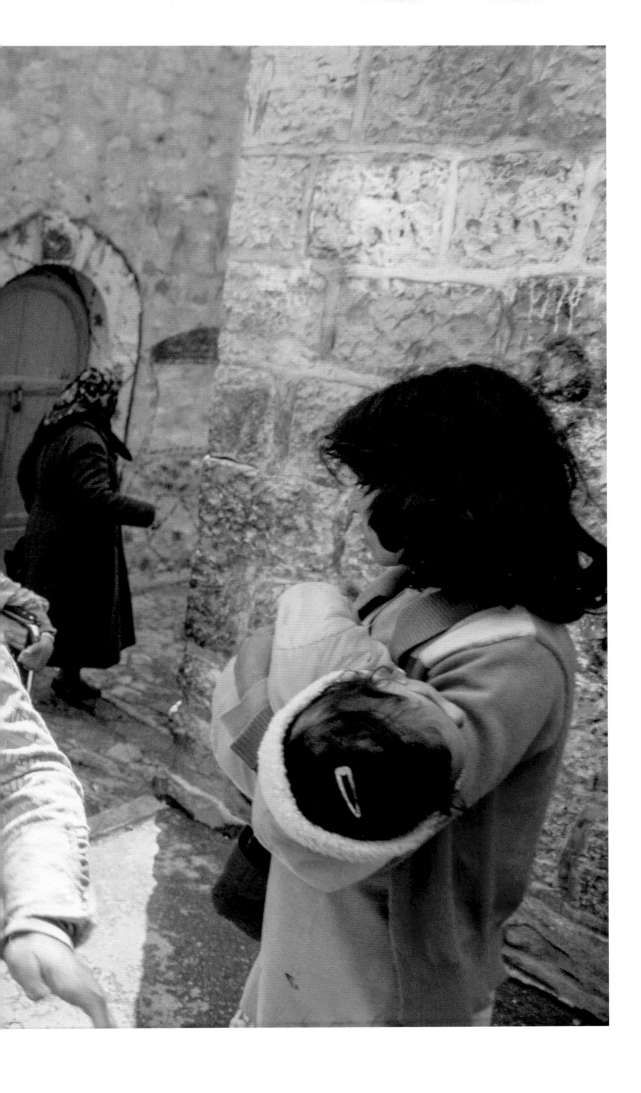

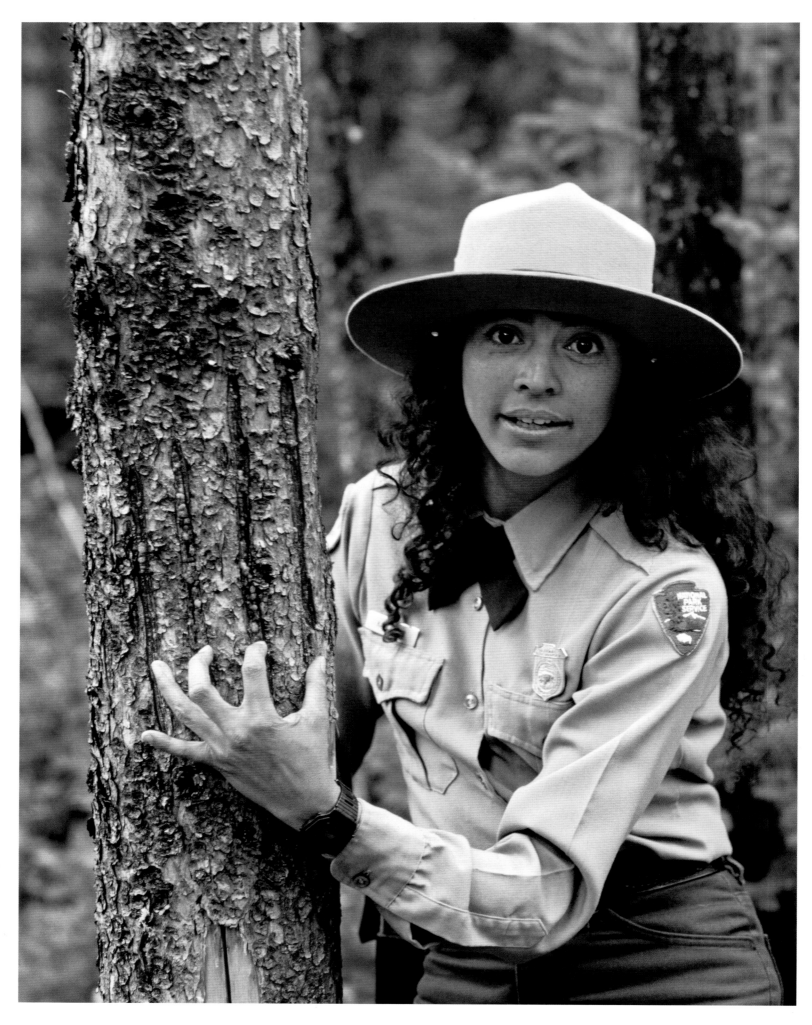

A park ranger points out grizzly bear marks in Glacier National Park in Montana. *Lowell Georgia, 1985*

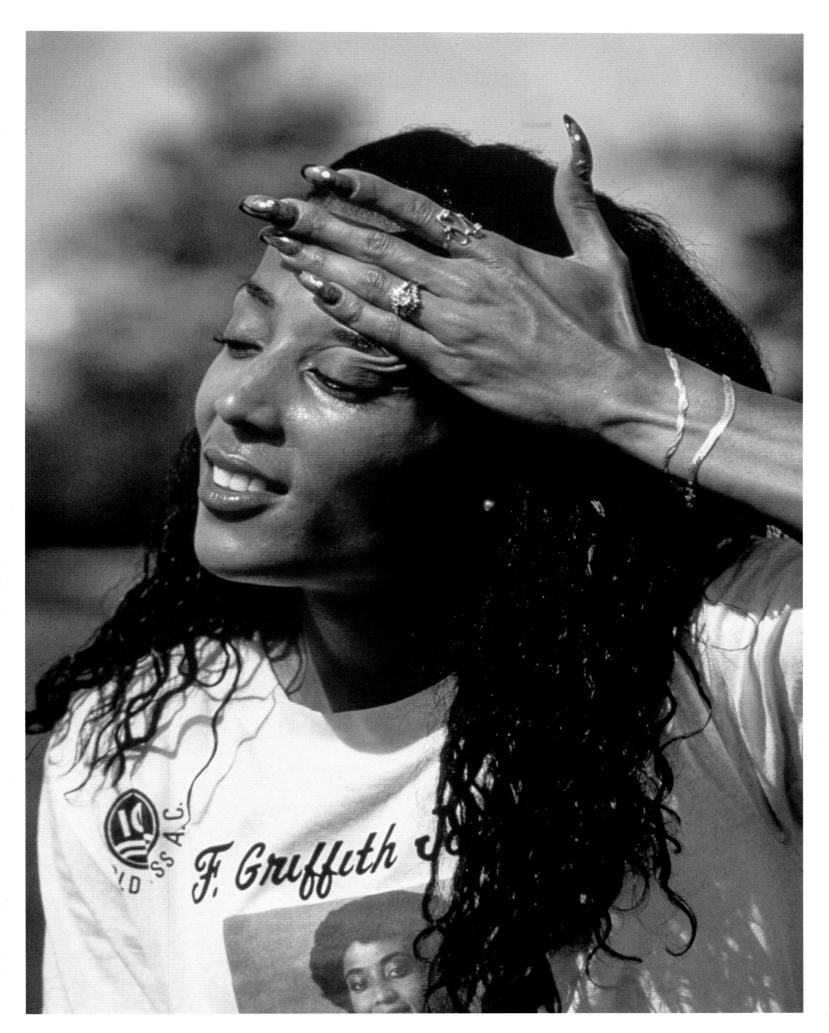

U.S. Olympic track star Florence Griffith Joyner displays her trademark fingernails. **Gerd Ludwig, 1988**

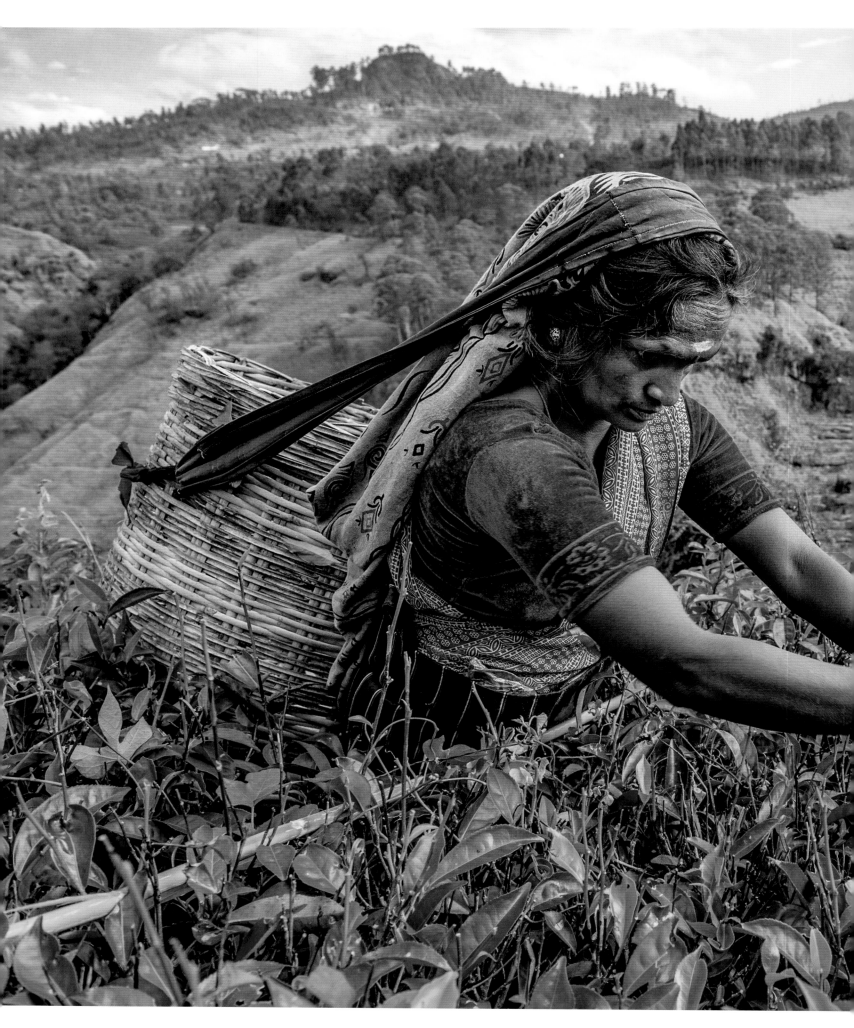

Women work the fields, picking tea, which they carry on their backs in Sri Lanka. *Ami Vitale, 2015*

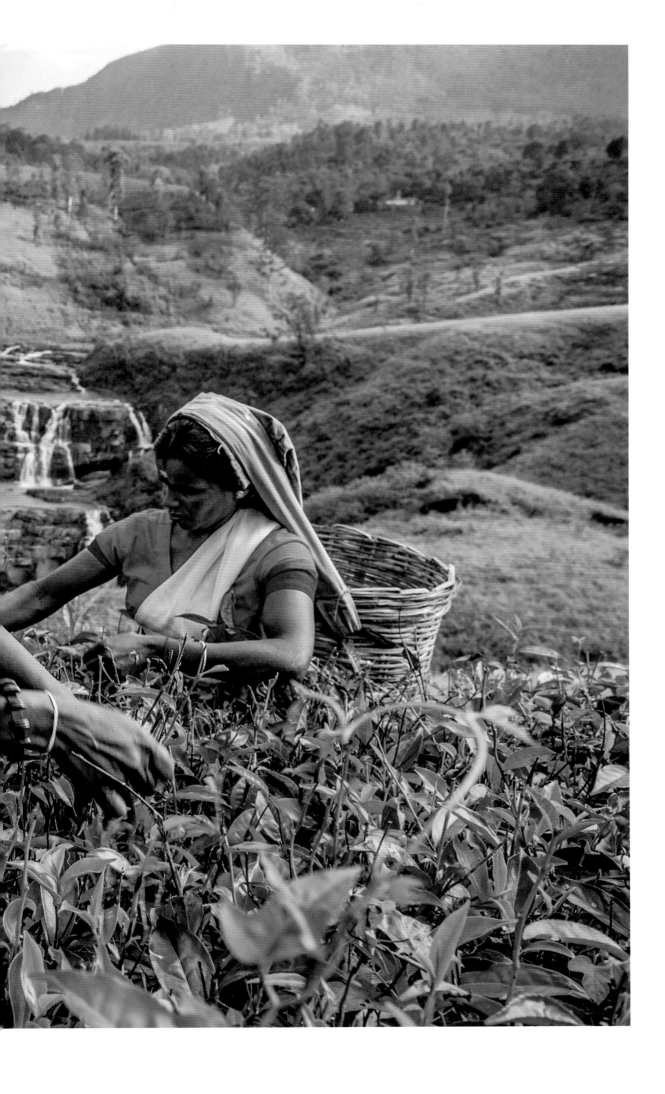

An Akashinga ranger, a member of a specially selected all-female conservation force, is on patrol to stop poaching in Zimbabwe. **Brent Stirton, 2018**

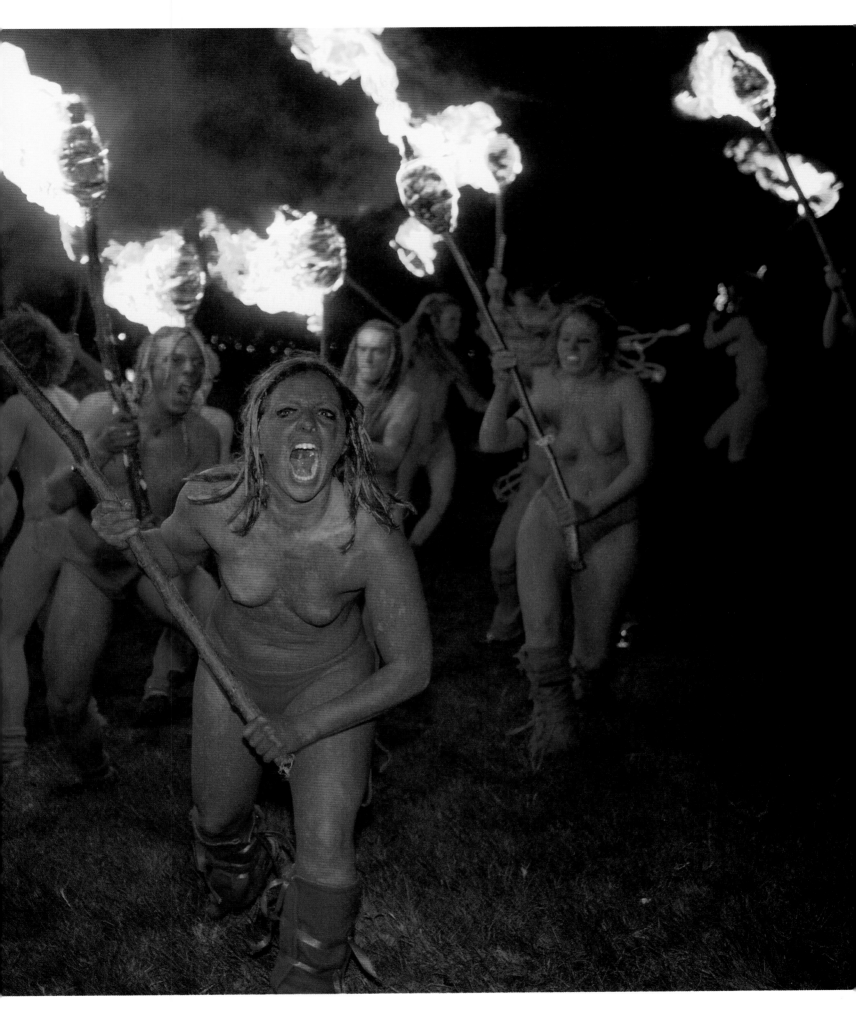

Red-painted performers participate in an ancient Celtic May Day festival that celebrates fertility at the Beltane Festival. **Jim Richardson, 2009**

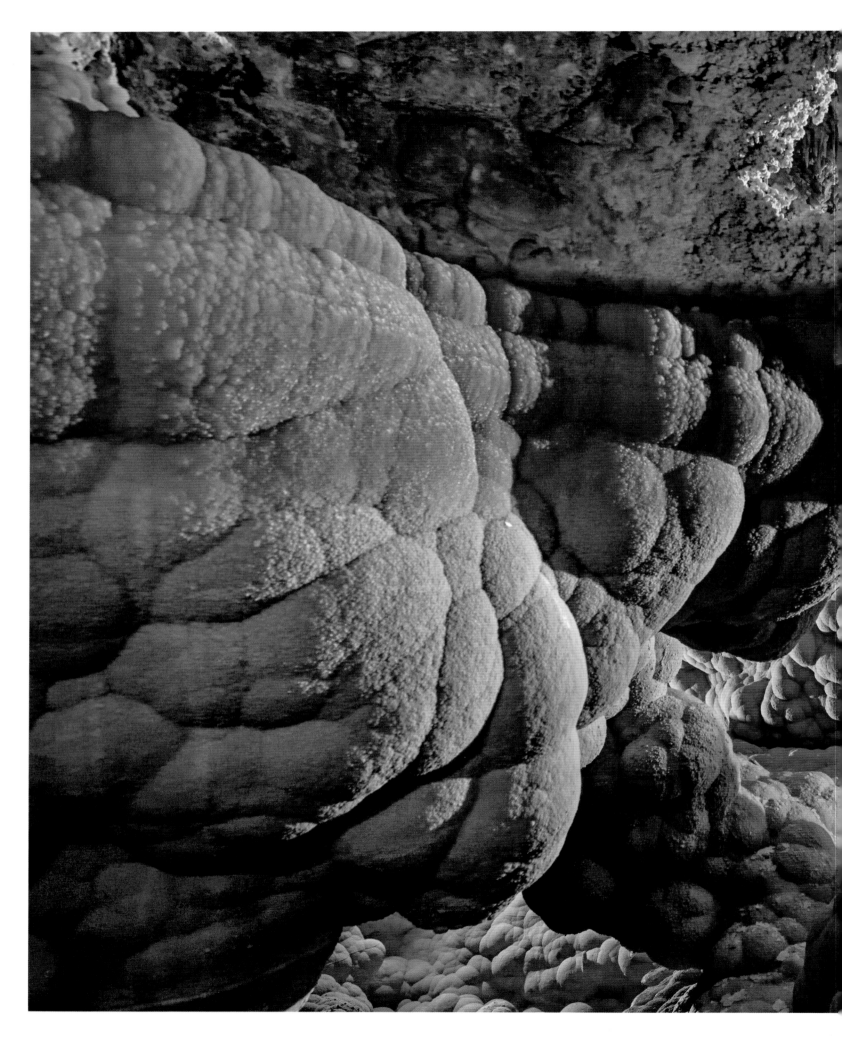

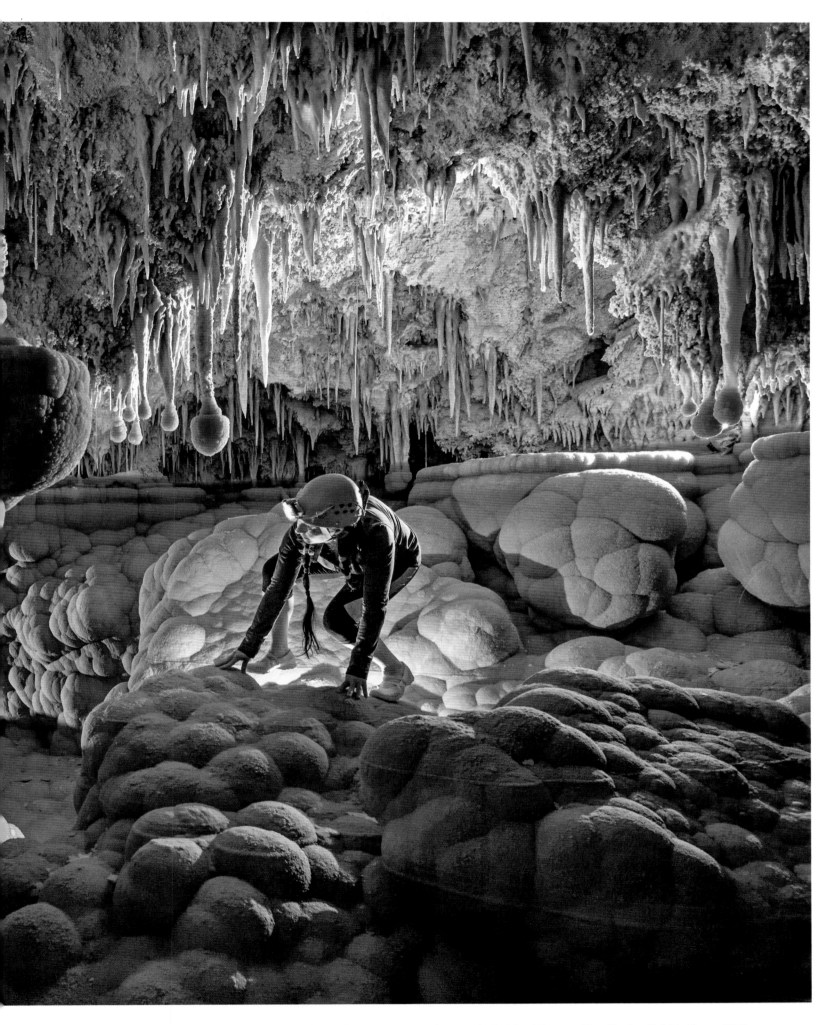

An explorer climbs over giant cave mammillaries that were once underwater in Carlsbad Caverns, New Mexico. **Robbie Shone, 2017**

HOPE

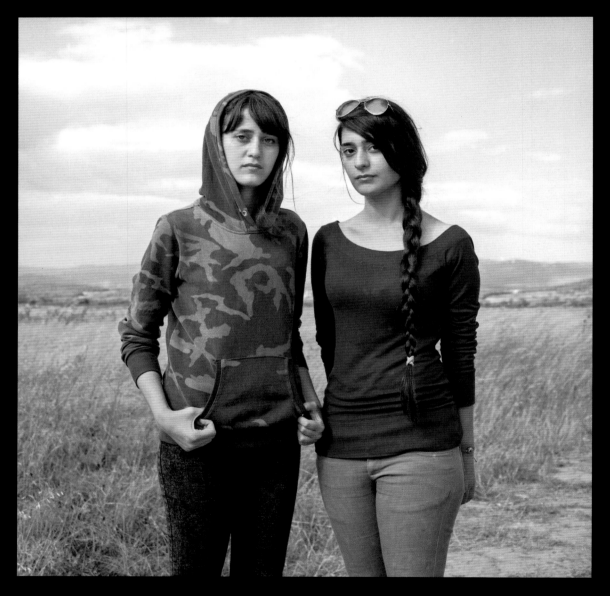

Syrian refugees wait on the Greece-Macedonia border for a chance to cross. *Rena Effendi, 2015*

Strength, love, beauty, wisdom, joy: Each is a facet of the human experience that National Geographic has chronicled in these pages. We've captured moments of universality that remind us how alike humans are—grief at a loss, valor in defense of others, resilience in the face of adversity.

And that brings us to hope, as common in each of us as breathing and yet as distinct to each of us as a fingerprint. We can see ourselves in all of these photos, in the hopes that they represent. The young newlyweds may hope for the longevity of the elderly couple beside them. The pediatric nurse surely shares the new mother's hopes that the baby will thrive.

The patients enduring treatment, the activists pressing their causes, the rebellious and curious young: They're living Oprah Winfrey's hopeful philosophy that "the world gets fixed when you fix yourself"—one person, one woman, at a time. And then go forth, as women have throughout history, to carry that hope into the future. ∎

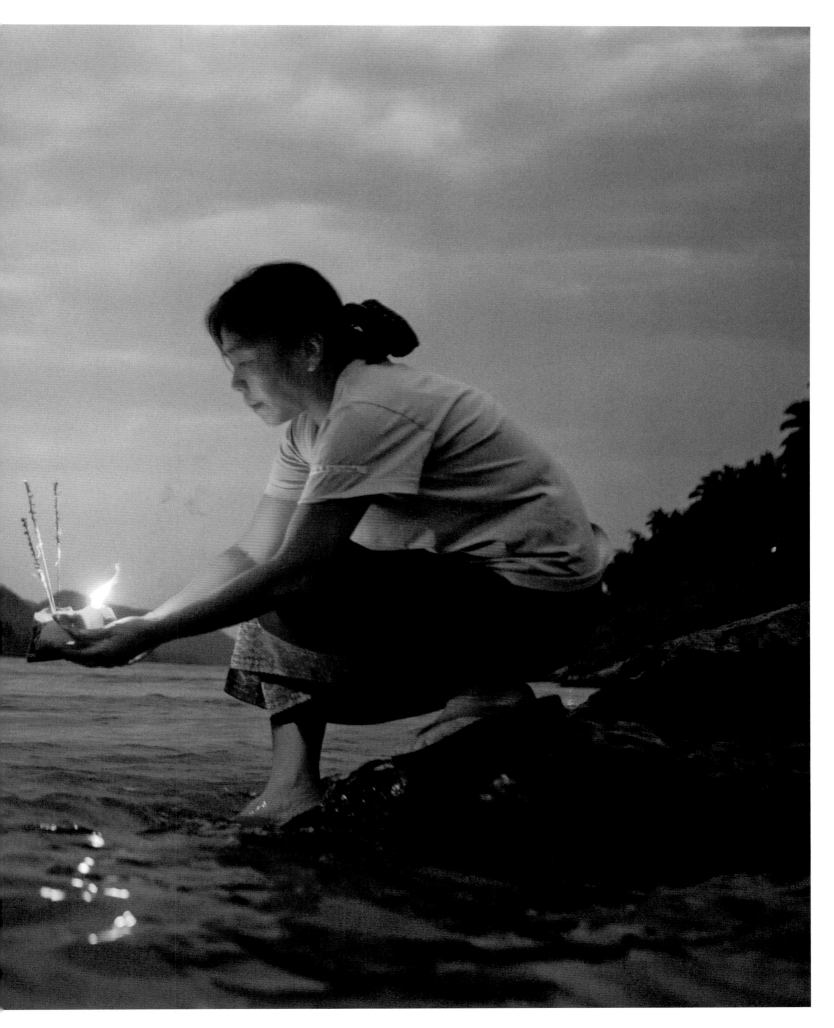

A woman launches an offering on the Mekong River, "the mother of waters," during a New Year's celebration in Laos. *John Stanmeyer, 2009*

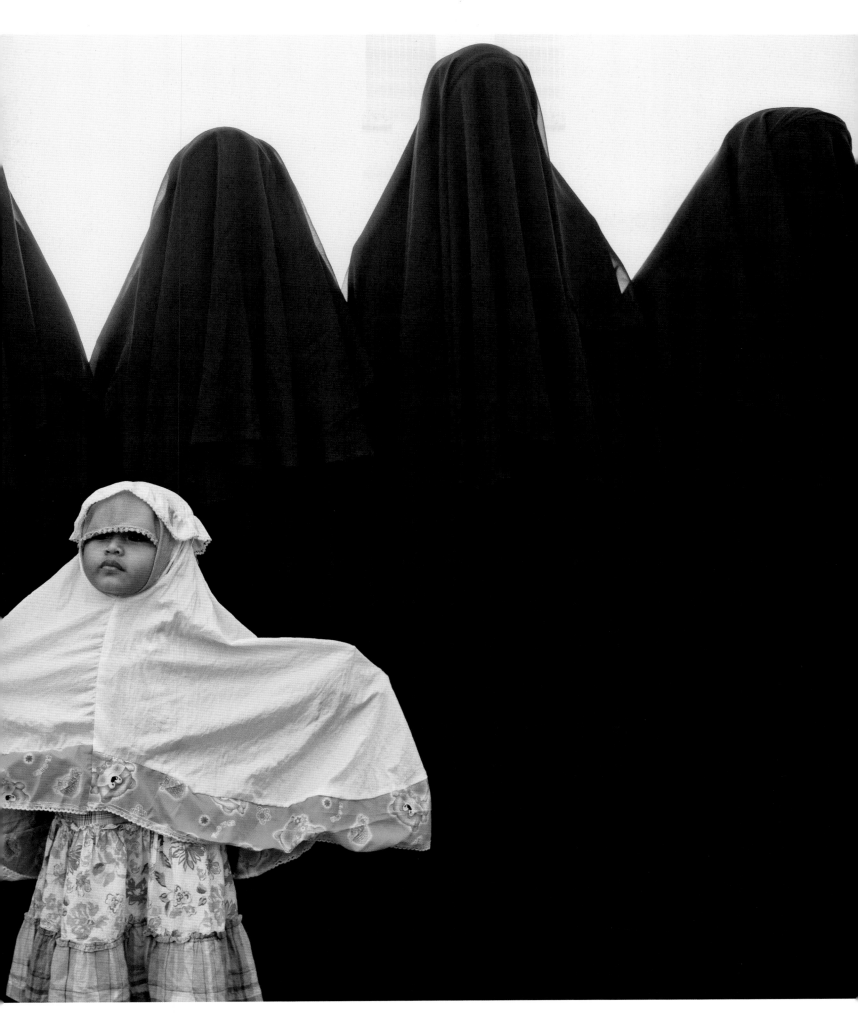

A young girl and women of the An-Nadzir commune begin the celebration of Islam's Feast of the Sacrifice in Indonesia. *James Nachtwey, 2007*

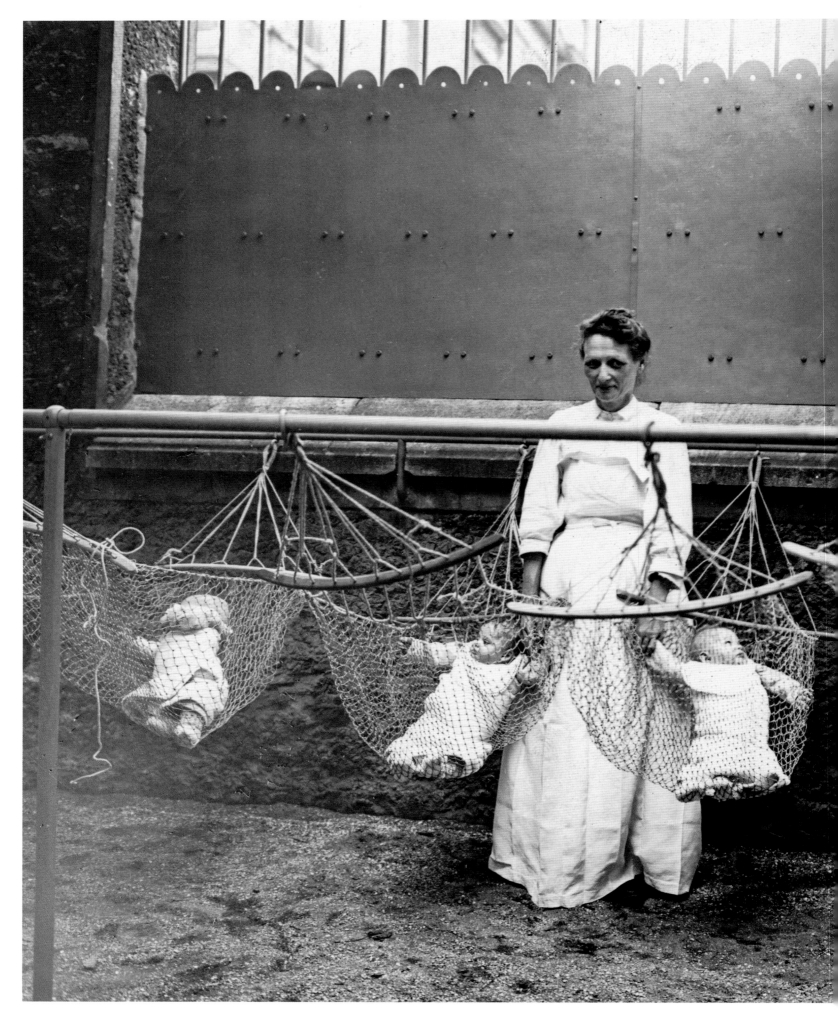

French mothers put their babies in nursery hammocks while they work during World War I. *H. C. Ellis, 1918*

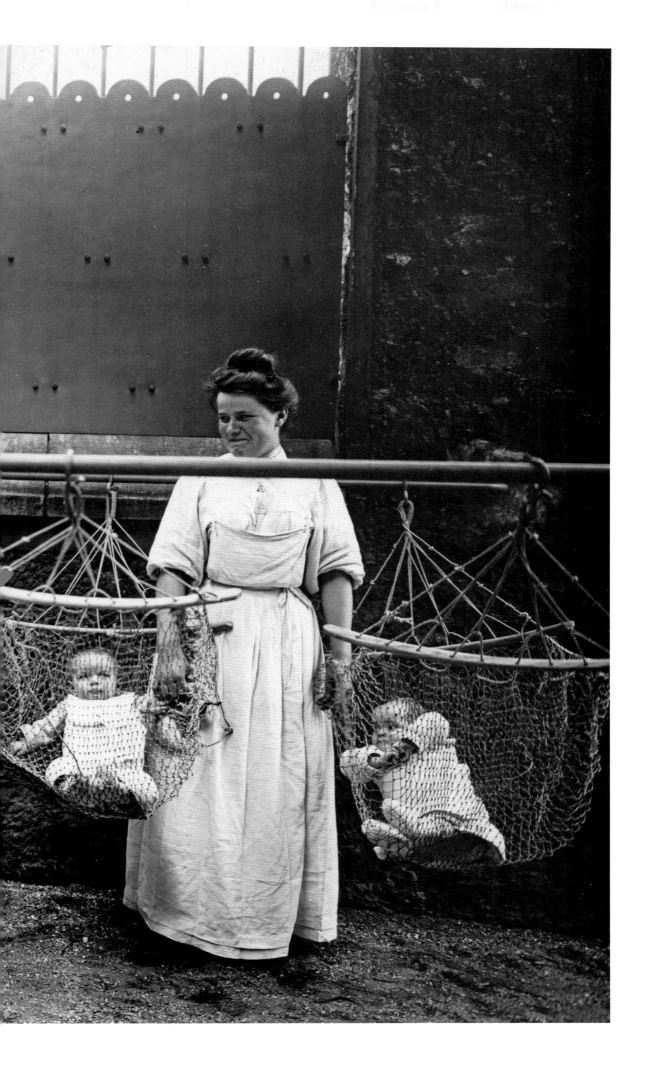

A woman waves the American flag during the March for Freedom rally
at the Lincoln Memorial in Washington, D.C. **James P. Blair, 1963**

Iman Saleh, a journalism student at Wayne State University in Detroit, who is Muslim, wraps herself in an American flag hijab. *Wayne Lawrence, 2017*

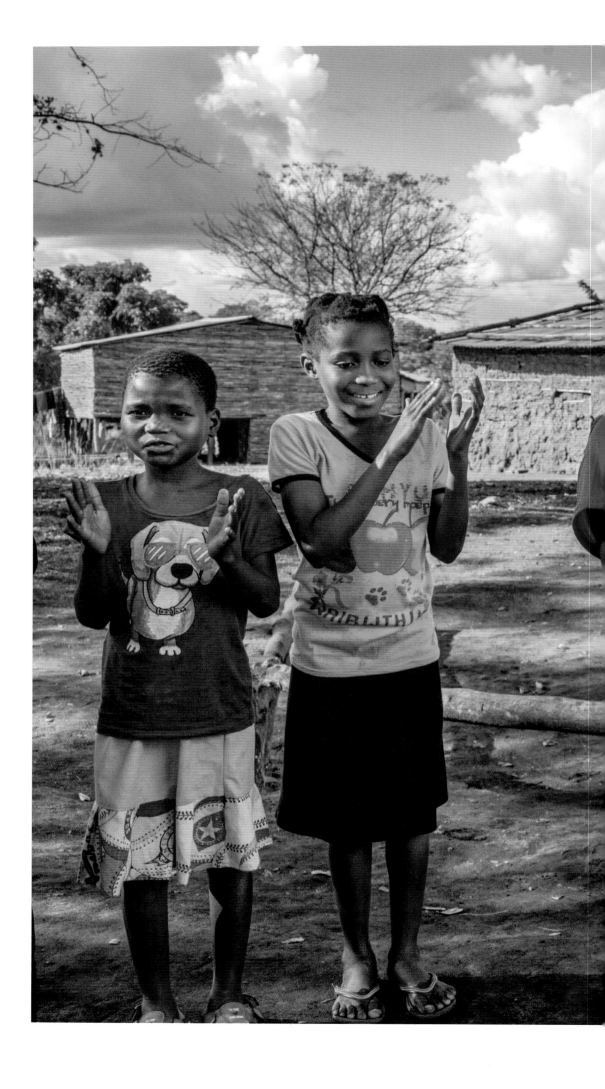

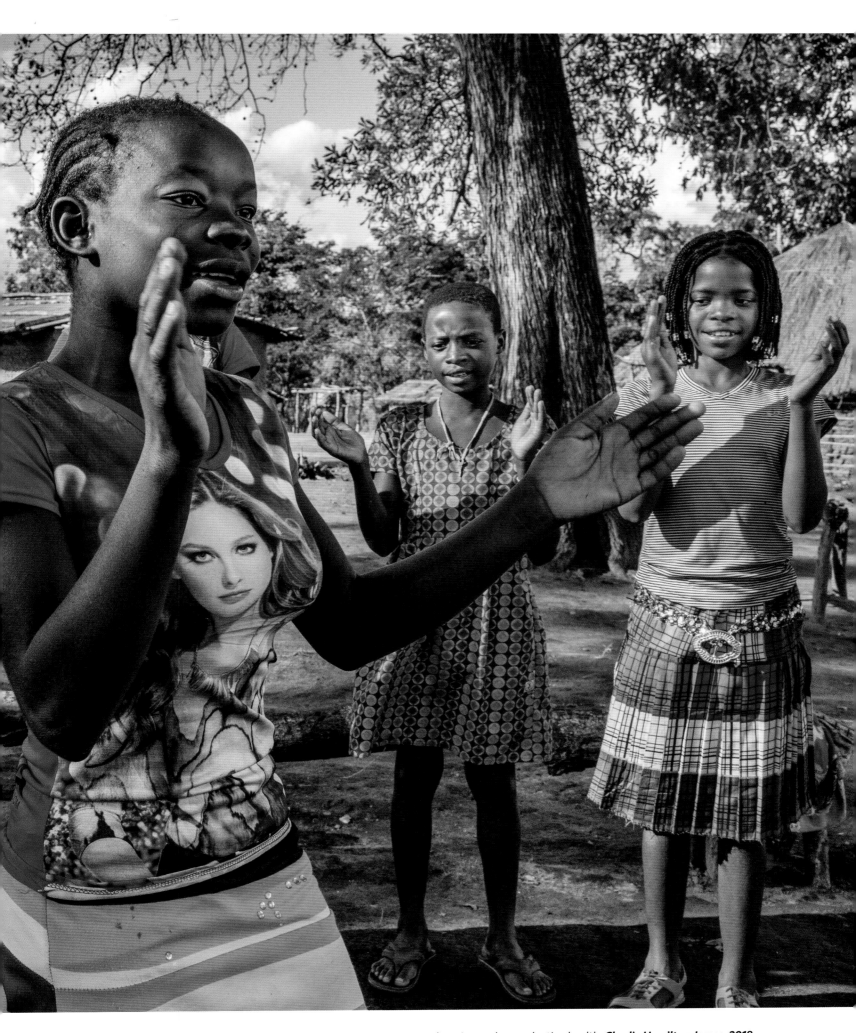

In the farming village of Mussinhá, Gorongosa Girls' Clubs meet to promote education and reproductive health. *Charlie Hamilton James, 2018*

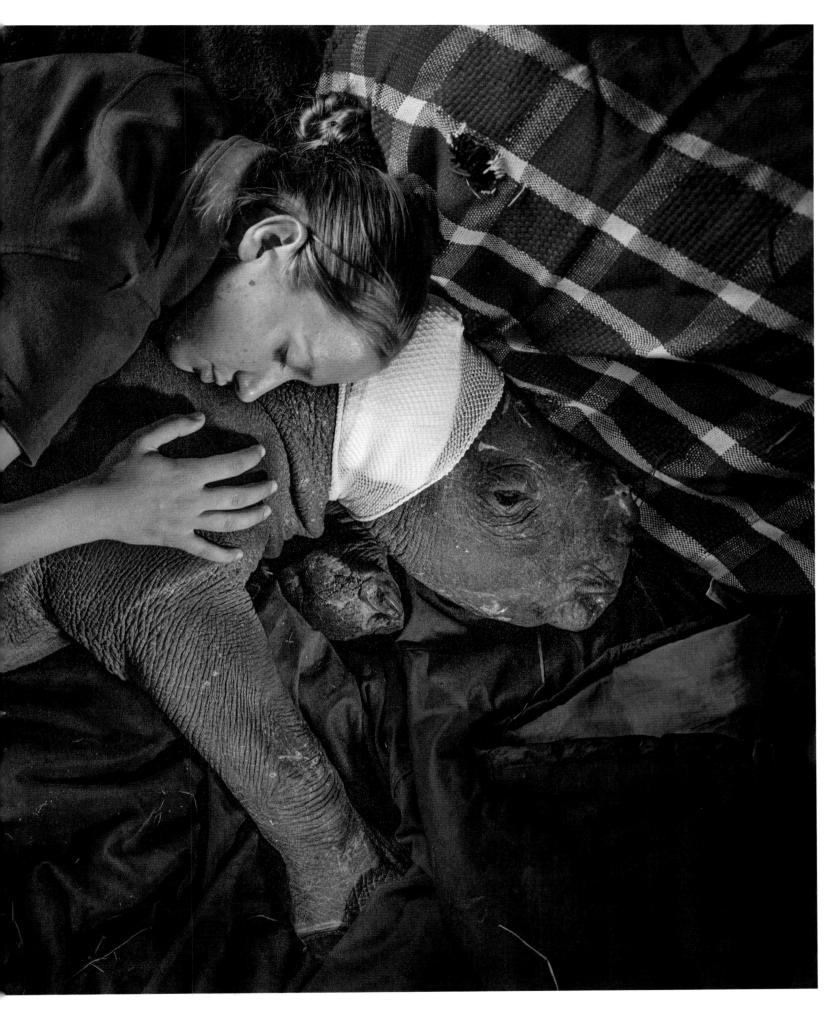

Dorota Ladosz, a sanctuary staff member in South Africa, comforts an orphan rhinoceros named Lulah that suffered injuries inflicted by hyenas. **Brent Stirton, 2016**

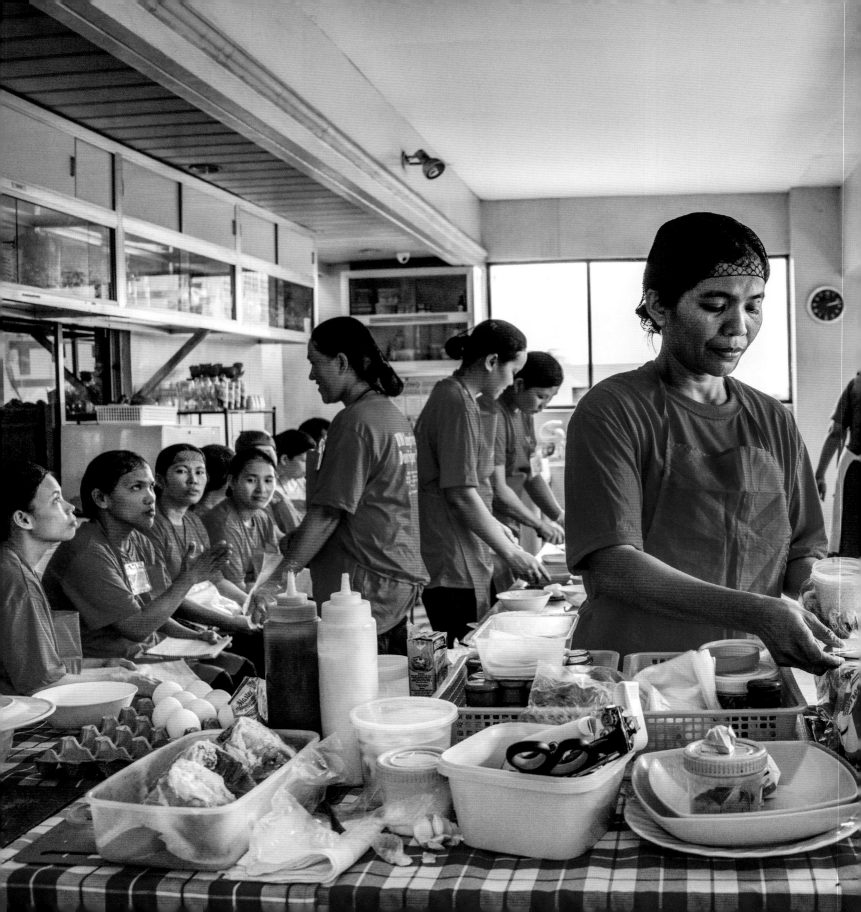

One in 10 Filipinos live abroad—workers are our greatest export. While on assignment for *National Geographic* I took this photograph at a school for domestic workers in Manila to help portray the Filipino diaspora. In our country it is traditional to eat with our hands and have meals together family-style; here domestic workers are trained to arrange salad spoons, cook foods they've never tried before, and learn what a four-course meal is. It's a physically and emotionally draining job—made even harder in a country not your own. You are tasked with caring for those in front of you in order to take care of those you left behind.

This image reminds me of how incredibly proud I am to be Filipina. It reminds me of the strength we are raised with. In covering the diaspora, I took a closer look at *alaga*, or "care," that is deeply embedded in our culture, especially among women. We are expected to care for others before ourselves, to quietly endure. I was raised with this kind of care, and that is what love means to me. ∎

HANNAH REYES MORALES

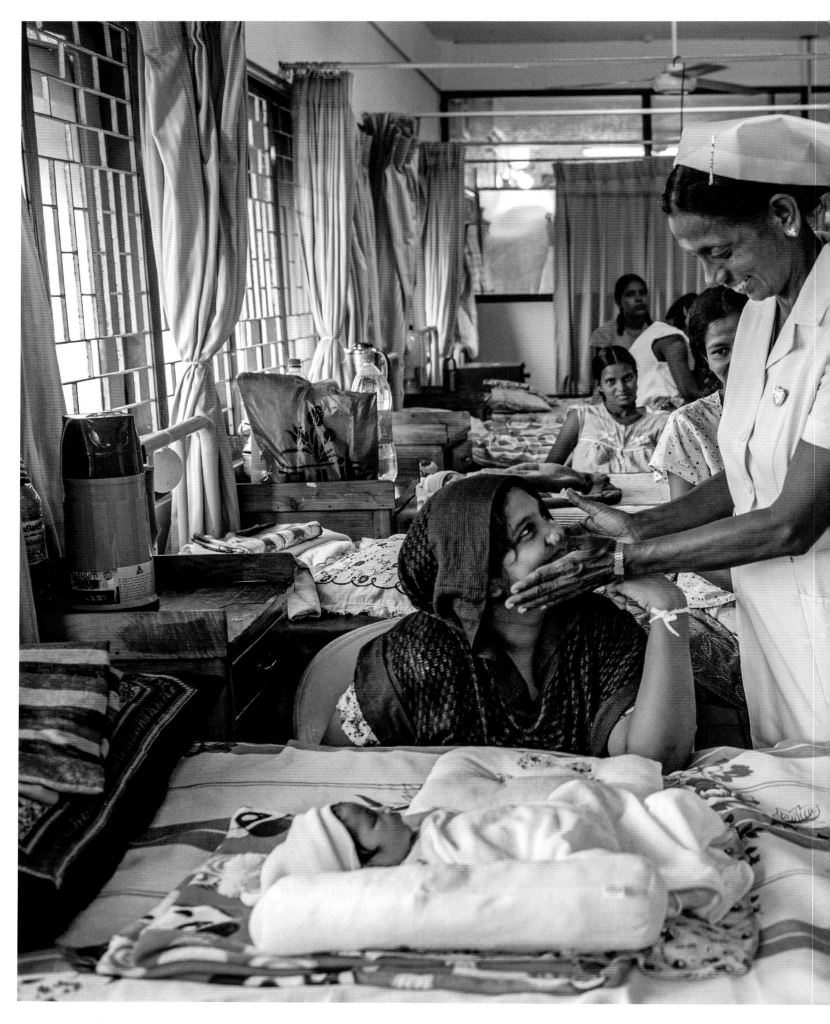

A mother receives praise from a nurse as her newborn baby rests at the Jaffna Teaching Hospital in Sri Lanka. *Ami Vitale, 2016*

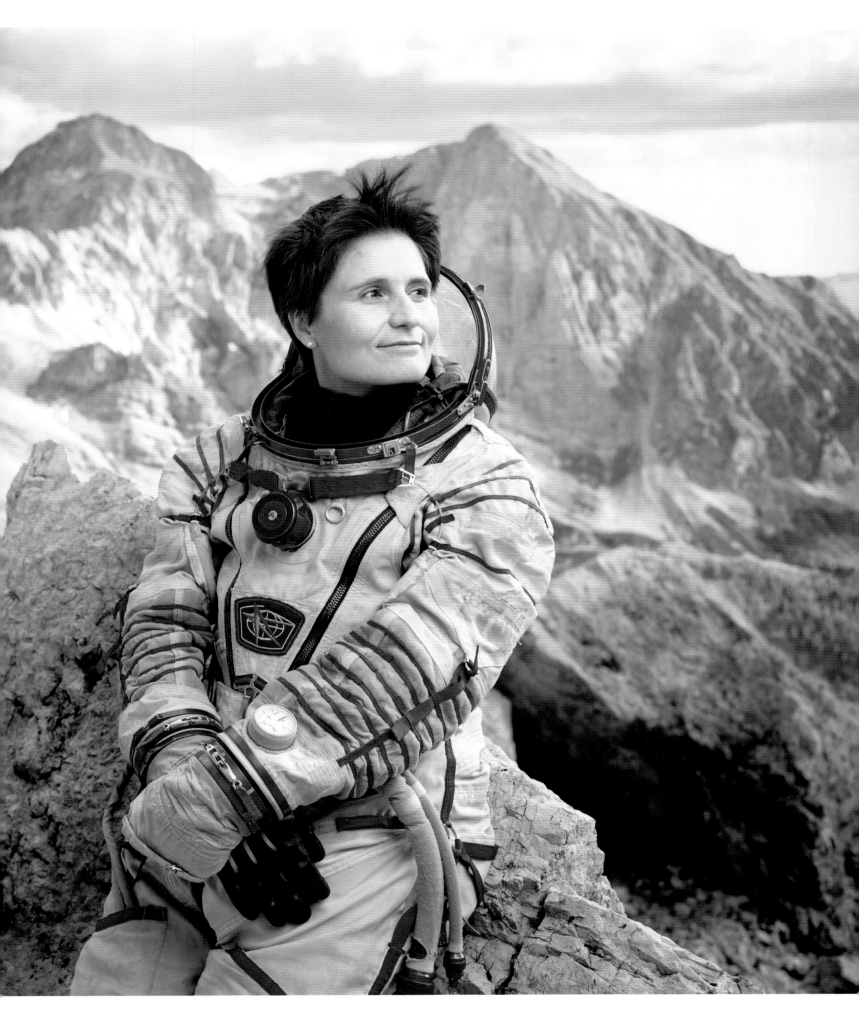

Italian astronaut Samantha Cristoforetti once held the record for the longest space mission by a woman—nearly 200 days. *Martin Schoeller, 2017*

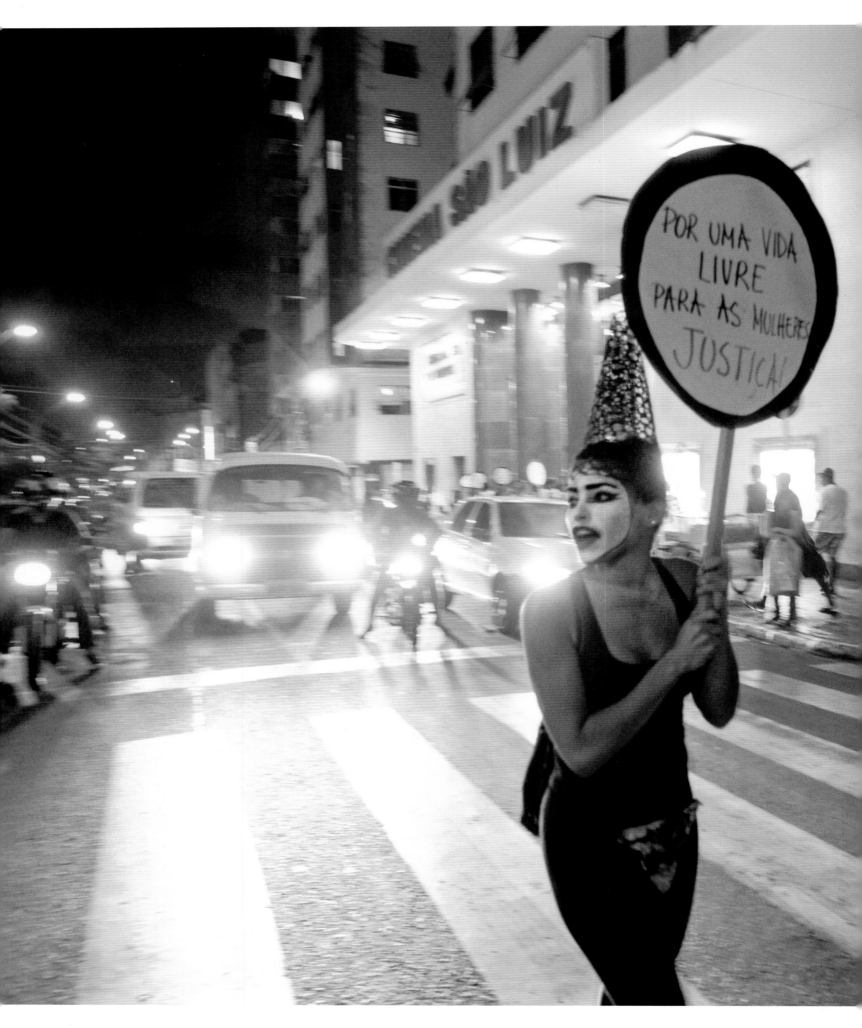

An activist in Recife, Brazil, participates in a demonstration demanding the end to violence against women. *John Stanmeyer, 2010*

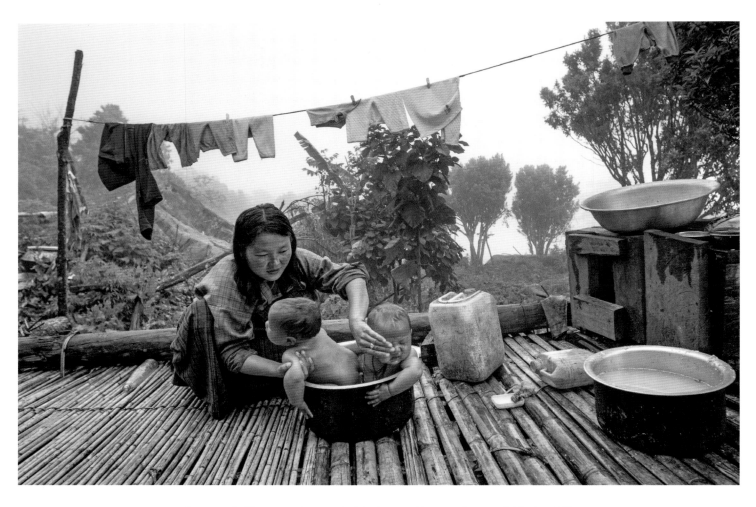

A woman in Bhutan washes two babies in a cooking pot. *Lynsey Addario, 2008*

An infant rests with her mother at Movie Wonderland Theme Park in Manchuria. *Fritz Hoffmann, 2006*

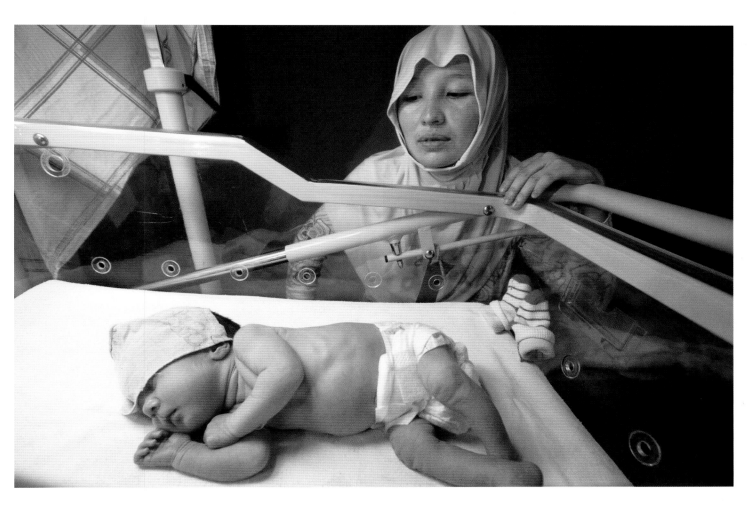

A mother in Kazakhstan keeps watch over her prematurely born child. *Gerd Ludwig, 2011*

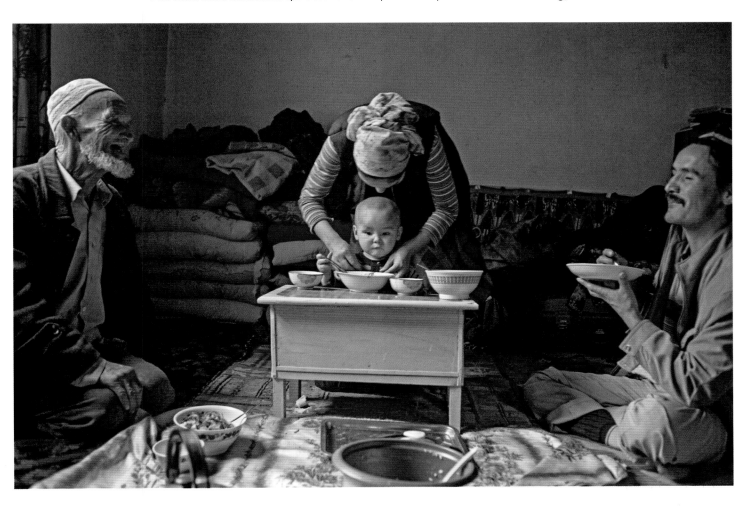

A Uyghur family shares a meal in Layka, China. *Carolyn Drake, 2008*

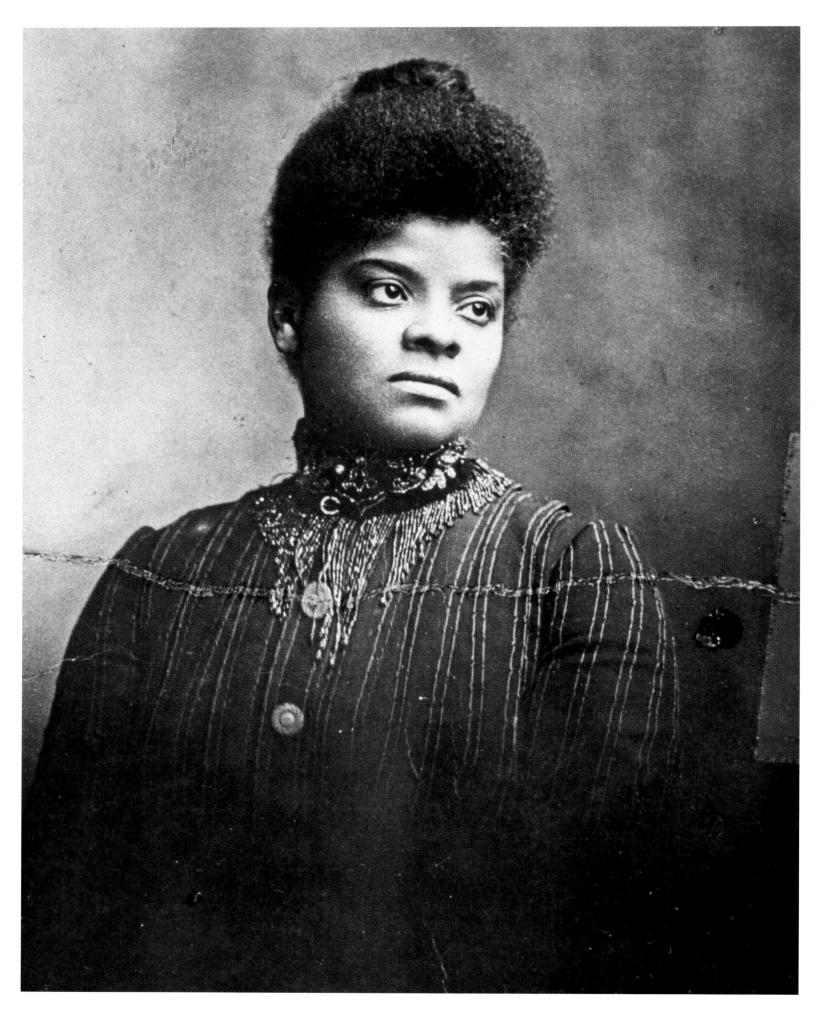

Journalist and civil rights activist Ida B. Wells rallied against injustices faced by people of color until her death in 1931. *Cihak and Zima, 1890s*

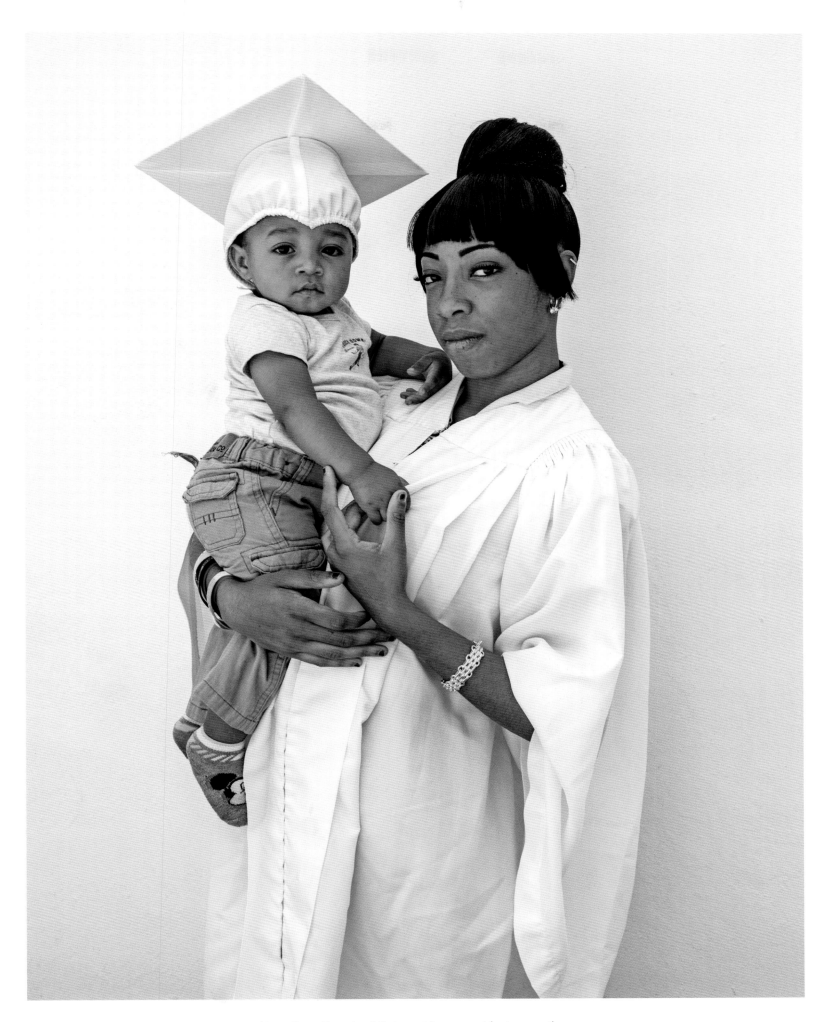

At an alternative school that provides support for teen mothers, a recent graduate holds her 11-month-old son. *Kitra Cahana, 2016*

THROUGH
THE LENS

On my first *National Geographic* assignment, I visited Bidibidi in Uganda, one of the world's largest refugee settlements. I've often thought about what I would bring with me if I was forced to leave my own home, and when I asked that question here, the word that kept coming up was *milaya*. These colorful, beautifully embroidered bedsheets have been made in South Sudan for generations; the one you see here is being held behind 17-year-old Irene "Soni" Sonias by her sisters.

By the end of 2018, I had taken more than 100 milaya portraits while working on other stories in Bidibidi. I was struck by the pride and joy in each of the women's faces when showing me these beautiful patterns from home. This is something they've learned from their mothers and grand-mothers; it's a part of both their history and their future, once they teach it to their own children. The war forced many women to leave their homes behind, but I've also seen how it has made them grow. Many sell milayas to become more financially independent. Soni, by the way, moved back to South Sudan and is now studying in Juba to be an accountant. ∎

NORA LOREK

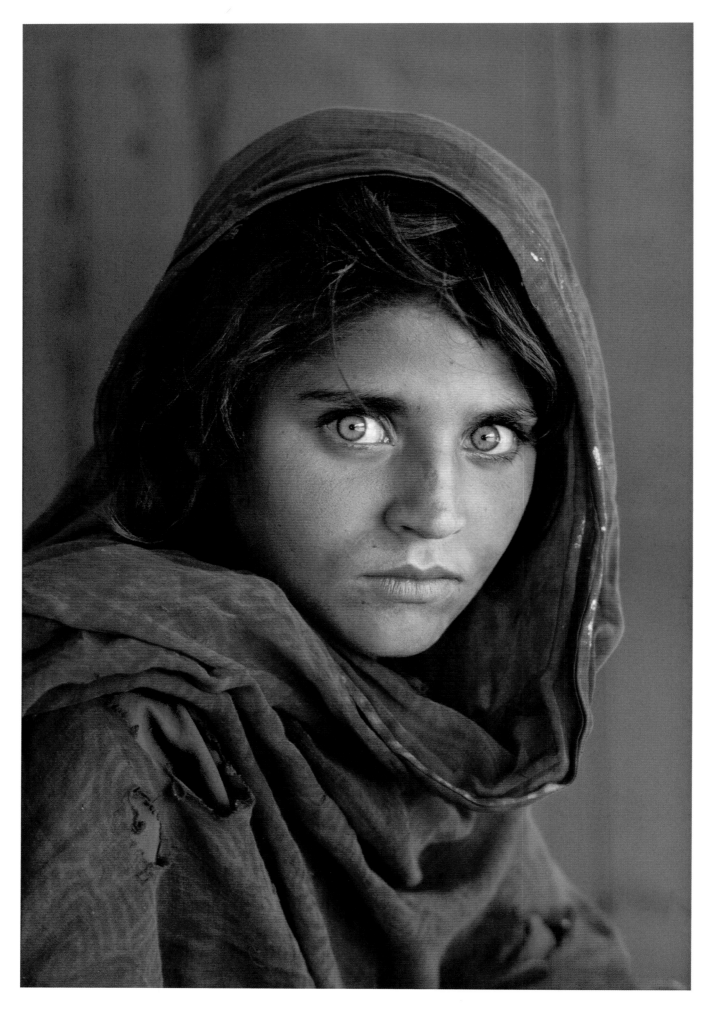

The "Afghan Girl," Sharbat Gula, sits at a refugee camp in Pakistan. **Steve McCurry, 1984**

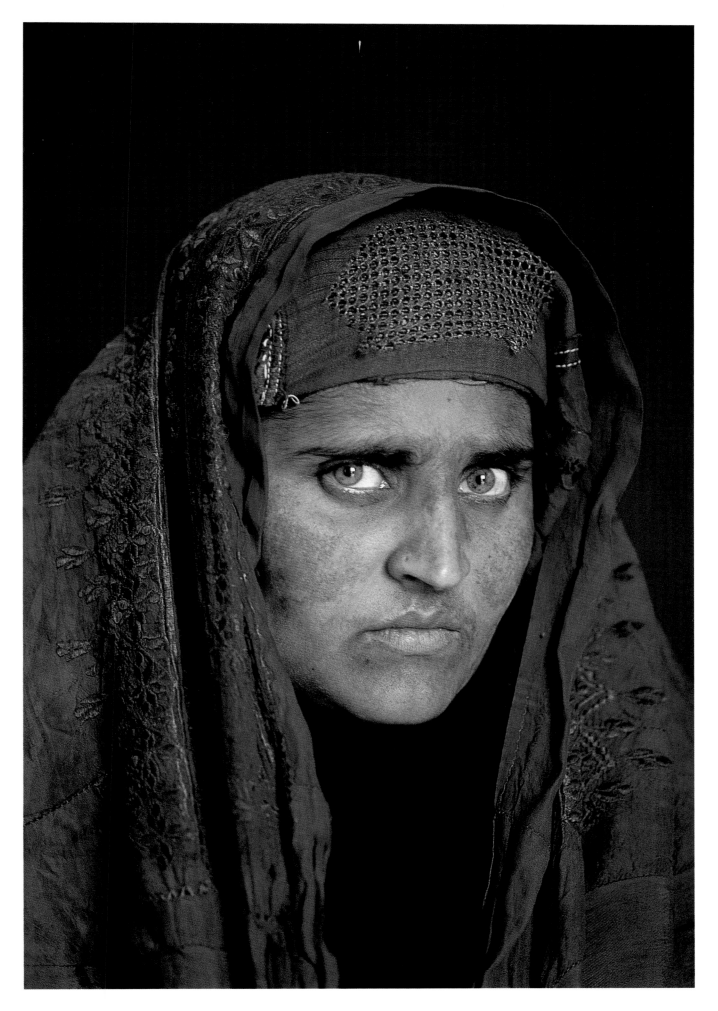

Eighteen years after her photo was taken, Sharbat Gula, now living in the mountains
near Tora Bora, gazes at the camera again. **Steve McCurry, 2002**

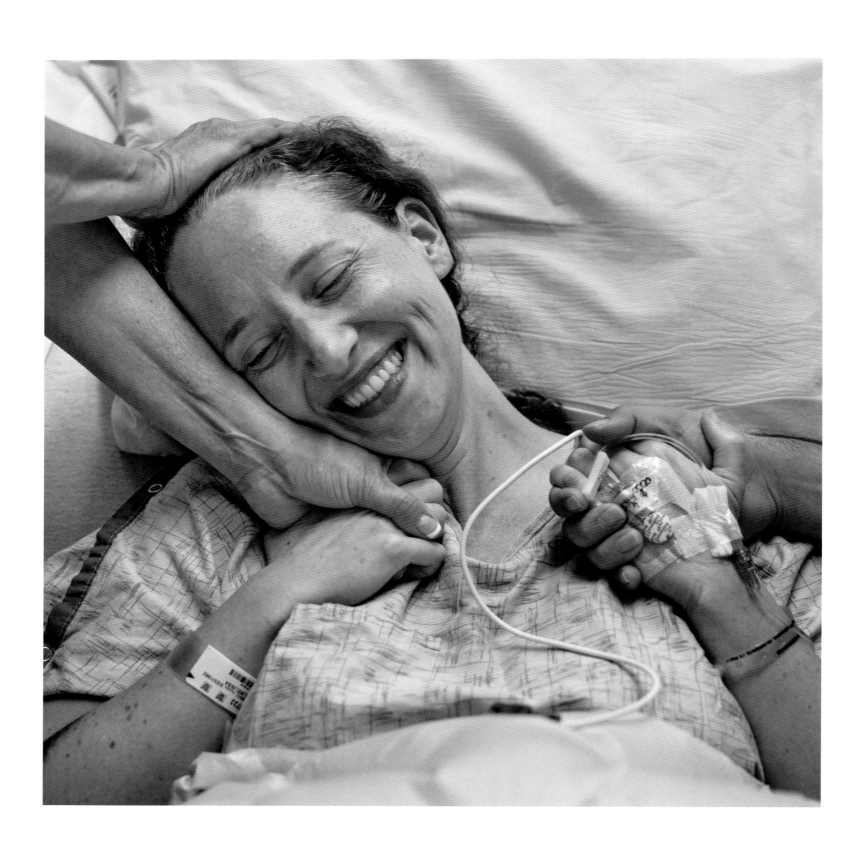

A woman in Sacramento relaxes with the support of family after donating her kidney to a stranger. *Lynn Johnson 2017*

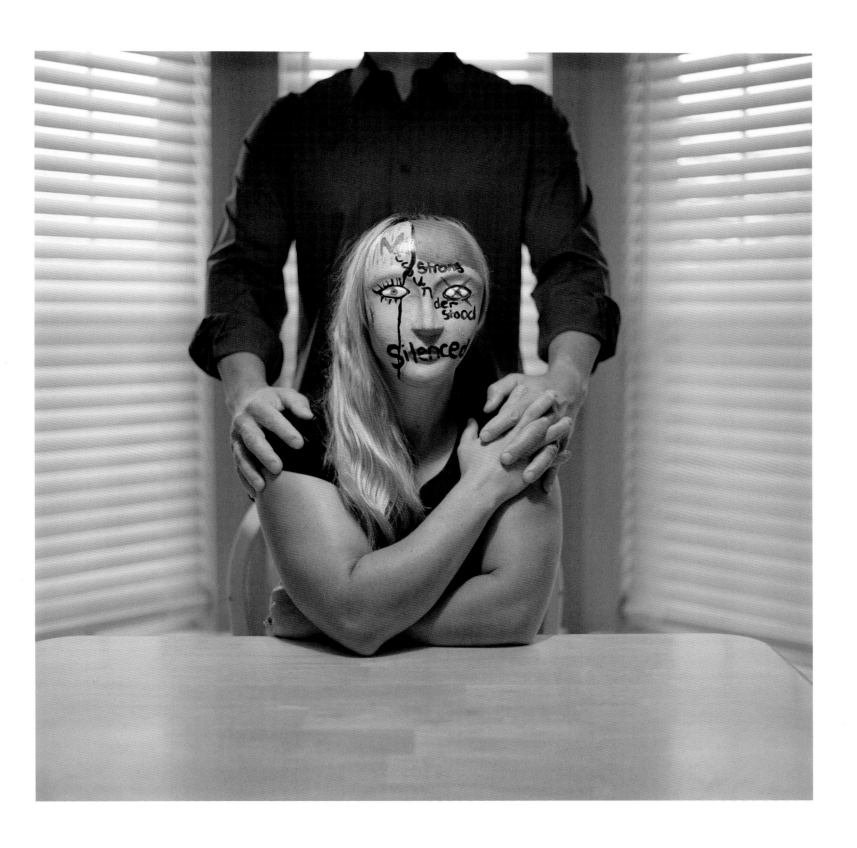

A Marine gunnery sergeant, who served in Iraq and Afghanistan, wears a mask created at a therapeutic art program at the National Intrepid Center of Excellence. *Lynn Johnson, 2015*

Maya Ying Lin, who designed the Vietnam Veterans Memorial, stands in front of her creation on a snowy day in Washington, D.C. **James P. Blair, 1985**

THE LENS

This is the moment during Katie Stubblefield's face transplant that the donor's face rested briefly in between owners and identities. It's a completely unique and surreal moment. What in our everyday lives prepares us to witness the transfer of one person's essential identity to another? On the surface, this image is about the men surrounding the surgical table and the possibilities of human transplantation. But, as with many situations, it is women who made this moment significant. It was Katie, suffering from depression and the challenges of teenage years, who raised a gun to her face and pulled the trigger. It was a woman who pioneered face transplantation. It was a woman who was brave enough to donate her granddaughter's face to Katie. And it is a shocking fact that there is a 70 percent increase in suicide rates for young women today, largely because of the powerful influence of social media. ∎

LYNN JOHNSON

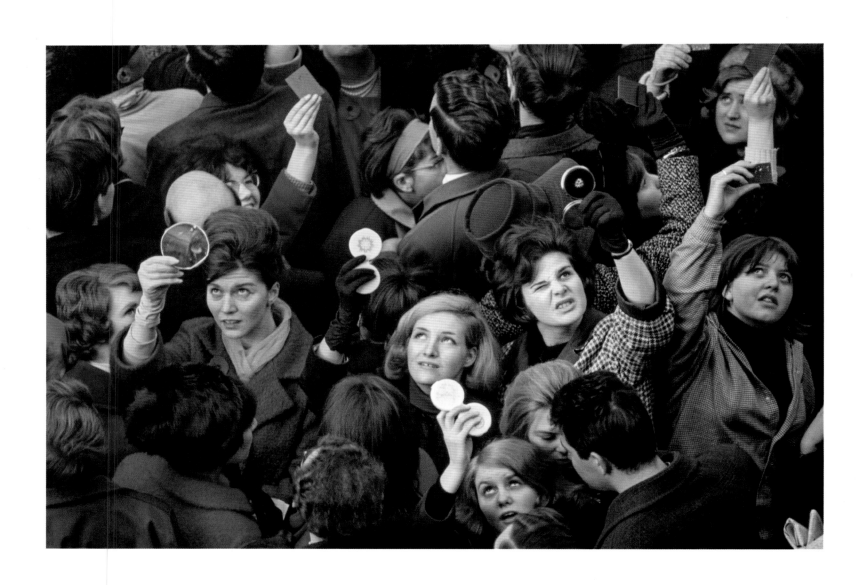

Women in London use compact mirrors to catch a glimpse of the queen. *James P. Blair, 1966*

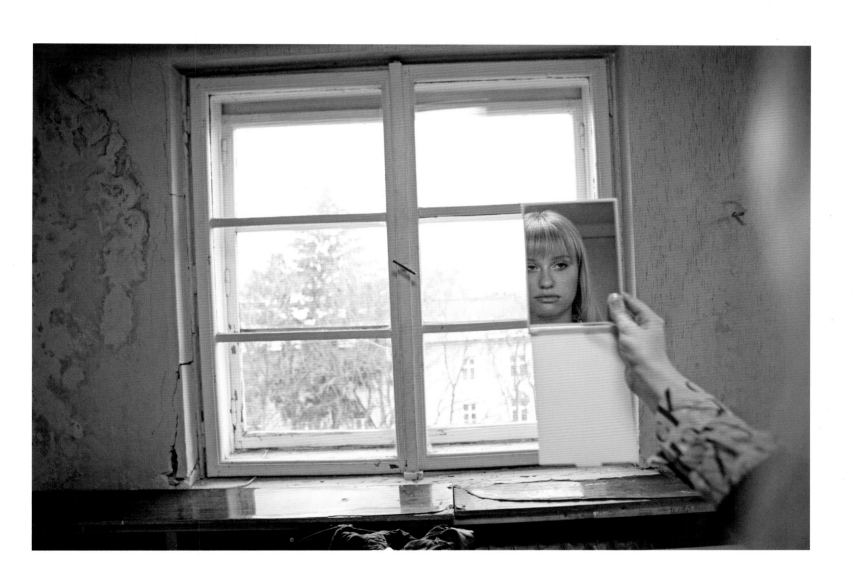

An aspiring model in Ukraine studies her reflection in the mirror. **Carolyn Drake, 2007**

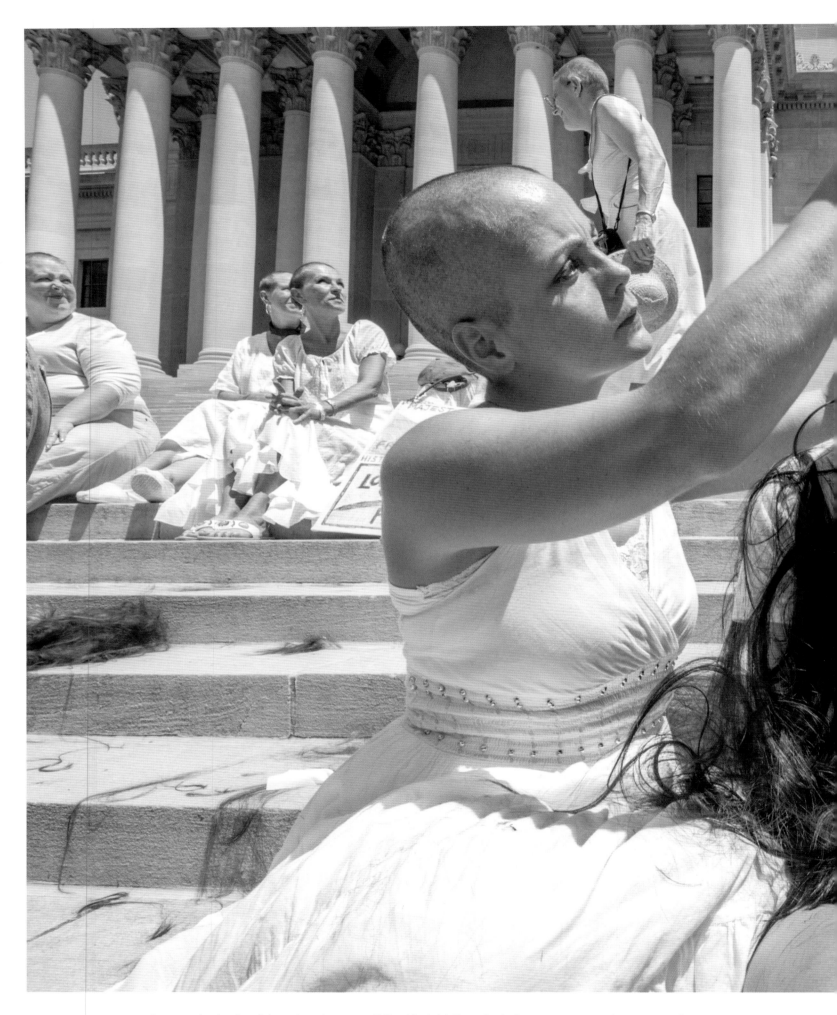

A woman has her head shaved on the steps of West Virginia's State Capitol to protest mountaintop removal and the devastating health and human rights violations in coal mining communities. *Ami Vitale, 2012*

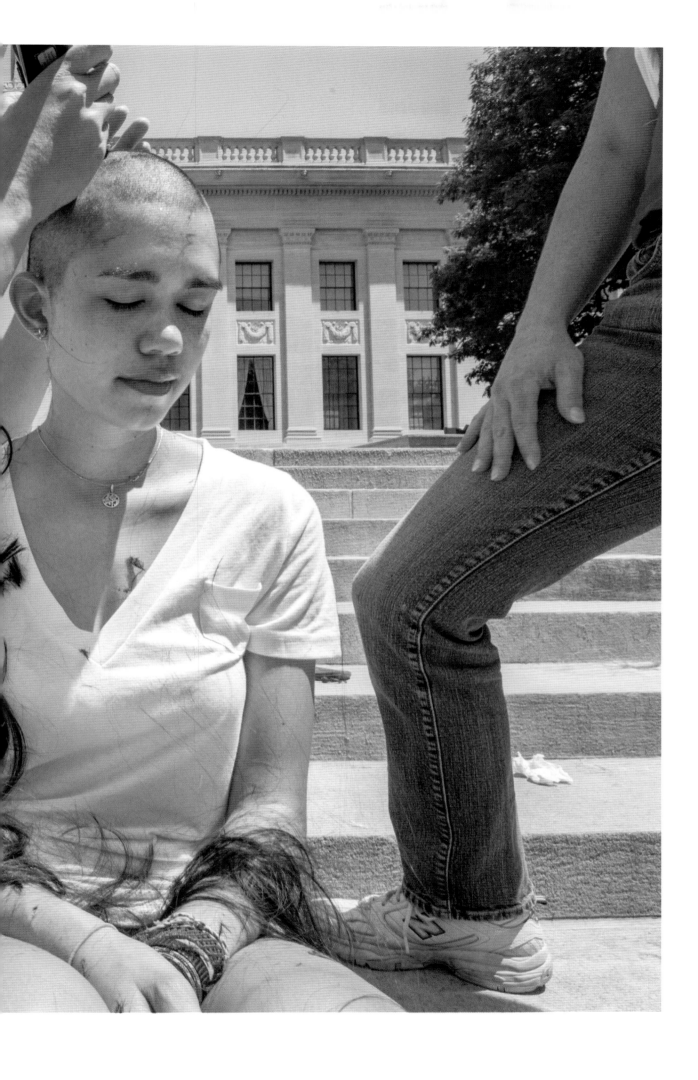

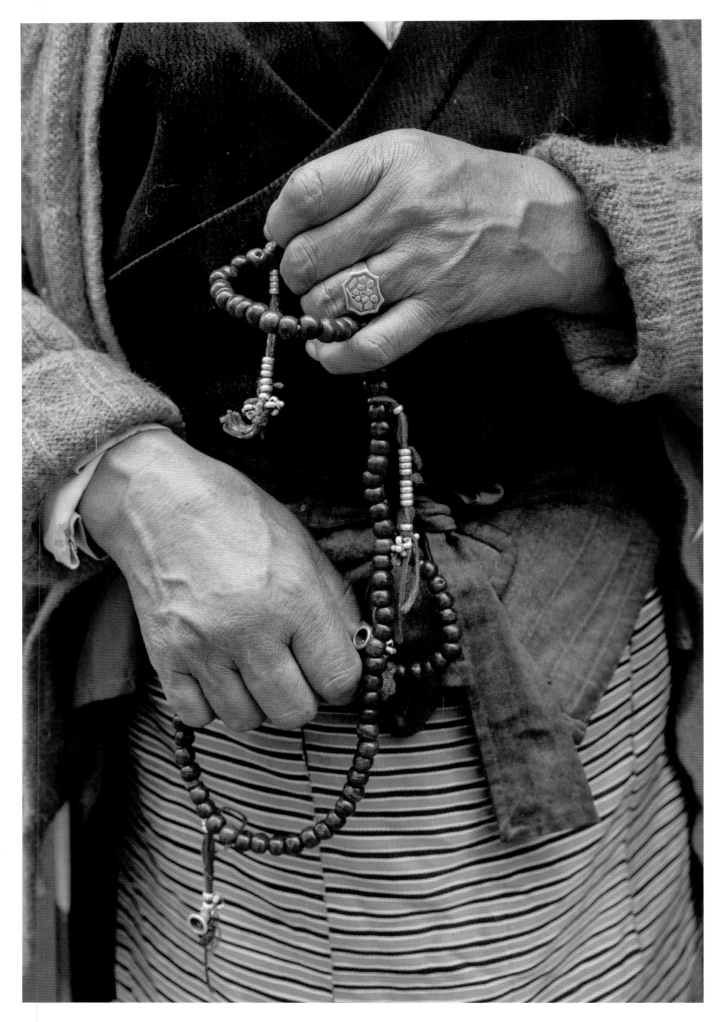

A Nepalese woman holds prayer beads. *Pete McBride, 2006*

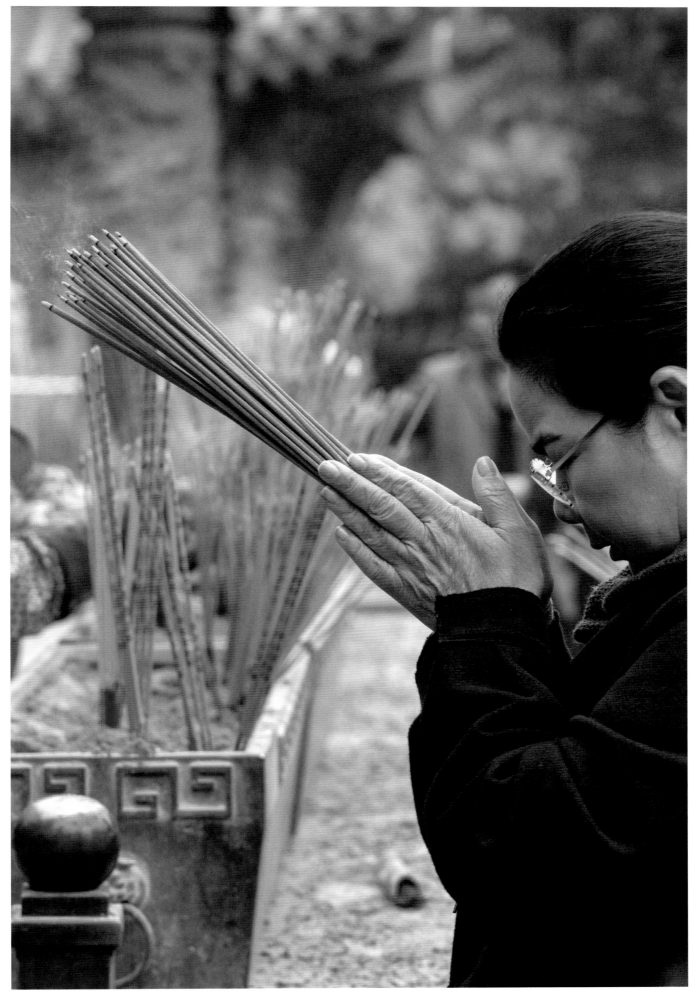

A worshipper holds incense sticks inside the Wong Tai Sin Temple in Hong Kong. *Sean Gallagher, 2012*

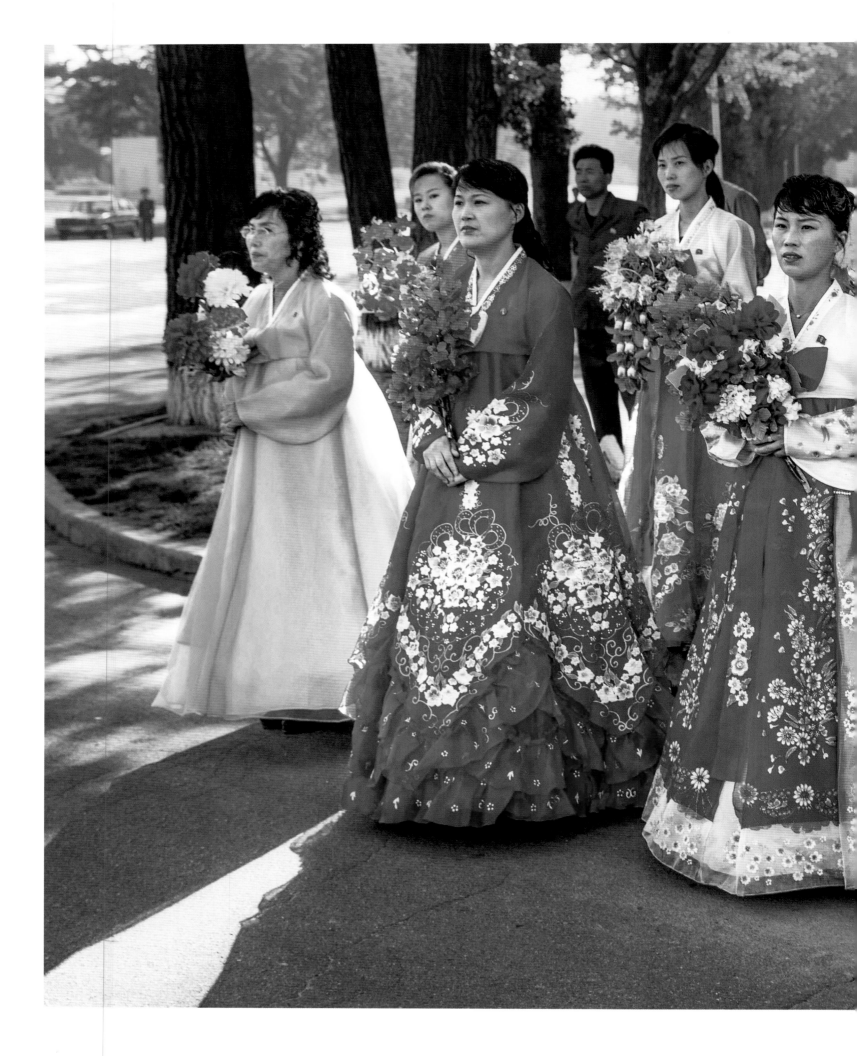

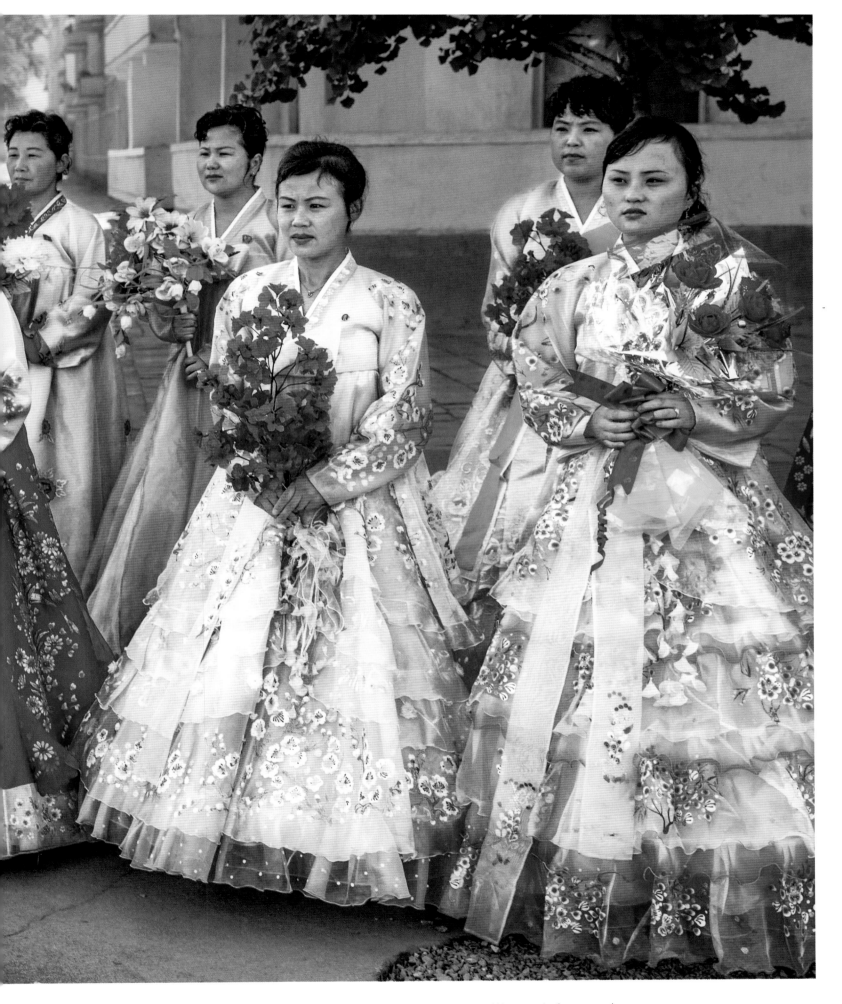

North Korean women gather on the street in central Kaesong before a march
for peace and reunification on the Korean peninsula. *David Guttenfelder, 2015*

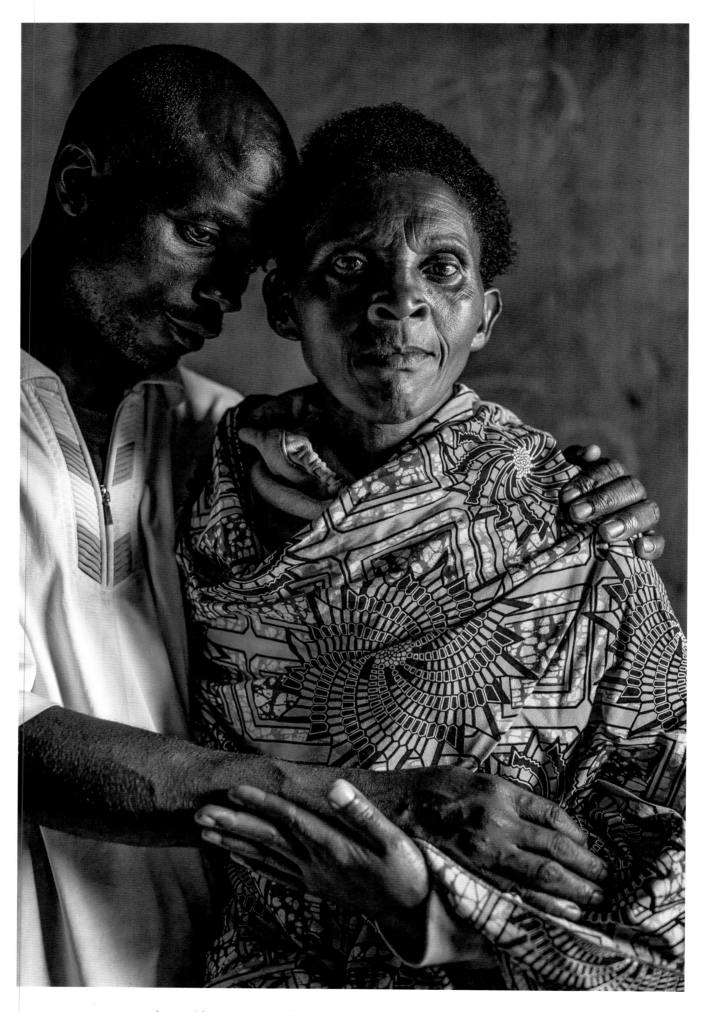

A genocide perpetrator in Rwanda asks forgiveness of a woman whose children he had targeted by killers. **John Stanmeyer, 2017**

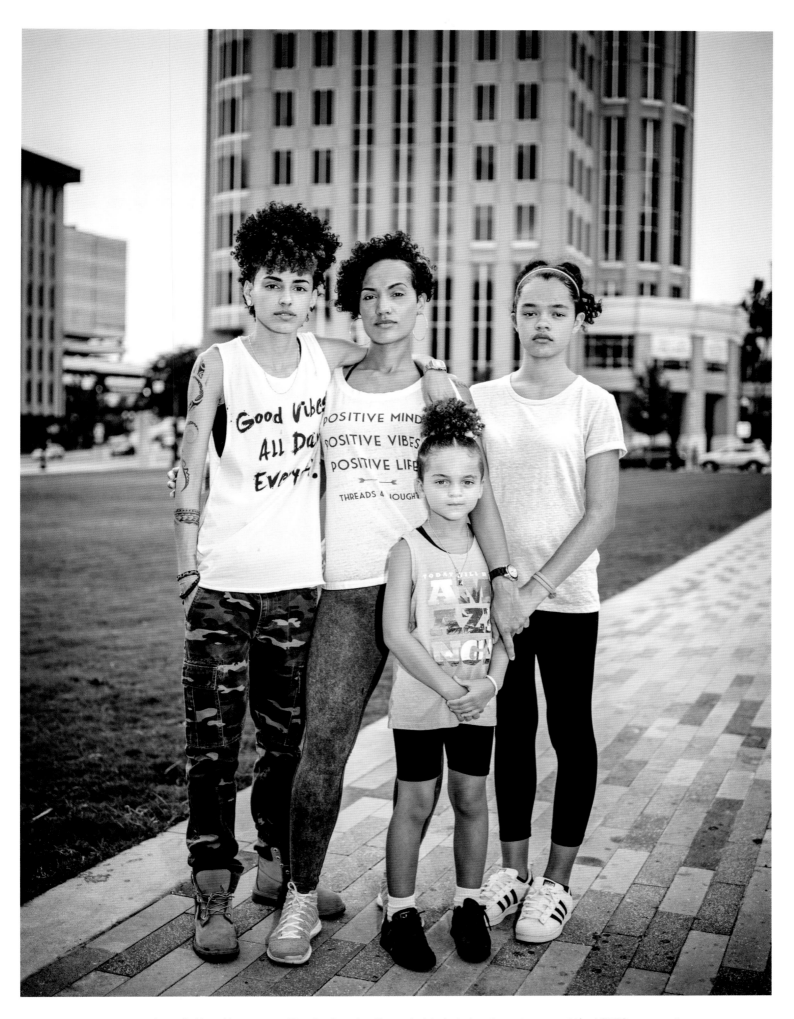

Xiomara Flores (left) and her partner Timisha Grandstaff stand with their daughters to support the LGBTQ community after the Pulse nightclub shooting in Orlando. *Wayne Lawrence, 2016*

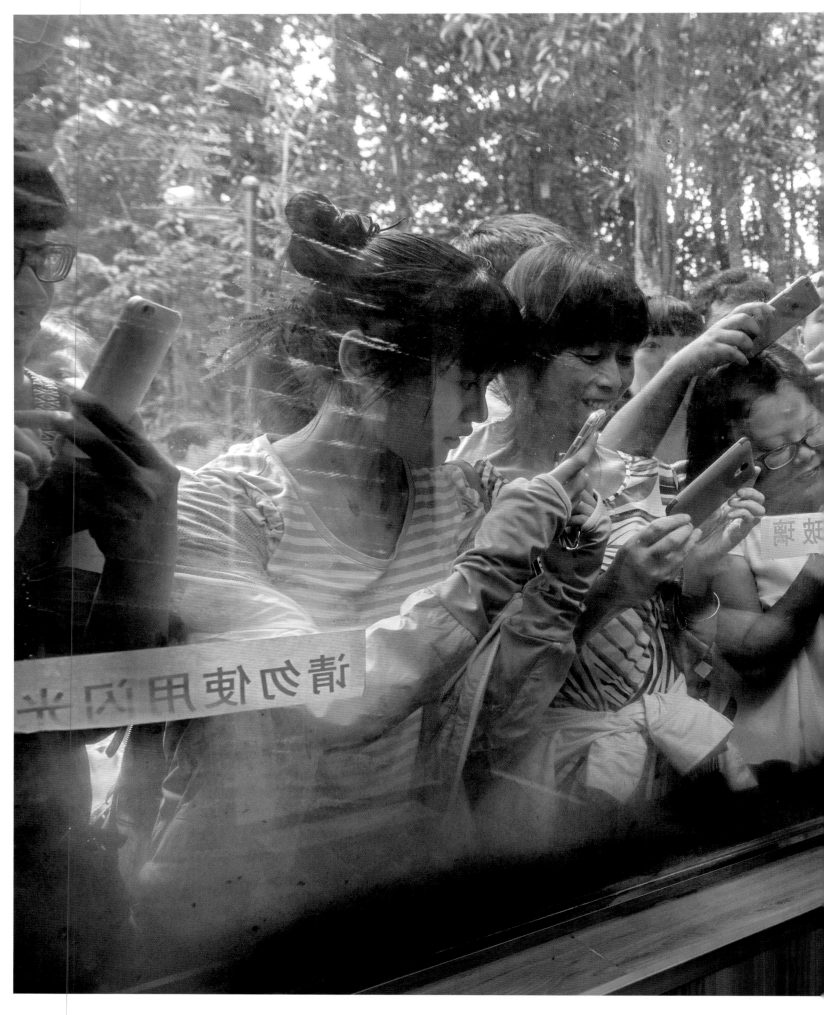

A caregiver cradles a baby panda at the Bifengxia nursery in China, so visitors can get a better look. *Ami Vitale, 2015*

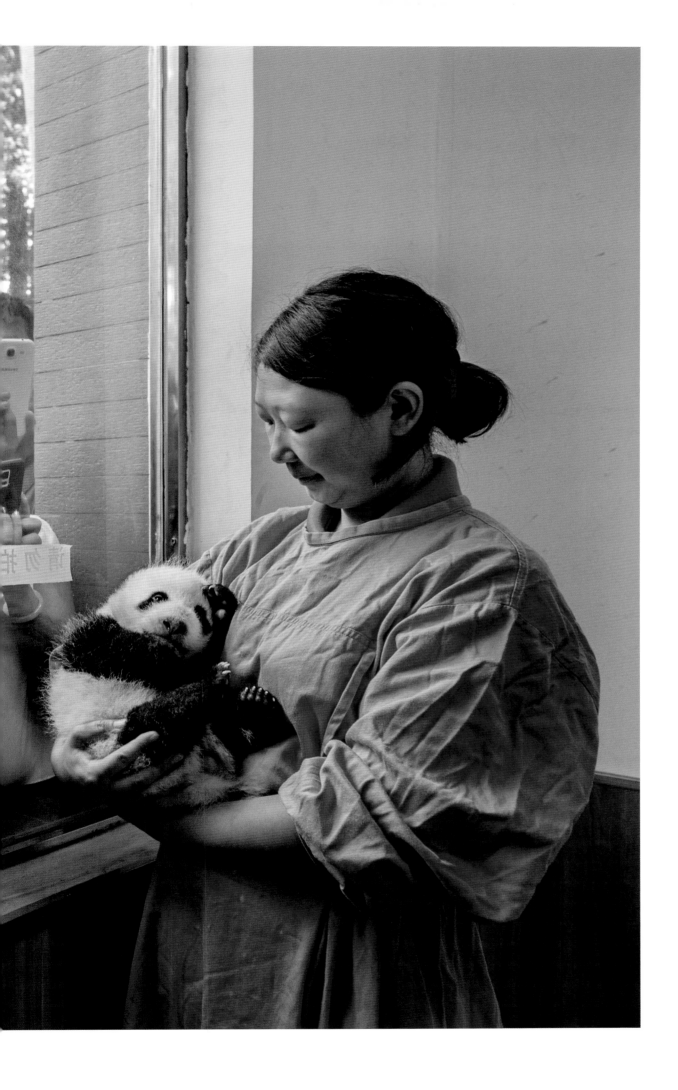

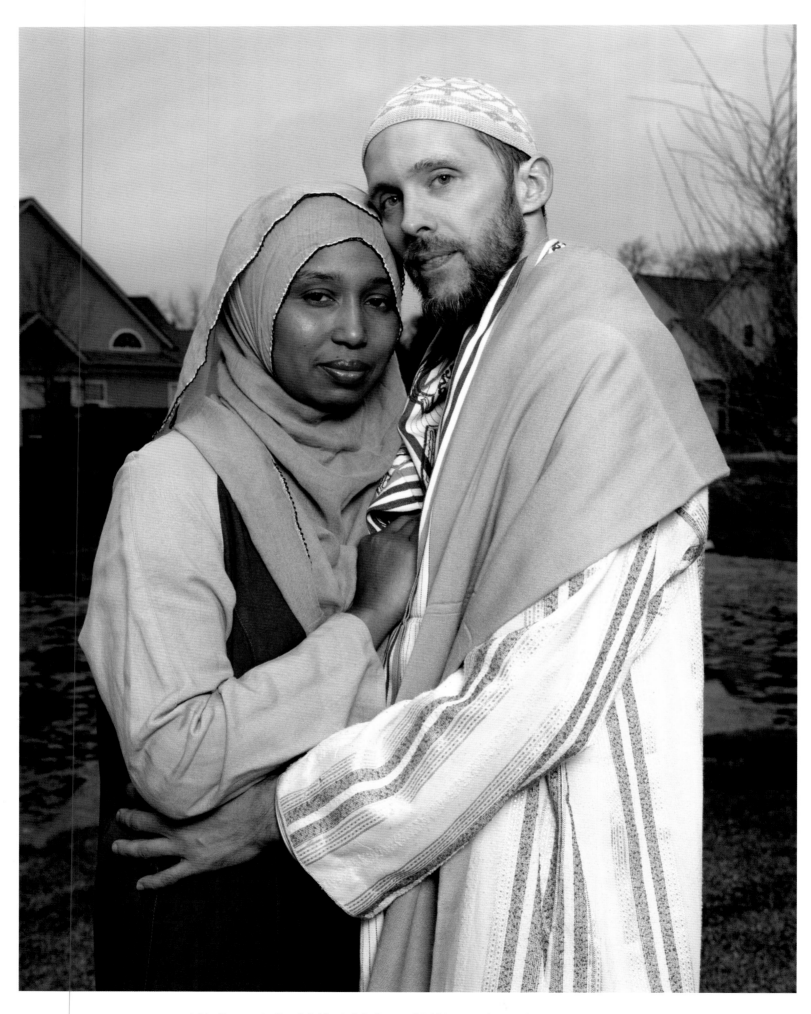

A Muslim couple, Kamilah Munirah Bolling and Adil Justin Cole, stand outside their home in Farmington Hills, Michigan. *Wayne Lawrence, 2017*

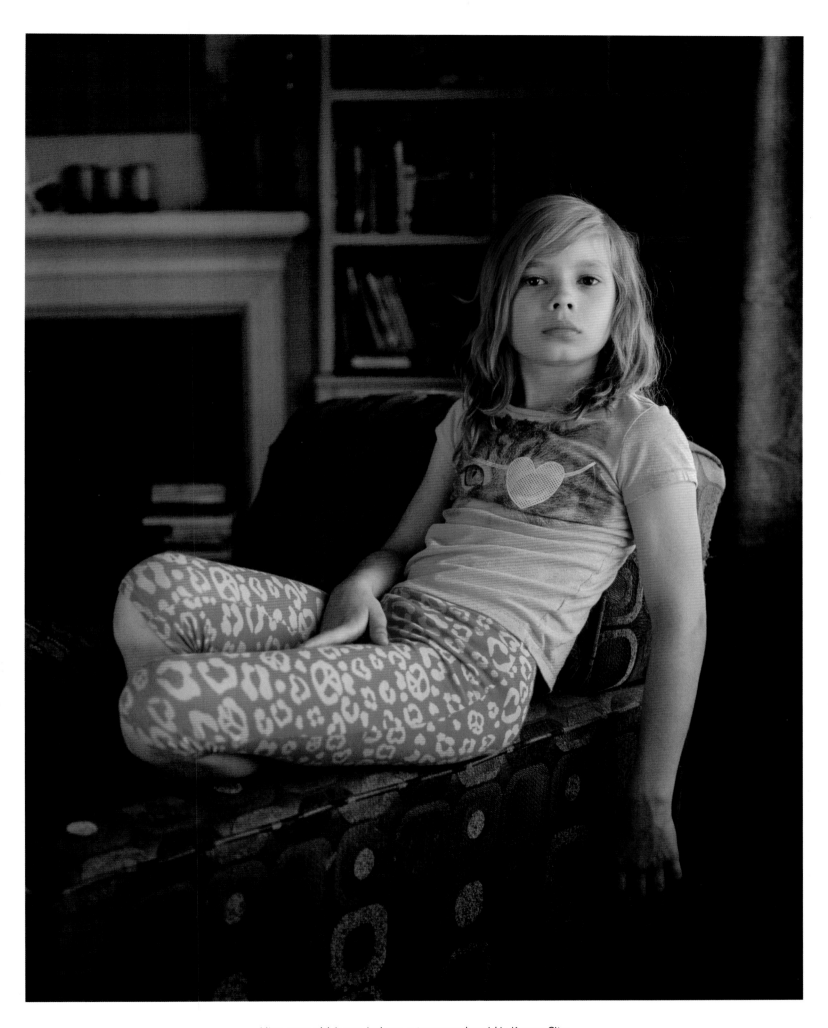

Nine-year-old Avery Jackson, a transgender girl in Kansas City, says "Everything about being a girl is great." **Robin Hammond, 2016**

Residents of San Miguel de Allende, Mexico, participate in the Day of the Dead parade. *Kirsten Luce, 2016*

Karambu Ringera, founder of the International Peace Initiatives in Meru, Kenya, takes a moment to ponder the future. *Greg Davis, 2016*

PORTRAITS

OF

POWER

*Feminism is very much about being able
to live a full and dignified life—
and if that's the definition of feminism,
I can't imagine why anyone
would be against it.*

ALICIA GARZA

Alex Morgan, photographed by Erika Larsen on Hermosa Beach, California, December 17, 2018

ALEX MORGAN

For someone who just turned 30, Alex Morgan has a long and varied résumé. Her soccer prowess has made her an Olympic gold medalist and a 2015 FIFA Women's World Cup champion. She was voted U.S. Soccer Female Player of the Year for 2018 (and 2012). She's been named Player of the Year four times, including in 2018, for the FIFA confederation that includes the Caribbean and North and Central American associations. She's been on *Sports Illustrated*'s cover once, holding a FIFA trophy—and in its pages twice, modeling in its annual swimsuit issue. She's written a series of soccer-themed novels for preteen girls, and she plays forward for the Orlando (Florida) Pride in the National Women's Soccer League. She is also at the front, with her U.S. soccer teammates, of the fight against gender discrimination in her sport.

NATIONAL GEOGRAPHIC: What would you say is your greatest strength?

ALEX MORGAN: My greatest strength is feeling confident enough to know I can always bet on myself. When I set my mind to something, I never stop working until I accomplish it and feel like I've reached my full potential. Additionally, throughout my career, I have always made sure I surround myself with people I can trust to support that ambition, and who serve as a sounding board to advise me and ground me through every decision I make, personally and professionally. They aren't people who will just tell me yes, but people who tell the truth, who state their opinions and have my best interests at heart. They help me hear what I need to hear, and not just what I want to hear.

NG: Have you had what you'd call a breakthrough moment in your life?

AM: Absolutely. My breakthrough moment was in March 2016 when four of my U.S. Women's Soccer teammates and I filed a federal wage discrimination complaint with the Equal Employment Opportunity Commission against our employer, U.S. Soccer, over pay and working conditions. As of March 2019, the EEOC still had not issued a ruling—so 28 of us filed suit in the U.S. District Court against U.S. Soccer, seeking an end to the institutionalized gender discrimination that the women's team has endured for years. The court filing describes practices and policies of discrimination against women players including paying us less than the men's team players for substantially equal work and denying us at least equal playing, training, and travel conditions and promotion of our games. Going public about the discrimination and bringing this to people's attention has helped the team—and I realize how much support we have from our families, friends, fans, and the

men's team, which has been incredibly meaningful to us. As professional athletes, we have a responsibility to all the little girls around the world who look up to us. We want those coming up after us to understand how important it is to come together and use your voice and influence for the greater good. We want to change the narrative for women in sports and have an impact on history.

NG: What are the biggest hurdles you had to overcome?

AM: As an athlete, the biggest hurdles I've had to face are injuries. These injuries have come in waves throughout my career and they have tested me mentally and physically. It's so hard when there is a physical barrier preventing you from doing your job and holding you back from what you love. It's hard on your mental health; it feels out of your control, but you have to trust that your body will heal the way it's supposed to. It also can be extremely frustrating to get back to your peak performance level after being out for so long. Ultimately, I've found that these experiences have been valuable to my career because once you make it past the injury, you come out stronger mentally and physically.

NG: Do you consider yourself a feminist?

AM: Yes, absolutely. As a female soccer player, I see and live through the gender disparities every day in our sport. We fight for respect every day within the game of soccer—every day! With our complaint filed with EEOC, my teammates and I are fighting for equal play for equal pay, an issue that I know can apply across many different industries. Women should be compensated fairly alongside their male counterparts. My team's specific situation alone

All too often, as women, we feel empowered to set goals for ourselves, but we don't feel comfortable aggressively trying to achieve them. We're shamed or criticized or perceived as "too ruthless."

would be reason enough to consider myself a feminist, but I stand alongside women fighting for their rights in their respective situations all over the world. While we have witnessed some progress, there is still a long way to go.

NG: What do you think is the single most important change that needs to happen for women in the next 10 years?

AM: The single most important change is getting more women in senior roles and putting women in positions of power, where they can implement policies that lead to long-lasting change. That means a woman being paid a dollar to every dollar that a man makes. And that means having fair maternity and paternity benefits for people who want to

have families: That's a necessity. The addition of fair and equal paternity leave would really help women in the workforce and alleviate stress and stigma.

NG: What is the most important challenge facing women today?

AM: There are so many challenges facing women today across the globe. One of the ones I feel is most important—in the workforce and in our personal lives—is that women need to feel unapologetic about going after their dreams, whatever they may be. It's a cultural shift and change of mind-set across our society that needs to happen. All too often, as women, we feel empowered to set goals for ourselves, but we don't feel comfortable aggressively trying to achieve them. We're shamed or criticized or perceived as "too ruthless." We need to feel comfortable and supported pursuing our dreams, and unapologetic going after what we want.

NG: What living person do you most admire?

AM: I'll name two: tennis champion Billie Jean King and former first lady Michelle Obama. Billie Jean King is someone I have looked up to and admired for being the best in her sport—but not being comfortable or content with only that. Billie Jean King campaigned for years for equality for women in sports. She led the effort that resulted in Title IX becoming law in 1972 and prohibiting sex discrimination in all federally funded school programs, including sports. She opened up so many opportunities for women in sports, and I am in awe of all she has accomplished. And Michelle Obama is someone who is not afraid to share her opinion, is not afraid to share her vulnerabilities—she is such a badass woman! I gravitate toward her; I strive to make decisions like her. She takes everything in stride, and has flawlessly dealt with the adversity she faced in her life. She's an incredible, magnetic person.

NG: What do you think is your most conspicuous character trait?

AM: Empathy. As someone who has played sports from a young age, I love to be on a team and work in a collaborative environment. I am able to connect with people on a deeper level because I have this natural pull to put myself in other people's shoes. When I'm making a decision, I go through all the what-ifs; I want to be sure I've considered how the decision impacts other people in my life.

NG: Where are you most at peace?

AM: I would say I'm most at peace when I'm at home with my husband and my dog. That's the place where I smile and laugh and enjoy my life the most.

NG: Last question: If you could give advice to today's young women, what would it be?

AM: Don't be discouraged in your journey. If people talk badly about you, if people say you can't achieve something, don't let it discourage you; let it drive you and steer you forward. No matter where you're at in life, or what you are trying to accomplish, people will always have their opinions. Listen to yourself, listen to your gut, and listen to the people in your life that you trust. Let your passions be your guide. ■

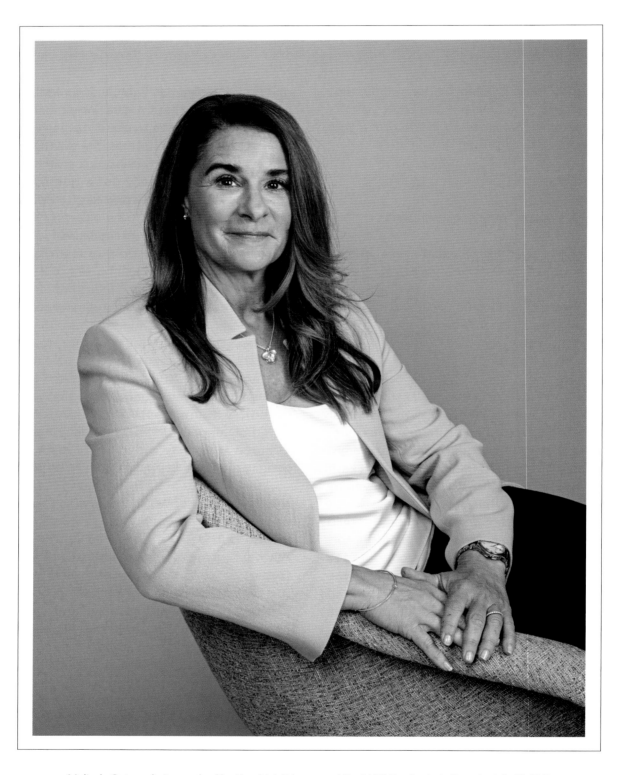

Melinda Gates, photographed by Kendrick Brinson and David Walter Banks in Seattle, July 31, 2018

MELINDA GATES

When multibillionaire Warren Buffett announced in 2006 how he'd disburse his fortune, most of his donation went to one philanthropy he said is run "with both head and heart." That's the Bill & Melinda Gates Foundation, which Melinda Gates co-chairs. A Dallas native, Melinda French joined Microsoft Corporation in 1987 straight out of Duke University, where she earned two bachelor's degrees and an MBA in five years. Employed in product development, she met Bill Gates at a Microsoft company picnic in 1988. They married in 1994 and formed the forerunner to what is now the world's largest private foundation. Since leaving the corporation in 1996, Melinda Gates has focused on family (the couple has three children) and the foundation's work, especially its efforts to improve the health, education, and economic status of women. In 2017 she penned an op-ed for *National Geographic* advocating access to contraceptives for the more than 225 million women around the world without modern reproductive healthcare. And in 2016 she and her husband were awarded the Presidential Medal of Freedom by Barack Obama, the highest civilian honor in the United States.

NATIONAL GEOGRAPHIC: What is the most important challenge facing women today?

MELINDA GATES: There isn't a country on Earth where women have achieved true equality, and the barriers they face look different in different places. But no matter where you are in the world, understanding these barriers is the first step to dismantling them—and that requires making a concerted effort to gather better data about women and their lives.

When I first started working in global health and development, I was shocked to learn how huge the gaps in the data are. We don't have reliable information about how many girls are going to school, how many women have the chance to earn an income, what their health and safety looks like, and whether they're dying preventable deaths. And without that data, we can't design effective policies or interventions to meet women's needs. In 2018, data is power. We won't be able to close the gender gap without first closing these critical gender data gaps.

NG: What do you think is the single most important change that needs to happen for women in the next 10 years?

MG: You could answer this question a lot of different ways, but there is strong evidence that helping women exercise their economic power is one of the most promising entry points for gender equality. When women have the chance to earn an income and exercise decision-making power over the money they make, it changes everything for them and for their families. One study found that when mothers in Brazil had control over their family's money, their children were 20 percent more likely to survive. That's an astonishing statistic.

NG: A few questions about you, now. What are the biggest hurdles you've had to overcome?

MG: I went to an all-girls school where we were told every day that girls could do anything. But, like a lot of women, when I got into the workforce, I realized the rest of the world hadn't quite caught up to that message. When I started at Microsoft, I was often the only woman in the room, and that can have an effect on you. These days, I spend a lot of time thinking about the biases and barriers women encounter in the workplace. From a policy perspective, I think there's a lot more we could be doing to make sure that women are equally empowered to succeed at work—paid family and medical leave, for one.

NG: Have you had what you'd consider a breakthrough moment?

MG: When Bill and I got engaged in 1993, we celebrated by taking a trip to East Africa—our first trip to that continent. We were excited to go on a safari and see the savannah and have a whole range of experiences we'd never had before. But what really moved us were the people we met. It was the first time we confronted the realities of extreme poverty and

> *When women have the chance to earn an income and exercise decision-making power over the money they make, it changes everything for them and for their families.*

the human potential it destroys. What we saw on that trip inspired a lifelong conversation about how we could use the resources from Microsoft to contribute to a better, more equal future.

NG: What do you consider your greatest strength?

MG: I draw a lot of strength from family—and from my kids in particular. I've known almost my whole life that I wanted to be a mother, and when I had my children, they changed everything for me. I stayed home with them when they were young, but they're also the reason I decided to take on a more public role at our foundation. I wanted them to see me out there in the world living my values and doing everything I could to put my beliefs about equality and social justice into action. I

love them first and foremost for who they are, but also for who they make me want to be.

NG: Do you consider yourself a feminist?

MG: Absolutely. I'm proud to say I'm a feminist, but I also think that being a feminist isn't just something you say; it's something you do. I feel that I have an obligation to use my voice to advocate for equality and to speak out against unequal power systems. And I try to use every platform I can to amplify the voices of other people—men and women—who want to play a role in advancing those conversations.

NG: What living person do you most admire?

MG: Former U.S. president Jimmy Carter, Archbishop Desmond Tutu of South Africa, and activist Malala Yousafzai all come to mind. I've always been inspired by the clarity of their values and their consistency in living up to those values.

NG: Which historical figure do you most identify with?

MG: I have enormous admiration for [19th-century English mathematician] Ada Lovelace. In the earliest days of computers, when most people thought of them as very basic calculators, she predicted that their powers could eventually be applied to "all subjects in the universe." She wrote that in 1842!

NG: What advice would you give to young women today?

MG: Fitting in is overrated. I spent my first few years at my first job out of college doing everything I could to make myself more like the people around me. It didn't bring out the best in me—and it didn't position me to bring out the best in others. The best advice I have to offer is: Seek out people and environments that empower you to be nothing but yourself.

NG: What is your most conspicuous character trait?

MG: That's a hard question to answer about yourself. I like to think that it's my optimism. I would hope that the people around me see me as someone who is willing to confront the complexity of some of the really difficult challenges the world faces without losing hope that things can get better or my belief that we need to engage in the work of helping make it better.

NG: And finally: Where are you are most at peace?

MG: There's nothing like floating down Seattle's Lake Washington in a kayak. I try to meditate a few minutes each morning to create some peace for myself. ■

Amani Ballour, photographed by Stine Heilmann in Gaziantep, Turkey, January 12, 2019

AMANI BALLOUR

On Amani Ballour's social media accounts, some of her posts are routine—for example, noting milestones like her 2012 medical degree from the University of Damascus. But many more of the pediatrician's posts are unsettling, even heartbreaking: scenes from Syria, where regime forces and rebels have been fighting since 2011. There are photos of injured patients—mostly children—at the hospital Ballour managed in Eastern Ghouta, outside Damascus; and photos of the corpses of children, many of them victims of chemical attacks. Often, there are tweets in political support for Syria's freedom or thoughts about Al Ghouta, the home she was forced to leave behind. After years of "shelling and daily killings" in Eastern Ghouta, Ballour says, the government routed residents from the rebel stronghold; since late 2018, she's been serving patients in North Ghouta, Syria. Ballour has been on the forefront of calls to action—speaking to media and from her own accounts about the horrors her country faces—and the hope for real change. Even in desperate times, some in majority-Muslim Syria don't want to see a woman doctor, Ballour says. She believes that, with effort, women "can change this reality . . . but it will always be this way if we remain scared, staying home."

NATIONAL GEOGRAPHIC: What would you say is your greatest strength?

AMANI BALLOUR: My greatest strength is my confidence in myself. I faced and overcame a lot of difficult things in the war and the siege in Syria—and in my society, which is controlled by men. I was the first woman to reach an important position of central hospital leadership, at a very critical time. I support other women in their work, so we all can succeed in our professions. I believe in what I do, because I am driven by humanity—and I believe that truth will triumph in the end.

NG: Can you identify a breakthrough moment in your life?

AB: During my time as head of the hospital in Eastern Ghouta, I succeeded in building trust with my staff of both women and men. That was a big achievement, as it is unusual in our society for a woman to be in charge.

NG: Of the hurdles you've had to overcome, which were the most difficult?

Jennifer Doudna, photographed by Erika Larsen in Berkeley, California, January 10, 2019

JENNIFER DOUDNA

When Jennifer Doudna was in the sixth grade, her father gave her a copy of *The Double Helix* by DNA pioneer James Watson, and she was hooked. As a biochemistry graduate at a small California college, Doudna says she was "sort of amazed" to be accepted for graduate studies at Harvard. There she contributed to pioneering research on RNA, a field that became her passion. Doudna spent years investigating an unusual molecular sequence—acronym, CRISPR—and how it functioned. In 2011 she and microbiologist Emmanuelle Charpentier joined forces in research; the next year, they published revolutionary findings on how CRISPR, combined with an enzyme, Cas9, can cut DNA strands with surgical precision. The result: a gene-editing technique that's been called the most significant scientific breakthrough of the past century. Now a professor at UC Berkeley, Doudna continues her research and advocates for ethical standards in the use of gene-altering technologies.

NATIONAL GEOGRAPHIC: Let me just dive right in, and ask you: Do you consider yourself a feminist?

JENNIFER DOUDNA: That's a great question. I'd say that I'm a budding feminist, and I'll tell you why. Earlier in my career, I was very, very keenly interested in not being seen as a "female scientist," but just being viewed as a scientist, gender neutral—somebody who was professional and dedicated to what I was doing, but not given any particular advantages or disadvantages based on my gender. I think that's how many people feel about being identified with a particular group: They want to be valued for who they are as a person, fundamentally, and what their contributions are, rather than being given some kind of special dispensation for things that were out of their control according to their birth.

So, that was true for me, probably through my 40s. But over the last decade or so, I've seen—up much closer to me—this kind of bias that happens. It's mostly unintentional, but I do see bias against women. And that has made me much more aware of the importance of being very open about the challenges that women face, the ways that women are viewed in the national and international media, and the way different cultures are portraying women, in their professional roles especially. We need to continue to discuss these issues and ensure

that women feel welcome and enabled to contribute fully to society in whatever way they feel is important to them—whether it's through being moms, or being involved professionally, or some combination.

NG: What do you think is the single most important change that needs to happen for women in the next 10 years?

JD: Hmm, what would I say? There's lots of cliché answers to that, like better child care or more access to equal pay for equal work. I think it really comes down to women feeling that they are welcome in all sectors of professional life—and that includes in business, in boardrooms, and in leadership roles in companies, as well as in academia, my line of work. There continues to be a need for women to be included at those highest levels of leadership, since right now we're excluding a large fraction of people because they don't feel enabled or they don't feel welcomed to contribute. Among the women that I oversee as an academic adviser at a large public university, I frequently see women who doubt their abilities. I don't know if it's a cultural thing, but I think women much more than men in general tend to doubt their abilities—whether it's their ability to succeed in a course, or to be successful applying for a fellowship, for a job or a promotion, all the way up to the very highest levels of leadership in corporate America.

NG: It's so true. I had a young woman ask me the other day, "What do you do when you get imposter syndrome?" [This term, coined by psychologists in the 1970s, refers to people who doubt their talents or fear they are frauds, despite accomplishments proving otherwise.] I told her, well, I just try to plow through it, act confident, keep going. But you'd rarely have a man ask anything like that.

Walk into a room like you own the place. A man would do that without compunction.

JD: Exactly. So we have to change that somehow.

NG: To switch gears a little bit: What historical figure do you identify most with?

JD: Probably Dorothy Hodgkin [the British chemist who won the 1964 Nobel Prize in chemistry for her use of x-rays to determine the structure of penicillin and other important biochemicals]. I read a biography of her a few years ago and it really struck me how she had faced all sorts of challenges as a woman in her profession. She had a family, but to conduct her work she had to live for long periods of time apart from her children. Just imagine how challenging that would be, but how driven she was—to be the best and to really do her work at a high level, but also to be a responsible mother and spouse. It really affected me.

NG: And what about a living person?

JD: It might be Michelle Obama. I think she's amazing from everything that I've seen and read about her. She is just the most dignified woman—incredibly smart, very accomplished professionally, seems to be a wonderful wife and mother. She embodies the classiness that I aspire to myself.

NG: You're the second person I've talked to who's said that.

JD: I'm not surprised.

NG: Now, what is your own breakthrough moment?

JD: If you're asking about a moment that changed the trajectory of what I've done professionally as a scientist, the one that really stands out is during the time I was beginning graduate school at Harvard. I was from a small town in Hawaii, a public-school product, and I was sort of amazed to find myself at this graduate program at Harvard Medical School. There was a wonderful afternoon I was feeling not particularly self-confident about my abilities to succeed in this environment with a lot of very smart people around me, when my adviser, Nobel Laureate Jack Szostak, came up to me and wanted to get my opinion on an experiment. Can you imagine being a graduate student and being asked by someone who seemed light-years away in achievements and ability asking for my opinion about an idea? It made me realize that my opinions were valued; he trusted me, so maybe I should trust myself.

NG: What do you think is your greatest strength?

JD: Oh, probably my stubbornness. I get an idea in my mind and I don't want to give it up. It's something that probably hurts me at times, but I think stubbornness is a quality that has allowed me to do a lot of the things that I have done in science.

NG: So what are the biggest hurdles you had to overcome?

JD: Just doubts that I've had at various times. Wondering, "Do I really have the ability to become a biochemist and be a successful scientist?" My definition of success was not success in terms of monetary reward or even professional recognition. It was more at the level of, "Can I actually do science that I'm going to be proud of? And can I feel like I've made the right choice with my life, that I decided to do something that I can actually do well?" There were a number of times when I was younger when I thought maybe the answer is no and maybe I'm on the wrong track. And again, my stubbornness came into play, because I'm also not a quitter. So I'd have voices in my head doubting what I was doing—but then I'd have contradictory voices saying, "But you're not going to quit." I'm stubbornly going to continue to do this because I think it's the right thing to be doing. I think, at some level, we all face these doubts and have to figure out ways to overcome them.

NG: What advice would you give to young women today?

JD: First: walk into a room like you own the place. A man would do that without compunction. The other thing I tell them is to choose your life partner wisely. Having a partner in life who is supportive of you—of decisions about children, about careers, about lifestyle—goes a long way in enabling women to achieve their full potential. ∎

Asha de Vos, photographed by Mark Thiessen in Washington, D.C., June 13, 2018

IN CONVERSATION WITH

ASHA DE VOS

Asha de Vos has stopped at nothing in her mission to become a marine biologist. Low on cash after graduating from college in Scotland, she worked in potato fields to save money so she could travel to New Zealand, where she lived in a tent for six months and worked on conservation projects. She later made her way onto a whale research vessel bound for her native Sri Lanka by writing to the researchers every day for three months, until *no* turned into *yes*. In the Maldives, she was permitted to join the vessel on its trip around the globe—as a deckhand. But she soon earned a position as the team's science intern and was allowed to stay on for the duration of the voyage. On that vessel, she encountered the marine mammals that have become her passion: Sri Lanka's blue whales. The first and only Sri Lanka native to have earned a Ph.D. in marine-mammal-related research, de Vos has dedicated herself to studying the whales and the many threats they face, from ship strikes to pollution. Through a Pew fellowship, she is paving a way for others to follow, building what will be Sri Lanka's first marine conservation research and education organization.

NATIONAL GEOGRAPHIC: What do you think is the most important challenge facing women today?

ASHA DE VOS: I'd say it's the fact that women have started to take leadership roles and move forward at a faster pace than men are able to handle. Men are starting to learn that women can take on these leadership positions, and see the potential for women to really change the world—but, somehow, there's a lag. So at the moment, we're still struggling with trying to bring everyone up to speed and create that equality.

NG: Does this lag arise from some men still thinking that women can't do things that men can do?

AD: There's definitely that. Sometimes where I come from, Sri Lanka, there's almost amazement when women achieve things. With my work, for example, most people say things like, "Yeah, but you're doing a man's job, right?" They're not considering the fact that it doesn't matter who you are or what your gender is. If there's a job to be done, anybody can and should be able to do it. At some point we will value women

and diversity and the fact that you don't have to be a man to do some of the stuff we do.

NG: So what do you think is the single most important change that needs to happen for women in the next 10 years?

AD: I think there has to be more role modeling of women—for men and for women, for boys and for girls. The achievements of women have to be showcased with as much excitement as those of men, and not just to women. Women shouldn't be role models for only women and girls; women should be seen as role models for boys as well. That can change things for future generations.

NG: All right let's turn to you. What were the biggest hurdles that you had to overcome?

AD: First of all, I was creating a sort of new field in Sri Lanka; marine conservation was pretty unheard of before I started. Even Sri Lankans were curious about what I would do with a degree in marine biology, despite this being a beautiful tropical island surrounded by warm tropical seas waiting to be discovered. I think that's partly because we come from a culture of exploitation when it comes to the ocean, but we've never had a culture for protection. So that was one of the big things, trying to change that mind-set. And I have gotten a lot of backlash; I've had men try to stop me from getting permits, and I've been threatened by people for doing this work. Because my research is about conservation and trying to stop whales from getting killed by ships, there are people who felt that I was trying to get in the way of the country's economic development, which was never the case. Protecting a species that a country has come to depend on is a positive thing.

Try to be defined not by your gender, but by your capacity. The harder you work, the more you throw yourself into something you're passionate about, the more your work starts to speak for itself.

The other challenge is that marine conservation is very, very Western-centric: almost perceived as a field that belongs in the developed world. And as someone from a tiny little island in the developing world, when I started talking about this work I had lots of people who wanted to come and take over. So when I discovered that there's a population of blue whales that were staying all year round in our waters, I wanted to dedicate my life to understanding this population and protecting them. When I reached out to researchers across the world who worked with similar species, their main interest was to come and do the research themselves; they didn't

believe we had the capacity. So I had to prove myself, not just as a woman, but as a locally grown woman. And I also had to show that our country has the talent and is completely capable.

NG: Do you consider yourself to be a feminist?

AD: I wouldn't say I'm a feminist because I find the word *feminist,* unfortunately, has been used and abused in so many different ways. If you tell people you're a feminist—especially a man—I've noticed they just shut down. Oftentimes they say, "Oh you're a feminist. Feminists are bra burners, right?" That's the perception, these women who would just go gung-ho to the ends of the Earth to prove a point that women can do something better than men. I don't think it helps open doors and allow people to sit at the same table and have a causal conversation as it was intended to do in the past. It's a bit unfortunate; maybe it's time for a new word.

I always tell people I'm an equalist, which, you know, by definition is exactly the same thing. I believe that everyone should be equal—men and women. I think the point is not that women are better, it's that we can all do it. We need to all be on a level playing field if we want to make any progress. I want to make sure that everybody sits at the table as an equal and can have a part in the conversation.

NG: What would you say is your greatest strength?

AD: My passion for storytelling. Eight years ago, most of the country didn't even know we had whales in our waters. Today, they're a species that's celebrated as almost a symbol of our country.

NG: Is there a historic figure that you most identify with?

AD: Not really. For me, my role models would be my parents. I always tell this story, but when I was young—maybe five, six years old—my mom turned to me one day and she said, "You know, if we can educate only one child, it would be you. Your older brother is a boy, and the system is created to support boys. But it doesn't necessarily support girls, and I want you to stand on your own two feet." At the time, it didn't really make sense to me, but as I've gotten older I've realized how huge that was: the confidence that she had in me from a young age, the idea that I was of equal value.

And what I do also wouldn't have been possible without my father, who, though he comes from a typical South Asian family, always told both my brother and me, "I will give you a good education, but you have to promise me that you'll do something that you love." Because of my parents, we had wings. It was empowering; I believed I could do whatever I wanted to do, and that's helped me become who I am.

NG: That's a great story. What advice would you give to young women today?

AD: I would say, try to be defined not by your gender, but by your capacity. The harder you work, the more you throw yourself into something you're passionate about, the more your work starts to speak for itself. That's actually what's helped me. At the start everyone was like, "But you're a girl." And today, nobody cares what I am. I am a necessity: The system needs me to help to make changes. I would say to any girl out there, that's what you want to aim for; to be defined not by your gender, but by your capabilities. ■

Donna Strickland, photographed by Erika Larsen in Washington, D.C., November 28, 2018

DONNA STRICKLAND

After earning a bachelor's degree in engineering physics in her native Canada, Donna Strickland went to New York's University of Rochester to pursue a doctoral degree in optics—essentially, the science of light. With her doctoral supervisor, Gérard Mourou, Strickland developed technology to produce ultrashort, high-intensity laser pulses. She was just 26 when she published a scientific paper—her first—on the technique, which she and Mourou called "chirped pulse amplification," or CPA. More than three decades later, CPA has revolutionized lasers' use in delicate eye surgeries, material sciences, and other realms. Shares of the 2018 Nobel Prize in physics went to Mourou and to Strickland—only the third woman to receive it (Marie Curie was the first, in 1903; Maria Goeppert Mayer the second, in 1963). Strickland's now an experimental physics professor at the University of Waterloo in Ontario, and has served as president of the Optics Society of America.

NATIONAL GEOGRAPHIC: What do you think is the single most important change that needs to happen for women in the next 10 years?

DONNA STRICKLAND: Actually what I would like to see is that, in the next 10 years, if we really have made it, that we won't even have to talk about it. I think that's really the point that we want to get to. I am a little surprised at the big deal this has made, that I am the third woman to win the Nobel Prize in physics; I had not even realized that I was. But also what I don't want—and what I do sort of see—is this huge pendulum swing: To try to get women ahead, we're leaving some men behind. There are far more women at university now than we've ever had, and in many of the disciplines women are outnumbering the

men now. At some point we have to start worrying about why boys are not going, because we want everybody there who should be there.

NG: Do you consider yourself a feminist?

DS: I actually don't quite know what the word *feminist* means. I grew up in the women's lib era and I certainly bought into the women's lib of the '70s; I just thought what they were saying is that I can do anything and be anything. I certainly bought into that, but I have to say that we somehow lost it. For example, I was asked around 1991 to be at a booth at an event on nontraditional careers for women. Probably our only female astronaut at the time was also there, so I wanted to be at her booth to hear what she was talking about—

everyone wanted to be at hers. But when people came to mine to hear what it was like to be a physicist, they all looked like they were just so, so bored. Then I said to them, "The one thing about being a woman physicist is that it's pretty easy to find a man, because the field's only 10 percent women." The next thing you know, they're all like, Really? Really? And I said, "That's the part you're interested in?" I mean, come on. Did we lose the whole thing in the '90s—women hearing you could do what you wanted to do—because somehow it switched: We were all too tired because we were trying to do everything? Now, feminism is so wrapped up with the #MeToo effort— and if women are feeling that they've had all of these things happen to them, it's time to stop it from happening. But I think that's separate from feminism, because to me feminism is about equal opportunity. I believe in that and I've always believed in that.

NG: So what are the biggest hurdles you have had to overcome?

DS: I've only had one big hurdle to overcome. Because most female scientists are married to male scientists, we face what physicists call the two-body problem, which is that you have two people in almost the same field trying to find jobs. There are very few science jobs in the world, you have two people wanting almost the same type of job, and you're trying to find jobs together. After we got married, I moved from Ottawa to California, whereas my husband stayed in New Jersey. I always joke about how a lot of people try living together before marriage, but we tried marriage before living together.

NG: It's hard to have a dual career.

DS: It is. I had a great research job, but after a

I grew up with parents who encouraged me: Do what you want to do and what you know you're good at. So that's my advice to everybody.

year I thought, "This is ridiculous. I'm married, I'm in my 30s, and if we want to have kids . . ." So I sort of took a step back from my career for that reason. A job as a member of the technical staff came up at Princeton, which really means that you're not on your own academic career, you're now a support person for other people's jobs. And I said, "Whatever. I'll do it." And it turned out to be a great thing because I got to have two children. I moved to Canada five weeks before having my second child and I took the next four months off. And then luckily, the University of Waterloo took a chance with me, because I had been out of the academic trajectory for four years. It's an unusual thing to do.

NG: So you were able to overcome that hurdle of stepping away, but were able to get back on track?

DS: I was lucky, yes. So I try and encourage young women when they're thinking about this and wondering about when they should have kids. I say, "Have kids when you want to have kids. If you're going to try to fit it into some career pattern, you may be sorry. When you know you're ready, have your kids, and let the chips fall where they may."

NG: That ties nicely into my next question: What advice would you give to young women today?

DS: I think the main thing is to know yourself. I knew who I was and what I was good at and what I wasn't good at. So it didn't infuriate me at all when people would say, "But those are boys' subjects."

NG: Did people say those things to you?

DS: I actually had a teacher say it to me in high school. Obviously, I knew I was going to focus on math and science, but I had to take some history and geography classes. [After a big project] I just leaned back and said, "Whew, I'm done. That's the last history I'll ever have to do." The teacher heard that and she said, "What are you going to do then?" And I said, "I don't know, but it's going to be in math and science." And right away she said, "Those are boys' subjects." As the student, I couldn't tell her, "That's a stupid thing to say." I turned to my male friend who was going into English or history and I said, "Do you know you like girls' subjects?" But I didn't ever stop and think, "Am I doing the wrong thing?" I grew up with parents who encouraged me: Do what you want to do and what you know you're good at. So that's my advice to everybody.

NG: What is your most conspicuous character trait?

DS: That I talk to much. Or I laugh too much.

NG: Is there a historic figure you most identify with?

DS: When they told me that I was one of only three women that had gotten the Nobel Prize in physics, everybody knows one of the other women is Marie Curie. Everybody. But not everybody knows Maria Goeppert Mayer. Of course, it was her Nobel Prize–winning work that I actually cited in my own Ph.D. I find that quite remarkable. People will forget my name too, for the same reason. There's only ever the first, right? And Marie Curie is more than just the first: She's still the only person, man or woman, to win a Nobel Prize in two different categories. She won in both physics and chemistry.

NG: Is there a living person you admire?

DS: Angela Merkel, because she's a scientist who is working in the political realm, which I find amazing. She's taken her scientific approach to politics and tries to reason out her ideas rather than using emotions. And I think she's been an incredibly strong and effective leader for Germany, and even the world. I hope the world can find more leaders like her. ■

Interviews have been edited for length and clarity.

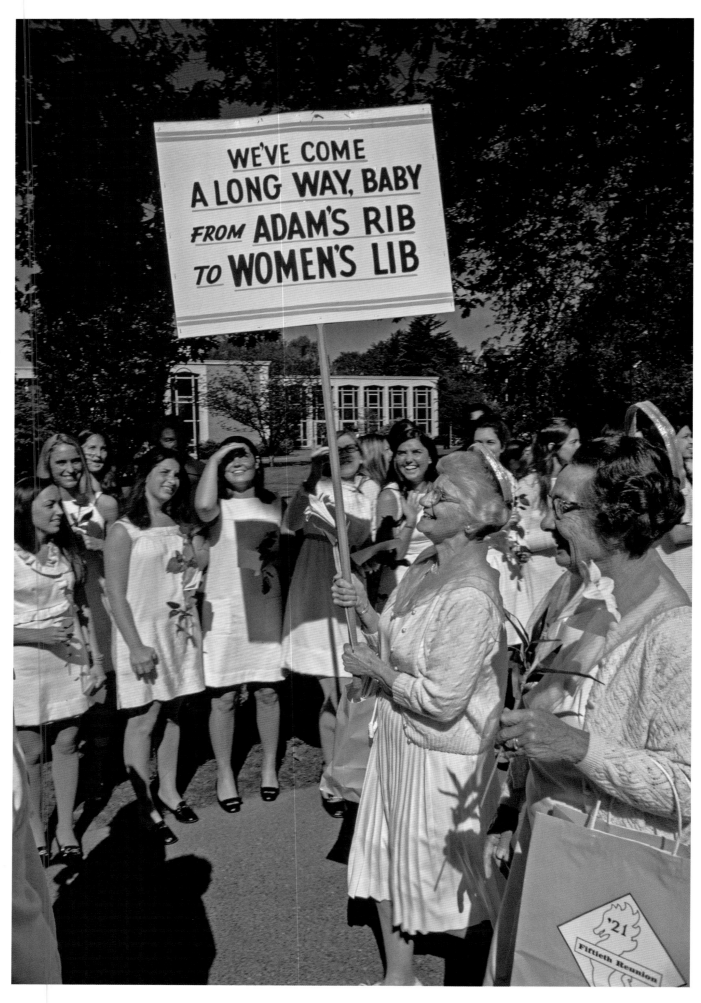

Smith College alumnae march before new graduates in Northampton, Massachusetts, emphasizing the strides that women have made. **David Arnold, 1972**

CONTRIBUTORS

Putting together *Women: The National Geographic Image Collection* was no easy feat. We are forever grateful to the talented photographers—across 150 years of the Image Collection's archive—who contributed their work to these pages. Along with the historical and modern photographs in this collection, 17 of our female National Geographic photographers shared personal stories about their images featured as Through the Lens photographs throughout the book.

JEAN CASE, the National Geographic Society's Chairman of the Board of Trustees, is an actively engaged philanthropist, investor, and a pioneer in the world of interactive technologies. She and her husband, Steve Case, created the Case Foundation in 1997, which has been recognized for its innovative efforts to address significant social challenges through entrepreneurship, innovation, and technology. Before co-founding the Case Foundation, she spent her career as a technology executive. Case was named Corporate Philanthropist of the Year by *Washington Business Journal* and received the Lifetime Achievement Award from the Harvard Business School Alumni Association of Washington, D.C. *(foreword, page 12)* ◼

SUSAN GOLDBERG is the editorial director of National Geographic Partners and editor in chief of *National Geographic* magazine. Under her leadership in 2017, *National Geographic* was a finalist for a Pulitzer Prize for Explanatory Reporting for its issue about gender, and the magazine has continued to win numerous other awards for photography, storytelling, and graphics every year. In March 2015 she received the Exceptional Woman in Publishing Award. Before her employment at National Geographic, Goldberg served as executive editor for federal, state, and local government coverage for Bloomberg News in Washington. In 2013 she was also voted one of Washington's 11 most influential women in media by *Washingtonian* magazine; in 2017 *Washingtonian* named her among the most powerful women in Washington across professions. *(introduction, page 15)* ◼

LYNSEY ADDARIO is a photojournalist who regularly works for *National Geographic,* the *New York Times,* and *Time* magazine. With no previous training, she began photographing professionally for the *Buenos Aires Herald* in Argentina in 1996. Addario first traveled to Afghanistan in 2000 to document women living under the Taliban and made three separate trips to the country before September 11, 2001. Over the past 15 years, Addario has covered every major conflict and humanitarian crisis of her generation, including those in Afghanistan, Iraq, Darfur, Libya, Syria, Lebanon, South Sudan, Somalia, and Congo. She is the author of the *New York Times* best-selling memoir *It's What I Do,* a chronicle of life as a photojournalist in a post-9/11 world. *(page 386)* ◼

EVGENIA ARBUGAEVA was born in the small town of Tiksi, located on the shore of the Laptev Sea in Russia. Her photographic work often looks into her Arctic homeland, discovering and capturing the remote worlds and people who inhabit them. Her work has been published in *National Geographic,* the *New Yorker,* and *Le Monde,* among other publications. She is the recipient of the ICP Infinity Award and the Leica Oskar Barnack Award. *(page 376)* ◼

KITRA CAHANA was born in Miami Beach, Florida, and spent her formative years between Sweden and Canada. At the age of 16 she moved to Israel to begin college and simultaneously was introduced to the world of photojournalism. One of her first photographs landed on the front page of the *New York Times,* where she later worked as an intern. Upon graduating from McGill University in 2009, she interned at *National Geographic.* The following year she won a prize in the World Press Photo contest. *(page 272)* ◼

JODI COBB spent three decades as a staff field photographer with National Geographic—the only woman to have held that position in its history. She has worked in more than 65 countries, documenting closed societies and disappearing cultural traditions. She was one of the first photographers to travel across China when it reopened to the West and the first to photograph the hidden lives of Saudi Arabian women and

Japanese geisha, and she exposed the brutal reality of people trapped in the tragic world of human trafficking. Cobb was the first woman White House Photographer of the Year and was named a "Nikon Legend." She was awarded the American Society of Media Photographers Lifetime Achievement Award, an honorary doctorate from the Corcoran College, and one of journalism's most prestigious honors, the University of Missouri Honor Medal for Distinguished Service in Journalism. *(page 144)* ■

KARLA GACHET was born in Quito, Ecuador. Her work has been featured in *National Geographic* magazine, *Smithsonian,* and the *New York Times*. She has published two books with her husband, Ivan Kashinsky, also a photographer: *Historias Mínimas: From Ecuador to Tierra del Fuego* and *Gypsy Kings*. Her photographs have won awards in competitions, including the World Press Photo, POY, and POYi Latin America, and have been exhibited in Ecuador, Guatemala, London, India, Peru, China, and the United States. Together with her husband, she created the collective Runa Photos, a platform for documentary photography. *(page 220)* ■

LYNN JOHNSON graduated from the Rochester Institute of Technology and was hired as the first woman staff photographer at the *Pittsburgh Press,* where she worked for seven years. Since then, she has climbed the radio antenna atop Chicago's John Hancock Tower, lived among fishermen on Long Island and guerrillas in Vietnam, and clambered around scaffoldings with steelworkers. Johnson is a regular contributor to *National Geographic* and has led workshops for refugees in Colombia and for young people at National Geographic Photo Camps. *(page 450)* ■

ERIKA LARSEN shot the majority of the Portraits of Power featured in this collection. She is a photographer and multidisciplinary storyteller known for her essays, which document cultures that maintain close ties with nature. Her work has appeared in *National Geographic,* including the 2016 single-topic issue *Yellowstone,* and the National Geographic book *Women of Vision*. Larsen has been a Fulbright Fellow for her study of the North Sami language, resulting in her first monograph, *Sàmi, Walking with Reindeer,* released in 2013. ■

SARAH LEEN is the director of photography for National Graphic Visual Media. For nearly 20 years before that, she worked as a freelance photographer for *National Geographic,* until 2004, when she joined the staff as a senior photo editor. She has published 16 stories and produced five covers for the magazine. As director of photography, Leen leads the photo and video staffs of *National Geographic* and *Traveler* magazines, as well as the National Geographic studio and the photo engineering department. She has won numerous awards for both her photography and photo editing from the Pictures of the Year competition and the World Press Photo Awards. *(page 130)* ■

NORA LOREK is a documentary photographer and regular contributor to *National Geographic*. Born in Germany, she has lived in Sweden since 2005 and holds a degree in photojournalism from Mid Sweden University. In addition to her regular assignments for newspapers she has been working on long-term projects with a focus on migration and human rights. Since 2018 she has been a member of Panos Pictures. She has worked on projects in refugee camps and informal settlements, accompanying refugees and migrants on their way along the borders of Europe and showing the solidarity of those in need of protection. In 2016 Lorek was the first Swede to win the College Photographer of the Year award, which led her to National Geographic and her ongoing projects in Bidibidi, Uganda, one of the world's largest refugee camps. She is the co-founder of the Milaya Project, a nonprofit that connects South Sudanese women in refugee camps with customers who want to support their traditional art form. *(page 442)* ■

DIANA MARKOSIAN is an Armenian-American photographer whose images explore the relationship between memory and place. She received her master's degree from Columbia University's Graduate School of Journalism. Her work has since taken her to some of the most remote corners of the world and has appeared in *National Geographic,* the *New Yorker,* and the *New York Times*. Markosian is the recipient of the Chris Hondros Emerging Photographer Grant, the Magnum Emerging Photographer Grant Fund, and the Firecracker Grant. *(page 286)* ■

HANNAH REYES MORALES is a Filipina photojournalist whose work focuses on individuals mired in complex situations created by inequality, poverty, and impunity, including human trafficking at sea and war crimes against Cambodians. Her work has been published in print and online in the *New York Times,* the *Washington Post,* the *Wall Street Journal, Time, National Geographic,* the *Guardian,* and Lonely Planet. She is a recipient of a Society of Publishers in Asia award for excellence in digital reporting for her work in the Outlaw Ocean series for the *New York Times*. She is currently based in Manila and travels around Southeast Asia. *(page 426)* ■

KATIE ORLINSKY was born and raised in New York City and began her career as a photographer in Mexico 13 years ago. She has photographed all over the world documenting everything from conflict and social issues to wildlife and sports. For the past five years Orlinsky's work has focused on climate change, exploring the transforming relationship between people, animals, and the land in the Arctic. Her work is frequently published in *National Geographic*, the *New York Times*, the *New Yorker*, and *Smithsonian* among others. She has won numerous awards over the course of her career from institutions such as the Art Director's Club, PDN30, Visa Pour L'image, and Pictures of the Year International. She was the 2016 Getty Images Grant for Editorial Photography winner and the 2016 Paris Match Female Photojournalist of the Year. She received a master's degree in journalism from Columbia University, and in 2018 was named the Snedden Chair of Journalism at University of Alaska Fairbanks. *(page 60)* ■

NINA ROBINSON is a documentary photographer, educated in Arkansas and New York. Her current work focuses on underrepresented communities, aiming to break the visual prejudices of race, class, age, and gender. Her work has been published in the *New York Times, National Geographic, Harper's* magazine, the *Atlantic, Manhattan* magazine, and the *Wall Street Journal.* In 2015 she developed a Photo-Therapy program at the William Hodson Senior Center in the Bronx, where, through the use of photography, older residents are able to openly explore personal and social issues. She continues to teach visual/social workshops like this in the American South. *(page 46)* ■

STEPHANIE SINCLAIR is a Pulitzer Prize–winning photojournalist based in the Hudson Valley, New York. She is known for gaining unique access to the most sensitive gender issues and human rights issues around the world. She contributes regularly to *National Geographic,* the *New York Times Magazine, Newsweek, Stern, GEO,* and *Marie Claire,* among others. She is the winner of numerous awards, including the Alexia Foundation Professional Grant, UNICEF's Photo of the Year, and the Lumix Festival for Young Photojournalism Freelens Award. *(page 72)* ■

MAGGIE STEBER was named one of 11 Women of Vision by *National Geographic* in 2013. Her work has taken her to 69 countries and has focused on humanitarian, cultural, and social stories. After working for more than three decades in Haiti she published her monograph *Dancing on Fire.* The winner of numerous awards, including the Guggenheim Foundation Grant in 2017 and the Leica Medal of Excellence, her work has been exhibited internationally and has been published in *National Geographic,* the *New York Times, Smithsonian, AARP,* the *Guardian,* and *GEO* magazine among others. Steber teaches workshops internationally, including at the World Press Joop Swart Master Classes, the International Center for Photography, and the Obscura Photo Festival. *(page 296)* ■

NEWSHA TAVAKOLIAN has had her work displayed at many international art exhibitions and museums, including the Victoria & Albert Museum, the Los Angeles County Museum of Art (LACMA), the British Museum, and the Boston Museum of Fine Arts. Her photographs have been published in *Time* magazine, *Newsweek, Stern, Le Figaro, Colors,* the *New York Times Magazine,* and *National Geographic.* In 2014 Tavakolian was chosen as the fifth laureate of the Carmignac Gestion Photojournalism Award and 2015 was chosen as the Principal Prince Claus Laureate. She became a Magnum Associate in 2015. *(page 112)* ■

AMY TOENSING is a photojournalist and filmmaker committed to telling stories with sensitivity and depth. She is known for her intimate stories about the lives of ordinary people. Toensing has been a regular contributor to *National Geographic* for 20 years, photographing the world from the last cave-dwelling tribe of Papua New Guinea to food insecurity in the United States. Her work has won numerous awards and has been featured in two solo exhibits at Visa Pour l'Image in Perpignan, France. Toensing was named the recipient of the 2018 Mike Wallace Fellowship in Investigative Reporting at the University of Michigan. She also teaches photography in underserved communities around the world including Pakistan, South Sudan, Kenya, and Jordan. *(page 396)* ■

AMI VITALE is a *National Geographic* magazine photographer, filmmaker, and Nikon ambassador. She has traveled to more than 100 countries, bearing witness not only to violence and conflict, but also to surreal beauty and the enduring power of the human spirit. In 2009, after shooting a powerful story on the transport and release of one of the world's last white rhinos, Vitale shifted her focus to today's most compelling wildlife and environmental stories. Winner of numerous awards, including being named one of 50 "Badass Women" by *InStyle* magazine, she recently published the best-selling book *Panda Love,* on the secret lives of pandas. *(page 230)* ■

Eight years after the Illustrations Library (today's Image Collection) was founded, a team of women led the charge in sorting and archiving National Geographic photography. **Charles Martin, 1926**

ABOUT THE NATIONAL GEOGRAPHIC IMAGE COLLECTION

The National Geographic Image Collection is one of the world's most significant photography archives. Its tens of millions of images capture the planet (and beyond) as explored by scientists, adventurers, writers, and photographers, from the 19th century through today.

The men who founded the National Geographic Society in 1888 did not aspire to create a world-class photo archive; at that time, photography was more the province of pulp publications than scholarly journals. But photographers with interesting images began bringing them to National Geographic: Photographer George Shiras came to the magazine's Washington, D.C., offices with about 1,000 shots of wild animals at night, which he had lit by mounting a flash on the bow of his canoe.

Some Society board members thought that photos were so lowbrow that in 1906, after the magazine published Shiras's pioneering shots, two board members resigned in disgust. But Society president Alexander Graham Bell and magazine editor Gilbert H. Grosvenor embraced the use of photos, which ever since have been at the core of the magazine's identity and mission.

As early 20th-century explorers and contributors traveled the world, they made images or purchased them from local sources and brought them to *National Geographic*. The photos formed unruly heaps on editors' desks—until 1919 when the Illustrations Library (today's Image Collection) was established. Meticulous librarians cataloged every photograph and artwork, filing them with typed field notes and organizing them geographically: first by continent, then country, then city, and finally by photographer. For 96 of its 100 years, the Image Collection has been headed by a woman.

The Image Collection's dedication to preserving history through photographs has made it an invaluable resource, and an essential reference to vanishing worlds. Governments, curators, and academics often find in our archive the only photographic record of a nation's early history, a lost culture, or an extinct species.

The archive houses important images made by a Who's Who of photographers: 20th-century shooters such as Margaret Bourke-White, Mary Ellen Mark, Ansel Adams, and Alfred Eisenstaedt, as well as the leading photographers today. It's also a visual record of some of humanity's greatest achievements: Amelia Earhart's flights and Jacques Cousteau's dives, Jane Goodall's findings about chimpanzee behavior and Bob Ballard's discovery of the wreck of the *Titanic*.

A vault at National Geographic's headquarters holds 11.5 million physical objects: photographs, transparencies, negatives, albums, glass plates, and autochromes, the first form of color photography. The film collection includes 500,000 films and videos. And the digital collection stores almost 50 million images on servers, with roughly 190,000 added to the archives every year. The archive's oldest photographs, circa 1870, are by William Henry Jackson, famous for his images of railroads and western U.S. landscapes.

Every addition to the Image Collection tells a piece of our world's story and furthers Alexander Graham Bell's mission for National Geographic: to illuminate "the world and all that is in it." ∎

ACKNOWLEDGMENTS

Women: The National Geographic Image Collection would not have been possible without the talent of a number of National Geographic's photo editors, designers, and editors. Thank you to National Geographic Books' editorial director and publisher Lisa Thomas, art director Sanaa Akkach, senior photo editors Moira Haney and Meredith Wilcox, deputy editor Hilary Black, creative director Melissa Farris, director of photography Susan Blair, senior editorial project manager Allyson Johnson, and senior production editor Judith Klein as well as National Geographic's director of photography Sarah Leen, photo editor Julie Hau, and senior content director Patricia Edmonds. Thank you also to our colleagues at the Image Collection—Alice Keating, Julia Andrews, Ashley Thomas, Susie Riggs, Lori Franklin, and Rebecca DuPont—who shared in our enthusiasm for this book and helped scour the archives and uncover many "firsts" for National Geographic women. For their time and effort, we owe our gratitude to Lauren McDonough, Tim Wendel, Nina Strochlic, Christina Nunez, Gretchen Ortega, Clayton Burneston, and Breann Birkenbuel. ◼

THE NATIONAL GEOGRAPHIC SOCIETY

The National Geographic Society is a global nonprofit organization that uses the power of science, exploration, education, and storytelling to illuminate the wonders of the world, define critical challenges, and catalyze action to protect our planet. Since 1888, National Geographic has pushed the boundaries of exploration, investing in bold people and transformative ideas, providing more than 14,000 grants for work across all seven continents, reaching three million students each year through education offerings, and engaging audiences around the globe through signature convenings and content. To learn more, visit *nationalgeographic.org*. ◼

ADDITIONAL CREDITS

Endpapers

First row, left to right: Joseph F. Rock; Wilhelm Tobien; Robert W. Madden; Wilhelm von Gloeden; Edward S. Curtis; Photographer unknown; Joseph J. Scherschel; Frank Hurley; Franklin Price Knott; Cihak and Zima; Edward S. Curtis; Luis Marden. **Second row, left to right:** Wilhelm von Gloeden; B. Anthony Stewart; Frederick Simpich; Hester Donaldson Jenkins; Ernest B. Schoedsack; Citroën Central African Expedition; Hester Donaldson Jenkins; Joseph F. Rock; Photographer unknown; Edward S. Curtis; William M. Zumbro; Barry Bishop. **Third row, left to right:** Adam Warwick; Edward S. Curtis; Maynard Owen Williams; Winfield Parks; Wilhelm Tobien; Eliza R. Scidmore; Underwood & Underwood; Edward S. Curtis; Eliza R. Scidmore; Maynard Owen Williams; Bruce Dale; David G. Fairchild. **Fourth row, left to right:** Photographer unknown; Charles Martin; Vera Watkins; Maynard Owen Williams; Wilhelm Tobien; Photographer unknown; Garrigues; Hans Hildenbrand; Lehnert & Landrock; Edward S. Curtis; Citroën Central African Expedition; Wilhelm von Gloeden. **Fifth row, left to right:** Jules Gervais-Courtellemont; W. Robert Moore; W. Robert Moore; Maynard Owen Williams; Maynard Owen Williams; Wilhelm Tobien; Maynard Owen Williams; Eliza R. Scidmore; Edward S. Curtis; Hans Hildenbrand; Dr. Joseph K. Dixon; Eugene Klein. **Sixth row, left to right:** Samuel M. Zwemer; Volkmar K. Wentzel; Jules Gervais-Courtellemont; Joseph F. Rock; Citroën Central African Expedition; Photographer unknown; Edwin L. Wisherd; Ella K. Maillart; Edward S. Curtis; Wilhelm Tobien; Frank Hurley; Wilhelm Tobien.

Interior

16, Martin Luther King, Jr. Memorial Library, Washington, D.C.; 17, Clinedinst Studio; 19 (UP), Photographer unknown; 19 (CT), Paul Zahl; 19 (LO), David S. Boyer; 20, Robin Hammond; 21 (LE), Hugo van Lawick; 21 (RT), Robert I. M. Campbell; 44-5, Panoramic Images; 51, NOOR for National Geographic; 90-91, Contact Press Images; 109, Kodak (Egypt) Ltd.; 126 (LO), Getty Images for National Geographic; 148, Royal Photographic Society/SSPL/Getty Images; 196, Library of Congress Prints and Photographs Division; 237 (UP), Magnum Photos for National Geographic; 265, © Brian Lanker Archive; 278, Official White House Photograph; 391, Magnum Photos; 404-405, Getty Images; 424-5, Getty Images for National Geographic; 440, University of Chicago Photographic Archive, [apf1-08637], Special Collections Research Center, University of Chicago Library; 453, Magnum Photos.

Since 1888, the National Geographic Society has funded more than 13,000 research, exploration, and preservation projects around the world. National Geographic Partners distributes a portion of the funds it receives from your purchase to National Geographic Society to support programs including the conservation of animals and their habitats.

National Geographic Partners
1145 17th Street NW
Washington, DC 20036-4688 USA

Get closer to National Geographic explorers and photographers, and connect with our global community. Join us today at nationalgeographic.com/join

For information about special discounts for bulk purchases, please contact National Geographic Books Special Sales: specialsales@natgeo.com

For rights or permissions inquiries, please contact National Geographic Books Subsidiary Rights: bookrights@natgeo.com

Financially supported by the National Geographic Society.

ISBN: 978-1-4262-2065-4

Printed in China

19/PPS/1

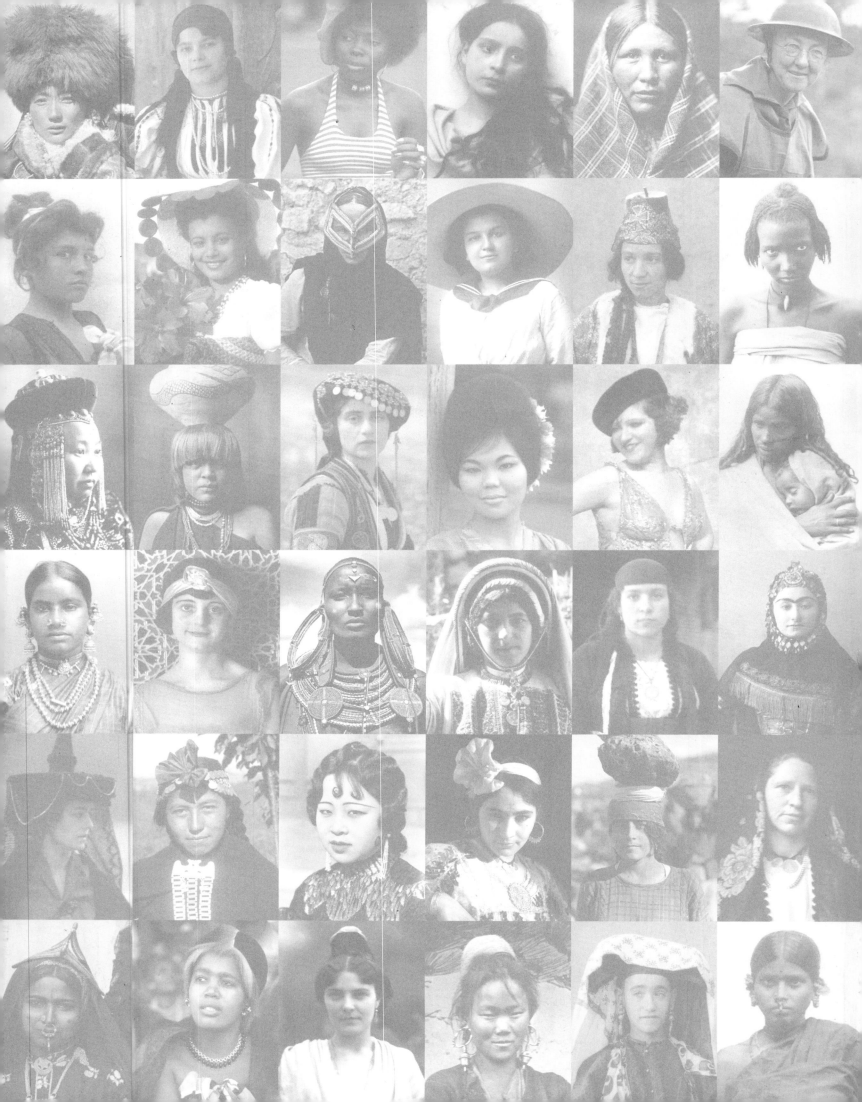